DATE DUE

OCT 1 2 2006			
JUL 2 6 2010			
DEC 1 2 2013			

CREATING CONNECTIONS BETWEEN NURSING CARE AND THE CREATIVE ARTS THERAPIES

CREATING CONNECTIONS BETWEEN NURSING CARE AND THE CREATIVE ARTS THERAPIES

Expanding the Concept of Holistic Care

Edited by

CAROLE-LYNNE LE NAVENEC, RN, PH.D.

and

LAUREL BRIDGES, MA (CMT), ADTR, MA (PSYCHOLOGY)

Cover Illustration by Michelle McGrath

CHARLES C THOMAS • PUBLISHER, LTD.
Springfield • Illinois • U.S.A.

Published and Distributed Throughout the World by

CHARLES C THOMAS • PUBLISHER, LTD.
2600 South First Street
Springfield, Illinois 62704

This book is protected by copyright. No part of
it may be reproduced in any manner without written
permission from the publisher. All rights reserved.

© 2005 by CHARLES C THOMAS • PUBLISHER, LTD.

ISBN 0-398-07555-7 (hard)
ISBN 0-398-07556-5 (paper)

Library of Congress Catalog Card Number: 2004058872

With THOMAS BOOKS *careful attention is given to all details of manufacturing and design. It is the Publisher's desire to present books that are satisfactory as to their physical qualities and artistic possibilities and appropriate for their particular use.* THOMAS BOOKS *will be true to those laws of quality that assure a good name and good will.*

*Printed in the United States of America
MM-R-3*

Library of Congress Cataloging-in-Publication Data

Creating connections between nursing care and the creative arts therapies
 : expanding the concept of holistic care / edited by Carole-Lynne
Le Navenec and Laurel Bridges ; cover illustration by Michelle
McGrath.
 p. cm.
Includes bibliographical references and indexes.
ISBN 0-398-07555-7 (hard) – ISBN 0-398-07556-5 (paper)
 1. Arts–Therapeutic use. 2. Holistic nursing. I. Le Navanec, Carole-Lynne. II. Bridges, Laurel.
 [DNLM: 1. Art Therapy–methods. 2. Holistic Nursing–methods. WM 450.5.A8 C912 2005]

RC489.A72C74 2005
615.8'5156–dc22

2004058872

CONTRIBUTORS

Margaret Bent, PhD, OTR/L, is Director of Competency Development Activities at The National Board for Certification in Occupational Therapy, Gaithersburg, Maryland. Her clinical experience includes developing and managing outreach mental health occupational therapy services in rural and underserved areas. Dr. Bent has written and presented nationally and internationally on a variety of topics, including gender-specific interventions for women with mood disorders, transitions, adult learning, stress and coping, educational innovations, and community-service learning.

Laurel Bridges, MA (DMT), ADTR, MA (Couns Psy), CCC, has a Master of Arts degree in dance/movement therapy and in counselling psychology. She has worked primarily with older adults in continuing care and with adults in private practice. She has taught at the University of Calgary and in a graduate dance therapy diploma program at Wesley Institute in Sydney, Australia. She currently coordinates and teaches in a graduate dance therapy training program in Calgary, Canada www.wesleydancetherapy.ca. Her research interests include the use of movement as nonverbal therapeutic approaches and the effect of creative expressive movement on chronic illness and pain.

Alan Briks, MA, ATR-BC, has had many years of clinical experience as an art psychotherapist working with various treatment populations in hospital psychiatry, community mental health clinics, and private practice. Alan maintains a private practice in Calgary for individuals, groups, and families and is an art therapy clinical supervisor. He is a clinical adjunct professor in the Faculty of Nursing at the University of Calgary and is a sessional instructor at the Alberta College of Art and

Design. His research interests include art therapy as a myth-making process, treatment modality for persons affected by brain injury, abuse issues, youth/young adults at risk, developing art therapy strategies and techniques for enhancing interpersonal communication, insight and conflict resolution, play and the creative process. Alan is also a multi-media visual artist who continues to exhibit his works in painting, architectural stained glass, and photography.

Jennifer Buchanan, MTA, is an accredited music therapist and past-President of the Canadian Association for Music Therapy. As one of Canada's best-known and most respected music therapists, Jennifer's efforts have been recognized in national magazines, as well as on radio and television. Jennifer has inspired and developed many music therapy programs in schools, universities, health care facilities, private and government centers, through her long established company, JB Music Therapy. For more information, see her website: www.jenniferbuchanan.ca.

Gerry Carr is a Certified Therapeutic Recreation Specialist and Director of Leisure Services at the Transitional Learning Center in Galveston, Texas. She has worked in rehabilitation programs serving persons with traumatic brain injuries for over fifteen years.

Barbara Christofferson, PhD, is a professional actor and teacher. She has studied, performed, and taught across Canada and in Switzerland, Germany, Great Britain, Guatemala, and India. Most recently, she toured Alberta playing Baba in Joanne James's play *My Grandma's Eyes* for Quest Theatre. She devised and performed Traviata, a Performance Creation about unresolved grief for the Reweaving the Web Conference on Suicide and Grieving in Saskatoon, Canada in 1998. Traviata was remounted in 1999 in Calgary to raise awareness for Street Teams, an organization which works to eliminate child prostitution.

Jane Edwards, PhD, is a senior lecturer at the University of Limerick and is Course Director for the MA in Music Therapy in the Irish World Music Centre there. She is Chair of the Commission for Government Accreditation for the World Federation of Music Therapy. Her PhD was attained from the

Faculty of Medicine at the University of Queensland, Brisbane, Australia.

Marcia Jenneth Epstein, PhD, is a musicologist and cultural historian with a particular interest in the effects of music and sound on health. She is co-professor and co-author, with Dr. Carole-Lynne LeNavenec, of credit courses concerned with the instruction of undergraduate and graduate nursing students in the principles of music therapy and other arts-based interventions. In addition to coaching the public speakers and teaching terrified adult beginners to sing, she teaches for the Faculties of Communication and Culture, Nursing, and Environmental Design at the University of Calgary.

Karen Fowler, RN, BN, MN (student), has worked in both an acute care and public health capacities for a total of twenty-five years with a maternal child focus. During completion of her undergraduate degree, she worked with a music therapist and became fascinated by the application of music to the health profession. A primary passion for her has become the use of music in health care, particularly with respect to childbirth.

Annamarie Fuchs, MN, began to work as a nurse in oncology/palliative care in 1990 after witnessing her mother's battle with metastatic breast cancer during her training. Her mother had always written poetry and encouraged her to describe her feelings about her mother's illness and those of the patients she cared for by writing poetry. She has taught palliative care courses for nursing attendants, and she is currently working in health services quality improvement.

Wende Heath, MA, MFT, ATR-BC, REAT, is a board certified Art Therapist, Registered Expressive Art Therapist, and a Marriage and Family Therapist in California. She is an art specialist at Marin General Hospital and California Pacific Medical Center in San Francisco, two hospital programs that have pioneered using art for healing. Under the auspices of the Institute for Health and Healing, she directs the Expressive Arts Program, bringing art to the bedside and art and imagery groups to cancer patients and seniors. She has worked as a potter, costume and clothes designer, sculptor, doll and puppet maker. She is the author of "Cancer Comics, the Humor of the Tumor," a booklet of humorous cartoons about cancer.

Susan Kierr, MA, ADTR-NCC, developed the Dance Movement Therapy program at New England Rehabilitation Hospital in Woburn, Massachusetts, from 1975–1985. During the following ten years, she implemented a program in New Orleans, Louisiana, using dance movement therapy with patients hospitalized on a skilled nursing floor. She has published in the *American Journal of Dance Therapy* and in Fran Levy (Ed.) (1995) *Dance and the Other Expressive Art Therapies: When Words Are Not Enough.* Her involvement in the American Dance Therapy Association has included member at large and chairperson of the Alternate Route Division of the Credentials Committee.

Carole-Lynne Le Navenec, RN, PhD, is a Calgary-based Professor of Family, Psychiatric and Community Mental Health, and Prison Health Nursing at the University of Calgary. In her role as founder and Director of the Creative Arts/Integrative Therapies research group (the CAIT group), and Research in Continuing/Chronic Care, she has conducted research on the responses of people with a chronic illness (e.g., dementia and traumatic brain injury) to music, and an upcoming project involving the visual arts. She has also developed web-based, credit courses pertaining to nursing scholarship, music and sound approaches, and a doctoral dissertation seminar that focuses on the development of nurse-scientists. Contact Info: cllenave@ucalgary.ca. Website: www.ucalgary.ca/cait.

Kim Morrison has a BFA from Moore College of Art and Design in Philadelphia, Pennsylvania and a Master Diploma in Art Therapy from the Vancouver Art Therapy Institute. She has worked in a variety of settings primarily with adolescents including inpatient, outpatient, and school settings and in an attachment disorder residential program. She is currently working in an art as therapy environment with underprivileged youth in a community development initiative. The adolescents' resiliency in the face of all kinds of adversity attracts her to this population.

Susan "Boon" Murray, Ed.D, CTRS is Associate Professor of Therapeutic Recreation at University of Wisconsin–La Crosse. In addition, she serves as Internship Coordinator and in 2000 published *A Daily Log for the Therapeutic Recreation Intern* that contains a diskette where prospective interns can customize

preformatted journaling pages. Murray's 1997 dissertation research consisted of using patients' creative journals of rehabilitation, including digital photography and artwork, as a container of lived experience (phenomenology) that might sensitize professional caregivers to patients' experiences of suffering and revitalization. Murray is a certified instructor for a journaling curriculum titled Journal to the SELF through the Center for Journal Therapy and facilitates journaling workshops for health care professionals; she has customized Parker Palmer's *The Courage to Teach* into a journaling intensive course for educators. Murray connects the modality of journaling as the extension of therapeutic process to other "creative arts" in her course *Facilitation Techniques in Therapeutic Recreation*.

Bonnie Osoff-Bultz, MSW, RSW, RDT, is a registered Social Worker on the Provincial Private Practice Roster with the Alberta College of Social Work and a registered Drama Therapist with the National Association for Drama Therapy. Bonnie has worked at the Alberta Children's Hospital for the past sixteen years as a therapist with a transdisciplinary team that specializes in the treatment of children and adolescents with cerebral palsy, developmental delay, and other unique neurological/orthopedic concerns. She is the Creative Arts Therapist for the Wood's Homes Stabilization Adolescent Treatment Program, Calgary and Area Child and Family Services, and runs parent, social, and life skills groups utilizing the creative arts. Bonnie has published in the areas of intensive care, adolescent groups, drama therapy practice, and selective posterior rhizotomy surgery.

Jon Parr-Vijinski, BA, MSc. student (Health Psychology), is a Toronto-based composer, arranger, and producer of a range of relaxing and stimulating music that is available on compact discs. In his work as a research assistant for Dr. Le Navenec's Creative Arts/Integrative Therapies Research Group (the CAIT group), he has also developed a videotape collection of nature scenes set to music that is designed to facilitate relaxation and stimulation for middle-aged and older adults. Contact Info: jonparr@sympatico.ca Website: www.ucalgary.ca/cait.

Diane Pirner, RN, PhD(c) (Nursing), is a Toronto-based Professor of Nursing at Ryerson University. Her research interests pertain to approaches for the provision of culturally sensi-

tive care for elderly populations in nursing homes and related settings, and the development of ethnographic case study methods. Contact Info: dpirner@ryerson.ca Website: www.ryerson.ca/nu.

Elizabeth Joyce Soderling, MSW, is a graduate of the University of Calgary, Alberta, Canada. Elizabeth has been working in the field of social work since completing her BSW in 1994. Elizabeth obtained her Masters in 2003, specializing in clinical practice during which time she practiced on the pediatric oncology unit at the Stollery Children's Hospital. Elizabeth works as a Child Abuse Investigator with Children's Services and Edmonton Policy on the Child At Risk Response Team in Edmonton, Canada.

Geraldine Taylor, MA, is a multi-award winning author and researcher on the emotional factors affecting learning and creativity. She has facilitated workshops for thousands of parents and professionals in the UK. Geraldine is an Accredited Practitioner member of the British Association for Counselling and Psychotherapy, and a counselor at the University of Bristol Student Counselling Service in the UK.

A. Lynne Wagner, RN, EdD, has worked as a staff nurse, a nursing in-service educator, a certified childbirth and parenting educator, a certified family nurse practitioner, and a nursing educator. Having recently retired after almost twenty years as Professor of Nursing at Fitchburg State College in Massachusetts where she taught community health, maternity nursing, and an interdisciplinary course on literature and disability, Dr. Wagner is presently working as a Nursing Career Coach through Fitchburg State College as part of a federal grant addressing the nursing shortage. Her research focuses on the art of human caring, mentoring, aesthetic inquiry, and reflective nursing practice through aesthetic expression. Dr. Wagner is a published poet and offers workshops on creative reflective practice.

Christine Zimbelmann, MS, ADTR, CMA, has worked in psychiatry for nine years on adult, adolescent, geriatric, and child psychiatric nursing units. In addition to her clinical work as a dance movement therapist, she has done staff education/training, supervision, and program development. Currently she works as a senior clinician in an outpatient day

treatment program and has a private practice in dance movement therapy (DMT) and DMT supervision.

To all the mentors in my journey up to, and since donning my nursing cap, particularly my late mother, Marie, who demonstrated how "things take time"; grade three teacher, Walter George Epp, who taught me how Mozart could really help me fly like a bird; Sister Marie Felicitas, the Director of the School of Nursing who understood my occasional naps during class as being related to changes in altitude; my late doctoral thesis supervisor, Dr. Norman W. Bell, who created my love of the case study approach; the late Gaile Hayes, a cherished friend and gifted music therapist, who created such an effect on people every time she sang; and finally, to my co-editor, Laurel Bridges, who has helped me so vividly see how dance/movement therapy, as well as other creative arts therapies, all have their parallels in nursing art, or what Florence Nightingale might have called the finest art.

<p align="right">CAROLE-LYNNE LE NAVENEC</p>

To my late parents, Ewart and Pamela Bridges who fostered in me a desire for creative expression in dance and art, a love of books and research, and through our international experiences, the strong motivation to connect and collaborate with others. To my co-editor Dr. Carole Lynne Le Navenec, whose vision, enthusiasm, and love of the arts have motivated her to create a research environment for creative art therapists and artists in health care that has made this book possible.

<p align="right">LAUREL BRIDGES</p>

PREFACE

This book seeks to create a closer connection between nursing care and the creative arts therapies in order to promote professional collaboration and to expand the concept of holistic care. Most of its twenty chapters explore the theoretical and practical implications of the creative arts therapies as illustrated in single and multiple-case studies. The chapters' authors are creative art therapists, nurses, social workers, therapeutic recreation specialists, and occupational therapists. They describe creative therapeutic approaches involving art, music, creative writing, dance/movement, and drama in various health care settings.

Creating Connections Between Nursing Care and the Creative Arts Therapies is designed for a wide range of health care professionals, including nursing; the creative arts therapies; psychology; social work; medicine; occupational, recreational, and physical therapies; and others who are interested in learning more about creative treatment approaches and their application to varied care settings. Its primary aim is educational advancement for health care professionals on the topic of how the creative arts therapies can assist patients or clients to achieve specific goals or outcomes. Some of the ways it will assist health care professionals include the following: to gain an understanding of the principles of creative art approaches in order to enhance the level of creativity in their evidence-based caring practices, to increase awareness of the ways creative expressive approaches can be applied in health care settings, to assess clients' or patients' responses to these approaches, to assist in making referrals to various creative arts practitioners, and for advocating for access to such therapies for clients and their families.

ACKNOWLEDGMENTS

The co-editors want to acknowledge the contribution of the following people:

Anne Nazareth, University of Calgary Nursing Faculty, for her secretarial assistance, enthusiasm, patience, creativity, calmness, and kindness. Her absolute dedication and the rays of sunshine she always creates were very evident.

Jay Gamble, PhD candidate, Department of English, University of Calgary. This soon-to-be doctor and specialist in creative writing, spent many hours doing a line by line review of the entire manuscript. He is to be commended for his conscientiousness, enthusiasm, and love for all things creative. We hope he will consider doing his post-doctoral studies in one of the universities mentioned in our book.

Michelle McGrath and Gord Southham, Learning Commons, University of Calgary, for assisting us in expressing this book's purpose and vision in a creative visual form on the cover illustration design.

All the co-participants, both chapter authors and the people who were discussed in the case studies; they indeed were co-creators in enhancing our knowledge and understanding of the caring practices that help the individual and his or her family feel more connected in body-mind-spirit.

Last but not least, we are truly honored that the publishers, Charles C Thomas, accepted our proposal a few years ago and assisted us every step of the way. It is only because of their consistent help that we have been able to realize this dream.

CONTENTS

Page

Contributors ...v
Preface ..xv

Chapter

1. Creativity, Collaboration, and Caring
 Carole-Lynne Le Navenec & Laurel Bridges3

Section 1: Art and Crafts

2. The Psychosocial Issues and the Use of Art with Clients with Childhood Cancer – *Elizabeth Joyce Soderling*17

3. Images of Anger from Adolescents in Art Therapy Groups – *Kim Morrison*38

4. Art Psychotherapy Transformations with a Self-Harming Late Adolescent Female – *Alan Briks*53

5. Breaking the Mold: Using Pottery to Rebuild Life Skills, An Occupational Therapy Perspective – *Margaret Bent & Geraldine Taylor* ..76

6. Improving Quality of Life for Persons with Traumatic Brain Injury: The Role of Therapeutic Recreation – *Gerry Carr*106

7. The Spark of Creativity: Expressive Arts in a Hospital Setting – *Wende Heath*116

Section 2: Music

8. Sarah's Song: Music, Pregnancy, and Childbirth – *Karen Fowler*131

9. The Contribution of Music Therapy to the Process of Therapeutic Change for People Receiving Hospital Care – *Jane Edwards*149

10. Unleashing the Positive through Music – *Jennifer Buchanan*156

11. How Music Moves People: An Analysis of the Emotional Responses of University Students to "A Musical Pharmacy" Using Hevner's Mood Wheel" – *Jon Parr Vijinski, Diane Pirner & Carole-Lynne Le Navenec*167

12. A Sound Basis for Well-Being: The Acoustics of Health – *Marcia Jenneth Epstein*187

Section 3: Creative Writing

13. Finding the "Friend at the End of Your Pen": What Makes Journaling "Therapeutic" for Patients and "Professional Growth" for Students – *Susan "Boon" Murray*201

14. The Embodiment of Nursing Art: Understanding the Caring-Self in Nursing Practice through Reflective Poetry-Writing and Art-Making – *A. Lynne Wagner*229

15. Poetics in Palliative Care: Reclaiming Identities – *Annamarie Fuchs*259

Section 4: Dance and Movement

16. Dance/Movement Therapy in an Adult Psychiatric Unit – *Christine Zimbelmann*275

17. Dance Movement Therapy and Nursing Care – *Susan Kierr* ...292

18. Application of Dance/Movement Therapy Principles to Nursing Care for People with a Dementia: A Non-verbal Approach – *Laurel Bridges*305

Section 5: Drama

19. A Template for the Multidisciplinary Team-led Social and Life Skills Groups Utilizing Drama and Other Creative Arts Therapies: Its Application for Girls Experiencing Neurological Challenges – *Bonnie Osoff-Bultz*335

20. Performance Creation as a Mode of Self-care: A Participatory Study of Caregivers and the Prevention of Burnout – *Barbara Christofferson*355

Name Index ...369
Subject Index ...372

ILLUSTRATIONS

		Page
2.1	What is it like to have cancer in your life?	33
3.1	Adolescent art	45
3.2	Adolescent art	45
3.3	Adolescent art	47
3.4	Adolescent art	47
3.5	Adolescent art	49
4.1	Client artwork	61
4.2	Client artwork	63
4.3	Client artwork	63
4.4	Client artwork	64
4.5	Client artwork	66
4.6	Client artwork	67
4.7	Client artwork, "How it was"	68
4.8	Client artwork	69
4.9	Client artwork	70
4.10	Client artwork	71
4.11	Client artwork	72
4.12	Client artwork	72
11.1	Mood wheel assignment	177
13.1	Belle's preformatted journal page completed by PT and OT	210
13.2	Belle's magazine photo collage, "good and bad"	211
13.3	Belle's journal page as physical therapy progress note	212
13.4	Belle's journal page as occupational therapy progress note	213
13.5	Digital photographs of Kimberly's rehabilitation activity	214
13.6	Kimberly's pylon drawing 6/5/95	216
13.7	Kimberly's magazine photo collage, "Amazing Grace"	218
13.8	Tonya's collage, "What I thought/expected my internship to be"	223
13.9	Tonya's collage, "What my internship has actually been"	223
14.1	Julie's collage about a patient who needed a thoracentis	235

14.2 Julie's drawing about a patient recovering from a myocardial
 infarction ..242
14.3 Julie's drawing about a patient with a respiratory flare-up244
14.4 Julie's drawing about a demanding patient246
14.5 Reflective process of discovery about caring-self255

TABLES

		Page
1.1	Summary of Chapters' Content	5–6
11.1	Illustrative Examples of Basic Elements of Sound	172–173
11.2	Emotional Responses to Song of the Nightingale	178
11.3	Emotional Responses to Etude	179
11.4	Emotional Responses to Madrigal of Light	180
11.5	Emotional Responses to Pastoral	181
13.1	Consent and Release Form for Clients' or Students' Journaling	224
18.1	Outcomes of Non-verbal Nursing Actions	325–326
18.2	Scenarios for Care-giving Role-play	327

CREATING CONNECTIONS BETWEEN NURSING CARE AND THE CREATIVE ARTS THERAPIES

Chapter 1

CREATIVITY, COLLABORATION, AND CARING

CAROLE-LYNNE LE NAVENEC AND LAUREL BRIDGES

INTRODUCTION

This book demonstrates three interrelated concepts: creativity, collaboration, and caring. In the following nineteen chapters, the authors have described creative art approaches in working with a wide variety of clients in different health or illness contexts. As these health care professionals seek innovative ways to care for their clients, they have illustrated how both creativity and collaboration are key parameters. In terms of the collaborative nature of the book, the reader will note that there is a sharing of knowledge regarding the diverse and innovative ways between the disciplines of assessing a client, of planning their interventions (including a strength and needs list), of implementing the particular type of intervention, and for evaluating outcomes of the treatment. These concepts of creativity, collaboration, and caring will be addressed more fully later in this introductory chapter.

How does this book differ from the many others on this topic? Certainly, there are books on the use of the creative arts in health care (e.g., Kaye & Bleck, 1998; Samuels & Rockwood Lane, 1998), holistic nursing (e.g., Dossey, Keegan & Guzetta, 2005), and the creative arts therapies in this domain (e.g., Goodill, 2003; McNiff, 1992; Malchodi, 1999; Nathan & Mirviss, 1998; Warren, 2000). However, there are several unique features of our book: (1) its exploration of the theoretical and practical implications of the creative arts therapies as illustrated in single and multiple-case studies; (2) the presentation of approaches from a range of practitioners in the creative arts therapies and from health care practitioners who use creative therapeutic approaches; and (3) the creation of a closer connection between nursing

care and the creative arts therapies in order to promote professional collaboration and to expand the concept of holistic care. As our title reflects, this process of creating connections is perhaps the most significant contribution of our book.

Creating Connections Between Nursing Care and the Creative Arts Therapies is designed for a wide range of health care professionals, including nursing, the creative arts therapies, psychology, social work, medicine, occupational, recreational, and physical therapies, and others who are interested in learning more about creative treatment approaches. Health professionals and artists who are interested in Arts in Medicine will be inspired and challenged to discover the ways that creative expression could further enhance the care of patients or clients.

Several benefits are available to the creative arts therapist who seeks to contribute to a particular nursing care setting: (1) awareness of the ways our approaches can be applied in a diverse range of nursing care settings; (2) a deeper acquaintance with the similarities of the various steps in the care process. For example, in nursing, we may use Parse's model (Mitchell, 1990) to guide our approach with the client in order to "synchronize rhythms through dwelling with" (p. 173) in a way similar to the one used by dance movement therapists who are guided by "Chace's dictum, which has been colloquialized as 'start where the patients are at' (Sandel, 1993, pp. 98–99) and join their rhythm; and (3) creating new ways to communicate between the disciplines through our use of shared language and concepts.

Some examples of how this book will help nurses and other health care professionals include enhanced understanding of: (1) the principles of creative art approaches in order to expand the level of creativity in their evidence-based, holistic, caring practices; (2) modes of assessing physical, social, psychological, and spiritual responses of clients who are participating in various creative arts treatment programs; and (3) possible reasons for making referrals to various creative arts practitioners and for advocating for access to such therapies for clients and their families.

Having discussed the benefits this book may afford its readers, it is also important to emphasize that for which it is not intended; it is *not* intended to equip nurses or other health care professionals to practice art therapy, dance/movement therapy, drama therapy, music therapy, or related approaches. Instead, the primary aim is educational advancement for health care professionals on the topic of how the creative arts therapies can assist patients or clients to achieve specific goals or outcomes.

Each chapter contains information about the therapeutic use of its art form(s) and in most cases, at least one illustration of its use in case study format. Pseudonyms are used for all case study subjects. The chapters are grouped by primary art form used. Therefore, there are five sections: one

each for art, music, creative writing, dance/movement, and drama. The chapters are arranged in each section by the life stage of the individuals described in the case studies; i.e., pregnancy, childhood, adolescence, adults (young and middle-age), older adults, and end of life.

The contributing authors are from Canada, the United States, England, and Ireland. As evident in Table 1, the professions represented (and the numbers involved) are as follows: nurses (5), art therapists (3), dance/movement therapists (3), music therapists (2), social workers (2), therapeutic recreation specialists (2), occupational therapist (1), musicologist (1), musician (1), and actor/educator (1). In addition, one of the social workers is also a drama therapist. All the authors are registered in and/or credentialed by their respective professional associations.

Table 1.1
SUMMARY OF CHAPTERS' CONTENT

Chapter # & Author	Art Form	Population of Case Study	Life Stage	Authors' Profession
2 Soderling	Visual Art	Childhood Cancer	Childhood	Social Work
3 Morrison	Visual Art	School Anger Management	Adolescence	Art Therapy
4 Briks	Visual Art	Abuse & Self Harm	Late Adolescence	Art Therapy
5 Bent & Taylor	Visual Art	Depression Mental Health	Young Adulthood	Occupational Recreation
6 Carr	Crafts	Traumatic Brain Injury	Middle Adulthood	Therapeutic Recreation
7 Heath	Visual Art	Physical Illness	Older Aults	Art Therapy
8 Fowler	Music	Childbirth	Pregnancy	Nursing
9 Edwards	Music	Theory	Education & Therapy Process	Music Therapy
10 Buchanan	Music	Vairous-3 Case Studies	Childhood to Older Adults	Music Therapy
11 Parr-Vinjinski, Pirner & Le Navenec	Music	University Students	Adulthood	Music/Psychology & Nursing

Continued

Table 1.1–*Continued*

Chapter # & Author	Art Form	Population of Case Study	Life Stage	Authors' Profession
12 Epstein	Music	Environmental	All Life Stages	Musicology
13 Murray	Creative Writing	Physical Rehab & Students	Adulthood	Therapeutic Recreation
14 Wagner	Writing & Art	Students	Adulthood	Nursing
15 Fuchs	Creative Writing	Palliative	End of Life	Nursing
16 Zimbelmann	Dance & Movement	Psychiatric	Young Adulthood	Dance/Movement Therapy
17 Kierr	Dance & Movement	Chronic Illness & Pain	Middle Adulthood	Dance/Movement Therapy
18 Bridges	Dance & Movement	Dementia	Older Adulthood	Dance/Movement Therapy
19 Osoff Bultz	Drama	Neurology	Late Childhood & Adolescence	Drama Therapy & Social Work
20 Christofferson	Drama	Caregiver Burnout	Adulthood	Acting & Education

Populations across the life span from childbirth to end of life are addressed, as can be seen in Table 1. The next nineteen chapters cover a range of topics pertaining to the role of the creative arts for health promotion and quality of life enhancement in a wide range of health care settings.

CREATIVITY

Although creativity is discussed extensively in the nursing literature, it is usually conceptualized as a thinking process. Grandusky's (1994) article "Cultivating Creativity," in the first issue of the *Creative Nursing Journal*, defined it this way: "creativity means generating new ideas, switching perspectives, and finding unique solutions to problems. It is an essential component of the critical thinking process" (p. 21). This definition of creativity as a thinking process is also endorsed by other authors in the social sciences. In the psychology literature, Nakamura and Csikszentmihalyi (2003) define it as

"a process by which new ideas, objects or processes are introduced into the evolution of culture" (p. 258). However, in the caring literature, creativity and intuitive practice are emphasized. (See the section below on caring.) Ruggeriero (1996), in *A Guide to Sociological Thinking*, cautions that creativity is not limited to the arts; instead, "any challenge can be approached more or less creatively" (p. 10). He also notes that all individuals can "learn to be imaginative, ingenious and insightful" (p. 10). In addition, Cropley (1990) stresses both the universality of creativity and its role in contributing to the maintenance of mental health. He explains that the characteristics of creativity, such as "openness, autonomy, playfulness humor, willingness to take risks and perseverance" (p. 168), are also characteristics that are associated with normal personality development. Cropley concludes that "the possibility of promoting mental health arises by fostering creativity in day to day life" (p. 167).

Although this inclusive way of thinking about creativity is encouraging, it is also crucial to stress the importance of artistic, creative expression as an essential component of creativity and its ability to foster improved mental and physical health. The current book's authors certainly approach their clients by applying innovative flexible creative thinking approaches. Furthermore, they also take "creativity" a step further into creative art *expression*. This creative expression involves the clinician and the client or patient in participation in an art form: hands on to work with a visual art material, ears open to listen to and create music, and bodies moving in dance and dramatic expression to express feelings. The creative art therapies have documented the restorative effect that a creative and expressive act has on the emotional and cognitive and often also the physical functioning of individuals and groups (Aldridge, 1993; Goodill, 2003; Malchiodi, 1999; Ritter & Graff Low, 1996). The emerging field of Arts in Medicine studies the connection between health and the arts rooted in the strong conviction of the transformative qualities of arts for individuals and institutions (Lippin, 1991). Two of Arts in Medicine's leading proponents, Samuels and Rockwood Lane (1999), describe the effect of artistic expression on patients:

> Art and music crack the sterile space of fear the patients live in and they open it to the joys of the human spirit. The spirit freed then helps the body heal. Art frees the immune system so it can function at its best, relieve pain, heal depression, and raise the spirit.... When we make art to heal, the creative spirit within us is awakened ... we are taken to the place of healing and healed. Art brings out our inner healer, which changes our whole physiology and our spirit mind and body heal. (pp. xiii–xiv)

As you read the chapters of this book you will see ample illustrations of the ways in which creativity and creative expression enhance health and well-being.

COLLABORATION

Collaboration has been defined by the American Nursing Association Congress on Nursing Practice as "a collegial working relationship with another health care provider in the provision of . . . patient care" (Kozier, Erb & Blaus, 1997, p. 68). This working together is seen to contribute to the goal of achieving a high quality of care. Elements that have been identified as essential in effective collaboration include mutual respect, sharing responsibility for the care provided, negotiation, and open communication (Kozier, Erb & Blaus, 1997). Similarly, Best (2000), a dance movement therapist, has found the following attitudes most helpful when collaborating with other mental health professionals: "respectful curiosity, mutual influence, self reflexivity, owning one's position and acknowledgement of context" (p. 198). Several authors who discuss the benefits of collaboration between varying disciplines emphasize the importance of acknowledging both similarities and differences in each profession's approaches (Best, 2000; Landy, 1995; Mariano, 1989). Best points out that awareness of diversity is a necessary part of collaboration. She believes that we learn more about our own beliefs when we see them in contrast to another profession's beliefs, using the analogy of needing to "bump up against objects, people, and concepts" (p. 197) in order to fully realize who we are.

Although nursing and the creative arts therapies acknowledge the importance of collaboration, the connections between the arts and nursing need to be further developed. In her analysis of art therapy, arts medicine, and arts in healthcare at the beginning of the new millennium, Malchiodi (1999) expresses her surprise that "there has not been more direct collaboration among art therapy, arts medicine and arts in healthcare" (p. 2). She believes that by starting with a basic belief in the creative art process as "healing and life enhancing" (p. 3), Malchiodi maintains that collaboration between the professions needs to increase in order to strengthen and expand that belief and further its application in health care settings.

The creation of this book is an example of collaboration at many levels. It was created by drawing together authors from North America and Great Britain who are involved in the arts in health care to write a chapter on the ways they utilize the arts in a health care setting. In one case, an occupational therapist and a writer and creativity and learning specialist combined their efforts in writing the chapter (Bent & Taylor). Many of the authors first came together in a research group for the Creative Arts Therapies at a Canadian University (Creative Arts and Integrative Therapies Research Group available at www.ucalgary.ca/cait). This research group is comprised of nurses, other health care professionals involved in the arts, creative art therapists, artists, dancers, writers, musicians, and actors interested in the healing

aspects of their art form. Over the last five years, this group has developed undergraduate courses in the arts therapies and nursing and engaged in several evidence-based outcome research projects. The members of this research group that contributed to *Creating Connections Between Nursing and the Creative Arts Therapies* contacted their colleagues to find others in related fields who use creative expressive means in a variety of nursing care settings.

The entire book has been edited through an ongoing collaboration between a nurse educator and sociologist and a dance/movement therapist and counselor who have also co-written this introduction. In the process of discussing the chapters written by authors of diverse professional backgrounds, we have learned much about each other's professions (nursing and the creative arts therapies) and have also learned more about our own disciplines through describing them to each other. Open communication, curiosity, and mutual respect have enabled us to attempt to emphasize the most important concepts in each author's chapter and to clarify those concepts that were not clear. We have sought to use language in this book that facilitates understanding and connection between the professions by reducing the use of jargon and by including brief definitions when needed.

In his discussion of the theme of collaboration between the creative arts therapies, Landy (1995) describes a fluctuation between the need for "isolation" (p. 84) or definition of each profession's unique skills set, emphasis, and treatment approaches and collaboration or sharing of similar language and goals. He conceptualizes this by using the metaphor of borders and walls between the professions and gives the following advice:

> We need community with those of our colleagues who have taken a similar journey. Yet in our quest for a unified field of creative arts therapy, let us not abandon our borders and walls. Just let them be neither too high nor too thick . . . let us search for ways to break through even as we retain. (p. 86)

Similar advice can apply to collaboration attempts between the creative arts therapies and the nursing profession. Each one of us has developed specific areas of expertise. Creative arts therapists, occupational and recreational therapists, and artists who work in health care settings cannot perform medical nursing procedures, and nurses are not trained to perform in-depth creative arts interventions. There are boundaries between our areas of expertise, but it is important that we do not allow those boundaries or walls to be so high that we cannot see the similarities between our goals and find ways to break through them by learning more about each other's disciplines and finding ways to work together in the common goal of providing a high level of care for our clients and patients.

CARING AND HOLISTIC CARE

The concept of *caring*, which Montgomery (1993) described as "a natural condition of being human" and "a readiness to help or connect with others" (p. 13), is viewed here as the essence of the art and science of nursing. Although there is a voluminous body of literature on caring, the debate continues about how it should be conceptualized in nursing practice and nursing education (see overviews by Beck, 2001; Benner & Wrubel, 1989; Kapborg & Bertero, 2003; Peplau, 1988; Scotto, 2003). Some perspectives of caring such as the one reflected in the "sickness-cure" mode (Quinn, 2005, p. 49) emphasize the *objective* components of caring; that is, activities performed by an "expert" that involved "doing to or for" (p. 49) another person who is in need of particular types of health care interventions. This perspective of caring often makes use of various types of (a theoretical) classification systems developed by nurses to summarize data about: (1) the patterns, challenges, or needs of the patient or client such as the system developed by the North American Nurses Diagnosis Association–NANDA (2003–2004); (2) the independent and collaborative treatments provided by nurses such as the Nursing Interventions Classification–NIC (McCloskey, Dochterman & Bulechek, 2004); and (3) specific patient or client outcomes that are viewed as being influenced by the nursing intervention(s) such as the Nursing Outcomes Classification–NOC (Johnson, Maas & Moorhead, 2000).

By contrast, other perspectives of caring in health care contexts emphasize its *subjective* component, and hence portray it as a relationship, as a way of "being with" another person in a way that facilitates "healing" (i.e., "wholeness or harmony of body, mind and spirit"; Quinn, 2005, p. 43). Viewed this way, "caring is expressed through meaningful participation in an experience with a client, rather than trying to control the outcome" made in advance by an "expert" (Mongtomery, 1993, p. 76). The nursing care process is depicted as including what are variously referred to as (1) *carative behaviors* such as facilitating trust, mobilizing social support and related approaches to creating authentic "presence" (Watson, 1994; see also Scotto, 2003, p. 289); (2) *caring qualities* (Montgomery, 1993) such as transcending judgment, having a hopeful orientation, and related "predispositional" qualities; empowering others through the mobilization of resources, advocacy, creating positive meaning and hope, and related "behavioral" qualities, and demonstrating "relational" qualities by taking steps to enhance self-awareness (including beliefs about treatment approaches) and capacity to identify the aesthetic qualities of caring (such as the capacity "to be sensitive to another person's rhythm" (p. 72); and (3) *caring dimensions* (such as those outlined in the "Caring Dimensions Inventory–CDI" (Watson, Deary & Lea, 1999, p. 1081). Thus, from this perspective, "the process" of caring is in the foreground, and

its "outcomes" constitute the background.

Of particular relevance to our book is that aspect of the debate about the nature of caring in regard to how nurse educators should go about designing curriculum threads about *the art* aspect of the art and science of nursing (Cook & Cullen, 2003; LeVasseur, 1999; Scotto, C.J., 2003; Watson, 1994). In this context, Darbyshire (1994) contended that in recent years "nurses have become increasingly concerned that the scientific and technological aspects of nursing [caring] are in danger of overshadowing the humanistic and artistic elements, which should be an integral part of both nursing education and nursing practice" (p. 856). Hence, he has developed a course that incorporates the arts and literature (or what might be coined "the Nursing Humanities"). According to Le Vasseur (1999), the art of nursing (or nursing art), which is inseparable from nursing science, includes "practical know-how," or knowing how to respond in variable situations" ... to "help resolve, move, or restructure the [patient's] experience" (p. 60). She cites an account of the everyday version of nursing art: I see "this art every time I walk into an environment where nurses are busy "creating" the day for another person. They are busy using light, space, sound, words, movement and touch to deliver the message of care" (pp. 60–61). Le Vasseur (1999) concludes by indicating that the art of nursing is "an *essential* [our emphasis] activity grounded by practice and manifest in helping patients create coherence and meaning in lives threatened by transitions of many kinds" (p. 62).

It is perhaps in the field of *holistic* care nursing (Dossey et al., 2005) that one senses the importance of caring approaches involving both "nursing art" and the creative arts. According to Kinney and Erickson (1998), "holistic" care is "directed at deficits within one subsystem without much consideration for the interaction between or among multiple subsystems" (p. 94). By contrast, a "wholistic" caring perspective recognizes that the latter are "in continuous interaction and that mind-body relationships do exist" (p. 94; see also Dossey, cited in LeNavenec & Slaughter, 2001, p. 42; Eliopoulos, 1999). Unlike curing, caring might best be reconceptualized in the concise, clear manner expressed by Scotto (2003), as an "offering of self" in a holistic manner:

> offering the intellectual, psychological, spiritual, and physical aspects one possesses as a human being to attain a goal. In nursing, this goal is to facilitate and enhance [the] patients' ability to do and decide for themselves ... [That is,] to promote self-agency. (p. 290)

These holistic approaches, which are sometimes referred to as *complementary and healing practices in nursing* (Snyder, Kreizer, & Loen, 2001), help strengthen the whole person as will be seen in all case studies of this book. The value of these approaches, as well as the creative arts therapies, for "whole person caring" is also reflected by Killick and Allan (2000, p. 16),

who are with the University of Stirling in Scotland. Although their comments in their three part series (beginning in 1999 and ending in May/June 2000) were directed toward the value of the arts for people with dementia, many of these benefits would apply to creating health and well-being in a range of health and illness contexts, and as a means of promoting self-care among nurses and other health care practitioners: (1) "The process and product (if applicable) may be a form of self-expression, an end in itself—an act of communication with the self" (p. 16); (2) "a form of communication between individuals" (p. 16); (3) "participation in the activity for its own sake"/ practical value (p. 17); (4) the aesthetic value, or the creation of a work of art "to bring something beautiful into being which enhances one's own and others' lives" (p. 16); and (5) the range of psychological benefits such as serving as a diversion, a source of satisfaction, provision of emotional relief, or as a formal therapy (p. 16).

Many of these benefits are also illustrated in this book's case studies. For example, Brik's late adolescent client reconnects with herself and her history through art. Furthermore, the non-verbal approaches suggested by Bridges allow her client with end-stage dementia to communicate with her therapist and other staff.

As nurses and other professionals who use the creative arts begin to collaborate with the creative arts therapists, let us strive toward identifying how it helps both our clients and ourselves as "carers" or "caregivers": "to clarify our visions, find our passions, work better in teams" and to access one's creativity (Lindeman, 2000, p. 5); "to let music speak when words cannot" (see Chapter 10) or to project ourselves in the image so that we can see the bigger picture (Lindeman, 2002, p. 5) as one of the authors in this book (Christofferson) did in her study of performance creation and self-care among mental health counsellors.

May all the readers find their "beat," "brush," "stroke," "sound," "role," "phrase," or "rhythm" as we begin our dance together to enhance holistic or integrative healing practices and authentic connections with others (Kreitzer & Disch, 2003). May we also not engage in "the ageism of knowledge" by passing judgments for the references used in this book that are over five years old. Like older people, these older references are still very relevant, and although "a best before date may apply to food purchases . . . it has no place in scholarship" (Gottlieb, 2003, p. 6).

REFERENCES

Aldridge, D (1993). Music therapy research 1: A review of the medical research literature within the general context of music therapy research. *Arts in Psychotherapy,*

20, 11–35.

Beck, C.T. (2001). Caring within nursing education: A metasynthesis. *Journal of Nursing Education, 40,* 101–109.

Benner, P., & Wrubel, J. (1989). *The primacy of caring.* Menlo Park, CA: Addison-Wesley.

Cook, P.R., & Cullen, J.A. (2003). Caring as an imperative for nursing education. *Nursing Education Perspectives, 24*(4), 192–197.

Cropley, A.J. (1990). Cretivity and mental health in everyday life. *Creativity Research Journal, 3*(3), 167–178.

Darbyshire, P. (1994). Understanding caring through arts and humanities: A medical/nursing humanities approach to promoting alternative experiences of thinking and learning. *Journal of Advanced Nursing, 19,* 856–863.

Dossey, B., Keegan, L., & Guzetta, C. (2000). *Holistic nursing: A handbook for practice* (3rd ed.). Gaithersburg, MD: Aspen.

Eliopoulos, C. (1999). *Integrating conventional and alternative therapies: Holistic care for chronic conditions.* St. Louis, MO: Mosby.

Gottlieb, L.N. (2003). Editorial. Ageism of knowledge: Outdated research. *Canadian Journal of Nursing Research, 35,* 3–6.

Goodill, S. (2003). An introduction to medical dance/movement therapy. [Dissertation Abstract] *Dissertation Abstracts International:* Section B: the Sciences & Engineering. Vol. 64(1–B), 2003, 419, US: Univ Microfilms International.

Grandusky, R. (1994). Cultivating creativity. *Creative Nursing, 1*(1), 20-39.

Johnson, M., Maas, M., & Moorhead, S. (2000). *Nursing outcomes classification–NOC* (2nd Ed.). St. Louis, MO: Mosby.

Kaye, C., & Blec, T. (1998). The arts in health care: A palette of possibilities. London: Jessica Kingsley.

Kapborg, I., & Bertero, C. (2003). The phenomenon of caring from the novice student nurse perspective: A qualitative content analysis. *International Nursing Review, 50,* 183–192.

Killick, J., & Allan, K. (1999/2000). The arts in dementia care: Tapping a rich resource. *The Journal of Dementia Care, 7* (4), 35-38. [see also Touching the human spirit in 7(5), 33–37; and Undiminished possibility in 8(3)].

Kozier, B., Erb, G., & Blaus, K. (Eds.). (1997). *Professional nursing practice: Concepts and perspectives* (3rd ed.). Upper Saddle River, NJ: Prentice-Hall.

Kreitzer, M.J., & Disch, J. (2003). Leading the way: The Gillette Nursing Summit on integrated health and healing. *Alternative Therapies in Health and Medicine* [Supplement], 9(1).

Landy, R. (1995). Isolation and collaboration in the creative arts therapies: The implications of crossing borders. *Arts in Psychotherapy, 22*(2), 83–86

Lippin, R (1991). A message for the President of International Arts-medicine Association. *International Journal of Arts Medicine, 1*(1), 4.

Le Navenec, C., & Slaughter, S. (2001). Laughter can be the best medicine. *Nursing Times, 97* (30), 42–43.

LeVasseur, J.J. (1999). Toward an understanding of art in nursing. *Advances in Nursing Science, 21*(4), 48–63.

Malchodi, C.A. (1999). *Medical art therapy with adults.* London: Jessica Kingsley.
Mariano, C. (1989). The case for interdisciplinary collaboration. *Nursing Outlook, 37*(6), 285–288.
McCloskey Dochterman, J., & Bulecheck, G.M. (Eds.). (2004). *Nursing intervention classification–NIC* (4th ed.). St. Louis, MO: Mosby.
McNiff, S. (1992). *Arts as medicine.* Boston: Shambala.
Mitchell, G. (1990). Struggling in change: From the traditional approach to Parse's theory-based practice. *Nursing Science Quarterly, 3*(4), 170–176.
Montgomery, C.L. (1993). *Healing through communication: The practice of caring.* Newbury Park, CA: Sage.
Nakamura, J., & Csikszentmihalyi, M. (2003). The motivational sources of creativity viewed from the paradigm of positive psychology. In L. Aspinwall & U. Staudinger (Eds.), *A psychology of human strengths: Fundamental questions and future directions for a positive psychology* (pp. 257–269). Washington, DC: American Psychological Association.
Nathan, A.A., & Mirviss, S. (1998). *Therapy techniques using the creative arts.* Ravesdale, WA: Idyll Arbor.
North American Nursing Diagnosis Association (NANDA). (2003). *Nursing diagnoses: Definitions and classification 2003–2004.* Philadelphia: Author.
Peplau, H. (1988). The art and science of nursing: Similarities, differences, and relations. *Nursing Science Quarterly, 1*(1), 8–15.
Ritter, M., & Graff Low, K. (1996). Effects of dance movement therapy: A meta-analysis. *Arts in Psychotherapy, 23,* 2, 249–260.
Ruggiero, V. R. (1996). *A guide to sociological thinking.* Thousand Oaks, CA: Sage.
Samuels, M., & Rockwood Lane, M. (1999). Foreword. In B. Gamin, *Art and healing: Using expressive art to heal your body mind and spirit.* New York: Three Rivers Press.
Samuels, M., & Rockwood Lane, M. (1998). *Creative healing: How to heal yourself by tapping into your creativity.* New York: Harper.
Sandel, S. (1993). The process of empathetic reflection in dance movement therapy. In S. Sandel, S. Chaiklin, & A. Lohn (Eds.), *Foundations of dance/movement therapy: The life and work of Marian Chace.* Columbia, MD: American Dance Therapy Association.
Scotto, C.J. (2003). Faculty forum. A new view of caring. *Journal of Nursing Education, 42*(7), 289–291.
Snyder, M., Kreitzer, M., & Loen, M. (2001). Complementary and healing practices in nursing. In N.L. Chaska (Ed.), *The nursing profession* (pp. 527–535). Thousand Oaks, CA: Sage.
Warren, B. (2000). *Using the creative arts in therapy.* London: Routledge.
Watson, J. (Ed.). (1994). *Applying the art and science of human caring.* New York: NLN Press.
Watson, R., Deary, I. J., & Lea, A. (1999). A longitudinal study into the perceptions of caring among student nurses using multivariate analysis of the Caring Dimensions Inventory. *Journal of Advanced Nursing, 30*(5), 1080–1089.

Section 1
ARTS AND CRAFTS

Chapter 2

THE PSYCHOSOCIAL ISSUES AND THE USE OF ART WITH CLIENTS WITH CHILDHOOD CANCER

Elizabeth Joyce Soderling

SUMMARY

This following chapter presents the use of art as a therapeutic means in working with children who have cancer. The case described is taken from the author's previous work (Soderling, 2002). The case study is a story of an adolescent girl who was diagnosed with cancer and the way in which an art intervention was used to help address the psychosocial issues that children with cancer may face. The chapter will begin by identifying the psychosocial issues facing these children, then the case will be used to exemplify how art was used and why.

INTRODUCTION

It is not fair and it is not just that children are diagnosed with cancer. As no one knows the cause, it cannot be prevented. Medical treatment advances have progressed significantly for this often tragic childhood disease. However, cancer no longer has to be a terminal illness for all children. The prognosis for children today is much more optimistic than some years ago. According to Canadian Cancer Statistics (2000), deaths of children from cancer have declined by more than 50 percent since the 1950s. For the period from 1996 to 2000, almost 1,300 Canadian children were diagnosed with a form of childhood cancer each year and "231 died each year from the disease" (Canadian Cancer Statistics retrieved June 5, 2004 from www.cancer.

ca/rgn/images/portal/cit_86751114/14133/195986411niw_stats2004-en.pdf. p. 64).

When children are diagnosed with cancer, their lives, as well as their family's lives, are significantly affected. Not only are there medical treatments and stressors, but there are also many psychosocial issues to handle. At one time, research was focused on dealing with death and medical issues. However, given the advances in medicine and greater survival rates, the focus has shifted to addressing the psychosocial needs of families. This case study focuses on the psychosocial aspects of childhood cancer. The case is a description of Beth (pseudonym), a thirteen-year-old girl, and her family whose lives were affected as a result of her diagnosis of cancer. In my role as her social worker, I had the honor and privilege of working with this amazing girl and her family along part of their journey.

The issues that will be described in this case are factual, but the names of the family members have been changed to protect their identity. The artwork utilized was done so with consent. A review of the literature, research, and theory, in relation to pediatric oncology, will be addressed and will speak to the emerging need for health care professionals to address the psychosocial aspects and the effects that cancer has on children and adolescents. One salient question for health professionals is what can we do to assist these children and their families through their journey to deal with the psychosocial issues that present themselves?

CASE DESCRIPTION

Identifying Information

This case study centers on thirteen-year-old Beth and her family. Beth is the eldest of three siblings born to Phil and Pauline. Phil and Pauline were married fourteen years, and they separated one year ago. Beth has two siblings, Kayla, aged nine, and Justin, aged eight. The family resides in a rural community in western Canada. I first met the family in October 2001, when Beth was referred to a specialist because of chronic leg pain.

Presenting Problem

In October 2001, Beth was seen in the hospital for treatment of chronic leg pain, which had been worsening in the last six months. What was initially seen as growing pains turned out to be a mass in the left femur. After a number of diagnostic tests, x-rays, bone scan, CT scan, and biopsy, the mass was diagnosed as osteogenic sarcoma (also known as osteosarcoma), a malignant

tumor of the bone. Varni, Christ, Lane, and Marcove (1995) cite this as the second most common cancer to affect adolescents.

Survival rates have improved from 15-20 percent in the 1960s to 60–80 percent today. The initial focus of Beth's care was pain management and assisting Beth and her family during medical procedures and through the crisis stage. Once the diagnosis was confirmed, Beth quickly moved into the treatment phase that included chemotherapy and subsequent abstraction of the tumor by way of a surgical procedure known as rotation plasty. The surgery involves removing the affected limb area, which was the femur in Beth's case. The rotation plasty, or limb salvage, involves reattaching the lower limb to the upper limb and rotating it so that the ankle becomes the knee joint. The foot then faces backwards in order to act as a lever for the prosthetic. My role as the social worker on the team was to conduct a psychosocial assessment of the family in order to assist them in adjusting to and coping with the illness.

RELEVANCE TO SOCIAL WORK

The unique aspect of social work is its broad focus. Whereas sociology focuses on the effects of the environment and psychology of the person, social work addresses the person in the environment. In the case of childhood cancer, the medical staff's main focus is on the illness, treatment, and cure. Social work with its person-in-environment perspective looks at the child with the disease in relation to the environment in which (s)he resides. As Fillios and Stovall (2001) state:

> the diagnosis of cancer in childhood quickly involves the child or adolescent, parents and all family members in the complex world of present day cancer treatment. This world acknowledges the importance of treating the child with a disease, not just the disease itself. (p. 143)

Social work in oncology is a relatively new specialty. It first gained recognition in the early 1970s and subsequently focused on the area of childhood cancer as the number of children surviving increased (Lauria, Clark, Hamann & Stearns, 2001). The first Social Work Oncology Group (SWOG) was formed by Marion Stonberg (Lauria et al., 2001) in the mid-1970s.

With the emerging research in psychosocial issues in childhood cancer, social work plays a significant role in working with the children and their families. On a multidisciplinary team, the social worker not only assists the children in coping and adjusting, but also works with the parents, siblings, and extended family. In addition, social work focuses on the impact of the illness on school, family life, and friends. The social worker's role includes

crisis intervention, adjustment counselling, accessing resources, advocating, problem-solving, pain management techniques, and support.

Psychosocial Issues

At one time, hematologists and oncologists focused on ways to control the cancer and prolong life. Today, doctors are aware of the need to look beyond the disease itself, and many hospitals now have psychosocial staff that includes social workers. What has brought about this shift in focus and why is it seen as so important? One reason is that medical advances have had a profound impact on childhood cancer both in terms of medical advancement and psychosocial advancement.

As medical advances are made and more children survive, there is more demand on examining the needs of survivors and what this means for those going through treatment. Today, the focus is not only on medical aspects but also the emotional and social well-being of the child. Spinetta (1981), who conducted a three-year study on the adjustment and adaptation of children with cancer, states that

> As medical progress in recent years has had increased the life span of children with cancer, concern has shifted from what in the 1950s and 1960s had been a preparation for an inevitable death, to helping the child and family in the 1980s prepare for what is becoming an increased change of long-term survival. (p. 5)

Varmia, Katz, Colegrave, and Dolgin (1996) concur with Spinetta (1981) that "this trend in survivability has led to a shift in psychological emphasis from crisis intervention confronting imminent death to facilitating coping and adjustment to a serious-life-threatening chronic disease" (p. 321). With the increased survival rates, the focus of research has shifted from issues of death to quality of life. Studies are now beginning to address the psychosocial aspects of illness (Sheilds, Schundel, Barhart, Fitzpatrick, Sidell, Adams, Fertig, & Gomez, 1995). The topics being studied include adjustment and adaptation to illness (Sanger, Copeland, & Davidson, 1991; Spinetta, 1981; Sawyer, Antoniou, Toogood, & Rice, 1997; Varni, Katz, Colegrove, & Dolgin, 1996); communication (Claflin & Barbarin, 1991; Foley, 1993; Spinetta & Maloney, 1978); cognitive functioning (Stenbers et al., 1994); worries and fears (Weiger, Chesler, Zeback & Goldman, 1998); school issues (Deasy-Spinetta, 1993); self concept and image (Anholt, Fritz, & Keener, 1993); role of family (Kupst, Richardson, Schulman, Lavigne, & Das, 1995); survivorship issues (Gray, Doan, Shermer et al., 1986; Speechley & Hoh, 1992); and parents' adjustment and coping (Dahlguist, Czyewski, Copeland, Jones, Taub, & Voughan, 1993; Grootenburs & Last, 1997; Nelson, Miles,

Reed, Davis, & Cooper, 1991).

Several key issues have been identified in the research on the psychosocial aspects of childhood cancer that have implications for practice. Key issues are identified that children and families will face and provides information on how families can be assisted to adapt in a positive way. With the research focus being on survival and the implications of such, the need for psychosocial supports is being recognized. Much of the research has been devoted to the psychological experience of childhood cancer. The purpose of this section is to highlight the psychosocial aspects, which will guide us in how we intervene with the families.

From the time the family notes concerns with their child through to diagnosis, treatment, remission, and possible relapse and death, the family is faced with different challenges along the way. As part of the treatment team, the social worker helps to assist the family throughout their journey. The goal is to assist the family to cope with and adjust to the illness. In order to fulfill this goal, it is important to understand and be aware of the challenges the family may face.

Common Themes and Issues

Although each child and family are unique, the studies and research in the area of childhood cancer have identified common psychosocial issues families will face from diagnosis through treatment and into survivorship or bereavement. Lauria (2001) identifies the following issues that families may face. Families will have *a need for knowledge and information in order to deal with the area of cancer.* Families need to be informed participants, and this includes the children themselves. Information needs to be provided at an age-appropriate level and needs to be tailored to meet the family's needs. At the initial stage of diagnosis it is helpful to provide information in a written or visual form, as the high level of stress and anxiety makes it difficult to process verbal information. The *physical impact on the child* diagnosed and the *emotional reactions of all family members* are common issues. The physical impact and changes from treatments and possible surgeries lead to side effects such as nausea, fever, immobility, infections, hair loss, disruptions to normal life, and sometimes permanent disfiguration due to surgeries. These physical impacts and side effects lead to emotional issues for all family members involved. Lauria (2001) goes on to identify the common emotional responses and feelings of shock, disbelief/denial, fear/anxiety, guilt, sadness/depression, and anger. Just like grief, which will be discussed later, the child and family can experience these feelings at any time and may re-evolve as new crises occur. Another common issue, and an important one, is the development of the child/adolescent. Lauria (2001) phrases the issue well: "young people are

'works in progress' and it is essential for oncology social workers and other team members to assist parents in promoting and supporting normal developmental activities and behaviors" (p. 124). This is a challenging task given that a diagnosis of cancer, with its treatment, can set a child back and that parents tend to become more protective. The issue of development will be discussed further in relation to adolescence, as that is the stage that Beth is at.

The next two issues identified by Lauria (2001) relate to the person-in-environment perspective previously mentioned. The *impact of cancer on family life, each family member, and the interaction the family has with the health care system* are also important factors to take into consideration. The cancer experience is not just about a child with cancer; it is also a family issue, one that extends beyond the family to friends, community members, peers, and medical staff. The family themselves and those associated with the family are greatly affected by the diagnosis.

Further to this is the fact they are thrown into a medical world with its own policies and practices with which the family is not familiar, leading to *uncertainty regarding treatment response and survival.* In my work with families, they have identified one of the hardest challenges as dealing with the fear of the unknown and the uncertainty.

The above-mentioned fear relates to this last issue that Lauria (2001) identifies: *the search for meaning.* Finding meaning will be different for each family and each individual as "they try to interpret the diagnosis or the suffering and trauma of their child in light of whatever beliefs and cultural attitudes they have about the nature and meaning of illness, life and death" (Lauria, 2001, p. 129). The search for meaning is an area where, as therapists, we need to be culturally sensitive and aware. The meanings and hope that families find never cease to amaze me.

Stages of Illness

The above issues and concerns, which can occur and reoccur throughout the cancer trajectory, often need attention at different times. By conceptualizing the cancer experience in stages, we may better assess where the family is at, what issues they are addressing and what interventions need to be developed with them. Lauria (2001) has shown how "cancer moves from the crisis stage of diagnosis through subsequent stages of chronicity and current crises" (p. 118). Similarly, Cincotta (1993) discusses the need to understand the stages of illness from the context of crisis or stage theory. He also identifies a pre-diagnosis phase. The nine stages that he identifies include: pre-diagnosis, diagnoses, induction, remission, relapse, coming off treatment, survivorship, dying, and bereavement. Lauria (2001) also identifies similar

stages; however, he omits the pre-diagnosis phase. Each stage has common issues and tasks. A stage framework allows social workers to assess where a family is at, what issues may be relevant, and how best to intervene. As it is beyond the scope of this paper to discuss each stage and its tasks in detail, a discussion of the stage related to this family will be presented in the chapter. The key point to keep in mind is that families can move in and out of the stages in a circular fashion. The stages also relate to the feelings mentioned in the previous section, which are connected to the theory on grief and crisis, a topic that is discussed next.

Grief and Loss

In regard to grief and loss, the literature concurs with my experience working with these families, in that no one person grieves the same way nor for the same reasons. Grief and loss are not only a response to imminent death but to a number of other losses. For some, it may be the loss of a loved one, for others it could be a loss of a material physical object, a loss of control, or a loss of social or economic standing.

Wolfelt (1992) defines grief as "the composite of thought and feelings about a loss that you experience within yourself" (p. 8). The stages of grief have been well documented, one of the earliest being Kubler-Ross's five-stage model for the terminally ill: denial, anger, bargaining, depression, and acceptance (Bear, 2002). The stages proposed by Kubler-Ross were in relation to the stages a terminally ill person may progress through, but over time, the stages have been adapted to fit for any loss or traumatic event (TLC Group, 2002). Although these stages were originally interpreted to occur in a linear fashion, it is now understood that the stages are circular and that no one person grieves in the same way (Wolfelt, 1992). Having knowledge of these stages is important in working with children with cancer as they and their families may go through the same stages in relation to being diagnosed with the accompanying losses.

The reason I identify the area of grief is to highlight that it is important for health care professionals to note that children and their families do experience many losses. There is the loss of normal life, as they know it. Children are hospitalized for long periods, leaving them isolated from family, friends, and school. Children lose control of their health and well-being. There is a loss in appearance, some temporary and some permanent, such as the loss of a leg in Beth's case. Wolfelt (1992) discusses the term "reconciliation" versus "resolution" in relation to grieving. As resolution often refers to returning to normal stage, Wolfelt prefers to use reconciliation in which the person works to integrate the new reality of moving forward in her or his life. Although Wolfelt relates this aspect to the loss of a loved one, I think it fits well for chil-

dren who are experiencing the losses mentioned above. In her book, *Armfuls of Time,* Sourkes (1995) has a chapter dedicated to anticipatory grief, and she discusses the losses above. She maintains that "loss, the core of anticipatory grief, can be conceptualized along three intersecting axes: loss of control, loss of identity, and loss of relationships" (p. 137). One of the goals of an oncology social worker is to assist the child to cope with and integrate this new reality into his or her life; knowledge about the phases of grief is necessary for healthcare professionals to intervene effectively.

Crisis Theory

Kathleen Ell (1996), in discussing crisis theory states, "stressful life events can perpetuate a state of 'crisis,' wherein people experience temporary feelings of severe acute distress and of being overwhelmed or unable to cope in ways that reduce the discomfort or the hazardous circumstances" (p. 168). Much of the beginning work with these families and children is crisis work. Having a child diagnosed with cancer throws the family into disequilibrium and perpetuates a crisis through which they must work. When a diagnosis is made, both the family, as a unit, and each individual are thrown into this unstable state, which constitutes a crisis (Lauria, 2001). Cox & Stovall (2001) identify this crisis state as characteristic of the diagnosis stage of illness and go on to say that "the social worker can help family members to understand how to manage feelings, how familiar coping mechanisms can be valuable in this new situation, and how to learn news ways of coping" (p. 153). When in crisis, it is common for people to experience feelings of confusion, anxiety, depression, and anger with an elevated psychological vulnerability, reduced defensiveness, and a regression in coping and problem-solving abilities. The idea is to assist families and children in mastering developmental and coping skills, to reduce the intensity of the psychological upset, and to get back to a state of equilibrium (Ell, 1996). Although there is the initial crisis at the time of diagnosis, it is important to remember that a crisis can reoccur at any time and that the same goal is key: to help the family through the crisis.

Developmental Theory

The recognition of psychosocial issues has brought with it the understanding of child development. Knowing where a child is at developmentally will influence how one intervenes and what issues the child is likely going to be facing. In addition, the need for open and honest communication has become apparent but cannot be done without an understanding of child development. Erikson and Piaget are the most noted when it comes to discussing child development. Both Erikson and Piaget have proposed stages

that children progress through from birth to adulthood. For the purpose of this chapter, just the stage that relates to Beth's age, thirteen, will be identified. In Erikson's developmental stage, Beth is at the stage he termed *identity versus role confusion* and Piaget's cognitive stage of *formal operations* (Beck, 1997).

For youth with a diagnosis of cancer, the developmental issues become pronounced and bring with it special challenges. For adolescents, this is a time where they are becoming independent from family, establishing their own identities, and testing limits. Adolescence is a time where family is less important and peers take on a significant role. For youth trying to find themselves and their own identity, self-image plays an important role. When a youth is diagnosed with cancer, these developmental tasks are challenged. As Cincotta (1993) cites, " a diagnosis of cancer at this time forces adolescents to become more dependent on family than they may want to be. The assault to self-esteem may be overpowering" (p. 3253). Cincotta (1993) goes on to discuss the role peers play during this stage and therefore the importance of ensuring that peers are encouraged to be apart of the treatment process for the diagnosed youth. *Self-image, body image, sexuality,* and *self-esteem* are key issues to be mindful of when working with adolescent cancer patients given the physical effects of treatment and possible disfiguring surgeries. In addition, *socialization, peers, school, independence,* and the promotion of a *sense of control* are important (Lauria, 2001; Sutton, Keller, Levine, 2001). Having an understanding of adolescent development allows for effective assessment and intervention. At this stage, youth have an understanding and appreciation for disease and death and may want complete information but may not always ask (Lauria, 2001).

ASSESSMENT AND PROBLEM IDENTIFICATION

The literature discusses the need for completing a screening and an assessment in order to determine whether families or children are in need of psychosocial support (Blum, Clark, Marcusen, 2001). The social worker completes a psychosocial assessment to determine needs, strengths, weaknesses, and any areas requiring further intervention or counseling. Faller (2000) speaks to the need of conducting the assessment from a person-in-environment perspective and discusses the importance of working with children from an ecological perspective: "social workers engaged in direct practice with children must be ever mindful of the ecology or larger context in which children live" (p. 264). Faller (2000) characterizes these contexts as the political, economic, environmental, cultural, and familial. As Webb (1996) states, "it is essential to look up, down, and all around while trying to analyze the

totality of the problem situation" (p. 57). Webb (1996) also discusses the importance of an ecological assessment and adds the biological aspect, calling for a biopsychosocial assessment. Webb (1996) identifies a "tripartite assessment" in order to conduct such an assessment which incorporates the individual factors, the situational factors, and the support factors (pp. 63–64). Such an approach fits well with a person-in-environment context which social work adheres to.

Beth's assessment was completed in a similar fashion to that described by Faller (2000) and espoused by Webb (1996). The assessment looked at Beth in relation to her environment/situation, as well as her individual and support factors. Webb (1996) also identifies the use of tools such as genograms and ecomaps to help ensure a broad assessment.

Individual Factors

Beth turned thirteen shortly after being diagnosed. For her age she presented as mature and articulate, appeared very strong-willed and determined, which was a strength that helped her to adapt so well. Beth appeared to be developmentally on task, and Pauline advised that Beth reached all milestones as expected and had no delays as a young child. There were no issues identified in relation to past medical issues or in relation to abuse. Beth attends grade seven, does well at school, is well-liked, and is physically active in sports.

Beth's age places her in Piaget's formal operations stage in relation to cognitive development (Berk, 1997). Given that at this stage youth are capable of abstract thinking, deductive reasoning, problem solving, and hypothesising (Berk, 1997), communicating directly with Beth in relation to her cancer was important. Beth was capable of understanding the seriousness of the diagnosis and had a concept of death and dying. For young children, the main concern is usually with being separated from parents while adolescents worry about the side effects, pain, and procedures as they can reason what effects they will have. Beth was involved in meetings and discussions, and the team communicated directly with Beth as well as her parents. The team recommends that information not be kept from the youth as it disempowers them and can reduce trust.

Power and control are important at age thirteen. Beth was in what Erikson defines as the identity versus confusion stage (Berk, 1997). At this stage, youths are trying to set their own identity, separate from their parents, and have some control over their own destiny. This is very important to understand in working with Beth as her diagnosis impedes this challenge. By no choice of her own, Beth has become more dependent on her parents and medical staff and has no control over the tumor in her leg that decides her

destiny. Providing Beth with any choices and input to help encourage a sense of control is vital to this stage of development. Sutton, Keller, and Levine (2001) speak to the importance of choices: "small decisions about food, clothing, room decorations, and how to spend free time can leave a great impact on reclaiming some control and sense of autonomy" (p. 235).

Beth presented as quiet, shy, and somewhat withdrawn when it came to expressing her emotions and fears. Beth was verbal and inquisitive in relation to her treatment and medical information but not as much when it came to her expression of emotion. One common reason children tend to be withdrawn is in order to protect their parents. Glazer and Landreth (1993) state, "often, the greatest problems for dying children are the pain and guilt they feel for causing their parents pain; so they try to protect the parents from themselves" (p. 66). Glazer and Landreth (1993) identify the importance of providing children with a safe environment that is warm and accepting where they are free to express their fears and worries. In working individually with Beth, I hoped that this would allow for an environment, away from parents, where she could express her feelings without having to protect them.

Environmental/Situational Factors

Beth was from a small town outside of Edmonton, so she was isolated from her peers while in hospital and often unable to attend school due to side effects and risk of infection. The school issue has been well documented and seen as an important aspect for children with cancer (Cincotta, 1993; Lauria, Clark, Hermann, & Stearns, 2001; Deasy-Spinetta, 1993). As Beth's treatment involved frequent and lengthy hospital admissions, consultation with her school was important, and involving the on-site teacher to implement an educational plan helped to minimize the disruption to Beth's education. Although school performance is important, it also has to be balanced with Beth's health and energy levels. Having a school program for each child allows for self-directed learning and fits with the child's illness and can be accomplished at her or his pace. During times when Beth was not hospitalized, she was encouraged to attend school as long as she felt up to it and her health allowed her to attend. For Beth, attending school was not only important academically but also socially, as at this stage peers play such a predominate role. Having friends and peers attend the hospital was also encouraged and seen as important for Beth's well-being. School was one area where intervention was important, as Pauline had advised that even when Beth was well she was reluctant to attend school. Pauline had attempted to talk to Beth about this, but she was not open to express her feelings. Pauline hoped that someone working individually with Beth would help her to express feelings in relation to this issue.

Although Beth was away from home, either one or both parents were always present with her at the hospital as well as aunts, uncles, and grandparents. Beth has two younger siblings who were not often at the hospital, as they had to attend school, so there was some isolation from them. The family provided a strong support for Beth, one another, and they appeared very close. Beth's parents had separated about one year ago, but for the most part, the parents were able to put this aside in order to support Beth. Some marital issues did arise, and they were dealt with between the parents and the psychologist. The family's patterns of communication were open, and the parents encouraged Beth to be involved in her treatment and were open and truthful with Beth in terms of medical information. This open communication has been seen as positive in studies in terms of coping and adjustment (Claflin & Barbarin, 1991; Foley, 1993; Koocher & O'Malley, 1981) and was certainly seen as a strength for Beth and her family. Folley (1993) discusses the importance of open communication with the children in order to achieve physical and psychological health and further states that "effective communication that facilitates the child's or adolescent's participation in the process may enhance development, support self-esteem, increase cooperation, and possibly mitigate non adherence to treatment" (p. 3285). Koocher and O'Malley (1981) also contend that the more open and honest the communication, the better the adjustment.

The issue of loss was predominant for Beth. The treatment for cancer alters the physical image of the patient and has side effects such as nausea, weight loss, and hair loss. In addition to this, Beth's cancer has to be treated with surgery during which the tumor is surgically removed from her leg. The procedure, known as limb salvage, leaves Beth with a permanent physical disfiguration. Beth is at the vulnerable teenage stage where self-image and self-concept are being developed, making this aspect very important in working with Beth. Although Beth has no control over the changes from the cancer and the surgery choices and options are provided in order to make this adjustment easier. Providing a sense of power and control can help Beth's adjustment and adaptability. Cincotta (1993) states that "regardless of medical advances, the look of the child with cancer has not changed," so providing children with choices and options becomes important in ensuring a positive self-image. Beth seemed to cope well with her initial image change in relation to hair loss and was confident in herself despite the physical change. Beth was provided with options and resources for wigs, as upon admission she had long, dark, thick hair. However, Beth chose not to wear the wig and instead wore a bandana or nothing to cover her head. This was deemed as a strength as Beth displayed a strong self-concept and self-esteem that extended beyond her physical appearance. It was hoped that this positive image would continue after the surgery. These situational factors described by Webb (1996) includes the

nature of the problem (presence of loss, trauma, life threat, element of stigma), psychosocial/environmental problems, onset of problem, and involvement of others. This area seemed to be the most predominant in terms of stresses for Beth in relation to the nature of the problem.

Support Factors

The support factors for Beth and her family were very positive. Based on my observations and conversations with her parents, Beth was a strong and determined young girl with effective coping abilities. In addition, her family was a cohesive unit that provided consistent support for each of its members. They had dealt with death and with cancer previously. The family responded as expected when in the initial stage of diagnosis and crisis in that they searched for answers, explanations, meanings, and alternate treatments. Beth and her parents asked questions of the health care professionals and wanted as much information as possible. The family had a strong sense of hopefulness, and was determined to make the best of a terrible situation. One of both of her parents were always present during Beth's hospital stay. A strong bond was evident between Beth and her mother. Beth also had extended family that came to the hospital to provide support. In addition, she had a best friend who came to the hospital a few times to visit. However, as mentioned previously, the maintenance of relationships with peers and siblings was a challenge, as the family lived a considerable distance from the hospital.

Challenging Factors

In contrast to the above-mentioned strengths, Beth demonstrated a tendency to "bottle up" or not express her emotions. For example, when Beth was asked how she was doing or feeling in relation to her illness and her treatment, her answers were vague. She usually stated she was "fine" and that everything was "fine." As anyone who has worked with adolescents knows, it is difficult to get a teenager to talk, especially to an adult, and Beth was no exception. Although Beth was reluctant to express any of her concerns verbally, we know from the literature on childhood cancer that given her age and diagnosis, she was likely facing some of the issues described earlier in this chapter.

Beth's treatment and in-patient stays isolated her from her school, friends, and siblings. Peer relationships are of most importance during adolescence. In addition, having control and independence is important at this stage, and the illness and treatment interfered with this sense of control. Self-image and self-concept are also of extreme importance in adolescence. Given that Beth's image is likely dramatically changed due to chemotherapy and the

disfiguring surgery, these challenges will have to be addressed by her treatment team.

Following the initial assessment, it was determined that I would work individually with Beth while the psychologist worked with the parents, and the child life specialist with the siblings. Her mother, Pauline, indicated that Beth had felt a connection with me from the time we first met, and therefore she believed that Beth may open up to me during individual counseling sessions.

The role of the social worker is to help children cope and adjust to the illness. In order to achieve this goal, it is important for the children to be able to express their fears and emotions. Because she was not comfortable expressing her feelings verbally, my challenge was to find a way for Beth to do this task in another way. At that time, one of my colleagues was developing a project called "Tile Tales." This project required that children paint a tile expressing what it was like to have cancer. Once completed, these tiles were to be displayed in a public waiting area of the clinic. I took the opportunity to use the tile-making intervention with Beth as described below.

PLAY AND EXPRESSIVE ART INTERVENTIONS

It is important to remember that each individual and family is unique and therefore requires different interventions. As noted by Blum, Clark, and Marcusen (2001), "a comprehensive program encompassing counseling services, resource utilization, and education will be most effective in meeting the changing needs" (p. 54). The importance of screening and assessment is highlighted in order to determine the best means of intervening for each individual. Blum et al. concisely summarize the purpose of interventions:

> Oncology social work services are designed to help patients and their families feel more in control of a situation that predictably makes them feel helpless and out of control. Interventions should be focused on helping people cope with the medical, emotional, and social problems they encounter at different points in the cancer experience. (pp. 53–54)

As each individual is unique, it is important, as a practitioner, to have a wide variety of tools and techniques to utilize with families who are experiencing illness. My practice framework encompasses an eclectic approach to ensure that the technique fits the client instead of trying to fit the client into the approach. In pediatric oncology care, it is beneficial to have knowledge of crisis intervention, problem solving, solution-focused approaches, behavior modification, and group and individual psychotherapy approaches. As Sourkes (1995) states, when working with children with cancer, "each therapist must find a pathway to the child that is congruent with his or her own

training, experience, feelings, and attitudes" (p. 10).

My role as the social worker involved assessment, accessing resources, assisting with pain management techniques, crisis intervention, and adjustment counselling. Although I had a number of roles and utilized a number of interventions, for the purpose of this chapter, I will focus on adjustment counselling. Part of adjustment and coping involves expressing one's feelings and emotions, which Beth, at times, had difficulty doing. The goal was to help Beth identify and address these emotions in order to enhance her coping ability. It was determined that a less direct approach than talking would be more effective in assisting her self-expression. For this reason, the art project described below was selected as Beth's treatment.

Childhood is a time of play. Anyone who has worked with children with cancer knows these children quickly mature beyond their years. Whatever the age, the child is thrown out of a life where they are invincible and carefree into the reality of a world where they have cancer. Play is what children do, so what better way to help them cope and adjust and be what they are, kids? Sourkes (1995) emphasizes the importance of play with children who have lost a sense of childhood. Play allows them to "re-enter" childhood and encourages "respite from the harshness of the immediate environment" (p. 5). Play is not age-limited, but needs to be developmentally appropriate. A playful and interactive use of art expression can readily engage adolescents. Riley (1999) states that "art used in therapy can meet the adolescents' needs for control, narcissistic expression, creativity, exaggerated logic, and experimentation directed toward appropriate individuation" (p. 65).

In the following section, I will discuss the art activity I used with Beth. Although I am not an art or play therapist and have little experience using those interventions, I will describe the ways in which art making was an effective self-expression tool for Beth.

Rationale for the Tile-Making Intervention

As stated previously, my goal was to assist Beth in expressing her feelings through art-making. Beth was experiencing trauma and crisis in relation to her diagnosis. Using an art technique was appropriate because it allowed Beth to put her thoughts and feelings on paper, thereby assisting her to express her feelings.

Art as communication is an effective way to work with teens as it is non-threatening and allows for communication without words. Riley (1999) said it well when he stated that "once the fingers begin to knead and play with the clay, the mouth seems to magically start to move" (p. 60). Beth's case proved this statement to be true. Once she began to draw, the verbal dialogue followed. Beth was asked to depict on her tile "What is it like to live with can-

cer in your life?" Her graphic response expressed six feelings that she has experienced.

Beth's Tile Tale

As stated earlier, the intent of my "Tile Tale" intervention was to facilitate expression and identification of feelings. Beth was asked "what is it like to live with cancer in your life?" At first, Beth had difficulty deciding what to draw and asked me for direction. I encouraged her to make her own choice and informed her that there was no right or wrong response.

The picture she drew and titled "Me" (see Figure 2.1 and front cover) in response to this question was a six-petal flower. Each petal contained a specific feeling and was colored a different shade. Whereas a shining sun was posited in the upper left-hand corner of the tile picture, the right side of it contained a cloud with raindrops falling to the earth. Beth described her tile in the following manner:

> The flower represents me and my feelings. The middle of the flower is ME [colored purple] and the petals are my different feelings. The different colors represent differing feelings. The sun represents good days when I'm feeling happy and doing something with my family. The cloud represents rainy and cloudy days when I'm feeling sad, confused, or worried. Sometimes, I feel better when I talk to someone about my sad feelings.

The feelings Beth indicated on her petals are the following: [from top left clockwise] worried, confused, mad, sad, happy, and tired. Those feelings are similar to those identified by Sourkes (1991) in her description of feelings about children's shock, fear, sadness, anger, loneliness, and hopefulness. At the start of the session, Beth was her usual shy self, quiet and reserved. Once she got into drawing her tile, she was more responsive to questions about the feelings she was drawing. She was able to provide examples of when and how she felt each of the feelings. Other issues were identified such as Beth's fear about surgery and the isolation she felt from her peers who she felt did not understand what she was going through. It would have been interesting to have looked at which order Beth identified the feelings; however, this was not noted at the time.

Utilizing the drawing proved beneficial for subsequent sessions as we were able to address the other issues Beth identified. Referring back to the drawing was helpful as I was able to say to Beth, "remember when you did your tile, you spoke about being afraid of the surgery, let's look at this." The same was done in relation to the peer issue she identified. After completing the tile, Beth was more open to addressing these other issues again using other play/art techniques, which will be addressed in the next section.

Figure 2.1. What is it like to have cancer in your life?

DISCUSSION

The tile intervention was also an assessment tool. Separating assessment from intervention is difficult as each can lead to the other. As Webb (1996) states, "assessment and intervention typically occur simultaneously" and that "assessment is an ongoing process, and therefore subject to elaboration and revision throughout the contact with the clients" (p. 58).

This intervention was successful in facilitating Beth's expression of emotions. However, other issues were identified in my ongoing assessment which required further intervention, such as fear about her surgery, and issues with peers related to isolation from them and their lack of understanding of her illness. Other expressive art techniques were used to address these issues. Beth drew over her legs the night before surgery to ensure the operation went well and to say good-bye to her leg. Beth labeled each leg for the doc-

tor saying "cut here" and wrote "do not cut this leg" on her good leg. In addition see drew faces on each of her toes. Beth and her mother did the artwork together and also drew scenic images that both enjoyed. Beth said doing this art on her legs helped her deal with some of her fear and was a way she could say good-bye to her leg.

To address the isolation from her friends, Beth was assisted in making a video of herself at the hospital that she could share with her friends. The issue involving peer acceptance is an important one for adolescents, as Redd (1994) has noted. This issue has also been emphasized by Riley (1999), who indicated that "Rejection by peers is the greatest threat. If therapists do not understand that these values are primary in the minds of their clients, they will be ignoring basic facts of adolescence." Beth's concern about social rejection was intensified because of surgical treatment that would make her appear different.

In a bad situation, everyone tries to find meaning, and it is no different for children with cancer. The use of the tile tale provided Beth with some meaning. One of the ways in which meaning was created was by identifying and processing her feelings. Another way was the creation of work as art that would be displayed for others to see. Beth agreed to display it as she thought it might help other children.

It was a privilege to work with Beth and her family. The strength and courage displayed by Beth was amazing. Throughout my involvement, I was able to see Beth start to come out of her shell and become more interactive and assertive in terms of her feelings and fears. Utilizing the art techniques described here, I believe, assisted in penetrating Beth's shell. The use of art is beneficial in working with young children and certainly was effective in working with Beth. Beth was able to identify and deal with her feelings and emotions using art as a medium. The powers of art were made clear to me from my involvement with Beth, and I thank her and her family for allowing me to grow and learn from their experience.

REFERENCES

Anholt, U., Fritz, G., & Keener, M. (1993). Self-concept in survivors of childhood and adolescent cancer. *Journal of Psychosocial Oncology, 11*(1), 1–16.

Appleton, V. (2001). Avenues of hope: Art therapy and the resolution of trauma. *Art Therapy, 18*(1), 6–13.

Atlas, J. (1992). Art and poetry in brief therapy of hospitalized adolescents. *Arts in Psychotherapy, 19*(4), 279–283.

Berk, L. (1997). *Child development* (4th ed.). Needham Height, MA: Allyn and Bacon.

Bear, J. (2002). Stages of grief. Retrieved June 6, 2002 from cancersurvivorson

line.org, http://www.cancersurvivors.org?Coping/end%20term/stages.htm.
Blum, D., Clark, E., & Marcussen, C. (2001). Oncology social work in the 21st century. In M. M. Lauria et al., *Social work in oncology: Supporting survivors, families, and caregivers* (pp. 45–71). Atlanta, GA: American Cancer Society.
Cincotta, N. (1993). Psychological issues in the world of children with cancer. *Cancer Supplement, 71*(10), 3251–3260.
Clafin, C., & Barbarin, O. (1991). Does "telling" less protect more? Relationships among age, information, disclosure and what children with cancer see and feel. *Journal of Pediatric Psychology, 16*(2), 169–191.
Council, T. (1993). Art therapy with pediatric cancer patients: Helping normal children cope with abnormal circumstances. *Art Therapy, 10*(2), 78–87.
Cox, M., & Stovall, A. (2001). Social work interventions with children and adolescents. In M. M. Lauria et al. (Eds.), *Social work in Oncology: Supporting survivors, families, and caregivers* (pp. 143–167). Atlanta, GA: American Cancer Society.
Dahlquist, L., Czyewski, D., Copeland, K., Jones, C., Taub, E., & Vaughan, J. (1993). Parents of children newly diagnosed with cancer: Anxiety, coping, and marital distress. *Journal of Pediatric Psychology, 18*(3), 365–376.
Deasy-Spinetta, P. (1993). School issues and the child with cancer. *Cancer, 71*(10) 3261–3264.
Ell, K. (1996). Crisis theory and social work practice. In F.J. Turner (Ed.), *Social work treatment: Interlocking theoretical approaches* (pp. 168–190). New York: The Free Press.
Faller, K. (2000). Individual change in children and direct social work practice. In P. Allen-Meares & C. Garvin (Eds.), *The handbook of social work direct practice* (pp. 261–280). Thousand Oaks, CA: Sage.
Folley, G. (1993). Enhancing child-family-health team communication. *Cancer 71*(10), 3281–3289.
Glazer, H., & Landreth, G. (1993). When a child is dying. *Education Digest, 59*(1), 65–67.
Gray, R., Doan, B., Shermer, P., Vatter Fitzgerald, A., Berry, M., Jenkin, D., & Doherty, M. (1992). Psychological adaptation of survivors of childhood cancer. *Cancer, 70*(11), 2713–2721.
Grootenhuis, M., & Last, B. (1997). Parents' emotional reactions related to different prospects for the survival of their children with cancer. *Journal of Psychosocial Oncology, 15*(1), 43–62.
Koocher, G., & O'Malley, J. (1981). *The Damocles Syndrome: Psychosocial consequences of surviving childhood cancer.* New York: McGraw-Hill.
Kramer, E. (1993). *Art as therapy with children.* Chicago: Magnolia Street Publishers.
Kupst, M., Natta, M., Richardson, C., Schulman, J., Lavigne, J., & Das, L. (1995). Family coping with pediatric leukemia: Ten years after treatment. *Journal of Pediatric Psychology, 20*(5), 601–617.
Lauria, M. (2001). Common issues and challenges for families dealing with childhood cancer. In M. M. Lauria et al. (Eds.), *Social work in oncology: Supporting survivors, families, and caregivers* (pp. 117–141). Atlanta, GA: American Cancer Society.
Lauria, M., Clark, E., Hermann, J., & Sterns, N. (2001). *Social work in oncology:*

Supporting survivors, families, and caregivers. Atlanta, GA: American Cancer Society.

Moon, B. (1998). *The dynamics of art as therapy with adolescents*. Springfield, IL: Charles C Thomas.

Nelson, A., Miles, M., Reed, S., Poprawa Davis, C., & Cooper, H. (1994). Depressive symptomatology in parents of children with chronic oncologic or hematologic disease. *Journal of Psychosocial Oncology, 12*(4), 61–77.

Redd, W. (1994). Advances in psychosocial oncology in pediatrics. *Cancer, 74* (4), 1496–1502.

Riley, S. (1999). *Contemporary art therapy with adolescents*. London, UK: Jessica Kingsley.

Sanger, M., Copeland, D., & Davidson, R. (1991). Psychosocial adjustment among pediatric cancer patients: A multidisciplinary assessment. *Journal of Pediatric Psychology, 16*(4), 463–474.

Sawyer, M., Antoniou, G., Toogood, I., & Rice, M. (1997). Childhood cancer: A two-year prospective study of the psychological adjustment of children and parents. *Journal of American Academy of Child and Adolescent Psychiatry, 36*(12), 1736–1743.

Shields, G., Schondel, C., Barnhart, L., Fitzpatrick, V., Sidell, N., Adams, P., Fertig, B., & Gomez, S. (1995). Social work in pediatric oncology: A family needs assessment. *Social Work in Health Care, 21*(1), 39–54.

Sourkes, B. (1991). Truth to life: Art therapy with pediatric oncology patients. *Journal of Psychosocial Oncology, 9*(2), 81–96.

Sourkes, B. (1995). *Armfuls of time: The psychological experience of the child with a life threatening illness*. Pittsburgh, PA: University of Pittsburgh Press.

Speechley, K., & Noh, S. (1992). Surviving childhood cancer: Social support, and parents' psychological adjustment. *Journal of Pediatric Psychology, 17*(1), 15–31.

Spinetta, J., & Maloney, L. (1978). The child with cancer: Patterns of communication and denial. *Journal of Consulting and Clinical Psychology, 46*(6), 1540–1541.

Stehbers, J., MacLean, W., Kaleita, T., Noll, R., Schwartz, E., Cantor, N., Woodward, A., Kenneth Whitt, J., Waskerwitz, M., Ruymann, F., & Hammond, G. (1994). Effects of CNS prophylaxis on the neuropsychological performance. *Children's Health Care, 23*(4), 231–250.

Sutton, A., Keller, J., & Levine, A. (2001). Part A: Working with adolescents: Patients, caregivers, and siblings. In M. M. Lauria et al. (Eds.), *Social work in oncology: Supporting survivors, families, and caregivers* (pp. 233–245). Atlanta, GA: American Cancer Society.

TLC Group. (2002, January 01). *Beware of the 5 stages of "grief."* Retrieved June 6, 2002, from http://www.counselingforloss,com/article8.htm.

Varni, E., Christ, G, Lane, J., & Margove, R. (1995). Psychological adaptation of long-term survivors of bone sarcoma. *Journal of Psychosocial Oncology, 13*(4), 1–22.

Varni, E., Katz, Colegrove, R., & Dolgin, M. (1996). Family functioning predictors of adjustment in children with newly diagnosed cancer: A prospective analysis. *Journal of Child Psychology and Psychiatry, 37*, 321–328.

Webb, N. (1996). *Social work practice with children*. New York: The Guilford Press.

Weigers, M., Chesler, M., Zebrack, B., & Goldman, S. (1998). Self-reported worries among long-term survivors of childhood cancer and their peers. *Journal of*

Psychosocial Oncology, 16(2), 1–23.

Wolfelt, A. (1992). *Understanding Grief: Helping yourself heal.* Florence, KY: Accelerated Development.

Chapter 3

IMAGES OF ANGER FROM ADOLESCENTS IN ART THERAPY GROUPS

KIM MORRISON

INTRODUCTION

In this chapter, the author describes the effect that art therapy, combined with a school system's anger management course, can have on high school students aged fifteen to seventeen years. Prior to starting each art project, the youth were asked questions that helped them think about their anger in a creative manner. Questions they responded to included the following: "how would I represent anger?"; "what does it look like for me"?; and "what does positive anger look like?" Their art projects reflected these themes. In addition to the art making, the students recorded their responses to those questions. Furthermore, they completed the Buss Durkee Hostility Inventory (Felsten, 1996) and the Locus of Control Inventory (Rotter, 1996) as part of the anger management course which followed the art session. In this chapter, information on anger and art therapy is provided and applied to the artwork of this group of youth. This author believes that art is a window to an individual's symbolic world and that anger is not to be suppressed but to be understood as a mode of communication.

The art therapist learned about each of the youth solely through his or her art. That is, she was not given any background information about them in advance. She observed the development of these individuals' expressive process through the symbols and colors they used in their art and the way they described them in their writing. In this way, the art was truly the communicator for the clients.

LITERATURE

Anger

Anger is considered by many theorists to be one of the five basic or primary emotions of everyday affect (Weiner, 1986). However, anger is often viewed negatively sense. One primary reason for this view is the perception that anger can reach such a level of intensity as to be potentially dangerous. Furthermore, anger, unlike some other emotions, is subjected to social and internal controls from its inception (Averill, 1982; Ben-Zur & Breznitz, 1991; Miller & Sperry, 1987; Tice & Baumeister, 1993; Underwood, Coie, & Herbsman, 1992).

Several researchers have studied anger separately from the other emotions due to its alleged relationship to hostility and aggression. Societal and cultural norms shape our expression of anger (Averill, 1982; Diamond, 1996; Furlong & Smith, 1994; Underwood et al., 1992). Finally, research has shown that there is a correlation between aggressive and angry individuals and subsequent health problems, both mental and physiological (Averill, 1982; Compas, 1987; Felsten, 1996; Furlong & Smith, 1994; Hogan, 1998; Tice & Baumeister, 1993).

As with all emotions, anger has cognitive, affective, and behavioral components (Furlong & Smith, 1994). Averill (1982) defined anger as:

> a conflictive emotion that is related on a biological level to aggressive systems and to the capacities for cooperative social living, symbolization, and reflective self-awareness; that, on a psychological level, is aimed at the correction of some appraised wrong; and, that, on the socio-cultural level, functions to uphold accepted standards of conduct. (p. 317)

However, anger must be differentiated from aggression and hostility. Whereas aggression, as defined by Berkowitz (1993), is a behavior that deliberately attempts to achieve a particular goal (as in "instrumental anger"), hostility is defined as a complex set of attitudes about an object that can motivate destructive behaviors (Berkowitz, 1993; Diamond, 1996; Felsten, 1996). In this view, aggression is seen as normal, natural, and at times necessary, but that violence is an extreme (Diamond, 1996).

Despite all of this research into the expression of anger, it remains a poorly understood emotion. Anger can be positive and negative, motivational or destructive. Anger can serve to solve interpersonal conflicts as it acts as a warning flag to the angered person that something does not agree with the angered person's sense of how the anger-causing event transpired. This can be used positively to solve interpersonal differences prior to the anger growing out of proportion (Compas, 1987; Kaplan, 1996; Furlong & Smith, 1994;

Modrcin-McCarthy, Pullen, Barnes, & Albert, 1998).

Many factors influence the expression of anger. For example, Kitayama and Markus (cited in Cox, Stabb, & Bruckner, 1999) indicate that the collective reality of a culture, such as the norms, customs, and languages of that culture, is one contributing factor. Those authors emphasize that how a culture experiences anger is related to the importance that the culture places upon an individual, as opposed to the importance placed upon the collective approach. Additional factors that influence the expression of anger include: the individuals' core beliefs based on their experience of home, work, and family life; their level of perceived control (or causal attribution); their cognitive and emotional developmental level; and their habitual emotional expressive style. All of these elements will affect the reaction one would have to a certain situation. Therefore, anger, whether felt internally or expressed externally, is shaped individually by the culture, the individual, family and work experiences, and the current situations resulting in a different expression for each individual. All of these elements must be examined when trying to understand an emotional outburst from an adolescent.

Regardless of what theory one adheres to, anger should be seen as a mode of communication. Anger is often a reaction to a perceived injustice that is regulated by numerous factors: social, physical, cognitive, developmental, and cultural variables. An adolescent's expression of anger is conceptualized by Modricin-McCarthy et al. (1998) as a sign that the possibly immature cognitive and emotional development of an adolescent is not able to handle the stress that has been perceived. It may be the adolescent's way of communicating his or her feelings of being overwhelmed. This approach to anger seemed most applicable to the high school students described in this chapter.

Art Therapy and Adolescents

There is another way of looking at anger that is related to art therapy. According to Diamond (1996), anger arises from a place of passion. It is a fundamental part of human existence, and it can be creative or destructive. Diamond further notes that creativity is "a constructive utilization of the diamonic" (p. 256). According to him, this creativity can be used as a way of coping and understanding the passion of anger. Kafka (cited in Diamond, 1996) believed that art can be the "axe for the frozen sea inside us." Moon's (1998) description of the role of art therapy with adolescents is conceptualized as follows:

> Art transforms the world which appears to the eye, into a world that takes on the reality in the human mind. It recreates the outside world in a metaphor of colored forms, whose symbolic character can at the same time make visible the

real response of the artist. (p. 76)

Although this explanation of the role of art is an excellent one, there is another element that makes working with adolescents an even greater challenge. This next quote, from Kramer (1971), well describes the polarities that the therapist must confront and solve with the adolescent population:

> Adolescence is not only a time when sustained insincerity becomes possible but also a period when a more conscious recognition of the difference between inner truth and pretense can be reached. The same individual's art can oscillate between the trite and the sincere, the banal and the original. If we accept these oscillations and put our weight on the side of truth, we can do our share in helping the adolescent become an adult who can stand on his own and who can tolerate conflict and ambiguities without resorting to rigid defense mechanisms. (p. 157)

It seems only fair that art would be an excellent medium for adolescents whose very existence is a conflict of adapting to the ever-changing demands of their bodies, their cultures, their emotions, and their minds. This author concurs with Kafka (cited in Diamond, 1996) that art can be "the axe" to release the adolescents' passions. However, anger is often used by the adolescent in less constructive activities. Art therapy allows the adolescent to reshape creatively, adjust, rehearse, and accept one's new realities (Riley, 1993).

Art therapy has been found to be an effective treatment modality for maintaining an adolescent's autonomy and sense of control while facilitating growth and change in a non-threatening manner (Emunah, 1990; Kramer, 1971; Moon, 1998; Tibbetts & Stone, 1990). Many adolescents developed a genuine attachment to the arts during this time of multiple developmental changes. Emunah (1990) and Diamond (1996) have shown that any creative medium is an effective manner of working out difficulties that adolescence presents. Most adolescents seem to have the urge to create. Engaging in individual, artistic acts may not be the sign of a "sick mind" or of adolescent "turmoil and storm," as has been thought in the past. Indeed, Emunah, Diamond, and Moon view artistic expression as a sign of a healthy mind that uses creativity as a tool to self-actualize. In this way, adolescents have increased control not only of their art, but also of their turmoil, thereby giving them an increased sense of accomplishment.

On the other hand, some might argue that art therapy is similar to the psychoanalytic concept of catharsis. Cathartic release is a way of relieving internal stress or aggression, thereby alleviating the adolescent's need to release the stress that has been heretofore contained in an internal and unbearable emotional reservoir. Both Kaplan (1994) and Emunah (1990) note that catharsis is beneficial only if it facilitates insights, thereby promoting the individual's self-esteem and personal growth. The author believes that art thera-

py is ideally suited to facilitate both carthasis and insight. In art therapy, the client releases the conflicts into the art while gaining mastery over the materials. The struggles released into the art are processed through discussion of the art with the therapist and through journalling. This process is self-actualization through art (Diamond, 1996).

Art therapy and conflict resolution have been combined in work with college-aged students (Kaplan, 1994, 1996, 1998). The rationale for this approach is that art therapy can contribute to the positive resolution of anger by creating new imagery surrounding an anger-inducing event. The art-making is believed to help the individual work through the verbal component that seems to lag behind the imagery component, thereby enhancing a positive conflict resolution (Kaplan, 1994; Thompson, 1996). In this way, the art making is a rehearsal of the new approach to solving the conflict.

Kaplan (1998) has observed that as one progresses through childhood, adolescence, and early adulthood, the individual's imagery of anger also changes with increasing maturity, through a sequence of concrete images (portrait) to metaphorical or abstract images (chaos). The combination of art expression of anger and anger management/conflict resolution utilized in the art therapy project described in this chapter is informed by these assumptions.

DESCRIPTION OF THE PROJECT

The Participants

The group of adolescents, aged fifteen to seventeen years, attended a curriculum-based anger management program within an "alternative school" setting. The sample includes Caucasian and Asian adolescents, nine females and three males. In this chapter, case studies of three of these individuals will be presented.

The Anger Management Course

The anger management course was a cognitive behavioral program created in the western United States. It was administered by a group of health professionals. The art therapist was not given extensive details about its components and origin. It was designed to teach the youth about the physical and emotional aspects of the anger experience. They were taught how to become more aware of their own body's physical warning signs that anger is approaching and how to stave off its advance through the use of a variety of techniques. The adolescents were given information about the ways that anger affects their lives and strategies to direct their anger to a more positive

outcome. Several personality inventories were also included in this course. The two inventories used by the art therapist to track changes were the Buss-Durkee Hostility Inventory (Felsten, 1996) and the Locus of Control Inventory (Rotter, 1966). The anger management course was conducted for twelve weeks, one session per week. This instruction in anger management was preceded by the art therapy sessions for forty-five minutes each day.

Art Materials

The art materials provided daily for the students to choose from included the following: water-based liquid tempera paint, oil pastels, crayons, chalk pastels, markers, non-firing clay, an assortment of brushes, paint trays, paint cloths, and a variety of sizes of white paper (8.5" × 11" and 12" × 18"). The paint colors available were black, white, brown, orange, yellow, red, indigo blue, purple, magenta, and green.

The Format of the Art Therapy Sessions

The format of the art therapy sessions was very unstructured. Each day, a different statement about anger was written on a white board above the buffet of art materials. The statements included: what does anger look like? and what does positive anger look like? These two questions were taken from Kaplan's (1996) research on the art of anger. The balance of the questions asked was created by the art therapist. These questions were designed to give the students a focus for their expression in order to maximize the limited amount of time in each session.

The students were free to choose whatever art material seemed to attract them on a particular day. They were also free to respond to the anger question however they wished. Art making took place during a thirty to forty minute time period. Subsequently, each student then wrote in their journal about his or her art piece for five minutes. At the end of each session, the students gave the art therapist their art and their journals. The content of their art and their comments in their journals were brief and quite abstract. There often was not a direct connection between their journalling and their art making. During the presentation of their case studies in this chapter, illustrative examples of their art and quotes from their journal will be presented.

The sessions presented in the case studies are the second, tenth, and the last session. These three sessions were also representative of the changes the art therapist saw through the series. The questions that guided the three sessions chosen for presentation here were the following: "if anger were something that you could see, what would it look like?" (used in sessions 2 and 10) and "what would positive anger look like ?" (used in the last session).

The case studies of three of the high school students will now be presented. Their art work was viewed by the art therapist as "windows into their symbolic world." Comments made about the adolescents are based on the art therapist's observation of their process of art making throughout the series of sessions. As mentioned previously, the therapist learned about the adolescents through their writing and their art making process, as opposed to reviewing their clinical files.

THE CASE STUDIES

Jake (pseudonym)

Jake is one of three males in the group. He had taken the anger management course without an art component in the past. His parents are divorced, and he lives with his mother. He and his mother seem to have an acrimonious relationship for he had described several fights with her over the course of the eleven weeks.

Jake's depiction of anger in session two was an "iron cross" painted in black and which occupied most of the page (Figure 3.1). His journal stated, "today I drew an iron cross. When I hear Black Sabbath and I see an iron cross, it makes me mad." Figure 3.2, done by Jake in session ten, in response to the same question (what does anger look like?) was a small drawing of a crooked line beside an L shape. He wrote, "I got hit by a car and my brand new bike got cracked." The art therapist asked for further clarification of that drawing, including if the crooked line was what anger looked like to Jake. He responded by drawing the mess of chaotic lines at the bottom of the page and added the descriptives "anger looks like this" and "crack in brand new bike frame." Jake's art work for session eleven, in regard to what "POSITIVE" anger looks like, was a centered black painting of a bike frame surrounded by force-field-like orange, pink, and yellow bands that seemed to emanate from the bike frame. He wrote that "BMX is the best way to make anger positive. When you are mad you ride way better."

Jake was a bit of an enigma to the art therapist at the beginning of the sessions. That is, he described things as he understood them, but the art therapist needed to ask for clarification from Jake on more than one occasion in order to understand fully his responses. When she asked for clarification regarding the iron cross, he stated that as well as being a depiction of anger, it represented the devil. Although Jake's third piece of art answered the question of what positive anger looked like, his response in a painting of the BMX bike was difficult to understand.

Figure 3.1.

Figure 3.2.

The art therapist subsequently reviewed the scores of the Hostility Inventory (Felsten, 1997) and the Locus of Control Inventory (Rotter, 1966) given during the anger management program in order to determine whether there was an association between the artwork and the inventories. Jake scored in the average range on the Hostility Inventory and in the "sit-

uation specific" range of the Locus of Control Inventory. These scores indicate that he believes he has control over the outcome depending on the situation. His artwork suggests that he is capable of managing his anger in a socially acceptable manner. In his second art piece, he drew anger as chaos, which Kaplan (1998) interprets as an emotionally mature depiction of anger. Jake was also very well aware of the cause of his anger (i.e., the cracked bike frame). His art, when aligned with his scores, assisted me to rate his ability to manage his anger as above average. Jake appears to harness his anger expression and direct it to an area where he succeeds, such as bike riding, as seen in his third drawing.

As the program progressed, Jake appeared to be relatively well-equipped to cope with his anger. However, given that Jake's imagery was concentrated around bikes, the art therapist wondered if his focus on bicycles when expressing anger was a defense mechanism.

In art therapy, you can only take a person where he or she is willing to go. According to a psychodynamic perspective of art therapy, if an issue needs to be addressed, the subconscious will express in the art, in the form of a symbol. One of Jake's symbols that I wished to explore further was the "iron cross," by asking questions such as "Where does it comes from?" and "What does he associate with it?" However, such insights may develop slowly as the art therapist built a trusting relationship that would bring out that information.

Elizabeth (pseudonym)

Elizabeth, one of the younger group members, scored highest on the Hostility Inventory. This rating increased twelve points from pre- to posttest. She did not complete the second Locus of Control Inventory at the end of treatment. She was a highly guarded individual. Elizabeth was ready to strike out verbally at the slightest provocation. Therefore, the approach used by the art therapist was to provide Elizabeth with adequate space and freedom, while observing her closely.

Elizabeth's session two artwork was comprised of every color on her paint palette dropped on a small page and folded over to mix and blend all the colors together. It is roughly heart shaped with a fold in the middle covering 80 percent of the letter-sized page. It was not a representational piece of art; instead, it was entirely an expressive process piece. Initially, she resisted making this art piece; however, she did it at the end of the session in a very short period of time. Elizabeth handed it over without writing a journal entry and with resistance being expressed in her body language. When asked to describe her work, she stated in a challenging manner, "this is my emotions all mixed up." Her strong enunciation of this

Images of Anger from Adolescents 47

phrase indicated that I "should not even try to make sense of this piece."

In contrast, her session ten art piece was very representational (Figure 3.3). It was a drawing of two houses with names and a stick figure between. Her mother is depicted as the house on the right with flames and devil-like horns. Elizabeth ("me") is the stick person in the middle with another house on the other side labeled "Dad." In her journal, she wrote, "my parents are separated." Although not verified with Elizabeth, I would suggest that this artwork communicates her feelings in the first art piece. As is often the case in art therapy, observing Elizabeth's subsequent artwork facilitated my understanding of her first art piece.

Her session eleven piece is indicative of her coping skills, her level of maturity and her current situation (Figure 3.4). It depicts dollar signs, a

Figure 3.3.

Figure 3.4.

stick person, and the statement "Daddy said I could." Her journal stated, "when I get angry, Daddy lets me do anything."

Elizabeth's art and test scores graphically describe the very chaotic world in which she had little or no control over the outcome. Based on her depiction of her mother, the art therapist wanted to investigate their relationship. She seemed to be mixed up and stuck in the middle, yet separated from both parents. Her depiction of her mother suggests that the nature of this relationship needs to be further investigated. Perhaps she was not getting along with or was blaming her mother for the parents' separation.

Her art also showed a less advanced level of emotional development. Her first abstract piece of art was probably not an actual expression of anger so much as it was an expression of how she felt that day. Her second anger piece was representational, and hence a depiction of the cause of her anger and not an understanding of the experience of anger.

This is an excellent example of ways in which a person's art may reveal the cause of one's behavior via the art. Elizabeth maintained her protective exterior throughout the sessions, but she still managed to "display" her world to the art therapist. Elizabeth had issues of anger regarding the events of her life, which came to the surface in her art expression. She had started to identify her feelings through art by the end of the eleven weeks as evidenced by an advancement from the "mess" of feelings to identifying one of the causes of the feelings. Given the representation of her mother with horns and fire in the piece from session ten, I would postulate that Elizabeth would need to address issues concerning her mother.

Tigerlily (pseudonym)

Tigerlily's artwork was the most demonstrably aggressive in the group. Her artwork also demonstrated the most change over time. She lived with her parents, a situation that was far from stress free. She was regularly "getting kicked out of the house" for not living her life according to her cultural tradition. She also has a police record.

Early in treatment, her artwork expressed fantasies about killing whomever had wronged her. The artwork completed in session two (no figure as it is a striking likeness to person involved) depicts her murderous rage toward a carefully drawn figure who was shot and stabbed several times. The individual's name was at the top of the page dripping in blood as are all the wounds. Her journal says, "I lost my temper at a guy who called me a fat b----. This is him dead. I don't care, he deserves it."

Her session ten art piece reflects a dramatic change. This art expression was a response to the same question as in session two, which occurred two

months earlier (Figure 3.5). It is a large, red, torn or cracked, bleeding heart. Her description was "love brings hatred and pain. This is my broken heart bleeding anger in the form of blood."

Tigerlily's session eleven (positive anger) art piece was a depiction of a bloody knife with three equal (=) signs, two black music notes, a box with lines and a pencil representing writing on a white background. In her journal she wrote, "when I am angry, I use writing poetry and music to make me feel better."

Tigerlily demonstrates the need for the art therapist to understand the whole story before attempting to assess a client accurately. Initially, she drew an alarmingly murderous art piece that was followed eight weeks later with a bleeding heart. The developmental level expressed in her artwork went from concrete and highly controlled to a metaphorical piece showing considerable change in her style of expressing anger (Kaplan, 1998). Her positive anger depicted her change in coping style from a combative state to one that included calming activities that helped her to process her world.

Figure 3.5.

Her inventory tests' results are interesting as well. In the Locus of Control Inventory, her pre-test scores indicated her belief that she had little or no control over the outcome of a perceived anger-provoking situation. In the post-test, her Locus of Control scores were significantly lower than her pre-test scores. This outcome illustrates that she increased self-control over the course of the eleven weeks. In the post-test, her Hostility Inventory scores were still above normal. This hostility was also expressed in her final piece of artwork, a depiction of a bloody knife with music and poetry. However, the depiction of coping activities involving music and poetry occupied more of the page than the knife. This phenomenon may mean she attributes more power to the poetry and music than to the knife. On the other hand, the visible connections from the anger (as represented by the knife) to the music and poetry are somewhat tenuous, suggesting that the relationship between anger and creativity is something that she is still working out.

I was only able to get a glimpse into some of what made up Tigerlily's inner world during our eleven weeks together. However, Tigerlily appeared to need the art expression and was very appreciative of the art therapist offering that opportunity. Art making helped her to discover how to manage her stressful world and to gain some confidence in herself.

CONCLUSION

Upon reflection following the completion of the group treatment sessions, it became even more apparent to me the importance of Moon's (1998) perspectives about art making for adolescents. As previously mentioned, Moon emphasized that making art is a way of making the symbolic mind a reality by communicating what they could not, or would not, express in words. At the same time, the adolescents learn another way of looking at, being with and coping with anger, themselves, and their respective worlds through their art making (Kaplan, 1998; Moon, 1998). Moon added that "Art is not a frill or a filler, it is a necessary" for adolescents (p. 6). In other words, the adolescent needs to learn that "one can battle one's demons" in a balanced and direct way using the art and yet still maintain control over one's world.

A fundamental question, however, pertains to deciding who would benefit from art therapy. Factors to consider include: (1) Has the individual voiced an interest in art?, and is it a language that one is comfortable using?; (2) for the person who has excellent verbal defense mechanisms, can the art be a way of learning about one's self indirectly and in a less threatening manner?; (3) if the person is not very talkative, would she or he be able to tell you a story in art work?; (4) does the individual need to resolve conflict with some-

one (e.g., authority figures) who has control over him or her? For example, if one brings together all members of a family and engages them as a group using art materials, the comfort that the adolescent feels using the materials may become a sense of control and power in a previously uncomfortable situation; and (5) has the adolescent spent a lot of time in therapy and "knows the drill"? If so, switching treatment media from "talk" to art may be just the break needed to assist the adolescent in self-expression. The art therapist's goal in this context is to channel and contain that angry energy of the adolescent into the art rather than allowing it to manifest itself in a verbal or physical manner. Once the built-up pressure is released through art making, the adolescent may feel safe enough to discuss the anger in a more socially acceptable way. At this stage, other methods of anger management can also be taught to the adolescents to equip them to deal with a similar situation in the future. They also may be able to rehearse new models of behavior through the art making. However, art therapy is not for everyone; some client motivation of the relationship building and peer support (in group settings) are necessary for therepy to move forward. Given these elements, even the most resistant can learn something about themselves, something that will help them to become productive adults.

REFERENCES

Averill, J.R. (1982). *Anger and aggression: An essay on emotion.* New York: Springer-Verlag.

Ben-Zur, H., & Breznitz, S. (1991). What makes people angry: Dimensions of anger provoking events. *Journal of Research in Personality, 25,* 1–22.

Berkowitz, L. (1993). *Aggression: Its causes, consequences, and control.* Philadelphia: Temple University Press.

Compas, B.E. (1987). Coping with stress during childhood and adolescence. *Psychological Bulletin, 101*(3), 393–403.

Cox, D.L. & Stabb, S. D., & Bruckner, K. H. (1999). Women's anger: Clinical and developmental perspectives. Philadelphia: Brunner/ Mazel.

Diamond, S.A. (1996). *Anger, madness, and the diamonic: The psychological genesis of violence, evil, and creativity.* Albany, NY: The State University of New York Press.

Emunah, R. (1990). Expression and expansion in adolescence. *The Arts in Psychotherapy, 17* (2), 101–107.

Felsten, G. (1996). Five-factor analysis of Buss-Durkee Hostility Inventory neurotic hostility and expressive hostility factors: Implications for health psychology. *Journal of Personality Assessment, 67*(1), 179–194.

Furlong, M.J., & Smith, D.C. (Eds.). (1994). *Anger, hostility, and aggression: Assessment, prevention, and intervention strategies for youth.* Brandon, VT: Clinical Psychology Publishing.

Hogan, B.E. (1998). *Major personality dimensions: A closer look at the construct validity of the behavioural anger response questionnaire.* Unpublished Master's Thesis. University of British Columbia. Vancouver, BC.

Kaplan, F.R. (1994). The art of anger: Imagery, anger management, and conflict resolution. *The Canadian Art Therapy Association Journal, 8*(1), 18–29.

Kaplan, F.R. (1996). Positive images of anger in an anger management workshop. *The Arts in Psychotherapy, 23*(1), 69–75.

Kaplan, F.R. (1998). Anger imagery and age: Further investigations into the art of anger. *Art Therapy Journal of the American Association, 15*(2), 116–119.

Kramer, E. (1971). *Art as therapy with children.* New York: Schocken Books.

Miller, P., & Sperry, L.L. (1987). The socialization of anger and aggression. *Merrill-Palmer Quarterly, 33*(1), 1–30.

Modrcin-McCarthy, M.A., Pullen, L., Barnes, A.F., & Alpert, J. (1998). Childhood anger: So common, yet so misunderstood. *Journal of Child and Adolescent Pediatric Nursing 11*(2), 69–77.

Moon, B.L. (1998). *The dynamics of art as therapy with adolescents.* Springfield, IL: Charles C Thomas.

Riley, S. (1999). *Contemporary art therapy with adolescents.* Philadelphia: Jessica Kingsley.

Tibbetts, T.J., & Stone, B. (1990). Short-term art therapy with seriously emotionally disturbed adolescents. *The Arts in Psychotherapy, 17*(2), 139–146.

Tice, D. M., & Baumeister, R.F. (1993). Controlling anger: Self-induced emotion change. In D.M. Wegner & J. W. Pennebaker (Eds.), *Handbook of mental control.* Englewood Cliffs, NJ: Prentice-Hall.

Underwood, M.K., Coie, J.D., & Herbsman, C.R. (1992). Display rules for anger and aggression in school-aged children. *Child Development, 63,* 366–380.

Weiner, B. (1986). *An attributional theory of motivation and emotion.* New York: Springer-Verlag.

Chapter 4

ART PSYCHOTHERAPY TRANSFORMATIONS WITH A SELF-HARMING LATE ADOLESCENT FEMALE

ALAN BRIKS

SUMMARY

Art psychotherapy has been found to be particularly helpful for those patients who have difficulty expressing or identifying feelings, those uncomfortable with verbal communication, or conversely, those adept at using words to hide their thoughts and feelings. The use of art in therapy provides an alternate, less threatening means of expression that enriches therapeutic communication. The purpose of this chapter is to illustrate how art psychotherapy delivered by the author helped an adolescent female who was experiencing self-harming behavior. An introduction to art therapy is presented first, followed by research and practice-based findings about its effectiveness for adolescents who are experiencing mental health problems. Next, the case study is presented to indicate Sue's (pseudonym) responses, as reflected in her artworks, through the opening and middle phases of an art psychotherapy process.

ART THERAPY PRACTICE: AN INTRODUCTION

Art therapy is a creative arts treatment modality involving the therapeutic use of visual art expression within a professional relationship, used by people who experience illness, trauma, challenges in living, and seeking person-

al development (modified from American Art Therapy Association, 2002). Art therapy practice is rooted in the psychoanalytic tradition, and many practitioners have a psychodynamic orientation. However, they are often eclectic in the sense that they may use aspects of Freudian, Jungian, or humanistic/existentialist psychology, cognitive, family systems, as well as other developmental and psychological theories in applied models of assessment and treatment. Art therapy is a viable treatment for a wide spectrum of populations including persons affected by psychological, developmental, medical, learning, or social impairments. People of all ages and ethnic backgrounds are served by art therapists in individual, couple, family, and group art therapy (American Art Therapy Association, 1997).

The treatment framework is dependent on patient/client need and budgetary restrictions and may involve brief, short- or open-ended, long-term art therapy. Art therapy process commences with a phase of assessment. Assessment protocols may be comprised of various art therapy assessment techniques or standardized formats and projective art tasks. In the early stages of therapy, the treatment goals will be jointly established between the therapist and patient/client, with input (when indicated) from the referring agent(s), parents, or guardians. The therapeutic process is periodically reviewed and goals may be revised or changed. The patient/client and the therapist review the art that has been created on an ongoing basis, as well as at the time of closure, thereby contributing to the integration of the process. Termination of treatment will optimally coincide with an adequate resolution of the presenting concerns and achievement of treatment goals. The closing phase will involve a review of the therapy, addressing the end of the therapeutic relationship, identification of what has been achieved, and what may require further attention in the future.

A hallmark of art therapy practice involves the use of spontaneous art production. Typically, the patient/client will be asked to create "whatever comes to mind." Spontaneous art permits the expression of a wide range of emotions, fantasies, conflicts, wishes, fears, etc. The therapist may on occasion suggest an open-ended directive art task with a specific rationale in mind. Directive art tasks are often utilized in a brief or short-term art therapy framework to enhance concentration on specific treatment issues.

OVERVIEW OF THE EFFECTIVENESS OF ART PSYCHOTHERAPY FOR ADOLESCENTS

Art psychotherapy is widely recognized as a treatment of choice for adolescents affected by mental health concerns. Several theorists agree that the importance of fantasy and creativity is a way for troubled youth to commu-

nicate personal experience (Blos, 1962; Esman, 1983; Malmquist, 1978; Winnicott, 1971). For many adolescents, art production serves as a valuable means of self-expression, while for some, it may provide their only vehicle for social participation. Creativity and fantasy life are necessary for continued ego strength throughout the adolescent years. Creative processes contribute to emotional maturation and can act as a healing force for development that has been delayed or disturbed (Blos, 1962; Malmquist, 1978).

An inherent problem in discerning an appropriate psychotherapeutic treatment for the adolescent population has been to find an effective channel through which a therapeutic relationship can be developed (Ekstein & Friedman, cited in Esman, 1983). Having outgrown the therapeutic play techniques used in early childhood, adolescents have not yet developed the cognitive and self-observing capacities needed for traditional psychoanalytic therapies. Inclined more toward action as a means of lessening tension and warding off anxiety, adolescents are often reluctant therapy candidates who do not readily engage in verbally-centered therapies (Esman, 1983, p. 141; Linesch, 1988).

Art therapy addresses adolescent treatment needs through an activity-oriented approach that encourages personal expression by way of art and the creative process. Psychoanalytic theorists recognize that fantasy and creativity serve the preconditions essential to adolescent character formation. These aspects provide adolescents a vital means to maintain ego strength and to work through the intra-psychic struggles of this turbulent developmental passage. Fantasy and creativity contribute to the accomplishment of developmental tasks of adolescence involving the process of separation-individuation, psychosexual adjustment, and the quest for personal identity (Blos, 1962; Malmquist, 1978). Linesch (1988) maintains that although many clinicians recognize the potency of creativity to support adolescent development, it is primarily the art therapists who have adapted this understanding to their methods of treatment. Art therapy is a natural fit for adolescents because it involves a developmentally appropriate, activity-oriented approach to psychotherapy. The spontaneity and flexibility of the art therapy milieu are well-suited to the treatment needs and temperament of teens. Artistic skills or abilities are by no means a requisite for a productive engagement in art. In fact, it is the art making that is emphasized as opposed to the esthetic merits of the product. In the art therapy process, the adolescent's struggles may be expressed, identified, and worked through on the level of visual imagery. Adolescent art therapy is utilized with individuals and groups or in the context of family or dyadic art therapy.

Adolescents present complex challenges to clinicians. Resistance to treatment is likely to emerge. This resistance tends to be reduced in art therapy because the focus is on creative activity rather than an exclusive emphasis on

the client-therapist encounter. In art therapy, communication becomes enriched through the production of visual imagery. Although adolescents are reluctant to reveal their problems verbally, they are usually comfortable with art. The opportunity to create visual imagery offers them an immediate, safe, and often enjoyable forum for self-expression, and the process of making art engages all the senses. Adolescents appreciate that in art making they are not pressured to explain themselves (Riley, 1998).

Art therapy is an effective treatment modality for the wide spectrum of adolescent treatment issues and mental health disorders (Riley, 1998). It can be particularly helpful in reaching withdrawn, almost totally non-verbal or highly guarded youths; youth who feel uncomfortable relating with adults; those presenting challenges to authority or oppositional/defiant behavior. The use of art in therapy can serve as a bridge to enriched understanding with adolescents across the cultures. Patients/clients who present with intense emotions, as may be apparent with borderline personality disorder, for instance, benefit from the symbolic expression of their feelings and dangerous impulses in their art product. The art-making process provides youth experiencing emotional breakdown or psychotic phenomena with a vehicle to express their turmoil safely, connect with their inner world and emotions, and rebuild their world. Art therapy has also been found to be highly effective with adolescents who are emotionally traumatized. For this group, creative visual expression affords an opportunity for them to put their verbally inexpressible experience into tangible forms, thereby facilitating their potential for insight and mastery over the trauma.

Although some adolescents may show an initial reluctance to engage in visual expression, an art therapist can use supportive art techniques to assist these youth in their adjustment to the art therapy milieu. The wide range of art media, as well as various possibilities in how these may be used, provides flexibility to suit individual personalities, preferences, variable moods, and attention levels of this population. Adaptations to the equipment and accommodation of suitable art materials and techniques also make art therapy a viable treatment approach for physically handicapped teenagers as well as those affected by developmental disabilities.

Verbal communication is by no means diminished through a focus on therapeutic art production; indeed, it may be substantially enhanced. For example, Riley (1998) has commented on adolescents in art therapy: "when they are not pressed to talk, paradoxically they will" (p. 21). Usually teens want to talk about their imagery. The art production serves as a catalyst for discussion, furthering communication of the individual's concerns and issues, while contributing to the development of the therapeutic relationship. When trust is established within the treatment relationship, the depth of content in art expression and level of rapport will be enhanced (McNiff, 1992).

Symbolic visual expression and verbal discussion complement each other by facilitating the enrichment of therapeutic communication.

In addition, the adolescents' sensitivity and perceptiveness are realized through interaction with their visual imagery. The artwork created is often significant and meaningful to the individual and can be emotionally charged. Observation and dialogue with the completed image can raise awareness and promote connection to their emotions (McNiff, 1992). These on-going processes of integration and working through issues contribute to the potential for new directions and change. Creative expression plays a central role toward enabling therapeutic transformations, while the art product will simultaneously reflect those changes.

In summary, based on my knowledge of the research literature and my many years of clinical art therapy practice, the use of art psychotherapy with an adolescent population is advocated for the following reasons:

- It is applicable to adolescents at all developmental levels for the full spectrum of mental health issues and rehabilitation.
- Art creates a positive association to therapy through an avenue of personal expression that is often enjoyable for adolescents, and less threatening than verbal communication. Art offers a safe, transitional space for teens. A focus on art may also help alleviate some of the common obstacles in developing a therapeutic relationship with youth who are distrustful, oppositional/defiant, often "non-verbal" or withdrawn.
- Art in therapy can serve in bridging the nuances of cultural diversity and may enable teens with physical handicaps and illnesses to enhance their capacities for expressiveness.
- Creative visual expression enriches therapeutic communication. Through art, the adolescent may express a broad range of feelings, fantasies, and inner conflicts. Similarly, the imagery that this expression evokes can serve as a springboard for the development of meaningful rapport.
- Artistic expression permits release or externalization of conflicted, disturbed, or complex emotions; anxiety; and inner conflict. It can function to order internal chaos, thereby providing a safe way to contain all emotions.
- The art process can play a central role in securing or restoring identity, thereby contributing to the integration of the personality, and in activating an inner healing process. This aspect includes, for example, the promotion of ego strength and self-esteem.
- Through creation and apprehension of their art, adolescents may connect to their sensitivity or utilize their perceptiveness. That is, by reflecting on their imagery, teens can become more closely connected with their feelings, gain insight, and further their personal understanding.

- Art therapy is an activity therapy. The adolescent is encouraged to take an active role in working toward his/her personal development. This aspect can serve to reduce therapeutic resistances while promoting autonomy.
- In the production of symbolic visual expression, ego defenses are maintained. The imagery content can be processed on the level of the symbolic metaphor, thereby allowing the inner experience to be objectified and issues to be addressed in a tolerable manner because defenses remain preserved.
- Symbolic visual expression provides a "timeless" perspective, bridging aspects of the youth's past and present, as well as being predictive of future directions. Art processes can permit safe regression and expression of formerly repressed emotions, conflicts and traumatic experience. The art therapy process can be highly advantageous for working through issues pertaining to unresolved emotional needs, loss and reparation, abuse, and trauma.
- The artwork or art series that the patient/client creates in art therapy is a tangible, lasting product that can serve as a permanent record for review of and reflection on the therapeutic process.

CASE STUDY

The concepts of adolescent art therapy will now be illustrated through a case presentation and a series of images selected from the early-through-middle phase of a long-term therapeutic process. Treatment occurred at an adolescent out-patient psychiatric unit. The patient, a seventeen-year old female, who will be identified as "Sue" (pseudonym), presented with a history of abuse, family conflict issues and self-harming behavior. The therapeutic process with this highly motivated young woman was memorable and provided a rich learning experience for me early in my career as an art therapist. The visual imagery that she created throughout the course of treatment was often vivid, illuminating the connection between process and content. A presentation of selected images that Sue created, as well as a discussion of aspects of the therapeutic process, will serve to illustrate her therapeutic transformations.

A child protection worker from social services referred Sue to the adolescent unit. Social services had originally been assigned to Sue's fifteen-year-old brother, who reportedly was having difficulties coping and was severely depressed. On admission to the adolescent unit, Sue was reported to be deeply depressed, suicidal, socially withdrawn, and suffering from very low self-esteem. She had confided to the social worker that she "scratches" herself, which was subsequently found to be an understate-

ment.

The social worker provided additional information about Sue's family, whom she described as middle-class, transient, and highly dysfunctional. The home was in an extreme state of disorder and was filthy. Communication between the parents was strained. Although the parents provided for the material needs of their children, they were emotionally detached and neglectful of both Sue and her brother. There was reportedly no sexual expression between the couple. Sue was expected to keep house and cook meals when her mother left the home on frequent trips, so was cast into a premature maternal role. Sue had limited interaction with her brother and eighteen-year-old sister. She was "the quiet one in the family," pleasing and cooperative. Sue had never dated and had only one girlfriend whom she considered to be a close friend.

Sue's mother had previously been treated for clinical depression, which was linked to having given up her first child before marriage. Sue's father had a history of alcohol abuse. Her sister was hospitalized for anorexia in the early stages of Sue's treatment. An active court case was proceeding pertaining to the family's challenge of a social service recommendation that Sue's brother be hospitalized for psychiatric treatment at another facility.

After conducting an initial art therapy assessment with Sue, I was taken aback that the opening line of the psychological report stated, "There is no overt indication of psychopathology." That conclusion may have been due to Sue's ability to mask her conflicts, to appear to be coping and to be reasonably well-adjusted. She was intelligent and performed well academically and presented with a neat and well-groomed appearance despite her emotional turmoil.

Early art therapy sessions were devoted both to assessment and commencement of treatment. Diagnostic impressions that the health team formulated during the early phase of treatment included clinical depression, presence of borderline personality traits, post-traumatic stress disorder (PTSD), and a masochistic character structure. Other findings were in accord with diagnostic features reported in psychological testing such as the identification of mood swings, her detachment from emotional expression, inability to acknowledge her own anger, and her need to turn away from adult sexuality. Mention was also made that due to the severe early trauma and a lack of adequate emotional support from her parents throughout her life, Sue had not internalized a positive image of herself and others.

Although art psychotherapy sessions were initially held on a weekly basis, it became apparent after a short period of contact that she needed two sessions weekly. Following approximately one year of therapy, Sue

requested a reduction to one session per week, which we subsequently maintained, except for the occasional additional appointment. Sue's therapeutic process had occurred over a period of three years, eleven months.

In the early sessions, Sue's presentation could be characterized as guarded and extremely cautious. She seemed detached from her emotions, dramatic, and at times "testy"; that is, she revealed self-harming behavior as if to explore if the art therapist was truly committed to her care. She demonstrated limited eye contact and said very little. Sue would often silently rehearse her speech, with her lips faintly moving, and carefully edit her words before speaking. It became apparent that she was experiencing considerable pressure from her parents to stop coming to therapy. However, despite parental pressure, I sensed from the outset that she was deeply invested in the therapeutic process.

Sue's Creation of Images

During the initial assessment phase of therapy, I requested that Sue create a variety of images in any order she wished. These images included: (1) a pictorial collage; (2) a spontaneous image, the House, Tree, Person (H-T-P) series of drawings (J.N. Buck as cited in Hammer 1980); and (3) a Kinetic Family Drawing (Burns & Kaufman, 1970), which is a picture of a family doing something. The first image that Sue produced (not included here) was a pencil drawing portraying a little house next to a tree, thereby combining the house drawing and the tree drawings of the H-T-P series. In the first session, there was limited rapport between the therapist and the client and not much discussion about this image. Her line pressure was quite faint; there were several breaks in the line and no ground-line was used, suggestive of depression, fragile ego strength, and a lack of connectedness with the environment. The feeling tone conveyed in the image was empty, isolated, and desolate. The house portrayed was rather inaccessible, with no doors or walkway, and only one small round window. Its shape seemed to resemble a coffin, rather than a house. The tree appeared barren as it had no leaves.

In contrast to the first picture, the spontaneous painting that Sue created in the second session (Figure 4.1) was "charged" with affect. She described the image as "a bright rainbow over a dark sea" and elaborated on how the rainbow signified her feelings of hope. This image is suggestive of the beginnings of a therapeutic alliance. The rainbow, which connected one island in the sea to another, seemed to imply the development of relationship between herself and her therapist. She was expressing, through the transference, her hope in the therapy. In the image, little red lines resembling "slashes" could be detected in the black sea area, in the

Figure 4.1.

rainbow, and in the upper cloud to the right. In this way, she may be reflecting the "repetition compulsion" pattern to cut herself over and over again. She represented the red color of blood in the dark band of sea.

On that same day, I had noticed dried blood stains on Sue's left sleeve. Although I provided an opportunity for her to raise the subject, she did not discuss it. In a subsequent session, the blood on her white sleeve was wet and literally dripping to the floor. I recall making a remark to Sue to the effect that "It seems as though there is something you would like to bring to my attention." From that point onward, this topic and symptom of self-mutilation became open to discussion. Sue explained that she had been cutting herself several times per week during the last two years. She indicated the cuts were most often inflicted to her arms, yet sometimes she would cut other parts of her body.

I had suggested to Sue that she could go to the hospital emergency for treatment of the laceration. I offered to accompany her if she wished. She responded that her cuts were not life threatening and that she did not wish to be seen in the emergency department at this time. This was my first experience in treating a person presenting with the symptom of self-mutilation. In the therapeutic interaction, I somehow managed to project a sense of calm despite my squeamishness with blood. Between the time of that late morning session and an early afternoon team meeting, I had uncharacteristically left the clinic to swim at a local pool. Only upon later reflection did I realize the connection between the swimming and my

need for release and cleansing.

At the Adolescent Team meeting later that day, I received helpful guidance concerning the matter of Sue's cutting. This advice focused on the value of going beyond the symptom, which was evidently not life threatening, to concentrate on the emotions and underlying issues. Although the team psychiatrist had considered prescribing medications, Sue was opposed to using them.

In a subsequent session, Sue described feeling "bad and ashamed" after cutting herself and expressed the desire to gain insight into this behavior and to learn how to stop it. Stopping the self-abuse was an essential initial goal of her therapy with me. Periodically during the therapeutic process, Sue reflected on the various ways she made sense of this behavior: (a) a "way to feel something," "I like the pain," which indicated to the therapist that cutting was not an overt suicidal gesture; (b) "exciting," which appeared to me to be a way to stimulate herself; and (c) a means of coping with anxiety and channeling her sexual drive. Insights that emerged in the latter stages of therapy were Sue's realizations that cutting served as "a way of being in control of my body," and furthermore, it provided a way to separate herself from her mother.

Stopping the self-abuse was a delicate issue to address. The art therapist had to show a certain tolerance and flexibility with her cutting, yet he needed to convey to Sue that stopping it was a prerequisite for continuing therapy. Some of my questions to her were very focused: "Do you want to continue hurting yourself?" or "Have you not experienced enough pain?" I believed that Sue's participation in art making would be an extremely valuable tool for substituting the act of cutting herself. I had suggested to her that when she experienced the urge to cut herself, she instead do a drawing reflecting her mood, write about it, or paint the act of cutting.

During some of the early art therapy sessions, Sue made several inferences to being burdened by a dark secret. She would start to verbalize it, uttering one or two words, but would then fall silent. In the twelfth session, I suggested that she paint or draw what she could not say. I also suggested that it would be okay if she did not want to show me the picture; instead she could paint over it. The black "cover over" shown in Figure 4.2 is in itself a highly significant image. Structurally, the grid she drew seemed to serve as some sort of a barrier. If this were a human figure, the red grid would be at the place of the genitals; if the figure were a face, the grid would be at the place of the mouth. She revealed in a subsequent session that her mouth and genital areas were aggressively violated in a sexual assault.

In the following session, Sue began by creating a spontaneous marker

Figure 4.2.

Figure 4.3.

drawing as shown in Figure 4.3. With a black marker, she portrayed a memory of the trauma, a forced abduction and sexual assault that occurred when she was ten years of age. She described how the perpetra-

tor, a man of about fifty, coerced her to get into his car and "give him directions." He took her to a field and violently sexually assaulted her. When it was over, the perpetrator put $2.00 in her hand, and abandoned her in the field.

Sue's attempt to tell her mother what had happened could only come out in the form of a cue. She told her mother that a strange man had given her $2.00. In her response to Sue's description, her mother did not ask any questions nor notice anything was wrong, yet took the money from her daughter and put it in her purse.

Figure 4.4.

Figure 4.4 which was from the twenty-fourth session, illuminates this young woman's character, at a time when she is overwhelmed with anxiety. She discussed the image portrayed as "a giant threatening bear claw hanging over her head and several smaller claws tearing away at her clothes and skin." On one level, this image can be seen to be reflective of a harsh and punitive superego, and on another level, it resonated with the heinous sexual trauma that she had suffered as a child. The figure that she drew had no mouth, as if she has been unable to express her pain outwardly. I followed her metaphor, and used this imagery to assist Sue to identify the major difficulties and persecutory forces confronting her, removing them "claw by claw" as it were. One claw was identified with her sexual abuse victimization, another to feeling targeted by her father's aggression, another to her mother's rejecting stance, another to feelings of isolation in her social milieu, and so on.

Figure 4.5 was created by Sue in the thirty-sixth session. Although this image of a scene of self-mutilation seems rather ghastly, the act of cutting herself had actually ceased by this time (four months into therapy) and had been symbolically substituted into the art making. There were, however, two later exceptions. The first reoccurrence of cutting was in reaction to the judge's comments in her brother's court case to the effect that her father was "a highly caring, protective, and concerned parent." The second occurrence was triggered by her mother's response to being informed by Sue that she had been sexually assaulted. She recounted that mother showed little reaction and no compassion toward her. Although morbid, the type of imagery seen in Figure 4.5 served to absorb her previous self-destructive acts. In processing it, Sue reflected on an incident of the previous year when she had cut herself in the school bathroom and smeared blood on the wall. On the day following this cutting episode, Sue was quite upset when she discovered that the blood, which was her cry for help, had been wiped away. She expressed her fantasy that "a dumb cleaning lady had washed it away." Sue was now able to identify her feelings of anger and sadness at her mother, who could not listen or understand her pain. Sue's mother appeared to be in denial about her daughter's anguish and self-harm. One illustrative example of the latter was when her mother, upon finding a blood stained blouse in the laundry hamper, remarked, "Oh, more pizza stains."

I would like to emphasize that Figure 4.5 is not the most highly charged drawing that she produced during this period. Indeed, Sue created numerous disturbing images that expressed her deep-seated anger, anguish, and pain. Her drawings reflected a number of themes. One significant theme was her experience of the horror of sexual abuse. Another theme was self-sacrifice in the family context. In an unsettling image that she entitled

Figure 4.5.

"Sacrifice to the Gods," she portrayed her head as being severed from her body. This decapitated head was lodged in a tree. The image revealed a mind–body split. On certain levels, the sacrifice had seemed suggestive of the wish to detach herself both from her body as well as from the family. A portrayal of her self-mutilated arm served as an emblem for her struggles and pain. Two images that she created served to express outwardly what she termed "The Inner Demon." Producing these images was cathartic for Sue, a purging of the inner demon.

At one point in her drawings, there was a symbolic transformation from blood to red tears in the imagery, corresponding to the onset of a mourning process. Sue became more vivid and spontaneous in her presentation and interaction. She began to display her feelings, often appeared sad, and on several occasions, she sobbed during the sessions. She was demonstrating a deeper connection with her emotions than was previously evident.

Figure 4.6 depicts a young child and a young woman, which seems to be a maternal figure. This pencil, charcoal, and marker drawing was created by Sue while she was on summer vacation. It was discussed by the two of us upon her return. This image imparts a theme of nurturance and the emergence of a positive self-object. In this drawing, she was, I believe, trying to communicate to the therapist her ability to care for herself during her absence from therapy. Her associations to the image reflected an important stage in her process. She identified the child on the left as the emotionally needy and wounded child within herself and the figure on the

Art Psychotherapy Transformations

Figure 4.6.

right as a generous, caring young woman. Both figures are situated on cold, gray, desolate sides of the image, while a focused beam of sunlight shines between them. She described the pointed stone in the center of the picture as an "obstacle" separating the two figures. In relation to that image, Sue discussed her difficulties in reconciling and accepting her childhood. This image reflects her struggle to achieve her goal of self-love and integrate the wounded child within. On another level, it appears to express her wish to be nurtured by the idealized mother whom she has portrayed in the drawing.

Figure 4.7 How it was..

Figure 4.7, which was done a few months later, is a faint pencil drawing that depicts the nature of her emotional experience of interacting with her mother. Sue entitled this image "How It Was." Her mother (who has no physical disability) is portrayed as somewhat decrepit and handicapped, standing in a rigid posture, and gesturing her arm for Sue to go away. Sue portrays herself as feeling very diminished, and as experiencing a loss of identity in front of her mother. The only figure that appears to stand with a balanced, upright posture in this image is Sue's cat. At this point in therapy, Sue was expressing her feelings of anger and sadness concerning her mother's neglect and rejection. The title she chose for this image implies her present attempts for change in regard to "standing up" for herself. She was also searching for ways to separate or distinguish her identity from that of her mother.

The next three images selected, Figures 4.8, 4.9, and 4.10, which come from sessions 126 and 127, were rendered with pastel and pencil. Sue stated that the first picture was a self-portrayal in which she is situated beside a gorge with a great waterfall. In this dream-like fantasy scenario, she is sitting near a cliff's edge with her four cats. It is noteworthy that in reality, Sue is very strongly attached to her family's cats. Furthermore, in her imagery, the cats appear to serve as a substitute family. Across the river,

Figure 4.8.

she observes three wounded animals: a rabbit, a dog, and a bird that have been snared by hunters' traps. In her discussion of this image, she spoke of the brutality of the hunters and the suffering of the animals, whom she feared would die. She discussed her figure's helplessness and deep sadness (symbolized by the waterfall) in her inability to help the animals and set them free. Following our discussion, she spontaneously created another image that included a log bridge above the waterfall, thus creating a route of access over the gorge. Having now crossed over the bridge, she portrayed herself in the next image freeing the animals from the traps, and subsequently bandaging their wounds while her cats watch her from the opposite side of the gorge. In the following session, Sue completed the triptych series of three inter-related images. In the last drawing, she has brought the cats over the bridge and depicts the liberated animals recovering from their wounds. She has built shelters for the animals, has bandaged their wounds, and has nurtured and fed them.

The significance of these images is their expression of an active quest to

Figure 4.9.

repair the wounded self. Sue is able to work through her internal "splitting" (as graphically represented by the gorge) by establishing a link with her past. The imagery illustrates her capacity for integrating the hurt and the neglected aspects of herself. Through her identification with the therapist, she becomes the healer who cares for the wounded animals. This imagery is suggestive not only of the wish but seemingly the actualization of liberation from the tyranny of the harsh superego. It marks Sue's developing capacity for self-care. On another level, the liberation of three trapped animals also appears to reflect Sue's quest for repair within the context of her family system. In reality and simultaneous to this phase of therapy, Sue has taken personal initiative in arranging that she and her two siblings commence a family therapy process.

A subsequent Figure 4.11 illustrates Sue's struggle with a peer, during her ongoing process of working through issues of victimization. She described this picture as portraying a recent incident occurring in a bar. Sue and her girlfriend had been seated in the last chairs available, which

Art Psychotherapy Transformations

Figure 4.10.

was an area close to the line of fire of an on-going game of darts. A problem arose because of her friend's request that Sue sit closest to the dart target (or danger) area and Sue's passivity in accepting that seat. The choice not to use color in this image is suggestive of Sue's affective inhibition in the context of her peers within group settings. It also reflects her depression in playing the role of victim, which is a role she has played in the family system. The focus of this session was on Sue's efforts to increase her capacity for self-assertion and to develop strategies in more directly communicating her feelings to significant others.

The final Figure 4.12 was completed approximately two years into therapy. Sue described this relatively healthy drawing as reflecting her desire to develop a slow-paced, intimate relationship with a gentle, understanding young man. She entitled the picture, "Talking." It was evident that her prior sexual abuse had a significant impact on her inhibitions and avoidance of intimate relationships. However, by this point, Sue had come a considerable distance toward working through her experience of sexual

Figure 4.11.

Figure 4.12.

abuse and related issues. In addition, her experience of a positive quality of relationship with the therapist may have also contributed to her readiness to risk entering a relationship with a boyfriend.

Concurrent with the course of treatment, Sue appeared to achieve the developmental transition to young adulthood. This movement had been apparent in some of her more recent imagery, in which she had begun to portray herself as a sexualized young woman. Soon after the creation of this image, Sue discussed the development of one short-term relationship with a young man who was primarily interested in sex. However, a year or so later, at the time of therapeutic closure, she was involved in a more lasting, intimate relationship with a somewhat troubled young man whose alcohol problem and emotional remoteness mirrored attributes of her father. Although this may not be the optimum relationship she sought, Sue described experiencing pleasure in her sexuality for the first time. In the context of that relationship, she indicated feeling quite pleased with her increased capacity for self-assertion and her ability to communicate her needs verbally.

Latter Phase of Therapy and Therapeutic Closure

The remainder of Sue's therapy afforded continued support and opportunity for her to refine processing of issues that have been previously identified. Sue had addressed on deeper levels her family conflicts, in particular working toward resolution of concerns pertaining to her relationships with her mother and father. Other topics included broaching the obstacles Sue encountered in developing an intimate relationship with her boyfriend, in her body image and self-acceptance, while she had also placed an increasing emphasis on the development of her personal autonomy. In the latter stages of therapy, Sue had been able to maintain regular part-time employment while continuing her academic studies. There were no further episodes of self-harming behavior. In fact, there had been marked development of progressive movement over the course of therapy, from a passive, victimized stance to an increased capacity for self-assertiveness and self-care. Presenting with an increased level of self-confidence, Sue reported having become more socially active, developing new and satisfying peer relationships.

Excerpts from Sue's written reflections on her therapeutic process, presented during a session in conjunction with a therapeutic review in the latter phase of therapy follow:

> In the beginning of therapy I believe I feared myself and the world. I trusted nobody, not even myself. . . . I had this thing in me I called Enemy that would want nothing more than to hurt me. Anyway I feel completely or almost dif-

ferent. I have found a friend within me, and a love of life. It's a free feeling. I no longer have the horrible, horrible dreams I used to. I've found strength. I'm not as afraid anymore of the unknown, because I don't feel alone anymore. I've managed to overcome the need of cutting and hurting myself. I've managed to stay in school and get a job and finally I have a guy friend. I find that a major achievement for me.... I'm not afraid like I used to be. I can take risks and feel good about it. I've made many new friends.... I like that.... I'm OK now. I'm more honest I think, with myself, and others. I feel like I'm awakening from a dark, deep sleep.

Therapeutic closure was initiated by the therapist due to my acceptance of a clinical position in another city. Sue had made substantial progress through her treatment process and was still benefiting from on-going sessions. An adequate termination of therapy, involving review and integration of the therapeutic process and working through closure of the therapeutic relationship, had occurred over a period of three months. Although Sue revealed fear and insecurity over the prospect of closure, it had seemed apparent to us both that the treatment objectives had, in large part, been achieved. Sue was not inclined to follow up with another therapist at that time. Five years following the termination of therapy, I received an update of Sue's progress from a member of the out-patient adolescent treatment team. Reportedly, the accomplishments achieved by Sue in her therapy had been lasting. Sue had since moved away from home, was supporting herself through steady employment, and experiencing success in a university program. Sibling therapy that had been initiated by Sue was said to have continued for several years with a productive outcome.

In conclusion, art psychotherapy had been well-suited to address the complex set of treatment issues presented by this young woman. The art therapy milieu provided Sue a safe forum for personal expression and enhanced communication. Symbolic art expression had also served as an effective means to substitute physical self-harming acts, contributing to the eventual elimination of these maladaptive behaviors. As trust developed in the therapeutic relationship, the patient revealed courage in confronting painful experiences of childhood victimization and emotional deprivation. Through her art, Sue was able to re-enact early trauma and work through its impact in subsequent processing. Artistic expression played a crucial role in enabling the release of intense affect, while also furthering the integration of emotions. Imagery created through the treatment process reflected therapeutic transformations illustrative of progressive movements from isolation to experiencing quality of relationship, from self-harming tendencies to self-care, thereby overcoming victimization by taking an active stance in life.

REFERENCES

American Art Therapy Association. (1997). Brochure: *Art therapy: The profession.* Mundelein, IL: Author.

American Art Therapy Association: http://www.arttherapy.org

Art Therapy in Canada: http://www.arttherapyincanada.ca

Blos, P. (1962). *On adolescence: A psychoanalytic interpretation.* New York: The Free Press.

Burns, R.C., & Kaufman, S.H. (1970). *Kinetic family drawings.* New York: Brunner/Mazel.

Esman, A. (1983). *The psychiatric treatment of adolescence.* New York: International Universities Press.

Hammer, E. (1980). *The clinical application of projective drawings* (6th ed.). Springfield, IL: Charles C Thomas.

Linesch, D. (1988). *Adolescent art therapy.* New York: Brunner/Mazel.

McNiff, S. (1992). *Art as medicine.* Boston: Shambhala.

Malmquist, C. (1978). *Handbook of adolescence.* New York: Jason Aronson.

National Coalition of Arts Therapies Associations (NCATA): http://www.ncata.com.

Newsletter of the American Art Therapy Association (2003), excerpt: Art therapy: definition of the profession. Mundelein, IL: American Art Therapy Association.

Riley, S. (1999). *Contemporary art therapy with adolescents.* London: Jessica Kingsley.

Winnicott, D.W. (1971). *Playing and reality.* New York: Penguin.

Chapter 5

BREAKING THE MOLD: USING POTTERY TO REBUILD LIFE SKILLS

Margaret Bent and Geraldine Taylor

SUMMARY

This chapter illustrates the power of pottery used during occupational therapy intervention at a community mental health facility. Centering on a case study, the text traces the story of Claire, a freshman law student who attempts to take her own life. This case study profile is based on a number of clients who have received occupational therapy services at a community mental health facility in England. All names have been changed to protect the confidentiality of the persons involved. Through the medium of pottery, Claire is able to communicate her journey from meaninglessness to meaningfulness, isolation to connectedness, restraint to freedom, and dependence to independence. As well as enabling the client to find a level of coherence in the present, the therapy facilitates the development of life skills resulting in a greater sense of hope for the future. Sections of Claire's ten therapy sessions are included, along with observations by the therapist, and some extracts from her personal reflective diary.

WHAT IS OCCUPATIONAL THERAPY?

According to Neistadt and Crepeau (1988), occupational therapy is "the art and science of helping people do the day-to-day activities that are important to them despite impairment, disability, or handicap" (p. 5). Activities in this sense may include: personal care activities such as grooming, bathing, feeding; work and productivity activities, for example, home management,

job acquisition, retirement planning; and leisure activities such as hobbies, sports, and crafts. Furthermore, the fundamental philosophy of occupational therapy is based on the following three beliefs:

- People are individuals of worth and are inherently different from one another
- Activity is fundamental to well-being
- Where occupational performance has been interrupted, a person can:
 a. through the medium of activity develop the adaptive skills required to restore, maintain or acquire function, and/or
 b. Modify activity in order to facilitate occupational performance (Turner, 1996 p. 5).

It is critical, therefore, for occupational therapists to look beyond the immediate diagnosis and to understand the unique difficulties the person is facing. This is considered the "art" of the profession. The therapist is interested in how the person's roles, and daily occupations that constitute those roles, have been impacted by the disorder or disease. In addition, the therapist will examine environmental factors that may be influencing the person's performance of his or her occupations. Environment in this sense may include physical surroundings as well as the social and emotional climates that make up the person's world.

As it is in the nursing discipline, the "science" of the occupational therapy profession is the theoretical grounding that commonly guides practice. Although theory is an integral part of the occupational therapy process, therapists may have to adapt the therapy to meet the specific needs of the person with whom they are working. Schell (1998) describes this process as a "meta cognitive analysis" (p. 90). However, it is more commonly known as clinical reasoning. Occupational therapists use clinical reasoning to plan, direct, perform, and reflect on their practice. Schell suggests this is a "complex, and multifaceted process" (p. 90), as it requires the therapist to use a "different mode of thinking, depending on the nature of the clinical problem they are addressing" (p. 93). One of the guiding approaches commonly used in occupational therapy is client-centered practice. This approach, which can be viewed as an extension of Carl Rogers's (1942) client-centered therapy, has four distinctive assumptions:

- The client establishes the agenda for therapy
- The only relevant frame of reference for therapy is that of the client
- Dominance of professionals in the process of therapy is counter-therapeutic
- Therapists cannot actually promote change but can help to create an environment that facilitates change (McColl, Gerein, & Valentine, 1997, p. 512).

Thus client-centered practice can be used by occupational therapists to assist individuals in identifying and achieving their personal goals.

Bonder (1997) states that "occupational therapy focuses on what people do: whether they can do what they need and want to do and whether their lives are meaningful and satisfying" (p. 314). Furthermore, this author emphasizes the role of psychological factors in guiding people's ability to make decisions about what they want to do, and their ability to assess their level of satisfaction with their activities. These factors exert a powerful influence on the needs, perceptions, and evaluations of the individuals' world in the context of their personal experiences.

CASE STUDY

Jessica (pseudonym) is a senior occupational therapist who works with Southside Community Mental Health Team. She graduated five years ago, and after working in a State psychiatric hospital for two years, took a newly created position with the Southside Clinic Team. She thrives on her work in the community, believing that it provides the most realistic and meaningful environment in which to work with people who are experiencing mental distress.

Jessica quickly reads the referral. From the details dictated by Dr. Lewis (pseudonym), the consultant psychiatrist, her understanding is that this is a request to provide follow-up for a young girl who has recently attempted suicide. *Claire—law student, overdose, 5-day in-patient admission, major depression, sertraline hydrochloride (Zoloft) and buspirone hydrochloride (BuSpar), stable, supportive family, discharged Friday, please see a.s.a.p.* Jessica laments the fact that she rarely, these days, receives referrals prior to the person's discharge from hospital, and that, increasingly, these brief threads of someone's life are her sole introduction to a person who is in pain.

Preparing for the Initial Assessment of Claire (pseudonym)

Jessica phones Susan, the occupational therapist who works for Dr. Lewis to inquire about Claire's previous occupational therapy program while she was in the hospital. Susan informs Jessica that she carried out some ADL (activities of daily living) assessments with Claire when she was first admitted and did some kitchen activities with her before she was discharged. Susan's findings indicated that Claire's attention span had been variable, that she had difficulty initiating tasks, and that she needed prompting to complete activities, although these were all improving by the time of discharge. Additionally, Susan reports that Claire rarely interacted

with others on the ward, and she found it very difficult to talk about what had led to her suicide attempt. Susan concludes by saying, "Claire is a lovely girl, with a very supportive family. I think she would benefit from your help to get her back on track."

Having worked many years as an occupational therapist, Jessica is familiar with the pace of in-patient facilities, the pressures for discharge, and the anonymity of working with people, removed from their own familiar environment. The information about Claire, however, is sparse and leaves Jessica with many questions. What has led Claire to attempt to take her own life? What did her hospital admission achieve? What are the specifics of her family background?

Jessica telephones the number on Claire's referral sheet. A man answers, rather abruptly. Jessica asks to speak to Claire. A timid, young voice announces, "I am Claire." Jessica explains that Dr. Lewis has asked her to see Claire with a view to providing some follow-up since her recent discharge from the hospital. Claire does not respond. Jessica asks Claire if she would like to meet with her and suggests a date and time. Claire says, "Sure, if you'd like," rather flatly. Jessica confirms the appointment, and states that she is looking forward to meeting her.

Session 1

Jessica has had a busy morning, but she has managed to have a few moments with Dr. Lewis: "I'm going to see Claire this afternoon, the young girl who recently attempted suicide that you asked me to see." Dr. Lewis takes a few moments to recall Claire and thanks Jessica for seeing her. He adds a few more details: "She stabilized pretty well on the Zoloft; her sleep and appetite improved while she was in the hospital, and her father was very helpful regarding her discharge. He's going to arrange some extra tuition for her to get her through her first year of law school. Anyway, it will be good if you can help her increase her attention and sequencing skills, so she's able to continue with her studies."

Jessica's next task is to meet with her certified occupational therapy assistant (COTA) and discuss ideas for the gardening group they planned to start at the Southside Clinic. By the time this meeting is finished, Jessica only has ten minutes to prepare for her first session with Claire.

Jessica uses a number of evaluation techniques in order to build up a picture of a person's occupational performance level. According to Denton and Skinner (2000) occupational therapy evaluations with persons who have mood disorders should include:

- The client's history and prior functional level in ADL, work, and other

productive activities.
- An overview of functional activities that the client can and cannot perform.
- The client's and family members' needs, plans, and goals.
- The client's rehabilitation potential.
- The underlying components causing the functional performance deficits.
- Contextual factors affecting the client's functional performance (e.g., environmental, age, general health). (pp. 3–4)

There are numerous occupational therapy assessment tools that can be used in mental health practice. These include, but are not limited to, the following: observation; interviewing; functional assessments; assessments based on object relations theory; assessments based on the model of human occupation; assessments based on skill acquisitional theory; assessments based on biological theories; checklists; and computerized assessments. Hemphill-Pearson (2000) provided an overview of how these assessment tools can be used either singly, or in an integrated way, to conduct a comprehensive evaluation.

Generally, Jessica uses observation and interviewing as her tools of choice for the first meeting, or screening. Since she is an experienced therapist, this does not require much preparation other than using a semi-structured interview format based on Denton and Skinner's (2000) factors listed above.

Jessica's secretary announces that Claire is waiting to see her in the reception area. There she finds a young girl sitting rather awkwardly with an older man standing nearby talking on his mobile phone.

On seeing Jessica, the man looks at his watch, hurriedly ends his phone call, turns towards Claire, and says, "I'll be back in an hour to pick you up." Jessica steps in quickly and introduces herself to both of them. The man nods and hastily exits from the reception area. Claire gives Jessica a quickly fading smile, "That's my dad. He's very busy . . . has to get back to his office—he's working on an important case." Jessica touches Claire lightly on the shoulder and ushers her towards one of the interview rooms.

Jessica observes that Claire is tall, of medium build, slightly athletic, and stunningly beautiful. She has pale, clear skin. Her eyes are a deep, intense brown, and they are darting around, taking note of the details of this strange new environment. Her face is framed with brown-red shoulder length hair that looks shiny and freshly brushed. She is wearing a long brown cotton skirt, boots, and a brown suede jacket. Silver rings glint as she clutches her leather handbag. She has a "good girl" air about her, as she waits for Jessica to indicate that she may sit down.

Jessica introduces herself again and explains her role. Claire looks towards Jessica intently but does not respond or offer any signs of engagement. Jessica continues, outlines the purpose of the interview, and asks Claire if this is something she is willing to take part in. Claire nods, looks down, and begins to play with the strap on her handbag.

Jessica explains that Dr. Lewis has asked her to see Claire and that he has told her a little about her suicide attempt and admission to hospital. Claire continues to look down, and winds the strap tightly around her index finger. Jessica adds, "I understand too, that Susan, the occupational therapist, also worked with you while you were in the hospital?"

Claire lets go of the strap, which unravels with the loss of tension. "We made a sandwich," she says in a timid voice.

Jessica continues, "Perhaps we could start with you telling me a little bit about yourself?" Claire offers a string of facts: twenty-one years old; student at the University; one older brother; father (successful attorney) and stepmother at home. Jessica makes a note about the stepmother, with a question mark regarding the whereabouts of her real mother.

Suddenly Claire clears her throat and says, "I'm a student with the law program, in my second semester. It's not going well. I don't have any friends." She stops abruptly and returns to playing with her strap. Jessica wonders whether to stay with the issue of Claire's lack of friends or to try to obtain more information about Claire's background and her difficulties. Claire is clearly not at ease with volunteering information.

Jessica continues to gather some background information from Claire but detects barriers especially when discussing home life. She moves away from this area, intending to return when they have built up more trust. She returns to the issue of Claire not doing well at University. Claire is factual, displaying no emotion when discussing poor grades, repeating some classes, and not keeping up with the workload. Jessica moves on to Claire's lack of friends. Claire offers that everyone else seems to have friends, but no one has really been prepared to be her friend. Jessica says, "I wonder how you feel about friendships; I wonder how important they are to you?" Claire looks down and shrugs.

Jessica draws Claire's attention to the fact that there are only ten minutes left for this session. "Is there anything, Claire, that you would like to focus upon?" Claire seems to be trying; her mouth is working, but she is not speaking. She looks down. Jessica offers, "I wonder if there are things you would like to say, but at the moment it's too difficult. Something is stopping you. Perhaps it's too painful?" Claire nods. Jessica nods too, accepting this.

"I'd like to meet with you again: Tuesday afternoon at the same time?" Jessica offers Claire an appointment card. She takes the card, and places

it carefully in her jacket pocket and leaves the room very slowly while gazing at the floor.

Jessica spends a few minutes in the interview room reflecting on the session. Her overriding impression is a feeling of emptiness. She feels blank, helpless, and concludes that the session was full of nothing. Two major questions concern Jessica. Has she responded to Claire's passivity with too many questions? Has this felt persecutory?

Session 2

Jessica wonders if Claire will attend this second session or if she, or her father, will phone to cancel.

Intending to provide a more structured framework for their next session, Jessica goes to the shelf of medical and therapy texts. She reaches for the *Diagnostic and Statistical Manual of Mental Disorders (DSM-IV)* (American Psychiatric Association, 1994). This text sets forth the criteria that must be met for a mood disturbance to be considered pathologic. She thumbs the pages until she finds the criteria for the diagnosis of major depression. She scans the page:

> five (or more) of the following symptoms . . . present during the same 2-week period . . . change from previous functioning . . . depressed most of the day . . . markedly diminished interest in almost all activities . . . weight changes . . . insomnia . . . psychomotor agitation . . . feelings of worthlessness . . . diminished ability to concentrate . . . recurrent thoughts of death. (p. 356)

This list of cold, impersonal facts seems to Jessica pitifully inadequate for describing Claire. And yet, this is the diagnosis Dr. Lewis has given her.

There are no definitive blood tests that indicate whether or not a person has depression and render a definitive diagnosis of a disorder as complex as depression. Thus, the DSM-IV has reputedly become psychiatry's standard reference. Soloman (2001) stated that the problem with using this text as a definition is that it is entirely arbitrary. He added that "there is no particular reason to qualify five symptoms as constituting depression . . . [indeed] even one symptom is unpleasant. Having slight versions of all the symptoms may be less of a problem than having severe versions of two symptoms" (p. 20). He concluded by asserting that the only way to find out whether a person is depressed is to listen.

There has been no phone call to cancel the session. Jessica scans her filing cabinet for assessment tools. She pulls out two: The Role Checklist (Oakley, Kielhafner, Barris & Reicher, 1986) and The Interest Checklist (Klyczek et al., 1998). The secretary phones through, "Claire is here."

Jessica starts the session. "Thank you for coming."

Claire: "I *have* to come, don't I?"

Jessica: " You feel you have to come because . . . ?"

Claire: "Because of what I've done, because of my family, because of my course, because of *everything*."

Is Claire allowing Jessica an opening into her world? Jessica knows that she must respond gently.

Jessica: "And because of Claire? What about Claire?"

Nothing. Claire's eyes glance down. Her fingers engage with handbag strap. There is more silence.

Claire: "Where is all this going?"

"All this?" Jessica echoes, feeling that in those words, Claire is echoing something else, something said to her.

Claire: "All this talking."

Jessica: "I'd like to learn more about you, Claire. I wonder if we could work together on finding out more about you, who you are, what you would like to do with your life."

Claire gives a fleeting smile: "That's going to be hard."

Claire remains silent, and Jessica continues, "It seems that somehow Claire has got lost." Claire nods.

Jessica: "I wonder if we could try to find her together?"

Claire's expression gives nothing away, and although Jessica feels Claire has withdrawn, she does not feel it is a blocking withdrawal, more that it is a tiredness, possibly due to the intensity of focus on herself in the therapy room. More than half of the session is left. Jessica feels the time is right to change the pace.

"I wonder if you'd be willing to fill out these questionnaires for me? I use them to help me find out more about a person's interests and roles." Claire's eyes dart towards Jessica. She takes the clipboard, and grips the pen tightly. Jessica watches as Claire carefully, and systematically, completes the task.

Jessica decides to review *The Interest Checklist* first. Of the possible eighty-one items, Claire has marked six: sewing, reading, popular music, photography, painting, and mosaics. In addition, she has ranked these as casual interests, not things that she has done in the past three months or that she has a strong interest in. Jessica notes that these are all solitary endeavors. "Tell me a little more about these things that you've marked. When was the last time you did any of these?"

Claire replies dismissively, "I read a few magazines while I was in the hospital."

Jessica: "Can you tell me more about these art activities, Claire?"

Claire: "I used to do these with my Nan before she died. But not now."

Jessica gently asks what kind of art things she did with her Nan. Claire looks down, her fingers tight round the strap. A tear slides down her face. "We did all sorts of things, crafts, painting, dressing up, acting, singing. Anything to get away from the blackness."

Jessica: "Blackness. . . ."

Claire: "Mum's death." (She lifts her face up, eyes directed straight into Jessica's.) "She killed herself."

Jessica: "I'm sorry, Claire, that must have been very hard for you."

Claire: "Yea. Well. My Nan and I did those art things to take our minds off what happened. But dad didn't like it. Said I needed to concentrate on my studies if I was going to make it to law school."

Jessica: "So he discouraged you from doing your art?"

Claire: "Yes, so I stopped. He put all my stuff in a trunk in the attic." Her head drops. She looks like a docile child awaiting her next instruction.

Jessica: "And you haven't done any for a long time." The clock is ticking. "I wonder if you'd like to see what we do here?" Claire nods and rises immediately, her rapid body response at odds with her previous passivity.

Claire follows a few paces behind Jessica to the practice kitchen, the gym, the group rooms, the garden, and then the pottery room. Claire enters the room and scans the shelves. Her eyes focus on a clay mask. She walks over to it and traces the profile with her fingers.

Jessica: "Sometimes people find it easier to express their thoughts and feelings by doing something like pottery."

Claire: "Did someone who comes here make this mask?"

Jessica: "Yes. I wonder if this is something you'd like to do?"

Claire nods, and they arrange to meet the following week in the pottery room. Jessica accompanies Claire back to the main reception area. Outside she can see Claire's father sitting in a large black BMW. He is talking into his phone and writing on a document pad.

Jessica returns to the pottery room and looks at the clay mask. She believes that showing Claire around the facility, especially bringing her into the pottery room, was fruitful, particularly because of Claire's interest in art. There is, she feels, an unspoken and fragile agreement that she and Claire will work together.

Session 3

After reviewing her notes on Claire, Jessica examines *The Role Checklist*. There had not been time to discuss this during their last meeting, and the answers Claire has given provide valuable insights about how she views herself and her current roles. This questionnaire is divided into two parts. The first part consists of ten roles (e.g., caregiver, friend, student, worker),

for which the respondent is to indicate whether it is a past, present, or future role. Claire has listed two present roles–student, and family member, three past roles–caregiver, friend, and hobbyist, and one future role–worker. Jessica is particularly interested in her past roles. Who was she caring for? Why has there been a change in the way she views herself as a friend? Furthermore, there is a confirmation that her art activities have "been stopped." The second part of the questionnaire asks the respondent to indicate the value or importance of these roles. Claire has noted that being a student and a hobbyist are somewhat of value to her, whereas being a friend and a family member are very valuable. Jessica plans to use this information to explore Claire's perspective on her life roles in ways that are outlined next.

Claire enters the pottery room, looking slightly uneasy. She sits down at a table.

Jessica: "It's good to see you, Claire. I wonder if you had any further thoughts about our plans for today."

Claire: (quietly and as though frightened by her agreement) "It's fine."

Jessica begins by showing her some items that have been made by other clients who attend the Southside Clinic, including a photo frame, a trinket box, a small bowl, and a rose. In addition, she points out several books on pottery and some instruction cards on clay projects. Next, she gets out a lump of clay that has already been wedged and asks Claire what she would like to make.

Claire shrugs her shoulders, and asks Jessica "what *she'd* like to do." Jessica decides that the time is right to explore what is happening between them.

Jessica: "This is your session, Claire, but you'd like me to tell you what to do. I'm wondering if there's anything you would like to make for yourself?"

Claire appears to become angry; her fingers are clenched, and her eyes are directed at Jessica.

Jessica: "You appear to be angry, Claire."

Claire: looks away: "I'm sorry."

Jessica: "Sorry, because . . . ?"

Claire: "I got angry."

Jessica: "Angry with . . . ?"

Claire does not answer. Instead, she gets up, walks towards the bookshelves and starts flicking through the pages of the pottery books. After a while, Jessica comes over to her.

Jessica: "Perhaps it would help if I suggested a few things?" She recommends a coiled pot, a pinch-pot owl, or a clay rose.

Claire looks intently at Jessica as though trying to guess what Jessica

would like her to make. Then she states, "I'd like to try making a rose." Jessica, pleased that Claire has made a decision, senses that Claire really wanted to say, "I'd like to try to make a rose for you."

Jessica produces the instruction card and says she will make a rose also. She thinks it might be easier for Claire to talk if they are both engaged in an activity. Jessica rolls out the clay and traces some petal shapes with a small utensil. Claire follows. Jessica notices that Claire is almost obsessively detailed, following the directions to the letter, ensuring that each petal is exactly the same size and shape as the example. She constantly seeks reassurance from Jessica and is dismissive of her own efforts.

Claire: "Your petals are much better than mine. . . . I wish I could do ones as good as yours. . . . This isn't good enough to fire."

Jessica notes that this may indicate Claire regards her work as not good enough to be permanent, that she hasn't got enough to offer, or hasn't given enough.

Jessica understands that Claire is functioning at a fairly young level–a child, wanting to be reassured, to be approved of. She appears to Jessica as being in search of a mother figure, someone to copy, to please. This level of projection is often a characteristic of this early stage of therapy.

Claire: "This isn't good enough to fire, is it?"
Jessica: "Decisions can be difficult for you, Claire."
Claire: "I don't know the right thing to do."
Jessica: "The right thing?"
Claire: "What people want me to do."
Jessica: "You wanted me to tell you that you were doing the right thing when we were making the roses. And yet, I was remembering that you did so much artwork with your Nan, and I was admiring your skill with those little details on the petals and the way you persisted until they looked real."

Jessica feels that the ensuing silence between them is a comfortable one.

Jessica reminds Claire that the session is almost over. Claire suddenly looks at her watch; her body tenses, and Jessica can sense Claire's anxiety. Jessica remembers that Claire's father has been transporting her to these sessions.

Jessica: "Your dad will be collecting you? Claire nods.
Jessica: "I've noticed that he delivers you and collects you, Claire."
Claire: "Yea, a parcel, that's me." They share a moment of laughter.
Jessica: "I'm going to put my rose in the kiln, and it'll be ready to glaze at our next session. Would you like me to put yours in, too?"
Claire: "OK, give it a try."

After the session, Jessica writes a few notes in her notebook to act as a prompt for when she comes to write up Claire's chart at the end of the day.

Difficulty making decisions, constantly wanting reassurance, lacking assertion, passive. But I believe the laughter has firmed up our relationship. She then notes that she has gained insights about Claire's strength in this session. *Claire has experienced a lot of emotional upheaval; she may have to protect herself against her father, and probably has not been allowed to mourn the loss of her mother or her grandmother. Yet, she is coming here, it's so hard for her, but she's trying.* Jessica ends by recording that there are several goals she thinks Claire could begin to work on now and that these could all be addressed through their pottery sessions: making decisions; being more assertive; acknowledging her skills and abilities; being able to problem-solve independently; and renewing her role as a *friend*.

Session 4

Jessica begins this session by asking Claire a question: "May I tell you what I feel I know about you, Claire?"

She gives Claire an overview, including information gained from the interviews, assessment tools, and her observations of Jessica's behavior during the pottery activity. She concludes by saying that she thinks there are a number of areas on which they could begin to work. Jessica asks Claire if she has built up a true picture and if these are the kinds of things she would like to work on as goals.

Claire: "You're right about me, what you said." She continues, "I don't know if I can. I might have forgotten the way to do these things."

Jessica explains that it is natural to feel like this at the beginning but that together they can work on smaller goals and progress gradually. She suggests that they agree to meet for six more sessions and that Claire should choose two short-term goals to address first.

The reaction from Claire is mixed. Whereas her level of engagement shows her interest, her eyes closely examine Jessica's assessment report. However, her immediate reversion to a child role shows that her conditioning against taking initiative continues to be strong.

Claire: "You choose the first two goals."

Jessica: "Shall I give you some options for your first two goals, and then perhaps you could come up with one other goal yourself? Shall we do it that way?"

Claire agrees, signaling her reluctance by moving away from Jessica back into her chair. She listens to Jessica's suggestions and then slowly chooses the following goals:

1. By the end of the session, Claire will make one decision regarding the

glazing of the clay rose independently and without asking for reassurance.
2. Claire will, with the aid of resource books, independently choose a new pottery project by the next session.

Jessica waits for Claire's third goal, and finally it comes: "The parcel will drive herself here next week." They smile, acknowledging this joke between them.

Claire succeeds with the first goal. She chooses to paint her rose with a deep cerise glaze. Jessica shows delight in this aspect, yet is careful that her praise does not sound like a reinforcing parent.

Jessica: "That's a beautiful choice of color, Claire, I've seen roses like that. Cerise roses always look like they're made of velvet. You've captured that."

Jessica suggests that Claire work on goal number two for homework. She encourages Claire to take several pottery magazines home and to come next week with a decision for her second project.

Jessica inquires if Claire ever does journaling. Claire replies that she has done so.

Jessica: "Sometimes it can be helpful to remember our feelings in a journal, Claire. I wonder if you would like to record what feelings came up for you in our session today?"

Following Claire's departure, Jessica writes up the goals in Claire's chart. She believes that their relationship is more collaborative now and that the therapy is becoming client-centered. There is a real sense of camaraderie. Much of Claire's background and her feelings, however, remain unexplored. Jessica makes a note to discuss these aspects during her supervision group as she feels it would be valuable to share perspectives on her work so far with Claire.

Within the mental health arena specifically, supervision is "an intensive, interpersonal focused, one-to-one relationship in which one person is designated to facilitate the development of therapeutic competence in the other person" (Loganbill et al., 1982, p. 4).

Session 5

Jessica has Claire's rose, glazed and fired, looking fragile but beautiful, ready for her to see. Claire comes into the room holding her journal tightly. Jessica notices that the pottery magazines are crumpled and placed towards the back of the journal.

Jessica: "It's good to see you again, Claire. Are those car keys I see in your hand?"

Claire nods but does not return Jessica's smile.

Jessica: "You drove yourself here today. . . ."

Claire, with her eyes down, motions her chin upwards.

Jessica: "Something has happened, Claire. Something has upset you."

Claire: "It's pointless being here, it's not helping me get back to law school. And my dad says he doesn't know why he's paying for me to come here and have fun."

After a few moments, Jessica asks: "Do *you* want to go back to law school Claire?"

Claire: "Well that's the plan."

Jessica: "Whose plan, Claire?"

Claire: "My dad's and my stepmother's plan. Nothing's going to change, nothing ever changes. . . . They promise it will, but it never does."

Jessica wonders if Claire has tried to change before. Has her life contained many unfilled promises? Was her suicide attempt one last effort to get someone to hear her?

Jessica: "I can understand why you feel so upset, Claire. Returning to law school is what your father would like for you, but this is his plan and not yours. How does this make you feel?"

Claire shrugs and whispers, "Trapped. What I want doesn't matter. It's all for them."

Jessica: "And yet you found the courage to drive yourself here, Claire. I sense that Claire isn't completely lost. Claire does matter."

Jessica, who wants to fortify Claire's efforts, does not ask her if she had been able to decide on a next pottery project. It may be that working on this task has triggered the episode with her father.

Jessica takes a piece of raw clay from one of the bins and shows Claire how to start wedging. This technique involves throwing the clay forcefully onto the workbench to remove air bubbles that could ruin the piece during firing. She encourages Claire to do the same. Claire begins this action gently. Subsequently, she progresses to thrashing it down on the table, and she begins to cry.

Jessica: "I'm wondering what you're thinking about, Claire."

Claire: "I'm thinking about all the fun I used to have with my Nan, and how my dad put a stop to it. He's still trying to control what I'm doing."

Jessica: "And yet you came here today. You did that for yourself."

Claire stops wedging momentarily and says, "Yeah, I did, didn't I?"

The clay has been wedged enough; there is no risk of any air bubbles being left after all that beating.

Jessica: "I wonder if you'd like something to make for your Nan?"

Claire considers for a while. Jessica wonders if Claire would be able to draw on what she remembers of her Nan's support and love and whether

these memories and renewed feelings would help her to find a sense of self again. Or would, she wonders, Claire be overwhelmed by the grief of losing this beloved grandmother?

Claire agrees to act with a wholeheartedness that surprises Jessica.

Claire: "I think that's a great idea. I'd like to make a vase and decorate it with violets; they were one of her favorite flowers."

Jessica finds some instructions on how to make a clay vase using a plaster mold and slip (Breines, p. 64). Claire works intently on this project.

Watching her at work, Jessica asks, "I wonder if we can think about ways to bring fun into your life now, Claire. Would you be able to think about this? Is this something you could write in your journal?"

Claire: "What do you want? You want me to write an *essay* about having fun?"

Jessica sees that Claire is not angry and that she may actually be teasing her.

Without waiting for Jessica's response, Claire says, "OK, I'll do that. Ten ways to have fun if I wasn't who I am. . . . I'll write something, wait and see."

Jessica: "I had your rose ready for you, Claire, but there were other things to explore. Would you like to see it now?"

Claire nods and Jessica hands the rose to Claire.

Jessica: "This is your rose, Claire. I wonder what you feel about your rose?"

Claire shrugs at first, looks uncertain: "It's . . . it's a lonely rose, all alone. . . . If it was real, it wouldn't last, things don't last. But . . . but, it's not real. It's going to stay with me. Can I keep it?"

Jessica wraps the rose carefully in layers of tissue, and Claire picks up her car keys to leave.

Jessica takes the vase mold and moves it to the side where other projects are waiting to go into the kiln. She reflects for a few moments. The beginning of today's session had felt such a low point, and yet through their clay work, Claire has been able to express her anger symbolically and to move towards a reconnection with her sense of self. Her reflections on her rose show that Claire is beginning to express her more sensitive feelings. In addition, Jessica reflects on the power of humor to bond the relationship between them. She understands that through this humor, Claire has been able to regain an element of control and begin to initiate.

Session 6

Jessica has the mold ready on the table and asks Claire, "Would you like to open this up and get your vase out?"

Claire carefully undoes the mold, the two halves falling apart like opening petals. Her eyes wide, she looks at the vase, her fingers examining every inch.

Claire: "This has come out alright, hasn't it?"

Jessica: "Yes, it has. It's a beautiful shape. Did you say you were going to paint violets on it?"

Claire cautiously opens her journal. Jessica sees that there is a card inside: it is cream colored, slightly glossy and with pale violets painted in watercolors.

Claire: "When I went home last week, I thought about my Nan, and I found this card she had sent me after mum's death. It's got violets on it, like the ones I want to paint on this vase." She hands the card to Jessica.

Jessica focuses on the violets, "They're beautiful Claire." As though reading her mind, Claire reaches forward and opens the card. "You can read it if you like."

To the most special granddaughter in the world, I will love you always, Nanny XXX

Jessica: "She helped you so much."

Claire: "Yes. Things were really awful, even before. . . ."

Jessica: "Before?"

Claire: "Before mum killed herself."

Jessica: "Can you tell me about it, Claire?"

Claire: "She couldn't cope without a drink. My dad was going to be a partner at the law firm, and there were all these social events. She hated the falseness of it all, and she started to drink to help her get through it."

Jessica: "And your dad?"

Claire: "He got mad with her. Said she was ruining his chances, kept her at home. She got worse. Drank first thing in the morning, all day, everyday. Nobody else knew. It was our secret."

Jessica: "You shared this secret, Claire."

Claire: "It was awful, terrible. I was so afraid. I didn't know the right thing to do. I couldn't tell anyone. I wanted. . . ."

Jessica: "You wanted?"

Claire: "I wanted someone to help *me*."

Jessica: "And your brother, your Nan?"

Claire: "Tim was at university. My Nan tried to help. She didn't know all of it, but she arranged for mum to see the doctor. But my dad canceled the appointment. Told her to stay out of it."

Jessica: "And what about you, Claire?"

Claire: "I tried to please them all. Tried to help my mum. Did everything at home, the cooking, cleaning, shopping, everything. Had to make everything right."

Jessica: "*Had* to make it right."

Claire: "Everyone was so unhappy."

Jessica: "You wanted everyone to be happy."

Claire: "I wanted my mum to be happy. I couldn't bear it, how unhappy she was. Sometimes she couldn't even move. Towards the end I even washed and dressed her."

Jessica: "Towards the end?"

Claire takes a deep breath, her whole body quivering: "I had to stay late at school one night for a rehearsal. She knew that. When I got home, the house was dark. I found her on the bed, bottle of vodka on one side of her, empty tablet bottles on the other side. Found out later dad had got his partnership that day. But why didn't she write to me? Why didn't she leave a letter? Why didn't she leave me with *something*?"

Jessica: "I'm sorry, Claire, so sorry."

For a while they both looked at the card in silence. Claire stops shaking. She looks at ease; her shoulders have dropped.

Claire: "How do I paint these violets then?"

Jessica gets out the brushes and shows her where the glazes are kept.

Jessica: "You might like to try practicing first on some paper. Draw out the shape of the violets and then use tracing paper to transfer the design onto the vase."

Claire draws the violets thoughtfully. Jessica notices that Claire uses the eraser only once before tracing the design onto the vase. She selects a number of glazes and begins mixing the colors to ensure a perfect match.

As Claire starts to paint, it seems appropriate to Jessica to continue their discussion.

Jessica: "Your mother, Claire. What a hard time that must have been for you."

Claire: "It was hard for us all."

Jessica: "Your dad in particular perhaps?"

Claire: "He threw himself into his work, the partnership. He was away a lot. Met and married Gabby, my stepmother. We moved house." The pace of Claire's voice seems to echo the quickness of events following her mother's death.

Jessica: "And what about you?"

Claire: "They assumed I would follow."

Jessica: "Follow?"

Claire: "Go into law too, like Tim."

Jessica: "It sounds like you had no choice, no part of the decision?"

Claire: "I didn't know what I wanted. I didn't know how to think after her death."

Jessica: "Could it, perhaps, have been a relief for them to do the think-

ing for you?"

Claire nods, puts down her paintbrush. "But it didn't work out, I couldn't handle it. I tried to tell them, but they wouldn't listen."

Jessica: "No one listened to you and you felt . . . ?"

Claire: "Wiped out, not there, gone. So I made up my mind to end it all, too."

Jessica: "End it all, too."

Claire: "Only I couldn't even do that right, could I?"

Jessica touches Claire's hand while gently supporting it.

Jessica: "I'm so pleased you're here, Claire."

Claire looks up, hesitates, and says, "So am I."

Jessica acknowledges that this has been an intense session: "Thank you for talking to me as you have today. I was going to ask if you'd had any further thoughts about having fun, what you'd written in your journal, but it didn't seem to be the right time for that."

Claire: "Well, I *have* written one or two things. Bet that's a surprise for you!"

Jessica: "I wonder, could I ask you to bring this up when the time seems right for you?"

Claire: "Sure. I might even have written a bit more by then."

Afterwards, Jessica reflects on the session. She believes that the pieces are beginning to fall into place. By using pottery as the therapeutic medium, and through the process of the therapeutic relationship, Jessica now knows more about the father's role in contributing to Claire's sense of meaninglessness, restraint, isolation, and dependency.

Session 7

Claire arrives wearing a pair of pale yellow jeans and matching shirt. She has a periwinkle silk blue scarf tied loosely around her neck and has her hair piled high onto her head with a blue "scrunchie." This is the first time that Jessica has seen Claire wearing anything but brown and the first time that she has changed her hairstyle.

Claire: "Hi Jessica, how are you today?"

Jessica: "I'm very well. That's a beautiful scarf, Claire."

Claire: "Yeah, Lucy, my friend from high school gave it to me one Christmas."

Jessica: "It suits you, shows off your wonderful skin color."

Claire accepts the compliment and asks, "So what are we going to do today then?"

Jessica reinforces the importance of client-centered therapy: "What would *you* like to do today Claire?"

"I dunno. . . ." She says airily. "I've brought my journal along; we could start off with that if you'd like."

"Would *you* like to do that?" Jessica asks reminding Claire that this is her time and that she has choices.

Claire: "Yes, I would. I've written a list of fun things that I would like to do again. In fact, one of the first things was to do something different with my hair, and I've done that today!"

Jessica: "Yes you have. It looks very stylish. How does it make you feel Claire?"

Claire: "Well, for the first time for many months, I was actually able to look at myself in the mirror. Really look. Before it made me wince ever time I looked in every so quickly to see I hadn't smudged anything."

Jessica: "Made you wince?"

Claire: "Felt ugly. But today it was different. I focused on my hair, tried several different things with it, and it was kind of fun. It was like I forgot for a moment."

Jessica: "Forgot?"

Claire: "Forgot about everything. Forgot about not having any friends. Forgot about being unhappy."

Jessica: "Doing fun things again has helped you feel better about yourself."

Claire: "Yes, for a bit."

Jessica: "You said Lucy had given you that scarf. Would you like to tell me about her, Claire."

Claire: "We were friends right from the first day of high school. Did everything together, school, soccer club, babysitting, you name it. Then we both went off to college, different colleges. She's doing technology, I think."

Jessica: "Sounds like your friendship changed?"

Claire: "It's me. I changed. Lucy still wanted to meet up with me at Christmas, but I couldn't let her see me like this. Felt so ashamed."

Jessica: "Ashamed to let Lucy see you."

Claire drops her head. "Yes."

Jessica: "Do you still feel like that, Claire?"

Claire: "I dunno. I'd like to see her again. But it's been so long now."

Jessica: "How could you see Lucy again?"

Claire: "We could meet up for ice cream, when she's home for spring break. But, won't she think it odd of me contacting her out of the blue?"

Jessica: "What could you say about that, Claire?"

Claire: "I could explain, I've been out of touch with everyone, not just her. That it's been tricky, but that things are getting better now and I've missed her."

Jessica notes that Claire is thinking of saying things are getting better now. "How do you think Lucy would respond?"

Claire: "I think . . . I think she'd be fine with it. I think she would like to see me again."

Jessica: "Worth a try?"

Claire: "Worth a try."

Jessica: "What else do you have on your list, Claire?"

Claire: "Singing along to a song while driving my car, walking barefoot on the grass, putting on a CD and dancing for a whole track without feeling shy, buying a new lipstick, making my own jewelry, and saying hello to myself in the mirror first thing in the morning."

Jessica: "I wonder if you'd feel like trying one or two of these out for your goals this week?"

Claire: "I could try. I've kind of done the mirror one a bit already."

Jessica: "What about saying hello to yourself in the mirror every day this next week."

Claire: "Yes, I think I could do that."

Jessica: "Anything else?"

Claire: "Well, I could try the singing in the car one."

Jessica: "What would you like to sing?"

Claire: "Something upbeat. I really like The Beatles. Yellow Submarine?"

Jessica: "So by next session, you'll have sung along to Yellow Submarine, while you're out driving in your car."

Claire: "Yes, for sure."

Jessica: "And?"

Claire looks across towards the window. Her face looks serious. "I could write to Lucy and ask her if she's coming home for spring break."

Jessica: "Would you like to do that Claire?"

Claire: "Yes, I really would."

Jessica: "By next week?"

Claire: "I can send her a card and see how it goes."

There are only ten minutes left of the session. Jessica brings Claire's vase over from the cooling shelves. "This is your vase, Claire."

Claire takes it in her hands carefully. She turns it slowly, examining every flower, and then stands it on the table in front of her.

Claire: "It's beautiful. She would've loved it."

Jessica: "Your Nan?"

Claire: "Yes. The violets are just like the ones on her card."

Jessica: "I wonder what you'll do with this vase, Claire?"

Claire: "I don't know yet."

Jessica: "Is it something else you ..."

Claire interrupts her with a smile. "Something *else* I could think about in the week? Yes, why not? It would be good to think about that. I don't want to decide at once. It's got to be the right thing."

Jessica: "The right thing?"

Claire: "The right thing for *me*."

Claire picks up the vase, takes off her scarf, and wraps the vase carefully in it. "See you next week then."

Jessica notes that Claire is continuing to take more initiative. The issues of wanting to do what Jessica would like and doing the right things are still there, but not quite in the same form. She acknowledges, too, that parts of the session felt lighthearted and how much hope was in the room when they were discussing her friend Lucy. Jessica reflects that even so, the issue of Claire's relationship with her father has not been explored in any depth, and Jessica wonders how Claire will be when she returns to college and once the therapy sessions end. Three sessions remain, and it is now time to discuss endings with Claire.

Session 8

Jessica starts the next session with Claire by reminding her of the therapy contract they had both agreed to.

Jessica: "We have three sessions left, Claire. I wonder how you feel about this."

Claire looks anxious: "It feels like we've only just begun."

Jessica: "Begun?"

Claire: "Begun to get things done . . . get things right again."

Jessica: "Right again?"

Claire: "With me. Things right again with me. Feeling better about myself. Doing things for myself again. I'm starting to feel right again."

Jessica: "It's what we've been working towards, Claire. I'm wondering how you would like to spend our last three sessions?"

Claire does not respond immediately, and then she opens her journal at her goal page: "I've achieved all the goals we'd set last week, every one."

Jessica: "That's wonderful Claire. Can tell me about them?"

Claire: "The first one I did was to sing along to Yellow Submarine. I did that when I drove away from here last week. It felt great. And I didn't stop, even when I was at the stoplight. This guy in the truck next to me looked over and smiled. And I didn't stop singing; I smiled back! Then I did the mirror one everyday. And it kind of felt like a good way to start the day, as if I was starting out with the right frame of mind. Then Lucy, I bought a card with a rainbow on it, and wrote to her. I asked her how she was

doing, told her a little bit about what's been happening with me, and then suggested that she might like to meet up when she's home for spring break. So that was all the goals, every one done."

Jessica: "You've achieved a lot. I wonder how you would like to build on these"

Claire: "The other things on the list were: walking barefoot on the grass, dancing to a CD, buying a new lipstick, and making my own jewelry."

Jessica: "What kind of jewelry did you have in mind?"

Claire: "Beads. I love beads. I was thinking of doing bracelets, maybe some earrings."

Jessica: "Have you ever seen beads made of clay?" Jessica shows Claire some photographs of clay beads.

Claire: "I'd love to try making some of these."

Jessica: "Would you like to do that today, Claire? We could talk more about your goals while you work on the beads."

Claire: "Do you think I'd manage to finish making say a bracelet over the next three sessions?"

Jessica: "I think that's possible. Let's get the materials out together."

They both look over the instructions from the book (Breines, 1995, p. 70), and Claire starts to pinch small pieces of clay into uniform shapes. She makes some into small balls and others into rod-like shapes. Jessica shows her how to pierce each bead with a piece of wire while the clay is still wet. While Claire is working, Jessica encourages her to talk more about her goals.

Jessica: "So you have already sung along to the CD track. I wonder how you would feel about dancing along to a track now."

Claire: "That one is harder to do. Especially if I catch sight of myself in the mirror at the same time."

Jessica: "It would be difficult for you if you saw yourself dancing."

Claire: "Yes, I'd be embarrassed."

Jessica: "You've been saying 'hello' to yourself every morning in the mirror."

Claire: "That's true. Maybe it wouldn't be so hard for me now."

Jessica: "What music would you like to dance along to, Claire?"

Claire: " Love Me Do, that's got a really good beat. . . ."

Jessica: "By next week?"

Claire: "Yeah, by next week."

Jessica: "And . . ."

Claire: "I could walk barefoot on the grass. First thing in the morning, while the grass is still wet and fresh. We have a hummingbird feeder. I could walk over to that and check on that, see that it's ready for when they come back."

Jessica: "That sounds magical, Claire."

Claire assembles all the beads she has made so far. "I wonder if I made some slightly smaller ones, they could be used for matching earrings?"

Jessica notes Claire's initiative and says, "I'll show you the earring fixings that we have. That might give you an idea of the size of the bead you would need to make." Claire looks at the fixings and begins to work on assembling some finer beads in the same ball-shape and rod-shape designs.

Jessica, remembering that they had talked about Claire's vase at the end of their last session, says, "I wonder if you've had an opportunity to think about your vase, Claire. The one you made for your Nan."

Claire: "Oh, yes. I'm going to put it on my study desk at college, so I know my Nan is always with me."

Jessica wonders how Claire can go back to the place where she was so unhappy. She remembers Dr. Lewis saying that her dad was going to pay for extra tuition.

Jessica: "Your desk, at college, Claire. At the law school?"

Claire looks up from her beads, and breaking out into a smile. "I'm going back to college. But I'm not going to do law. I'm thinking of trying art school."

Jessica: "Art school, Claire?

Claire: "Yes, I've always loved doing arty things, as you know—drawing, painting, anything like that. Coming here, doing this pottery, has helped me to think about what I'd really like to do with my life."

Jessica remains silent, waiting for Claire to continue.

Claire: "I want to study art. Spend my time learning more, more techniques, skills, finding my niche. And maybe one day I'll go into teaching art somewhere, I dunno. Haven't thought that far. What I know now is that I want to go to art school."

Jessica: "Sounds like you've made a definite decision."

Claire: "I have." She looks down, fiddles with the wire that has pierced the beads, "but I don't know how to tell dad about it."

Jessica: "I wonder what would be the way to go about that."

Claire: "I just don't know. He'll go mad, say I'm letting him down, the family down."

Jessica: "Letting him down, the family down. And you, Claire?"

Claire: "I don't want to let him down. He's kept us all together, been the strong one, I don't want to disappoint him."

Jessica: "He's kept you all together, been strong since your mother's death."

Claire: "Yes, in many ways."

Jessica: "And yet?"

Claire: "I think he's struggling, too. He knows he can't fix everything, but he still tries to."

Jessica: "Can't fix everything?"

Claire: "He couldn't help mum. Didn't know how too. He was very ashamed. Threw himself into his work, encouraged us all to do that, as a way of coping."

Jessica: "He coped, and encouraged you all to cope, by not referring to what happened with your mum."

Claire: "Yes, we've never talked about it. I wouldn't know how to start."

Jessica: "What is it that you'd like to say to him, Claire?"

Claire is silent, verging on tears. She then says, "I'd like to know how he feels. I'd like to know that he still thinks about mum, still misses her. That . . ."

Jessica: "That?"

Claire: "That—this is hard to say, Jessica. I don't know if I'd ever be able to say this to him. . . ."

Jessica: "But this is something you would like to say. . . ."

Claire: "Something I'd like to *know*." She takes a deep breath and runs at what she has to say: "I'd like to know he hasn't brushed mum aside when he married again, she isn't just forgotten. I know she got drunk, and she made him ashamed, but she could be. . . . He *has* to miss her, too."

Jessica: "Tell me what your mother could be, Claire. . . ."

Claire says crying, "She could be so nice, she was my friend, she loved me, she knew all about me, until it all went wrong, she was the best mother in the world. She made up stories, sang to me, we dressed up, we did all those things, and without her. . . ."

Jessica: "Tell me how you feel without her, Claire. . . ."

Claire: "I'm so lonely. My dad married again, Tim's got his college friends, there's no one there for me. Sometimes I don't think there will *ever* be anyone there for me."

Jessica: "No one there for Claire because . . ."

Claire, whispers, seeming like a reflection of the child-like self of earlier sessions, "They all abandon me, everyone abandons me."

Jessica: "I understand, Claire."

Silence. It is almost the end of the session. Claire seems content to sit in silence, and Jessica respects this. Claire, getting up to leave, says, "I'll try to talk to my father. Just a bit. Let me think about it. If I've managed it, I'll tell you. Ok with you?"

Jessica: "Ok with me."

Jessica gathers together the beads and takes them over towards the firing shelves. Jessica believes that through working on the clay beads, Claire has demonstrated her ability to continue to take initiative and also to make

choices independently, the latter being something that had been missing in their previous sessions. In addition, Claire has expressed that she is starting to feel better about herself, starting to feel right again. Jessica reflects on Claire's courage in being able to discuss the sense of abandonment, which is, Jessica believes, at the core of Claire's unhappiness and withdrawal. Does Claire feel that she, Jessica, is also abandoning her? In many ways, Claire is regaining a strong sense of control. Her decisions, goals, and thoughts about her future have given her a feeling of meaningfulness, and she is taking her first steps towards independence.

Session 9

Jessica has put the beads out on the table. They have been fired and are ready for Claire to decorate. Claire arrives, looking tired. She is wearing a gray wool cardigan and dark green jeans. Jessica observes that Claire is not wearing make-up today, and her eyes look dull and lifeless.

Jessica: "Hello, Claire."

Claire does not respond. She walks over to the table and picks up a few of the beads.

Jessica: "They've been fired. They're ready for decorating now. You could use clay paints and paint on a specific design. Or you could use glaze for a more uniform color."

Claire shrugs. "I'll do glaze." She walks across to the cupboard and selects some blue glazes.

Jessica watches Claire settle at the table and start the glazing. Claire is avoiding her eyes. She looks "out of reach," in her own world.

Jessica: "Claire, I'm sensing you're not really here with me this morning. . . ."

Claire puts down the beads. "I haven't forgotten the goals, Jessica. I did talk to my dad." She picks up the beads and carries on.

Jessica: "Do you feel you could talk to me about it?"

Claire: "No. No, I don't. Oh, I don't know. I wrote it in my journal. Will that do?"

Jessica: "Yes."

Claire reaches for her journal. She opens it and scans the page. "He said, 'I don't want to talk about the past. It's best not to. Thinking about the future is the only way to go.' I pleaded with him to listen. He cut me off. But I carried on, told him that I didn't think I had a future until now. Didn't want there to be a future. Didn't want to wake up any more. Didn't want to open my eyes and feel all that pain all over again, every day. That I couldn't get away from it. I hurt so much."

Jessica: "You told him how you felt, Claire."

Claire: "But he didn't want to hear it. Said he didn't have time to talk."
Jessica: "And you. . . ."
Claire: "Pleaded with him to talk *now*. Said I didn't know how he felt after mum died. Said he'd never talked to me about it, or Tim. And he said we were too young, that he wasn't going to tell his feelings to children."
Jessica: "How did *you* feel, Claire?"
Claire: "Cut off. Like I didn't matter. And angry . . . like I wanted to shout at him that if I didn't do what he wanted, was he going to try to forget *me*, make *me* someone no-one ever talked about. . . ."
Jessica: "Like your mum. What did you do with your anger, Claire?"
Claire: "Well, believe it or not Jessica, I didn't let rip. I told him I wasn't a child any more. I told him how excited I am now, that I haven't felt like this for a long time. That I know what I want to do with my life."
Jessica: "And. . . ."
Claire: "He said he wanted to understand. Wanted to help. But. . . ."
Jessica: "But?"
Claire: "Then he said, why don't I try art school for a while, six months."
Jessica: "How did this make you feel, Claire?"
Claire: "Like he doesn't trust me. Like I'll try it out, see sense, come back to law. Feels like he's hanging over me, just waiting for me to change my mind."
Jessica: "I wonder how else you could view it, Claire."
Claire does not respond immediately, but finally says, "That I'm trying. Giving it a go."
Jessica: "As a chance for your future."
Claire looks up, smiles at Jessica, and says, "Yes, following *my* dream."
Claire has finished glazing the beads and has them ready to go into the kiln. Jessica reminds Claire that next week's session is their last one and suggests that she might like to spend the time assembling the beads into the bracelet and earrings.
Claire: "I'm going to call it my Jessica friendship bracelet, to remind me of you. That all right with you?"
Jessica: "All right with me!"
Claire walks towards the door. "Jessica, I really am going to make it at art school."
Jessica: "Yes, you are, Claire."
Jessica reflects that it has not been easy for Claire to speak with her father, to confront him about his feelings, and to stand against his wishes for her future. Claire is clearly determined. She is breaking away from the restraints she has felt in her life, and she is becoming independent. With her idea for a friendship bracelet, Jessica understands that Claire has come

to terms with the approaching end of the sessions and has even found a way to celebrate them.

Session 10

The beads have been fired, and Jessica has the jewelry fixings ready for Claire to assemble the bracelet and earrings. The beads are a mixture of blues — some deep and mottled, others pale like the sky. Jessica notices that the rod-shape beads have been glazed in a shade nearly the same as Claire's periwinkle scarf. As she ponders how Claire will pull together the beads to complete the overall design, Claire walks into the room.

Jessica: "Hello Claire."

"Hell," Claire says softly, "I'm going to find this session hard, Jessica."

Jessica: "So am I, Claire. It's so good to work with you, and I'm proud of you."

Claire: "What's it to be, then? Bracelet making first, or shall I tell you about my dad? No, don't say it . . . 'which would I like to do first.' I'll tell you about my dad. Well, . . . he looked at my art school brochures, and he said is going to come with me to see some of them."

Jessica: "I can hear a *but* in there somewhere."

Claire: "It's good, him taking an interest—it's a first step, *but* will it last?"

Jessica: "A vulnerable first step."

Claire: "That's Ok for now, isn't it?"

Jessica: "Yes, I think so."

Claire carefully examines her beads and tries out a variety of ways to sequence the design. She begins to thread the beads. "Oh, I almost forgot! There's more!" They smile at each other. "Remember I wrote to Lucy, my friend from high school? Well, it worked! I owe you one for that, Jessica! We're going to meet up during spring break. We're going to go to the mall and maybe even see a movie. And I thought, too, that I could buy a new lipstick while Lucy is with me. What do you think about that?"

Jessica, sharing Claire's humor, says, "Now *that's* an announcement!"

Claire jumps up, "Earring time!"

She carefully pieces together a series of three beads onto two strands of wire. She fixes each strand to each earring fixing. Jessica notices that Claire has deliberately left one of the periwinkle beads out.

Claire: "This bead is for you, Jessica. And also this card that I made for you." Jessica smiles, takes the gifts and thanks her.

Claire: "You know, one day I'd like to make something for my dad. Something out of pottery."

Jessica: "Sounds good. Maybe you could do that at art school."

Claire: "Yes, I could."

Jessica now asks Claire if she would once again complete *The Interest and Role Checklists* (Klyczek, Bauer-Yox, & Fiedker, 1998; Oakley, Kielhofner, Barris, & Reicher, 1986). The team members at Southside Clinic are cognizant of the need to develop effective outcome measures. To this end, as well as for reviewing goals, some of the team members ask their clients to rewrite their initial assessment measures during the last therapy session as a way of comparing and recording intervention outcomes.

Claire: "Yeah, I don't mind doing that. Could I see what I wrote on the first ones, afterwards?"

Jessica: "Sure."

Claire completes both checklists. Jessica reviews the interest checklist first. Claire has recorded eighteen activities that she now has an interest in, with twelve of them in the strong interest category. These include: writing, popular music, singing, driving, jewelry making, shopping, hairstyling, dancing, movies, ceramics, clothes, and drawing. Jessica shows Claire the two interest inventories:

"Wow, that's quite a change isn't it? I'm enjoying so many more things now," says Claire.

Jessica then reviews the role checklist. Claire has indicated four roles that she is currently performing: friend, family member, hobbyist, and volunteer, and two roles that she is planning to perform in the future: student and worker. She has rated all these roles as valuable and important to her. Jessica gives Claire the two role checklist inventories. While Claire is comparing them, Jessica asks, "The volunteer one, Claire?"

"Well, it's not something I'm *actually* doing yet. But I'm thinking of volunteering at our local elementary school. Help them do art activities. I thought I could do this over the summer."

Jessica: "That sounds like a wonderful idea, Claire."

Claire: "Thought I'd give them a call when I've left here."

Claire: "Well this is it. Thank you, Jessica, for everything. Is it all right to let you know how it all goes at art school?"

Jessica: "Of course it is. I'd like to hear."

Claire walks to Jessica and hugs her, then she leaves quickly, leaving the door slightly open after her.

Jessica writes some final notes on her sessions with Claire. A large number of issues have been addressed with Claire and fairly quickly. Claire has been able to talk about her despair and say what has previously been impossible for her to say. She will, Jessica hopes, be able to talk more freely in the future and be able to feel the benefits of friendship and social support. Her relationship with her father may remain problematic, but Claire has a direction and one she has chosen. Her grief for her mother and her Nan will obviously remain, but at least Claire has begun to

express it. Jessica records that Claire's relationships with her brother, and with her stepmother, have not been explored.

CONCLUSION

This case study has illustrated the power of occupational therapy in *enabling* the discovery of life's meaning. By using pottery as the therapeutic medium, and through the process of the therapeutic relationship, Jessica was able to nurture and support Claire in the following ways:

- Helping Claire reconnect with her previous artistic occupations and to a time where she felt creative, secure, and loved. Pottery was a compelling way to harness these memories and provided a strong foundation for Claire's growth and development.
- Encouraging Claire to take steps towards securing new roles in her life. Through therapy, Claire was able to break away from some of her former roles, e.g., as a caregiver and dependent daughter, and seek out and move towards new and more meaningful roles in her life, e.g., as a volunteer, friend, and potential worker. In turn, these roles will help Claire to move from a sense of abandonment and relative isolation to being part of a wider and socially supportive network. One possible more long-term outcome may be the development of more secure attachment patterns and an affective warmth, both within and outside of her family context (Bowlby, 1977).
- Providing visible indicators of choices made, challenges met, and new skills gained, thereby assisting Claire to make the confident transition to an environment of growth where she can begin to *take charge* of her own chosen directions.
- Enabling Claire to reflect on the significance of the pottery items chosen and created and to gain insight from these reflections. Claire was thus able to communicate her journey as she moved from isolation and dependence (the rose), to a sense of connectedness (the violet vase), and independence (the beads). The physical objects she molded reflected Claire's spiritual growth, a reforming and strengthening of her sense of self, an understanding of personal significance and power: Claire now has something to give and to offer to her world.

REFERENCES

American Psychiatric Association. (1994). *Diagnostic and statistical manual of mental disorders* (4th ed.). Washington, DC: Author.

Bonder, B. R. (1997). Coping with psychological and emotional challenges. In C. Christiansen & C. Baum (Eds.). *Occupational therapy: Enabling function and well-being* (2nd ed.). (pp. 312-336). Thorofare, NJ: Slack.

Breines, E. B (1995). *Occupational therapy: Activities from clay to computers. Theory and practice.* Philadelphia: F.A. Davis.

Denton, P. L., & Skinner, S. T. (2000). *Occupational therapy practice guidelines for adults with mood disorders.* Bethesda, MD: American Occupational Therapy Association.

Hemphill-Pearson, B. J. (2000). *Assessments in occupational therapy mental health. An integrative approach.* Thorofare, NJ: Slack.

Klyczek, J.P., Bauer-Yox, N., & Fiedker, R. C. (1998). The interest checklist: A factor analysis. *American Journal of Occupational Therapy, 51,* 815–823.

Loganbill, C. R., Hardy, E. V., & Delworth, U. (1982). Supervision: A conceptual model. *Counseling Psychologist, 10*(1), 3-42.

McColl, M., Gerein N., & Fraser, M. (1997). Meeting the challenges of disability: Models for enabling function and well-being. In C. Christiansen & C. Baum (Eds.), *Occupational therapy: Enabling function and well-being* (2nd ed.) (pp. 508–530). Thorofare, NJ: Slack.

Neistadt, M., & Crepeau, E. (1998). *Willard & Spackman's occupational therapy* (9th ed.). Philadelphia: J. B. Lippincott.

Oakley, F., Kielhofner, G., Barris, R., & Reicher, R. K. (1986). The role checklist. Development and empirical assessment of reliability. *Occupational Therapy Journal of Research, 6,* 157–170.

Rogers, C. (1965). *Client-centered therapy: Its current practice, implications and theory.* Boston: Houghton-Mifflin.

Schell, B. B. (1998). Clinical reasoning. In M. Neistadt & E. Crepeau (Eds.), *Willard & Spackman's occupational therapy* (9th ed.) (pp. 90-103). Philadelphia: J. B. Lippincott.

Solomon, A. (2001). *The noonday demon: An atlas of depression.* New York: Scribner.

Turner, A. (1996). The philosophy and history of occupational therapy. In A. Turner, M. Foster & S. Johnson (Eds.), *Occupational therapy in physical dysfunction: Principles, skills and practice* (4th ed.) (pp. 3–27). New York: Churchill Livingstone.

Chapter 6

IMPROVING QUALITY OF LIFE FOR PERSONS WITH TRAUMATIC BRAIN INJURY: THE ROLE OF THERAPEUTIC RECREATION

GERRY CARR

SUMMARY

Iso-Ahola (cited in Carter, Van Andel, & Robb, 1995) defined quality of life as "a subjective assessment of psychological and spiritual well-being which is characterized by feelings of satisfaction, contentment, joy, and self determination" (p. 17). More recently, Iso-Ahola (cited in Mobily, 2000) proposed that therapeutic recreation will "make a huge difference if it can make people believe in themselves (e.g., self-efficacy).... Believing in your skills and capacities (however limited) and finding enthusiasm for life's activities sets the stage for subsequent improvement in psychological and physical well-being" (p. 302). In this chapter, an overview is given of the role of therapeutic recreation for improving the quality of life of people living with a traumatic brain injury (TBI). This overview has been illustrated with two case studies. It has been estimated that more than two million Americans will sustain a traumatic brain injury this year. More than 200,000 of them will demonstrate ongoing deficits that will prevent them from functioning at pre-injury levels (Seale, 2000). Suggestions will be made for research in this area.

THE ROLE OF THERAPEUTIC RECREATION

Recreation experiences have long been recognized as valuable tools for social reform, especially in the inner city slums prior to the World Wars. The profession of therapeutic recreation grew out of the need to provide recre-

ation experiences for people who were institutionalized for social, physical, emotional, cognitive, and behavioral problems. According to Carter, Van Andel, and Robb (1999) "Recreation activities promote personal development through providing opportunities for self satisfying experiences, reinforcing a positive self image and the achievement of personal goals" (p. 6).

As society becomes more sensitive to the needs of persons with disabilities, the need to provide recreation experience to all has become more important. The World Health Organization defines health "as a state of complete physical, mental and social well-being, and not merely the absence of disease and infirmity" (cited in Carter et al., p. 9). These authors define Therapeutic Recreation as "the specialized application of recreation and experiential activities or interventions that assist in maintaining or improving the health status, functional capacities, and ultimately the qualities of life of persons with special needs" (p. 10). Therapeutic recreation professionals are trained and certified to provide therapeutic recreation services. The first case study will now be presented to illustrate the beneficial outcomes associated with Therapeutic Recreation for a person with a TBI.

Case Study 1: Jane Doe

Jane Doe (pseudonym), a 35-year-old single female, is currently recovering from an aneurysm. She was admitted to the rehabilitation program approximately sixteen months after her injury. Prior to her injury, she was living independently and working at a local dry cleaning store. She had many friends and reported her interests to be watching TV, listening to music, cooking, gardening, and swimming. During the assessment, the Certified Therapeutic Recreation Specialist (CTRS) found Jane to have many strengths including high levels of motivation, adequate cognitive skills such as attention and memory, adequate physical skills (e.g., independent ambulation), and adequate social skills. Her deficits included severe expressive aphasia and right hemiparesis.

It was recommended that Jane receive therapeutic recreation services to assist her in developing the skills to participate in leisure activities that would promote long-term health and well-being. Initial goals in therapeutic recreation were to assist her to explore a variety of leisure activities and to explore adaptive equipment to increase her independence. Service was provided for Jane in the following ways: for one individual session to explore her interests, group sessions to provide opportunities for socialization, and community contact to increase independence in all areas. In all of the activities, Jane's greatest barrier was her aphasia. She was able to practice using strategies such as a letter board, picture boards, gesturing, and drawing. Using these strategies in a variety of settings increased her

comfort and helped provide feedback to the therapist who helped her develop the strategies. In exploring her leisure interests during individual sessions, Jane discovered that she enjoyed arts and crafts activities. She was able to use a piece of equipment called a "crafter's second hand" (S&S Worldwide Arts & Crafts website: www.snswwide.com) to compensate for decreased use of her right hand.

When Jane progressed to living in an apartment, she asked for supplies to take home for the evenings and weekends. At this point, the goals of therapeutic recreation were to increase her independence in planning and organizing home and community-based leisure activities. Through the use of planning forms and budgeting activities in cooperation with the occupational therapy department, Jane was able to plan and budget for craft activities. Initially, she required some assistance to follow her plans and her budget. She was able to identify community interests and followed through independently using public transportation. One of our biggest concerns with Jane was that she have access to a variety of resources in her home community. Fortunately, she was returning to a setting with an outstanding community therapeutic recreation program. We contacted the recreation center, which subsequently sent us a brochure of their programs. The programs were reviewed with Jane, and she chose her interests. Registration forms were filled out in advance so that all she had to do was get herself to the center at the appointed time. We also identified stores close to Jane's home so that she could purchase arts and crafts supplies. Due to this client's high motivation, our plan was very successful. Some of the therapeutic recreation outcomes most notable in this case were increased leisure awareness and increased awareness of community resources. Jane developed an appreciation of her leisure abilities as evidenced by her initiation of activities and her follow through. She also actively engaged in locating resources in her home community.

THE THERAPEUTIC RECREATION PROCESS

In order to provide the safest and most effective interventions for persons needing our services, all Certified Therapeutic Recreation Specialists (CTRS) utilize a process for developing programs and individualized treatment plans. The therapeutic recreation process has been clearly described by Carter et al. (1995). They note that the CTRS first conducts an assessment to determine the clients' strengths in barriers to leisure functioning. Next, goals are developed to assist the clients to overcome barriers to leisure participation, followed by the development of a program of interventions to assist them in meeting those goals. As the clients progress, the CTRS update the

program to meet their changing needs. Throughout the process, the therapist is monitoring change in the leisure functioning of the clients. The desired outcome is that the clients function more independently during their leisure time, thereby decreasing the effects of their illness or disability on their quality of life.

ASSESSMENT PROCESS

The recreation assessment is conducted using a variety of methods to collect information about the clients' pre-injury and post-injury leisure functioning. This information may be collected through review of records, interviews with the patient and family, observation of the clients' skills and abilities, and standardized testing. *Assessment Tools for Recreation Therapy: Redbook #1,* by Burlingame and Balshko (1999) is an excellent resource for finding standardized tests for Therapeutic Recreation. Areas assessed may include the following: leisure interests and awareness; motivation for leisure participation; and physical, cognitive, and social skills for leisure functioning.

Leisure Interests and Awareness

It is very important to determine the pre-injury leisure interests of the clients. This information may be obtained by asking them or by having the clients review a list or pictures of leisure and recreation activities. Often, we find that clients do not understand the words "leisure" or "recreation." Asking probing questions, such as "What kinds of things did you do after work or on the weekends?" or "What were your favorite hobbies?" will usually elicit their specific interests. The therapist may also assess the clients' awareness of the benefits of leisure participation as well as their awareness of the effect of their disability on participation in activities.

The Effects of Traumatic Brain Injury on Leisure Interests and Awareness

Depending on the nature of the injury and the clients' pre-injury lifestyle, information about interests may be difficult to identify. Some clients may be unable to remember their pre-injury interests or may have trouble finding the words to describe such interests. In this instance, the therapist may use pictures or speak to their family to obtain more information. Other clients may be able to identify their pre-injury interests, but they may now believe that they are no longer able to do the activity because of the injury. Furthermore, some clients may experience diminished awareness of the

deficits caused by the brain injury, which may lead to unrealistic goal-setting related to leisure participation.

Leisure Skills

As with any task or activity, there are a variety of physical, cognitive, and social skills required for successful participation in recreation and leisure activities. These skills can be assessed through observation, standardized testing (Burlingame & Blashko, 1999), and by reviewing the assessments of other disciplines (e.g., physical therapy, occupational therapy, speech/language pathology, and neuropsychology).

Effects of Traumatic Brain Injury on Leisure and Recreation Skills

Mermis and Duke (cited in Stumbo & Bloom, 1990) describe the implications of traumatic brain injury for therapeutic recreation in rehabilitation. Depending on the areas of the brain injury, a variety of skills may be affected. For example, physical or motor deficits may include decreased use of one or both sides, decreased balance, decreased endurance, and poor coordination. These deficits have an obvious effect on the clients' participation in sports activities. Similarly, poor fine motor control and inability to use one or both hands may affect the people's ability to play a simple card game or to participate in an art activity.

Social deficits can be the result of speech or language problems, or personality and behavioral changes caused by the brain injury. Some of the more common deficits noted are a decreased ability to understand or express spoken words (receptive and expressive aphasia) or the inability to articulate due to muscle weakness or incoordination (dysarthria). Personality changes may take the form of immaturity, impulsivity, sexual inappropriateness, and decreased frustration tolerance. These deficits can have profound effects on one's ability to communicate or maintain social contacts for leisure participation. For example, Hallet, Zalser, Maurer, and Cash (1994), who investigated changes in adult roles following traumatic brain injury, found that about 50 percent of the participants had experienced "a friend role loss" (p. 241). The latter concept refers to social isolation, which may lead to feelings of loneliness and embarrassment.

Cognitive deficits may include the following: disorientation, decreased attention span and concentration, as well as alterations in memory, judgment, ability to plan and problem-solve, and intellectual functioning. These deficits affect the individual's ability to participate in leisure and recreation activities in many ways. For example, the person's ability to initiate and fol-

low through with leisure plans independently is affected by alterations in higher cognitive functions such as problem-solving and planning.

PROGRAM PLAN

Once the assessment is completed, the therapist develops goals and objectives based on the client's strengths and limitations for leisure functioning. This step, which is often called a program plan, includes specific interventions and time frames for its implementation. The plan may call for individual, group, or community sessions.

Goals and Objectives

Therapeutic recreation goals and objectives are developed in conjunction with the interdisciplinary treatment team. The team may include a case manager, a physical therapist, an occupational therapist, a speech/language pathologist, a neuro-psychologist and/or cognitive therapist, and a vocational rehabilitation specialist. Berger and Regalski (1990) note that "Consistency and repetition are key elements to effective rehabilitation of the brain injured" (p. 450). They emphasize that

> The therapeutic recreation specialist's report of the patient's social, leisure, and community functioning provides the treatment team with a reality mirror of the patient's everyday life experiences. It illustrates how the patient is carrying over skills developed in the structured clinical setting to practical activities of recreation, and community reintegration outings, which are less structured environments. This feedback assists the treatment team in evaluating the patient's total care program; if problem areas are identified, revisions can be made. (p. 453)

In brain injury rehabilitation, goals usually refer to long-term outcomes of participation in the program. For example, the client will develop the skills to plan, organize, initiate, and follow through with home- and community-based leisure activities. An objective is usually short term and specifies a specific outcome or behavioral change that should result from participation (Carter et al., p. 126). An objective might address a specific change in attention to task or a specific social skill. For example, the client will maintain attention to the leisure task for 30 minutes with minimal cues. The objective can then be updated to demonstrate progress toward the long-term goal.

Interventions and Time Frames for Implementation

Therapeutic recreation specialists use a variety of activities as interventions to help clients meet their goals for an independent leisure lifestyle. The

interventions are chosen on the basis of their needs, abilities, and interests and the resources available to the therapist. Cognitive tasks such as simple card and board games assist them with attention, memory, ability to follow directions, fine motor skills, and social skills such as turn taking. Physical activity and exercise such as team sports encourage cooperation and gross motor skills. Creative activities such as painting, drawing, ceramics, and crafts are often used to foster self-expression, develop fine motor skills, and facilitate a sense of accomplishment.

Community reintegration outings led by a therapeutic recreation specialist help clients to increase independence in the community. In addition, clients may gain a greater sense of self-confidence that may have been shaken by their injury. Outings may include going to movies, bowling, shopping, and going out to eat. Some specialized interventions include gardening and animal-assisted therapy. Such activities, which require more training and knowledge by the therapist, may address a very specific interest of the client. Therapeutic recreation specialists are able to adapt all these activities to ensure that clients are successful. The activities can subsequently be made more difficult as the clients improve. Activities may also be adapted using equipment so that they may participate more independently. For example, a person in a wheelchair may participate in bowling by using a ramp, or a card holder may be used for playing cards by a person who has the use of only one hand. There are adaptive devices for fishing poles, pool cues, water skis, and snow skis. A therapeutic recreation specialist can assist the clients to find these resources and to teach them how to use these devices. Although clients are sometimes sceptical about the use of adaptive equipment, once they experience success, they are usually convinced.

In addition to adaptive devices and activities, the therapeutic recreation specialist may also assist the client in developing strategies to increase initiation and follow through with activities. One strategy may include having them compile a list of activity interests as well as planning forms to assist with initiation. Planning forms cue the client to remember specific details in planning and may also assist in helping them follow through with the activity. Some examples of cues may be how much money is needed for the activity, the time frame of the activity, and things that may need to be brought along on the activity.

Intervention is dependent upon the needs of the client. In brain injury rehabilitation, it is essential that clients have time to practice strategies for increasing participation. It is also important that family and caregivers be educated in the use of these strategies.

Discharge Planning

Discharge planning, which is the last step in the clinical therapeutic recreation treatment process, is considered from the first day that clients are admitted into rehabilitation. Once plans for discharge are known, each client's treatment plan is adjusted to address independent leisure functioning in his or her particular setting.

Key aspects of discharge planning are amount of support needed, strategies for increasing success, equipment needs, and community resources. The amount of support needed is usually based on the amount of intervention needed by caregivers or family members to assist the client in initiating and following through with the activity. Ideally, the client would be able to use strategies such as lists, calendars, and planning forms independently to initiate and follow through with the therapeutic recreation activities. Family members and caregivers are educated in the use of these strategies prior to the client's discharge.

When possible, equipment is also purchased prior to the client's discharge. For example, a card holder or crafter's second hand is useful for this population. Basic adaptive equipment can range in price from $6 to $50 (USD). More expensive adaptive equipment such as beach wheelchairs are also available. If it is not possible to purchase equipment, family members are given information about how to order the equipment. S&S Worldwide Arts & Crafts catalog (www.snswwide.com) and Access to Recreation (www.ACESSTR.com) are good resources for equipment and supplies. Finally, community resources are explored. This aspect may be as simple as finding the local theatres and bowling alleys. However, in many cases, more supportive resources are needed. City parks and recreation departments often provide programs for people with disabilities. The therapeutic recreation specialist may contact the staff at the recreation center to obtain more information about the programs so that specific recommendations can be made. Many communities have brain injury associations that may provide social outlets for people recovering from such conditions. For example, the Brain Injury Association of Texas offers a weekend camp twice each year. Some parks and recreation departments offer open recreation times or specific trips into the community. Clients are able to develop relationships and enjoy ongoing activities which increases their quality of life. Effective discharge planning can increase the quality of life of people with brain injuries by insuring that quality leisure experiences continue after the client leaves rehabilitation. The following case study will illustrate the ways in which therapeutic recreation enhanced the quality of life for another adult with a traumatic brain injury.

Case Study 2: Francoise LePuil

Francoise LePuil (pseudonym) is a 20-year-old, single female who sustained a severe injury in an automobile accident. She came into rehabilitation approximately three and one-half years after her injury. A great deal of the time between her injury and her admission to post-acute rehabilitation was spent in a nursing home. She had a long history of drug abuse and had dropped out of school in the tenth grade due to pregnancy. The accident happened shortly after the birth of her daughter. Upon admission to the program, Francoise demonstrated low self-esteem as evidenced by repeated verbalization of her inability to do anything. Evaluation by the Certified Therapeutic Recreation Specialist (CTRS) found that Francoise had very limited leisure interests prior to her injury. This client reported that she spent most of her time "hanging out with friends" and abusing alcohol and drugs. Although she mentioned a past interest in drawing, she had not participated in that activity for many years. Francoise also reported a current interest in playing dominoes. She was reluctant to participate in activities offered and demonstrated decreased interactions. In addition, she was in a wheelchair and had decreased use of her right hand. Francoise was unable to identify any realistic goals for her future, and she did not see the importance of leisure.

Initial therapeutic recreation goals focused on increasing her participation in activities and in social interactions. Individual and group therapeutic recreation sessions were scheduled. She was also seen during community reintegration outings on the weekends. During individual sessions, the therapist worked on building a rapport with Francoise. As her trust grew, the client became more willing to try new activities. She demonstrated a high interest in arts and craft activities but was reluctant to try. Once she began to try, she received positive feedback from the therapist and from her peers. An increase in self-esteem was evident through her smiling and willingness to display her work.

Francoise developed a special interest in card stamping and often sent cards to her daughter and other family members. During this time, she was also seen in groups to focus on social interactions. As her confidence increased, her interactions also increased. In addition, we began to see increased initiation of activities when she was given a choice. Once discharge plans were in place, the client and the therapist began to explore resources in her home community. She was very excited about getting her own apartment and was able to identify places in her community where she could purchase supplies. She also identified other resources for community involvement such as church.

The Therapeutic Recreation treatment was very effective because she

began to trust the therapist. As described by Carter et al. (1995), "Trust is an essential ingredient in the helping relationship, since it decreases the psychological and physical stress associated with the client's need" (p. 77). Once Francoise trusted the therapist, she was able to see her strengths and try new activities. Her ability to do more increased her self-esteem and increased the likelihood that she would follow through with her new interests in her discharge community.

SUMMARY AND CONCLUSIONS

In this chapter, the author has explained the role of therapeutic recreation in improving the quality of life for individuals living with the consequences of traumatic brain injury. Clients can gain the confidence needed to continue such participation in their discharge communities from exploring interests to experiencing participation in a wide variety of activities. Future research might focus on the conduction of follow-up studies of clients to determine the effectiveness of treatment strategies offered by therapeutic recreation programs as well as identification of specific indicators about the importance of recreation and leisure participation for their overall quality of life.

REFERENCES

Berger, J., & Regalski, A. (1990). Therapeutic recreation. In E.R. Griffith (Ed.), *Rehabilitation of the adult and child with traumatic brain injury* (pp. 449–462). Philadelphia: F.A. Davis.

Burlingame, J., & Blaschko, T.M. (1999). *Assessment tools for recreation therapy*. Redbook #1. Ravensdale, WA: Idyll Arbor.

Carter, J., Van Andel, G., & Robb, G. (1995). *Therapeutic recreation: A practical approach* (2nd ed.). Prospect Heights, IL: Waveland.

Hallet, J., Zasler, N., Maurer, P., & Cash, S. (1994). Role change after traumatic brain injury in adults. *The American Journal of Occupational Therapy, 48*(3), 241–246.

Mobily, K. (2000). An interview with Professor Seppo Iso-Ahola. *Therapeutic Recreation Journal, 34*(4), 300–305.

S & S Worldwide Arts & Crafts. Retrieved April 20, 2004 from www.snswwide.com.

Seale, G. (2000). *Brain injury rehabilitation: Evaluating the options for achieving functional outcomes*. Unpublished Inservice Materials. Galveston, Texas. Transitional Learning Centre.

Sumbo, N.J., & Bloom, C.W. (1990). The implications of traumatic brain injury for therapeutic recreation services in rehabilitation settings. *Therapeutic Recreational Journal, 24*(3), 64–79.

Chapter 7

THE SPARK OF CREATIVITY: EXPRESSIVE ARTS IN A HOSPITAL SETTING

WENDE HEATH

The Expressive Arts, including painting, sculpture, music, dance, and literature, can bring joy, pleasure, and laughter to patients and staff in medical settings, qualities often in short supply. Making art or hearing music reminds us that no matter how ill or busy we are, we can always tap into the magic of our imagination. This frees patients from being just "the cancer patient in bed 4," passive with no power, to the person who has cancer who still also has an imagination, a creative spark. This spark can be utilized to tell her story, imagine her healing, aid in her recovery. My goal in describing this process is to encourage other hospitals to begin to experiment using the Expressive Arts with their patients.

Just a word about the field of art in medical care. The leaders in the field have joined together in the Society for the Arts in Healthcare. The members are artists, art therapists, landscape architects and hospital planners, performing arts programmers, and medical personnel who are interested in bringing more art and beauty to their facilities. If this field interests you, I urge you to visit their website at http://www.theSAH.org and join this growing movement.

In this chapter, I will describe my personal experience as a patient, as well as my professional experience working with oncology, pediatric, and senior citizen patients at two hospitals in a western state in the United States. I have a license in Marriage and Family Therapy and am Board Certified in Art Therapy with a background as a potter, costume designer, doll and puppet maker. I direct the Expressive Arts Program that is part of the Institute for Health and Healing (IHH) at each facility. We work with four other modali-

ties: Massage Therapy, Guided Imagery, Pastoral Care, and Integrative Medicine Nursing, to bring psychosocial and spiritual care to patients in the hospital. We work together because we believe we are all doing the same work, only going through different doors.

IHH offers a year-long internship for Expressive Arts and Art Therapy graduate students, as well as for the other four modalities. During the internship year, the students attend weekly classes and workshops with the interns from the other three modalities. The classes include medical subjects such as "Cancer 101" or "How to work with Pediatric Populations," as well as didactics on "Meditation," "Self-Care," "Avoiding Burnout," and "The Importance of Presence." The interns work on most of the floors in the hospitals, especially pediatrics, oncology, pre-term maternity, and heart transplant units. In addition, they work with seniors who have health problems.

At the end of the year, the interns receive a certificate in Integrative Medicine and Spirituality with an emphasis on Expressive Arts. IHH programs began ten years ago, and the Certificate Program graduated its fourth class of interns in August, 2004.

We think we are putting into daily practice what every good health care worker knows: there is no split between mind, body, and spirit. The psychosocial care of patients needs to be given much greater attention in all medical settings.

Medical art therapy is a new field and many of its practitioners come from both an art and a medical background. Some of the training is specialized with many years of training in art and graduate work in psychology. Practitioners need the ability to be flexible in terms of modality, using whatever expressive art is appropriate for the patient and the setting. We often work right at the bedside as well as in an office and an outpatient clinic. However, what we do is not so specialized that all health care workers could not benefit from knowledge of the field. Stories of patients and the use of art in the hospital can be utilized by people not specifically trained in art, but who have an appreciation for it.

Rather than in-depth case studies, I will present sketches of patients and staff to give the flavor of the work we do in the hospital. Sometimes, our interactions are brief, one-time visits. Patients often have short hospital stays, with the onset of managed care and the availability of more out-patient procedures. Often, we do brief therapy with a lot of intensity. On the other hand, sometimes we see patients in the transplant unit over many months as they wait for an organ, or we see pediatric patients with cancer or a chronic disease off and on throughout a year. This extended hospital stay allows for more in-depth, long-term therapy.

Place

I will begin discussion of expressive arts in a medical setting with a short discussion of place. I see expressive arts in medical settings in the broadest sense: what the patient sees, hears, feels, smells, and touches in the setting as well as the art on the walls and the art made by the patients. Architects, interior designers, and hospital administrators are paying more attention to providing healing spaces for patients. This need has been emphasized by Annette Ridenour (1998). In designing a facility, she believes the focus should not be on the color of the furniture or whether it matches the carpet. Instead, the emphasis should be on who the patients are and what they need to feel to be comfortable in this environment. The questions she emphasizes are based on significant effect art has on feelings and on promoting reduced stress levels in patients and improving their well-being.

The colors white, gray, and chrome may be efficient medically, but they feel cold, unfriendly, and scary to patients. One does not have to be an artist or architect to know what is needed in terms of place to heal. Most people would say a setting close to nature with plants and pleasing colors, or a cheerful and quiet environment with as much as possible surrounding them that feels like home.

I found myself five years ago with the diagnosis of breast cancer, terrified and unprepared for the experience of the medical cancer world. My medical care, at an unnamed hospital, was good. My psychosocial care was horrible. From doctors' offices to pre-surgery waiting rooms, I was faced with an efficient and clean medical world. Nothing in my environment said "human beings are cared for and loved here. You needn't feel fear."

The staging area for radiation therapy was a cold, sterile room with not one picture, flower, or plant. The radiation technicians, who had brought in a radio, which they had purchased with their own money, apologized. On the other hand, the more commonly used radiation room was different. It included a large, backlit photograph of a beautiful garden on the ceiling which I grew to love through my six weeks of therapy.

When I asked why there was such a difference between the staging area and the radiation rooms, the technicians said they had never thought about it. I believe that the first place a radiation patient (or any other patient) sees as they begin their treatment should be warm, welcoming, human, and filled with beauty.

One does not need to spend lots of money unless a new facility is being planned. In that case, specialized architects, landscapers and artists can be hired in the planning stages. To ensure that art is an integral part of the healing facility, there should be an adequate budget for art.

But what can be done short of new design? Paint is cheap, and plants are

easily obtained. Photographs of nature (even borrowed from a calendar), views of nature, and original artwork from your community can be solicited.

At the hospital where I work, we have turned the hallways and atrium of the Cancer Center into the Artrium Gallery. An art committee of local artists, some of whom have had cancer, choose and hang four "Healing Shows" a year. A variety of artwork has been exhibited, including photographs of nature, healing prayer flags, humorous paintings, mandalas, and children's artwork and poetry. Cancer patients going to radiation therapy pass this gallery each day, thereby having something transformational to view and to carry them through another day. In addition, the waiting room opens to a small garden of labeled plants used in the formation of drugs for chemotherapy.

We get wonderful comments about the Atrium Gallery from patients and visitors such as the following:

> This is the most unique, beautiful and uplifting exhibit I have seen. I am very moved by it and very impressed by the artist and her thoughts.
> I am most deeply moved by this exhibit. It truly does spiral deep in the consciousness and into the soul. The colors and patterns evoke a peace that moves one to tears. Thanks and blessings.
> Passed by your exhibit here at I am at this time working through a healing process. What a soothing inspiration!

People

Of course, the most important component of anyone's healing is the people they encounter. In a medical setting, there are many highly skilled people involved and that includes the expressive arts interns.

IHH's Expressive Therapy interns are master's students working towards a therapist's license and/or expressive arts credentials with a strong background in the arts. Sometimes we work with exceptional artists who have done a lot of their own spiritual work and work well with people. A number of nurses with art backgrounds have interned with us. Often people see us as volunteers like the "pink ladies" who deliver magazines. We are often called the "Art Ladies." Expressive arts interns are highly trained in two fields, art and psychology. They are also given additional weekly supervision and training. Academic excellence and artistic skill are very important attributes of an expressive arts intern, but we consider presence, the ability to be "present," the most important thing we do.

Presence

What is presence in a hospital setting? Presence is entering into the room and company of an ill person slowly, respecting where they are and trying to

bring them what they need in the way they need it. Presence is being grounded and breathing and being fully with the patient, not thinking about anything or anyone else or trying to "fix" them. Presence is acting as if we had all the time in the world to be with this person. It is a gift that is so rarely given. We are often the only people all day who are fully present with the patient. Rachel Naomi Remen (2000), a pioneer in being present with her patients, puts it this way:

> *The Celestine Prophecy* offers a simple and helpful description of the possibility within all human relationships. It says that there is a way of relating to others such that one deliberately listens for the hidden beauty in them. The place of their beauty is often the place of their greatest integrity. When you listen, the integrity and wholeness in others moves closer. Your attention strengthens it and makes it easier for them to hear it in themselves. In your presence, they can more easily inhabit that in them which is beyond their limitations, a place of greater freedom and sanctuary.... It has been my experience that presence is a more powerful catalyst for change than analysis and that we can know beyond doubt things we can never understand. (pp. 90-91)

Sometimes when we visit a patient at the bedside we do not make art or even talk but just sit with the patient. Sometimes we talk and laugh. Sometimes we play around with materials and often we make "fabulous art" that has meaning for the patients.

If a session is going well between artist and patient, they enter a space which is truly in the present. They are in synchrony with each other, the art materials, and with whatever has come up (memory, feelings about their illness or family, etc). According to Mihaly Csikszentmihalyi (1990), it is referred to as being in the "flow":

> Concentration is so intense that there is no attention left over to think about anything irrelevant, or to worry about problems. Self-consciousness disappears, and the sense of time becomes distorted. An activity that produces such experiences is so gratifying that people are willing to do it for its own sake.... (p. 71)

It is potentially an anti-boredom, anti-anxiety, and even an anti-pain experience. What can help this "flow" experience? A potential answer is the support of medical personnel who appreciate that something important for the patient's healing is happening and do not interrupt. Factors that can potentially ruin it are the millions of unavoidable interruptions in a hospital regimen. This cannot be helped because nurses and doctors have to do their jobs. Sometimes, however, an interruption can be pre-planned to allow for the "flow," especially the avoidable interruptions such as a friendly nurse who enters the room and says, "What are you drawing? Looks like a rabbit" (when it really is a dog). She then launches into a long story about how her

sister is the artist in the family and how she herself "can't draw a straight line." The "flow" is stymied in this instance.

The most important rules to remember to enhance the "flow" process are: (1) do not interrupt; (2) do not name or interpret the artwork; (3) wait until people are through making, drawing, sculpting. Then you can ask them *if they want* to tell you about what they have created.

An important part of presence is listening. However, hospital personnel are continually questioning patients about physical signs, appetite, etc., instead of active listening. What the patient needs is an opportunity to tell her story and to have someone "really" listen.

The importance of presence and storytelling is highlighted in the following encounter. While I was pushing the art cart (which is full of all kinds of art materials) on the oncology floor, one of the nurses asked me to explain what we did. I told her a little, to which she really did not seem to pay much attention. As it was quiet on the floor, she perched for a moment on a desk. We were quiet together. Then she said to me, "You know my grandmother is down the hall. It sure is a lot different to have a relative on this floor than someone I don't know." She talked about her grandmother for a minute or two. I asked if she would like to make her grandmother something. She thought a card would be nice. I gave her some beautiful materials, and for the next five minutes she put together a loving card for her grandmother. She delivered it to her grandmother's room. When she came back she said, "You know, I feel a lot better now." I said, "That's what we do," and she understood.

I was present to her in the moment to what this nurse needed. She was able to tell her story, and we were able to make some art that had the tangible result of being a gift for a loved one. The process of creating the card made her feel better, surely freeing her up to be a better and more present nurse for the rest of her shift. (Additional ideas of being present have been indicated by Osterman and Schwantz-Bartlett, 1996.)

Initially, interns find it difficult to work with very sick elders. The elders often look so gray and dull, unapproachable in their illness, and they remind the interns of their own grandparents. By being present and patient, we often hear the most wonderful stories about the patients' experiences in places that we have never been. Giving elders a chance to tell their stories reminds both patient and caregiver that they are more than just "the sick old lady in bed 2." Instead, they are their whole history. Interestingly, when they learn to be present with the elders, the interns grow to love this population.

Pens, Pencils and Paint

It is important when making art with people who are ill to use the best, most colorful, "glitziest" materials available. It is like setting a beautiful table,

a banquet of very special dishes for people with diminished appetite. Broken crayons, a few dried up markers, and computer paper do not belong in a hospital. Good paper, brushes, watercolor, glitter will whet the appetite. These materials are brought to the bedside in an old medication cart decorated with beautiful and fun images. We display a variety of the materials or projects on top of the cart to elicit interest. In groups, we carefully lay out watercolors, pencils, brushes, as well as markers and crayons on the work table. We offer interesting images cut from a variety of magazines for collage. We have found that it works better to have pre-cut images from magazines available than to give magazines to patients, especially teenagers. If a patient's ability to concentrate is low, they often get lost in reading the magazine and forget the point of the art exercise.

Much of the art-making in hospitals, especially in psychiatric centers/hospitals, has involved only the use of craft kits. Craft kits may be of benefit for patients who need concrete instructions to organize confused thinking, possibly related to a psychiatric process. One limitation of such kits is that they do not fully tap into the patients' own creativity and may cause them to think that they are being treated as children. By contrast, if given exciting, evocative materials and an interesting theme, even inexperienced "non-artists" will produce something that expresses who they are. Play will do the rest.

Play

Story-telling is not encouraged by a frontal attack such as saying: "Tell me all about yourself." The therapist will find out nothing, and the patient will often feel pressured to tell the therapist what they think she wants to hear. We have developed many playful activities which encourage the telling of a story. The following three activities have been used successfully with every population and age in the hospital.

IMAGE CARDS

Image Cards are the simplest of techniques and can be used with patients whose limited strengths prevent them from holding a paint brush. Pictures that readily evoke memories are cut out of magazines and pasted on 3" × 5" index cards. These cards are offered to patients as a game. "Pick your favorite, or pick three, or pick cards that represent your past, present, and future. No rules: do whatever feels appropriate." Next, we ask them to tell us why they were attracted to the images. Almost immediately, they tell you the story of growing up on a farm in Kansas or being a fighter pilot in WWII. For a short time, you tap into a healthy part of them as expressed in their memories. By your presence, your listening, you link that part to the present,

and they are energized. Sometimes they next take the image index card(s) and make it into a picture. We then encourage them to put the picture on the wall to remind themselves of the story. In this way, they feel that they are more than their illness; instead they are their whole histories.

WORRY OR WISHING OR PRAYER DOLLS

Another project assists the patients in processing their concerns or worries. We ask the patient to write a worry, a wish, or a prayer on a small slip of paper. We then offer them tongue depressors and a variety of glitzy fabric, hair, ribbons, feathers, and pipe cleaners. The paper is tightly wrapped around the middle of the stick and covered with fabric squares to serve as the dolls' clothes. A bit of pipe cleaner is twisted around a "clothed" tongue depressor to serve as the dolls' arms. The patient then decorates the doll to individualize it. When they are finished, we ask them to name the doll and tell us what it wants. Often the solution to the worry is in this wish. We attach a bit of oil-based clay to the bottom of the stick, thereby assisting the doll to sit on the bedside table. If the worry comes up again, the patients are asked to transfer it to their doll, who is designed for worrying, or carrying prayers and wishes. The presence of the doll softens the surroundings, often evoking laughter and delight. Children love this activity. Older people love it as well. Often they remark that they have not played like this since they were children with their grandparents. People love to play, especially with wonderful inviting materials.

STORY DOLLS

Story dolls are another simple project. The arms, legs, and torso of a figure of about 14" are cut out of stiff paper. Alternatively, the patients can cut out a one-piece paper doll of whatever size and shape. The patient attaches the body parts with paper brads and draws and decorates the figure with markers and colorful paper. Then the patient makes up a story about the doll, which is written on the doll as part of the decoration. This activity was suggested to a woman in an acute rehabilitation unit, who had recently had a leg amputated. She insisted that the doll have an amputated leg as well, and dressed her as an exotic dancer, mourning her loss. Over the next few months, she made legions of dolls, all representing aspects of herself and her world. She gave them away after she had filled the wall of her room with them. She was able to tell her story over and over again and to join with others through the gift of the story dolls.

Through the years, we have developed many other activities, including pre-drawn body images to depict pain, discomfort, or to convey information so that we can devise ways to ameliorate the pain through color and image.

We ask the patient to draw on the body outline what the pain feels like in color, shape, or image and intensity. We then imagine what it would take to make the pain feel better. Cooling blue "water" is used to sooth angry red heat in joints. Soft clouds are used to soften sore feet. Furthermore when a patient suggested that the pain in their shoulder felt like the bird who has talons in your shoulder, we could brainstorm with them ways to metaphorically remove their talons.

We redraw the image with the soothing or defensive images, often many times. We use imagery and imagination to bring the healing images closer and available to the patient when the pain returns. We give the patients a nonpharmacological method to lessen their pain.

We try to make all activities fun and easy, sometimes as simple as squishing "Model Magic," a clay-like material made by Crayola that is perfect for hospital use (e.g., no scent, no mess, does not stick to hands, good colors, and air dries to hardness). We try to design activities that are no-fail and creative. We provide pre-drawn mandalas for patients to work on at their leisure. When we are with them, we invite them to co-create artwork, drawing from both of our imaginations. Kids also love stickers and can make wonderful stories with them. Perhaps, even more effective is the transformation of medical materials such as surgery hats, tubing, and bandages into a new creation. Other activities have been described by several authors (Malchiodi, 1999; Rollins, 2004).

PARTICIPANTS

In-patient, Art at the Bedside

We work with all ages in the hospital. Children are naturally drawn to art, and women tend to be initially more open to art than men. Most adults have a lot of performance anxiety about making art. I believe that education in the arts in the United States is dismal and that most people's last experience making art was when they were in the second grade. Their experience was often disappointing, if not humiliating, because of initial lack of facility at art making or because a teacher or parent pointed out that giraffes are not purple. After several disappointments, unfortunately all art-making activities had been abandoned in favor of more "practical" pursuits.

Much of our initial work is coaxing people who do not see themselves as artists into believing, if just for the moment, that they are capable of art making. We design our art experiences so that they will find success and will enjoy the experience. In addition to using inviting art materials and the techniques that I have discussed, we use a "Zen" board to intrigue the most reluc-

tant but potential artist. The board is made of "magic paper" encased in a cardboard frame. With a Chinese bamboo brush, one paints with water on the paper. It makes lovely calligraphy marks and is fun to play with. The water gradually evaporates leaving the paper blank in five minutes or so. This non-permanence encourages experimentation. Eventually the patient says, "Do you have anything more permanent?" With a surprised look on our face, as if that had never occurred to us, we offer paper, pens, pencils, or paint that they would have initially refused.

Medical personnel often are very anxious about art making. They believe that because they have chosen to be scientists they cannot be artists. With the exception of some "scientist musicians," they long ago gave up any idea that they could fulfill both roles. I believe that scientists and artists have a lot in common. Medical personnel are curious, observant, inventive, and need to play with materials and tell their story as much as patients do. Although nurses and doctors are often too busy on their shifts to make art, whenever possible, we offer quick five-minute activities, especially around the holidays. For example, on "Red, White, and Blue Day" following the events of September 11, 2001, we offered staff wonderful red, white, and blue materials to make a symbol to wear. Everyone was receptive and enjoyed the opportunity to join together. For holidays, we also offer half-hour activities in the cafeteria or hospital lobby that the staff can do during their lunch hour such as making masks for Halloween or making Valentine and Christmas cards for those occasions.

Art and Imagery for Outpatients with Cancer

We offer a number of groups for cancer patients and their families. These groups seem to be most popular with breast cancer patients but are open to everyone. The groups are co-led by a guided imagery intern who begins the group with a short thematic guided imagery. The art therapy intern provides materials to draw, paint, or sculpt from the theme. The artwork is then discussed for theme and emotional meaning. The artwork from these groups has been phenomenal and has been inspirational to the patients and others.

Out-patient Groups for Seniors with Depression

Groups are offered to seniors who have been hospitalized and are not progressing in their healing. Many are depressed about their losses. We do a lot of artwork that encourages socialization and reflection on their history. Often, we do artwork just for fun, such as "silly hat day." Laughter is a great healer (see Le Navenec & Slaughter, 2001). One of the seniors made a hat with antennas that he said "could beam him up" to his deceased wife, whom

he missed a great deal. He left the group wearing the silly hat and said, jokingly, he would "wear it all the time." Two weeks later, he died or "was beamed up" as the group described it. The seniors had lovely happy memories of him and the fun day they had being silly.

Projects

I am often asked how to get started with an art program in a hospital. It is recommended to identify and contact medical personnel who are interested in the creative arts such as a nurse who paints or a doctor who plays the piano. In this way, one is engaging those staff who value the arts and can influence their colleagues to implement and/or support such programs. For example, several pediatric nurses at Floyd Medical Center in Rome, Georgia painted a colorful mural. These nurses followed this up by having pediatric patients paint ceiling tiles and began to decorate the pediatric rooms with colorful and homey fabrics. Subsequently, other departments began looking for ways to add art to their patient treatment environment. This art initiative led to the hospital administration deciding to start a creative arts program which involved visual art and music for their patients.

We developed a meditation book that is left in the meditation room. An art box is left with this book so that people can illustrate the prayers and messages that they write with collage and drawings. The meditation books thus became beautiful and inspirational for all the patients and visitors who visit the room. The following message or credo was left in 1998 by an anonymous patient in the meditation room at Marin General Hospital. It is a sample of the wisdom we all have and the importance of providing creative avenues to give voice to that wisdom. Begin small wherever you are and think big about what you want to create. Make art.

What I Have Learned

1. Pain takes a lot of attention.
2. We are mere mortals.
3. If I do not rise above a fear–survival outlook, I will suffer more.
4. I realize that I am in the room of and part of the room of the universal pulse that creates us all.
5. Small kindnesses mean so much in hard times. An MGH staff person said to me, "I like your top." I felt so human and loved. She noticed my blouse, of all things, in the midst of my self-absorption, and I felt so happy.
6. Art matters. Several paintings on walls have suddenly brought me back to myself.

7. Clean and orderly surroundings, with soft colors, really matter and influence my mood.
8. It's hard to be in this hospital because the fluorescent lights hum and are irritating. It takes effort to tune it out.
9. Televisions are really awful for people who don't want more sensory input.
10. When nurses introduce themselves by name, it really feels good.
11. We are bodies.
12. We are not our bodies.
13. I must remember to smile and have kind words for others too. I am glad that I seem to do this.
14. I really need a place like this meditation room to sit and let my thoughts write out. I hope somebody will read them and that my thoughts might help others.
15. I discovered the best parts of MGH by accident. I hope someone tells others: the meditation room; the chaplain; the views and there must be other parts I'm missing. Find them. Tell others.
16. It is hard to see my loved ones in pain.
17. I must allow others' paths in life to develop in their own way and at their own pace.
18. Thank God for friends. Any time you can find concrete things to offer, do it. Examples: Please come over if you want company; call us any time of day or night, even if you're just lonely, we mean it; we'll research that illness for you—is that ok? How to ask for help; Can you take my dog while I'm in the hospital? Please send my husband mail—it cheers him up, and me too; Please pray for us.

I conclude with a statement from Patch Adams (1998):

Modern medical practice often sacrifices contact with the patient in the name of efficiency. This loss of intimacy hurts both doctor and patient. So much of the great magic and therapeutic power of the doctor-patient relationship occurs because we spend time getting to know each other. Even in the sophisticated hospitals of this nation, patients suffer from afflictions that cannot be relieved by technology or pharmacology. For those patients, compassion and creativity in any form should be called into play. (p. 401)

REFERENCES

Adams, P. (1998). When healing is more than simply clowning around. *Journal of the American Medical Association, 279*(5), 401.

Csikszentmihalyi, M. (1990). *Flow: The psychology of optimal experience.* New York:

Harper & Row.

Darley, S. (Ed.). (2000). *Expressive arts activities from Marin General Hospital: A guide for expressive arts practitioners.* San Rafael, CA: Institute for Health and Healing, Marin General Hospital (Available for $10.00 from Box 70474, Pt. Richmond, CA 94807).

Kaplan, F. (2002). *Art, science and art therapy: Repainting the picture.* London: Jessica Kingsley.

Freeman, J., Epston, D., & Lobovits, D. (1997). *Playful approaches to serious problems: Narrative therapy with children and their families.* New York: W. W. Norton.

Kaye, C., & Blee, T. (1997). *The arts in healthcare: A palette of possibilities.* London: Jessica Kingsley.

Malchiodi, C. (1998). *Medical art therapy with children.* London: Jessica Kingsley.

Palmer, J., & Nash, F. (1991a). The hospital arts movement. *International journal of arts medicine, 1*(1), 34–38.

Palmer J., & Nash, F. (1991b). *The hospital arts handbook.* Durham: NC: Duke University Medical Center [Info.: www.SAH.org]

Remen, R. (2000). *My grandfather's blessings: Stories of strength, refuge, and belonging.* New York: Penguin Putnam.

Ridenour, A. (1998). Creativity and the arts in health care settings. *Journal of the American Medical Association, 279*(5) 399–400.

Section 2

MUSIC

Chapter 8

SARAH'S SONG: MUSIC, PREGNANCY, AND CHILDBIRTH

KAREN FOWLER

> when the first trace of life begins to stir, music is the nurse of the Soul;
> it murmurs in the ear, and the child sleeps;
> the tones are companions of his
> dreams–
> they are the world in which he lives.
> (Bettini cited by Lingerman, 1995, p. 254)

SUMMARY

In this chapter, an exploration will be presented regarding the effects of sound and music on our health and well-being. More specifically, it is about using sound for therapeutic effects in pregnancy and childbirth. Multiple research studies indicate the value of music to the unborn child, mother, labor partner, and birth attendants (Browning, 2000; DiFranco, 1988). This knowledge will be helpful for nurses, childbirth educators, midwives, physicians, and related professionals. Most importantly, this knowledge needs to be shared with expectant parents. Comments on music and health care in general are presented first, followed by an overview of the unique properties of sound. Topics addressed include the following: use of music during childbirth preparation classes; neo-natal response to music; and music during childbirth and in the postpartum period. By providing research-based knowledge and case studies, it is anticipated that the practical application of music in pregnancy can expand and grow.

The power of sound is as ancient as mankind. Considered the earliest sense to develop in the womb, hearing has a profound effect on our lives (Pope, 1995, p. 291). From the constant beat of the mother's heart, the rhythm of her respirations, and the rush of the fetus's watery world, sounds encompass an individual from one's beginning. The effects of sound are lifelong. From the love and nurturing heard in our mother's voices, earliest lullabies, and nursery rhymes, sounds are harbored in memory for the remainder of our lives. As students, the memory of our teachers' voices, which were sometimes gentle, sometimes scolding, also has an impact on our lives. Music helps pave the way to self-identity for teenagers; lovers delight in "their song"; and for others, solace is often found in music, or by contrast, in silence and solitude. And, as life as we know it slips from our bodies, sound is the last sense to leave (Pope, 1995, p. 291).

The healing properties of music are ancient. For example, King David was soothed by Saul's harp; Pythagoras was noted to prescribe music to restore balance to the mind and body. Lingerman (1995) explained that by using sounds in a particular pattern, the body can be restored to a more optimum state of health. Similarly, teachings from Plato have informed us that "music alters the soul and the soul in turn alters the body" (Harvey, 1995, p. 186). The close ties between music and healing are illustrated by Apollo, who was the Greek god of both medicine and music.

Music Therapy and Nursing

The ancient knowledge of the power of sound is being resurrected in new and innovative ways. Scientific studies from the post-Renaissance period also demonstrate the link between music and its associated healing properties (Buckwalter, Hartsock, & Gaffney, 1985; Cook, 1981). Music Therapy, as defined by the Canadian Association for Music Therapy (1992), is "the skilful use of music as a therapeutic tool to restore, maintain and improve mental, physical and emotional health. The non-verbal creative and affective nature of music facilitates contact, self-expression, communication and growth" (Canadian Association for Music Therapy brochure, p. 1). Music therapists are now considered an important part of the health team in many patient care centers and are involved in the active treatment of clients with a wide variety of health concerns.

The current growth of multidisciplinary approaches involving the arts in medicine suggests exciting possibilities. During the past twenty years, the application of music and its therapeutic effects have been widely visible in the field of nursing. Gerdner and Buckwalter (1999) emphasize that music as a nursing intervention cares for the mind, body, and spirit of the patient (p.

452). This holistic approach offers treatment for the entire individual rather than simply treating an illness. Further, these same authors provide a variety of practical yet effective ways for the nursing profession to assess, implement, and evaluate music in order to provide holistic client care (pp. 451–468).

Music and Health Care

In the past two decades, music has received new attention in the entire health care system. A description of its varied use follows. It has been used in dentistry to relieve pain and anxiety (Di Franco, 1988; Schwartz, 1993; Standley, 1991; Standley, 1996). Music for the elderly, especially for those with Alzheimer's disease, is proving very beneficial for both the patients and their relatives (Gerdner & Swanson, 1993; Millard & Smith, 1989). Hanser (1992) has studied its use in the treatment of depression in the elderly. Music is also used in the treatment of autistic children to provide a tool for communication (Buchanan, 1997). In addition, Cripe (1986) notes the therapeutic effects of music for children with Attention Deficit Disorder. Pre-operative fear and anxiety may be diminished by appropriate use of music (Harvey, 1992, p. 73; Schwartz, 1993).

Locsin's study illustrates the decreased requirements for pain control following obstetrical procedures and surgery when music is implemented (cited in Olson, 1998, p. 572; see also Di Franco, 1988, p. 208). Music is acknowledged to help alleviate associate fear, tension, stress, anxiety, and pain associated with pregnancy and childbirth (Browning, 2000; Clark, McCorkle, & Williams, 1981; Hanser, Larson, & O'Connell, 1983). To appreciate these aspects further, properties of sound, including physiological and psychological, are addressed.

Properties of Sound

The phenomenon of sound and music is multifaceted. Through harmony, melody, and rhythm, a portion of ourselves is accessed that other methods of communication do not appear to reach. Vibration is responsible for the unique properties of music and sound (Bunt, 1994, p. 158). The vibratory nature of music, according to Droh (1992), involves not only the arts but certain sciences as well. Pitch is another property of sound affecting the response of individuals. Livingston (1979) comments that the actual volume of sound suggests high pitches can inhibit the relaxation response (p. 363).

A further quality of sound is entrainment. Entrainment is an intriguing characteristic of sound, whereby vibrations of one force affect an opposing

force, resulting in a synchronicity or rhythm between the two objects (Goldman, 1992, pp. 195–196). Illustrative examples provided by Goldman (1992, p. 197) include altered respiratory rate, heartbeat, and brainwave activity (p. 197). He further explains this characteristic by commenting that as the breath is slowed, the heart and brain activities also slow, and the rhythms of these vital organs become more harmonious (p. 197). Further, this same author continues with reports that many individuals in past times used chants and drum beats to provoke changes in levels of awareness (p. 194). Olson (1998) adds to the concept of entrainment by implying the therapeutic use of music can create a restful and calming atmosphere (p. 571).

Physiological Responses to Sound

The physiological responses to music are well documented. For example, alterations in vital signs can change according to stimuli provided by music. Maranto (1992) suggests blood pressure or heart rate can be lowered by elements of sound (p. 23). Changes in respiration rates vary with the use of music (Browning, 2000; DiFranco, 1988; Livingston, 1979; Olson, 1998). Music also has the ability to alter muscle tension (Buckwalter, Hartsock, & Gaffney, 1985; Scartelli, 1984). Pain appears to be suppressed through the use of programmed music on women in labor (Browning, 2000; Hanser, Larson, & O'Connell, 1983).

The effect the mind has on the body is a relatively recent branch of medicine, called psychoneuroimmunology (Scartelli, 1992). Evidence of positive alterations in the immune system have been documented by the use of preferred music in studies by Bartlett, Kaufman, and Smeltekopp (1993) and Lane (1991) (cited in Pope, 1995, p. 293). Maranto and Scartelli (1992) acknowledge the exciting possibilities of using music therapeutically to enhance immune function. However, these authors recommend further research prior to accepting this conclusion fully (p. 150).

Music listening has been found to reduce stress. For example, Rider, Floyd, and Kirkpatrick (1985) have described the ways in which music, guided imagery, and progressive relaxation may have a positive effect on the autonomic nervous system. By studying the effects of music, imagery, and relaxation, the stress hormones produced by the adrenal glands or the corticosteroids were measured. Results indicate a relationship between the production of corticosteroids and an individual's health, suggesting music, imagery, and relaxation can enhance the immune system.

Psycho-physiological Responses to Sound

Music creates a psychological response. Indeed, McClellan (2000) explains that music is mainly listened to for the emotional reaction it creates (p. 137). Furthermore, this author comments that moods, not emotions, are created by music, and emotional responses to music are achieved by the listener. Winner (1982) elaborates that the unique construction of music is reflected in the emotions of the individual; certain sounds or music can imitate certain moods (p. 211). Moods, according to early studies by Altschuler (1948), are a result of alternations produced automatically in the thalmic region of the brain (cited in Cook, 1981, p. 259). Further details of this aspect are discussed next.

A response at the thalmic level is achieved through the sense of hearing. A brief review of this sense extends our appreciation of how sound is interpreted. The tympanic membrane or eardrum receives vibrations from the outer ear. From there, tiny bones in the middle ear are activated and send their signals via the oval window to the cochlea, somewhat like little drums. The cochlea is filled with fluid and reacts to vibrations from the oval window. From there, messages journey to the brain via the basilar membrane. The Organ of Corti, known as the nervous receptor for the sense of hearing, is found along the basilar membrane. Along the basilar membrane are tiny hairs that flow according to pressure or vibration from the fluid (Greisheimer & Wiedeman, 1972, pp. 288–291). Differentiated nerve fibers receive these signals, which are next interpreted at the thalmic level. The message then proceeds to the cerebral cortex, producing certain moods or feelings.

McClellan (2000) maintains that the psychological response to music involves a conscious choice to respond to certain sounds. By using an individual procedure, the listener may decide to "tune out" unwanted sounds and will either persist with listening or choose not to listen (p. 32).

Conversely, the inability to shut out unwanted sounds and the impact of noise in a hospital environment have also been investigated. Noise, as defined by the *Concise Oxford Dictionary* (1995), is "a sound, esp. a loud or unpleasant or undesired one" (p. 923). The negative effects of noise on well-being have been studied by various researchers (Griffin, 1992; McCarthy, Ouimet, & Daun, 1991; Pope, 1995). The study by McCarthy, Ouimet, and Daun (1991) maintains that noise provokes a stress reaction. By examining wound healing rates, these authors comment that the healing process is inhibited by excess sound in the environment. Griffin (1992) notes that too much sound in care facilities appears to coincide with sleep loss, enhanced pain sensitivity, and overstimulation (p. 55). Even Florence Nightingale (1969) remarked that sounds that are not necessary or provoke certain

responses are harmful to the sick (p. 44).

In addition to noise, Pope (1995) explores the effects of music and the human voice on hospitalized patients. This author encourages nurses to explore the impact of sound because this concept has had little recognition in the past. Results of Pope's review imply that while noise may, in fact, inhibit healing, vocal sounds and musical elements may provide incredible opportunities to promote health and well-being (p. 295).

Anxiety pertaining to labor and childbirth has been noted in several studies. For example, Hanser, Larson, and O'Connell (1983) used music to assist with breathing exercises, to elicit a relaxation response, and to divert attention from anxiety-provoking sounds in the hospital environment. In this small study, all women in labor reported music as being beneficial in pain reduction. Liebman and MacLaren (1991) explored the effectiveness of music to decrease anxiety in teenaged girls during the third trimester of pregnancy. Several factors were taken into consideration, including the relationship of the client and the therapist. Significant to this study as well was the actual time spent practicing and repeating the exercises given to the clients by their music therapists. The more time spent practicing resulted in enhanced benefits. The results indicated a significant decrease in perceived anxiety for those who received the music treatment. Other researchers have also linked a reduction of anxiety in the childbirth process with the use of music (Clark, McCorkle, & Williams, 1981; Rohner & Miller, 1980).

Guided Imagery, Music, and Childbirth

Like music, guided imagery or visualization also has a history dating back to ancient times (Vines, 1988). Further, Vines (1988) describes guided imagery as a technique used for beneficial purposes in order to facilitate constructive changes. This process allows the individual to visualize desired outcomes, which are then processed by the body to produce desired results (p. 35). In more recent times, Freud and Jung use guided imagery in therapy to reach the subconscious mind (cited in Summer, 1988). The noted psychiatrist, Leuner, who is credited with first developing methods for visualization, acknowledged that imagery worked because the client's state of consciousness is altered (cited in Summer, 1988, p. 5). Kolkmeirer (1989) comments that this changed degree of consciousness creates for the individual a link for connecting various components in a holistic manner (p. 75). Pioneers Green and Green add that this physiological process regulates itself through biofeedback (cited in Vines, 1988, p. 36). This intricate and not totally understood system in turn affects cerebral functioning, which can alter self-perception, self-esteem, and ultimately change behavior. Bonny and Savary

(1973) emphasize that concentration and relaxation are required to reach this altered state. The use of music in conjunction with guided imagery enhances the experience of this state of altered consciousness (Bonny & Savary, 1973). These authors conclude that once guided imagery is learned and practiced, induction of a changed level of awareness comes easily (p. 23).

According to Vines (1988), imagery and visualization can be used during labor, delivery, and the post-natal period (p. 41). This approach offers the potential to alleviate anxiety, reduce pain, minimize complications, and create an enhanced postpartum experience. Furthermore, Di Franco (1988) suggests visualization can aid the labor process as the mother pictures the birth canal widening and the subsequent birth of the baby. However, because of the power of visualization, she cautions that this action should be done only during true labor (pp. 206–207).

Music and Sound Specific to Pregnancy and the Neonate

Pregnancy can be enhanced and enjoyed by the expectant family through the use of music and sound. For example, Verny and Weintraub (1991), in their book *Nurturing the Unborn Child,* explore communication with the unborn child through various techniques, including the use of music. Further understanding has been provided by Dr. Alfred Tomatis, a French physician, noted for his recognition of the fetus's ability to hear while growing in the uterus. He maintains that this ability is capable of functioning at around eighteen weeks gestation (cited in Campbell, 1997, p. 18). Further discoveries revealed that active listening occurs at about 24 weeks gestation (p. 23), a notion suggested to revolutionize ideas of prenatal knowledge.

In contrast, a recent study by Kisilvesky, Pang, and Hains (2000) found that fetal responses to sound did not occur until thirty weeks. Using white noise generated from computers, forty-three high-risk newborns with gestational ages from twenty-seven to thirty-three weeks, and ninety-one low risk newborns from twenty-seven to thirty-six weeks gestation, were tested for increased cardiac activity and physical reactions. Both groups were found to respond to sound at thirty weeks gestation.

Specific types of music have been studied to explore their effectiveness for enhancing the well-being of both mother and fetus. For example, Verny and Collier (1998) have produced *Love Chords,* a collection of baroque and classical music. They maintain that the beneficial effects result from inducing relaxation as the mother responds to the music. Further, the authors state the musical elements from this recording, provide a calming internal rhythm similar to the beating of the mother's heart which in turn is heard by the developing baby (Verny & Collier, 1998, *Love Chords* CD insert). Ideally, the

nurturing established in pregnancy continues well into the postpartum period and facilitates the bonding of parent and child. Wiand (1997) attempts to determine levels of relaxation in pregnant women by listening to baroque and New Age music, and ocean sounds. The author further tried to identify if progressive relaxation alone or combined with the three styles of music assisted the women to achieve deeper levels of relaxation. Thirty-six women were chosen for the study. All women were in their final phase of their first pregnancy and all had been coached in the Lamaze method of childbirth. The results suggest the choice of music does not make a change, but in all results other than skin temperature, using music in conjunction with progressive relaxation, rather than relaxation techniques alone, revealed a notable increase in the ability to relax (p. 1). *Transitions,* a recording produced by Dr. Fred Schwartz along with musicians Joe and Burt Wolff, combines music with uterine sounds to offer reassuring, familiar, and restful effects not only for the newborn, but also for the mother as she proceeds through her birth experience (tape insert, n.d.). Harvey (1992), in conjunction with Dr. Schwartz and other researchers, attempted to discover the results these sounds would have on high-risk babies. They indeed found the *Transitions* tape to have the intended effect, not only for relaxing the infants, but also in terms of improving oxygen levels (cited in Harvey, 1992, p. 75). However, Dr. Schwartz cautions extreme care and observation of these tiny patients is required (*Transitions* tape insert, n.d.).

Although personal choice is the guiding principle for the selection of music in pregnancy and childbirth, hard rock or heavy metal may be an unhealthy choice of music for the fetus. For example, Clements, a hearing specialist from Great Britain, noted that increased fetal activity was demonstrated by mothers exposed to these styles of music, suggesting more restless and agitated states in the neonate (cited in Verny & Weintraub, 1991, p. 4).

Music and Circumcision

The effects of music on pain perception for circumcised infants was studied by Marchette, Main, Redlick, and Shapiro (1992). In this study of fifty-eight unanesthetized infants, forty babies were exposed to either uterine sounds or music during the procedure, and eighteen were not. The purpose was to determine whether music or taped sounds could minimize or decrease pain perception. A variety of methods, including monitoring vital signs, were used to assess pain response. Surprisingly, neither pain relief nor reduction was observed. The authors concluded music may not be a beneficial intervention for this type of procedure.

Music in Childbirth Preparation Classes

Childbirth preparation classes are an opportune time for educators to convey to the parents the concept of using sound and music to enhance their pregnancy and potentially decrease labor pain. Ideally, parents are introduced to these ideas early in pregnancy to optimize their birthing experience. Teaching might also include reminders that in addition to music, the fetus is influenced by other sounds, including the tone of its parents' voices. The parents' voices are one of the first sounds an infant recognizes at birth. Tomatis, in his studies of hearing, has also found that infants may not be calm until they hear their mothers' voices after birth (cited in Campbell, 1997, p. 19).

Conversely, parents may need to be reminded that stress and noise can have a negative impact on health and well-being (Griffin, 1992; McCarthy, Ouimet, & Daun, 1991; Pope, 1995). For example, Browning's (2000) research suggests instrumental, classical, or New Age music may be anxiolytic. In her study of eleven mothers using pre-selected music (based on personal choice), the majority reported that this type of music was most beneficial for pain and stress reduction.

Guzzetta (1991) remarks that older, more popular and classical music often creates feelings of excitement followed by sensations of calm. The musical elements such as harmony, rhythm, balance, and beat that provoke these same sensations while listening to classical music are not typically evident in New Age music. By contrast, this new style of sound creates a different set of musical rules and is designed to evoke more of an individual response. Guzzetta cautions that a relaxation response may be the desired outcome but may not be achieved in all cases (p. 160). Browning (2000) comments that music without words may be preferred by most mothers (p. 272). The personal tastes of parents should be the deciding factor when selecting music for their pregnancy and labor.

Introducing music into childbirth education is simple and fun to use for both educators and clients. Music can be used initially to create a comfortable atmosphere conducive to learning and for meeting other expectant parents. In addition, music can be used for relaxation and guided imagery while participants practice breathing exercises to learn to control the fear, stress, and pain of labor. Furthermore, the role of the childbirth educator is to help inform the labor and delivery staff about the significant benefits of using music during the actual birthing experience. Indeed, Di Franco (1988) comments that rushed staff may find that music can help create an atmosphere in the birthing room that is conducive to a sense of relaxation not only for the client but also for the nursing staff, thereby creating a much more restful environment (p. 209). While teaching clients the benefits of using music, it

may be helpful to have a discussion on personal responses to stress. It is critical to let people know that during experiences as intense as labor, any external sounds may prove to be too much, and at these times, silence may prove to be most beneficial. The use of a calming tone of voice by those in the delivery room (e.g., labor partners and birth attendants) may facilitate a positive response in the mother.

Browning (2000), a certified music therapist and doula, offers the following suggestions for those working with childbearing women:

1. All music should be chosen by the mother. The information on anxiolytic music may be helpful in assisting the mother's choice.
2. The music should be familiar to the mother before labor begins, and she should allow herself some time daily to listen in a relatively relaxed state. In associating preferred music with a pleasant activity before labor, she may be promoting a conditioned response during labor.
3. To avoid boredom, several different tapes should be made. They may not all be used during labor, but variety is necessary.
4. A special tape of music may be made that has significant meaning to the mother and her partner, and this can be played during delivery. The other side of this tape may contain lullabies for the baby to be played after the birth.
5. The mother should be the guide. Her verbal and nonverbal responses to the music are the key to a positive birth experience using music.
(Browning, 2000, p. 275)

Music Choices for Pregnancy and Childbirth

As mentioned previously, personal choice of music is paramount; however, music selection recommendations are available from several sources, and experimentation may be required. For example, Verny and Weintraub (1991) state baroque and baroque-like music may be preferential, choosing among famous classical compositions from Handel, J.S. Bach, and Vivaldi (p. 8). Philips Records (1996) has released a recording of soothing lullabies called, *Mozart for Mothers-to-be.* Compiled by Penny Bennett, this recording offers rest and relaxation for both mothers and fetus. DiFranco suggests that *Canon in D by Pachelbel* (p. 209) induces an intense sense of calm. Some types of New Age music and elevator music may not be appropriate for certain exercises because they can be too restful (Verny and Weintraub, p. 9). Because of this sedative effect, clients are advised not to experiment with relaxing music while driving. In addition, Verny and Weintraub recommend musicians Paul McCartney, James Taylor, or Judy Collins for easy listening (p. 9).

As mentioned previously, hard rock generally may not produce feelings of calm and relaxation for the baby and other musical choices may be more appropriate. Following the birth of the baby, music in the postpartum period may be advantageous for both mother and child (Bennett, 1996; Browning, 2000; Di Franco, 1988). Of course, traditional lullabies are a popular choice of music for playing to newborns.

Music in the Postpartum Period

In the postpartum period, the use of music can frequently produce sensations of calm and relaxation for the newborn. Conversely, a crying baby can lead to a distraught mother, and frustrated father. It may be appropriate to choose music for the newborn that the mother used during pregnancy. On the other hand, the parents may find that times of silence are necessary to restore a sense of personal harmony. Although this is not always possible with a new baby, the parents could be encouraged to find responsible, trustworthy caregivers to allow them to have the break they need. Lullabies may gently rock a baby to sleep, or calm the parents, or both. Lullabies traditionally are repetitive, which may contribute to their calming nature (DiFranco, p. 205).

Once more, premature newborns appear to respond positively to music. Dr. Fred Schwartz's *Transitions* tape has been used in many high-risk nurseries offering to provide a more nurturing atmosphere for the tiny patients (*Transitions* tape insert, n.d.). Furthermore, a study cited by Campbell (1997) showed that infant weight gain may be enhanced through the use of more specific music (p. 24). By contrast, research by Owens (1979) of thirty infants exposed to music found that no significance was noted in weight loss as compared to the control group of twenty-nine newborns. However, the researcher cautions that the findings may be inaccurate because the regular staff did not perform the weight checks (pp. 88–89).

CASE STUDY OF THE AUTHOR'S EXPERIENCE

This is a hypothetical case study of the author's experience.
I desperately wanted to have children and a family. I conceived and carried my first child with love and joy. However, during my pregnancy a tragedy occurred. My young niece drowned. Following the birth of my daughter, I suffered a postpartum depression followed by a severe nervous breakdown requiring hospitalization, months of therapy, and medication. In addition to the normal grieving process following the drowning, I

now had to heal from the depressive episode as well as learn to accept the new responsibilities expected of every new parent. I wanted to be a loving partner and learn to parent and provide my child with a healthy environment in which to grow and flourish. After five years, I found the courage to become pregnant again. This time I carried our son. However, during this pregnancy, I learned new ways to cope with the memories, fear, anxiety, and pain of labor and the prevention of postpartum stress, exhaustion, and possible recurrence of depression. During this period, I was working part-time as a nurse at the local hospital, specializing in labor and delivery.

I grew up in a family of musicians. However, I wanted to be a nurse. From the age of three, following surgery on my face for a congenital condition, I discovered a path for my life. Throughout my life, I continued to have frequent therapeutic and reconstructive surgery.

Without being consciously aware of the power of sound, this case study was permeated with music at several stages offering respite, healing, and hope for myself and often witnessing where music would bring the same for others.

Someone in my childhood home was always singing and not just humming. It was a sound coming from the heart. My parents sang for weddings, for the church choir, and practiced at home frequently (sometimes to the annoyance of myself and three brothers). The songs we sang were sometimes happy sounds; sometimes they expressed deep, unclear emotion, and, at other times, simply provided relief from the monotony of boring chores. My three brothers all played instruments. My oldest brother taught himself the guitar and was in rock bands as a teenager. My middle brother, a gifted musician from the time he was very young, played the drums. As a child, he was constantly "tapping," finding interesting sounds everywhere. At the table be would always be "tinkling" his cutlery on the tableware. My youngest brother played the trumpet, and loved music and children. All brothers went on to find careers in music or in related fields. It was a happy, loud home, a blend of unique voices.

Specializing in labor and delivery nursing, I worked for several years coaching women, through some of the most agonizing and exhilarating moments of their lives. Out of these experiences, I was able to develop childbirth preparation classes. At the same time, I continued to raise my family. After returning to university in the late 1980s to complete my bachelor of nursing degree, I was exposed to the research concerning the benefits of music and its application to health care, particularly in relation to pregnancy and childbirth. During this time, although the benefits of music seeped in unknown, my formal education gave the necessary cognitive framework to discover its meaning for my life. It was a momentous time;

I finally felt like I 'belonged' to my family; the music had just come through another channel. A new focus was discovered - how to move into another phase of my nursing career—offering clinical and research-based knowledge regarding the benefits of music to childbirth.

Presented next are several anecdotes in my personal and professional life where music offered comfort to either myself or to the patients, and other health professionals with whom I was working.

1. As a labor and delivery nurse, I occasionally went into the operating room for caesarian sections to help look after the baby following the birth. One particular time, I became very cognizant of the calm atmosphere in the operating theatre. This appeared to be a dramatic change of mood from the normally tense, busy, and noisy environment experienced at other times. I noticed that the surgeon was playing classical music during the procedure. After talking to one of the staff nurses, she stated that this particular doctor preferred to operate with music playing quietly in the background. Several years later, I spoke with this doctor, curious about his comments on the use of music. He replied that it was because it decreased his stress (Personal communication, Jeeva, September 2001).
2. When I had my postpartum depression and a subsequent nervous breakdown, I was hospitalized after having severe insomnia for several nights. I could recall, after being admitted, the distant sounds of the radio playing soft and soothing country and western music, offering the first moments of peace and relaxation I had felt for some time. Surrounded by this music, I finally allowed myself to drift into sleep.
3. During the Christmas season, while working in the birthing room assisting in a long, exhausting labor, once more I was puzzled by the calm atmosphere in the room. Noting the relaxed look on the faces of the other birth attendants and the quiet feel to the room, the reason dawned on me. The comforting and familiar sounds of Christmas music that was playing on the hospital intercom system was contributing to this feeling of peace.
4. For the birth of my second child, my husband, knowing the fear and anxiety I had gone through with our first child, found a recording called *Love Chords*. By using specially taped classical music, this recording was designed to offer the expectant mother several ways to enhance the pregnancy. I used it regularly and found the music to be very relaxing and uplifting. I continue to use it to this day, especially if I am feeling stressed or just want to relax.

5. As a parent, I had a "song" for each of my children and nightly would sing it to them as I tucked them to bed. Alternately, I would wind up familiar lullabies on favorite toys. Often my children would ask for 'the song' if they seemed unusually tired or bothered by something (or just wanted to stay up longer). It didn't seem to matter that I was not a particularly good singer. Instead, they seemed comforted by the familiarity of my voice and the words. I still remember my own mother singing to me at bedtime, offering a memory of security, trust, and love.

6. As an instructor for childbirth education classes, I often used music. I witnessed several occasions where the music seemed to provide an atmosphere of comfort and calm. As a new class was about to start, music seemed to decrease the tension as new parents became acquainted. At other times, music was offered during the instruction sessions about breathing techniques during labor. They wanted to continue practicing their breathing techniques at home with music. Many participants used music at home to decrease stress and would find those tapes with background nature sounds particularly relaxing. I would encourage them to take their choice of music to the hospital to play in the birthing room.

7. A friend described to me what she saw to be how she experienced music in her childbirth experiences: "I strongly believe that music played a big part in the safe and natural arrival (no medical intervention) of Leah and Reed. To me, music is comfort!! Listening to your favorite music can put you in a very calm and familiar place—if you close your eyes and listen you can be at any 'place and time' that was wonderful in your past. Or, you can simply be 'home.' You will soon forget that you are in a sterile, white-walled room, and the pain will be lessened because you can relax with the contractions. For me it was Van Morrison's 'Someone Like You' and Kenny Loggin's 'Celebrate Me Home' because they remind me of times with loved ones and times of love. I'm sure that if the hospital had country music playing, I would soon be crying and crooning to have the baby out! My first words of advice to my sister and friends over the years have been to include their favorite music in their bag of comfort; don't leave for the hospital without it" (Personal communication, Wilson, October 2000).

8. Another example comes from a colleague with several years of experience in labor and delivery. "I just love it when moms bring in tapes for their labor; I encourage all the new moms to bring in their music! It brings a nice atmosphere to the room and makes the environment less threatening" (Personal communication, Wilson, October 2000).

9. One final example. I often play music in immunization clinics to decrease the stress for parents while vaccinating their babies. I have observed mothers to be humming to the music, offering a more com-

forting focus, rather than anticipating the cry of pain from their babies. I see many opportunities for using music in the community, in active care, and in the home. For a fairly simple and inexpensive investment, the benefits appear to be profound.

SUMMARY AND CONCLUSIONS

I have named this chapter, "Sarah's Song," for the main character from a novel called, *A Matter of Time* (1987), by Beverly Byrne. In this book, "Sarah" inherits a memory for an ancient sequence of sounds that solve a modern day dilemma. Although fictitious, this novel reflects notions of Carl Jung's collective unconscious or the idea of stored memories and suggests exciting possibilities.

In summary, the benefits of music are multifaceted. In relation to pregnancy and childbirth, multiple research and case studies indicate the value of music for the infant, the mother, the labor partner, and the birth attendants. Although further research is required, sound and music and their enormous power need to be directed to those who can access them most, the direct caregivers and the expectant family. The present and future use of music and sound presents exciting possibilities for holistic patient care in a number of settings, such as: childbirth education classes, home births with midwives, low-risk birthing centers, hospital birthing rooms, neonatal intensive care units, or immunization clinics.

To conclude, the power of music and sound is vividly illustrated in the following quote:

> There is a tribe in East Africa in which the art of true intimacy is fostered even before the birth. In this tribe, the birth date of a child is not counted from the day of its physical birth or even the day of conception, as in other village cultures. For this tribe, the birth date comes the first time the child is a thought in its mother's mind. Aware of her intention to conceive a child with a particular father, the mother then goes off to sit alone under a tree. There she sits and listens until she can hear the song of the child that she hopes to conceive. Once she has heard it, she returns to her village and teaches it to the father so that they can sing it together as they make love, inviting the child to join them. After the child is conceived, she sings it to the baby in her womb. Then she teaches it to the old women and midwives of the village, so that throughout the labor and at the miraculous moment of birth itself, the child is greeted with its song. After the birth all the villagers learn the song of their new member and sing it to the child when it falls or hurts itself. It is sung in times of triumph, or in rituals and initiations. This song becomes a part of the marriage ceremony when the child is grown, and at the end of life, his or her loved ones will gather around the deathbed and sing this song for the last time. (Kornfield, 1993, p. 334)

REFERENCES

Bennett, P. (1996). *Mozart for mothers-to-be* (Recording). New York: Phillips Classics Productions.

Bonny, H., & Savary, L. (1973). *Music and your mind: Listening with a new consciousness.* New York: Harper & Row.

Browning, C.A. (2000). Using music during childbirth. *Birth, 27*(4), 272–276.

Buchanan, J. (1997). *JB Music Therapy Progress Reports.* Calgary, Canada (unpublished mimeo).

Buckwalter, K., Hartsock, J., & Gaffney, J. (1985). Music therapy. *Nursing interventions: Treatments for nursing diagnoses* (58–74). Philadelphia: W.B. Saunders.

Bunt, L. (1994). *Music therapy: An art beyond words.* New York: Routledge.

Byrne, B. (1987). *A matter of time.* New York: Fawcett Gold Medal.

Campbell, D. (1997). *The Mozart effect.* New York: Avon Books.

Canadian Association for Music Therapy (1992). Brochures. Waterloo, Canada: Author.

Clark, M., McCorkle, R., & Williams, S. (1981). Music therapy–assisted labor and delivery. *Journal of Music Therapy, XVIII*(2), 88–100.

Cook, J.D. (1981). The therapeutic use of music: A literature review. *Nursing Forum, XX*(3), 252–266.

Cripe, F. (1986). Rock music as therapy for children with attention deficit disorder: An exploratory study. *Journal of Music Therapy, XXIII*(1), 30–37.

Di Franco, J. (1988). Relaxation: Music. In F.H. Nichols & S. Smith Humenick, *Childbirth education practice, research and theory* (pp. 201–215). Philadelphia: W.B. Saunders.

Droh, R. (1992). Introductory remarks. In R. Spintge & R. Droh (Eds.). *MusicMedicine* (pp. 1–2). St. Louis, MO: MMB Music.

Fowler, H. & Fowler, F. (1995). *The concise oxford dictionary* (9th ed.). Oxford: Clarendon Press.

Gerdner, L., & Swanson, E. (1993). Effects of individualized music on confused and agitated elderly patients. *Archives of Psychiatric Nursing, VII*(5), 284–291.

Gerdner, L., & Buckwalter, K. (1999). Music therapy. In Bulechek, G. & McCloskey, J. (Eds.), *Nursing interventions: Effective nursing treatments* (pp. 451–468). Philadelphia: W.B. Saunders.

Goldman, J. (1992). Sonic entrainment. In R. Spintge & R. Droh (Eds.). *MusicMedicine* (pp. 194–208). St. Louis, MO: MMB Music.

Greisheimer, E.M., & Wiedeman, M.P. (1972). *Physiology & anatomy.* Toronto: J.B. Lippincott.

Griffin, J. (1992). The impact of noise on critically ill people. *Holistic Nursing Practice, 6*(4) 53–56.

Guzzetta, C. (1995). Music therapy: Nursing the music of the soul. In D. Campbell, *Music physician for times to come* (pp. 146–166). Wheaton, IL: Quest Books.

Hanser, S. (1992). Music therapy with depressed older adults. In R. Spintge & R. Droh (Eds.) *MusicMedicine* (pp. 222–231). St. Louis: MO: MMB Music.

Hanser, S., Larson, S., & O'Connell, A. (1983). The effect of music on relaxation of

expectant mothers during labor. *Journal of Music Therapy, XX*(2), 50–58.

Harvey, A. (1992). On developing a program in musicmedicine: A neurophysiological basis for music as therapy. In R. Spintge & R. Droh (Eds.), *MusicMedicine* (pp. 71–79). St. Louis, MO: MMB Music.

Harvey, A. (1995). Music in attitudinal medicine. In D. Campbell, *Music physician for times to come* (pp. 186–196). Wheaton, IL: Quest Books.

Kisilvesky, B., Pang, L., & Hains, S. (2000). Maturation of human fetal responses to airborne sound in low- and high-risk fetuses. *Early Human Development, 58*, 179–195.

Kolkmeirer, L. (1989). Clinical application of relaxation, imagery, and music in contemporary nursing. *Journal of Advanced Medical-Surgical Nursing:1*(4) 73–80.

Kornfield, J. (1993). *A path with heart.* Toronto: Bantam Books.

Liebman, S., & MacLaren, A. (1991). The effects of music and relaxation on third trimester anxiety in adolescent pregnancy. *Journal of Music Therapy, XXVIII*(2), 89–100.

Lingerman, H.A. (1995). *The healing energies of music.* Wheaton, IL: Quest Books.

Livingston, J. (1979). Music for the childbearing family. *JOGN Nursing*, November/December, 363–367.

Marchette, L., Main, R., Redick, E., & Shapiro, A. (1992). Pain reduction during neonatal circumcision. In R. Spintge & R. Droh (Eds.), *MusicMedicine* (pp. 131–136). St. Louis, MO: MMB Music.

Maranto, C. (1992). A comprehensive definition of music therapy with an integrative model for music medicine. In R. Spintge & R. Droh (Eds.), *MusicMedicine* (pp. 19–29). St.Louis, MO: MMB Music.

Maranto, C., & Scartelli, J. (1992). Music in the treatment of immune-related disorders. In R. Spintge & R. Droh (Eds.), *MusicMedicine* (pp. 142–153). St. Louis, MO: MMB Music.

McCarthy, D., Ouimet, M., & Daun, J. (1991). Shades of Florence Nightingale: Potential impact of noise stress on wound healing. *Holistic Nursing Practice, 5*(4), 39–48.

McClellan, R. (2000). *The healing forces of music.* Rockport, MA: Element.

Millard, K., & Smith, J. (1989). The influence of group singing therapy on the behavior of Alzheimer's disease patients. *Journal of Music Therapy, XXVI*(2), 58–70.

Nightingale, F. (1969 [1860]). *Notes on nursing.* New York: Dover.

Olson, S. (1998). Bedside musical care: Applications in pregnancy, childbirth, and neonatal care. *JOGNN, 27*(5), 569–575.

Owens, L. (1979). The effects of music on the weight loss, crying, and physical movement of newborns. *Journal of Music Therapy, XVI*(2), 83–90.

Pope, D.S. (1995). Music, noise, and the human voice in the nurse-patient environment. Image: *Journal of Nursing Scholarship, 27*(4), 291–296.

Rider, M.S., Floyd, J.W., & Kirkpatrick, J. (1985). The effect of music, imagery and relaxation on adrenal corticosteroids and the re-entrainment of circadian rhythms. *Journal of Music Therapy, XXII*(1), 46–58.

Rohner, S., & Miller, R. (1980). Degrees of familiar and affective music and their effects on state anxiety. *Journal of Music Therapy, XVII*(1), 2–15.

Scartelli, J. (1984). The effect of EMG biofeedback and sedative music, EMG biofeedback only, and sedative music only on frontalis muscle relaxation ability. *Journal of Music Therapy, XXI*(2), 67–78.

Scartelli, J. (1992). Music therapy and psychoneuroimmunology. In R. Spintge & R. Droh (Eds.) *MusicMedicine* (pp. 137–141). St. Louis, MO: MMB Music.

Schwartz, F.J. (n.d.) *Transitions* (audiotape) Atlanta, GA: Transitions Music Inc.

Schwartz, F.J. (1993). *Music and medicine.* In Bejjani, F.J. (Ed.) Current Research in Arts Medicine (pp. 375–378). Chicago: Cappella Books.

Standley, J. (1991). The effect of vibrotactile and auditory stimuli on perception of comfort, heart rate, and peripheral finger temperature. *Journal of Music Therapy, XXVlll*(3), 120–134.

Standley, J. (1996). Music as a therapeutic intervention in medical and dental treatment: Research and clinical applications. In T. Wigram, B. Saperston, & R. West (Eds.), *The art and science of music therapy: A handbook* (pp. 3–22). The Netherlands: Harwood Academic Publishers GmbH.

Summer, L. (1988). *Guided imagery and music in the institutional setting.* St. Louis, MO: MMB Music.

Verny, T., & Collier, S. (1998). *Love chords* (CD). Pickering, Canada: The Children's Group, Inc.

Verny, T., & Weintraub, P. (1991). *Nurturing the unborn child.* New York: Delacorte Press.

Vines, S. W. (1988). The therapeutics of guided imagery. *Holistic Nursing Practice, 22*(3), 34–44.

Wiand, N. (1997). Relaxation levels achieved by Lamaze-trained pregnant women listening to music and ocean sound tapes. *The Journal of Perinatal Education, 6*(4), 1–8.

Winner, E. (1982). *Invented worlds: The psychology of the arts.* Cambridge, MA: Harvard University Press.

Chapter 9

THE CONTRIBUTION OF MUSIC THERAPY TO THE PROCESS OF THERAPEUTIC CHANGE FOR PEOPLE RECEIVING HOSPITAL CARE

JANE EDWARDS

SUMMARY

Qualified music therapists can offer an important professional service within health care teams responding to the medical and psychosocial needs of people of all ages who are receiving care in a hospital. Music therapy interventions can address needs for relaxation, social interaction, reduction of anxiety, and creative self-expression. Music is a flexible and creative medium that lends itself gently and non-intrusively to the care and support of patients from many backgrounds and circumstances. This chapter provides introductory information on the profession of music therapy, its training, and therapeutic process.

MUSIC THERAPY

While many health care contexts around the world employ qualified music therapists as members of the multidisciplinary team, there are still many hospital administrators who wonder what benefits the music therapist might have to offer to their service recipients. This chapter seeks to paint a picture of the clinical provisions possible in music therapy, the rationale underpinning the development of such services, and the benefits of music

therapy services are provided with reference to the research and case study literature in the field.

What Is Music Therapy?

Music therapy is a creative arts discipline that concerns itself with the use of music as a medium through which a relationship between therapist and clients can be developed to serve the clients' needs and potentials. Salmon (2001) describes this as a space "bound by the presence of patient, therapist and music" (p. 142). While music is the main means by which the therapeutic relationship is developed, music therapy offers opportunities for listening or for experimentation and improvisation within music in order to aid self-expression and reflection, rather than focussing on the learning of music. Clients do not have to have any particular musical skill or training in order to benefit from music therapy and the purpose is to serve clinical goals in relation to clients' needs.

Music Therapists: Who Are We?

Music therapists are university-qualified practitioners who work from a knowledge base that includes clinical studies and theory, philosophy, and research findings based on the applications of music therapy within a clinical practice orientation. Only practitioners who are trained and qualified can call their work music therapy. Every country of the world has its own requirements for music therapy training and qualifications. The following examples outline practices in much of the English-speaking world; however, many other countries also have training and accreditation procedures for music therapists (see Maranto, 1993).

In the USA, practitioners can study at undergraduate or postgraduate level, and all practitioners must be board certified, by passing a national examination. In the UK, practitioners must complete an accredited training program and then become registered with the government authorities in order to practice. In Australia, graduates of accredited programs can apply for registration with the national association. In Canada, a music therapist is a graduate of an approved music therapy degree program. Music Therapist Accredited (MTA) is the certification of recognition provided to music therapists who have completed all academic requirements, including a 1000-hour internship, and have been approved by the Canadian Association for Music Therapy (CAMT). A Masters-level course has recently been accredited in New Zealand; however, previously practitioners there have been able to undertake a rigorous and high-level training through the professional association. In Ireland, at present there is currently only one university music

therapy program, a Masters degree that involves two years of full-time study at the University of Limerick. Graduates are qualified to practice in Ireland and can make application for recognition of their qualifications in other countries. For more extensive information on training requirements, readers are directed to the online journal in music therapy, www.voices.no, which has a "Country of the Month" column where country representatives highlight the local development of music therapy including minimum requirements for practice

Steps In Providing Music Therapy Service

Music therapy involves a number of key stages in developing and maintaining a therapeutic space in which clients can work. Usually music therapists undertake the steps of receiving referrals from the client, or from members of the health care team, and then undertaking follow-up of the referral to either provide further information about the client to the team or to assess suitability for music therapy service.

Depending on the context in which music therapy is provided, referral criteria are based on the professional expertise of the practitioner as well as the needs base of the client group. Relevant research is accessed to inform the range of needs of the client that can be met through music therapy and the means by which these can be appropriately met through music therapy. In music therapy work with hospitalised children, for example, referral criteria might include that the child has a need for opportunities for relaxation, for supported interaction with family members, or for self-expression. In work with adults in hospice care, referral criteria might include the patients' need for supported reminiscence.

Which Music Do We Use?

Although there is a large body of research within the music psychology literature that has concerned itself with the effects of music on human beings, this research has not always found what would be expected from the way we think about music in the commercial or contemporary context. For example, some research has found that there is no particular type of music that can create an expected response in changes to a listener's mood (Stratton & Zalanowski, 1997). In addition, further research has shown that it is not possible to achieve reliably predictable physiological changes in people who are listening to music (Davis & Thaut, 1989). This finding has led researchers to note that human music response should be understood as complex, idiosyncratic, and possibly inconsistent; impacted by a range of individual, unique factors.

Music listeners bring their own background and experience to bear on their response to music and consequently the music that one person can find lovely or soothing might be somewhat irritating for another person. This reinforces why the assessment process in music therapy is so important; it is essential to find out what the client likes or enjoys musically and then work this knowledge into the structure of the program, designing all aspects to meet their clinical needs but with reference to their musical experience and interests. In addition, even if people have a positive response to a piece of music at one time, there is no certainty that they will experience a similar or the same response the next time they listen to it. For this reason, the practice of music therapy is not necessarily concerned with finding the right music to achieve the desired effects but rather the development of a relationship in which clients can use music in ways that are helpful to them in their immediate circumstances. From my own professional experience working with a range of patient needs, I concur with O'Callaghan (2001) that the "experience of music therapy . . . can be viewed as idiosyncratic, context bound and dynamic" (p. 156). Music therapists must therefore be flexible and creative practitioners who are able to make sensitive and thoughtful responses to the spontaneous interactions with their clients that occur in sessions, whether musical, verbal, or non-verbal.

The Music Therapy Role

The music therapist is responsible for designing and implementing a series of sessions that will provide opportunities to the client to address areas of therapeutic need. Hogan (1999) has suggested that patients who present with difficulty with verbal communication may experience song choice to be a non-threatening medium through which they can express their emotions and feelings.

EVALUATION AND RESEARCH FINDINGS

Recent research studies into music therapy with patients hospitalized with cancer, patients receiving hospice or palliative care services, and people who are older and have additional support needs support the importance of the creative arts and music therapy service in the provision of high quality care. It is simply not appropriate any more for administrators to use budgetary requirements as a reason to not introduce or extend such services when the international refereed literature makes such a compelling evidence for music therapy service as a means by which to deliver clinical goals.

In a study of 128 cancer patients receiving treatment at a large hospital in

Melbourne, Australia, O'Callaghan (2001) found that almost all patients reported via anonymous surveys that receiving music therapy was a positive experience for them. In a study of the clinical effectiveness of music therapy with eighty hospice patients, Krout (2001) found that even a single music therapy intervention was effective in increasing subject pain control, physical comfort, and relaxation. Music therapy has also been reported as a means by which hospice patients can be supported to achieve pain management goals (Trauger-Querry & Haghighi, 1999).

In a series of three case reports, Magill (2001) showed that music therapy could offer relief to patients experiencing severe cancer pain and associated suffering. In my professional experience, many individuals report an improved sense of general well-being after a music therapy relaxation session. Their relaxed state is also reflected by both their changed affect and a more relaxed breathing rate.

Evaluation in music therapy is undertaken regularly in order that the team might be kept informed of the work undertaken and any progress or changes made. In working with hospitalized children, the music therapist might track and record instances of the child demonstrating effective coping strategies or increased interaction if they have been referred because of withdrawn behavior. Sometimes progress notes might constitute the therapist's impression of changes that have occurred through careful clinical observation or at other times, it may consist of making observations of differences and changes in the way the patient is playing or his or her musical interaction and reporting these. In palliative care, the music therapist might track and report any outcomes relating to psychosocial care that arise in the work with the patient including changes in interactions with family members, changes in communication, or cognitive changes.

In addition, the research emerging in music therapy is at an exciting stage with the acceptance of the need for different research paradigms to be used to underpin the development of new knowledge in our field. Qualitative research methods have also been explored more fully in recent years, and this has added a breadth to both the practice and knowledge base of the profession worldwide (see Wheeler, 1995).

CONCLUSION

Music therapy is a contributor to the health care services in many countries of the world. Music therapy is a professional discipline that has been exploring and expanding its borders for many years and in many different ways. Patients are given opportunities in music therapy for creative play, for self-expression, for positive interaction with family members and other

friends and community members. Music draws us together, offering intimacy, creativity, and a lifeline in difficult or confusing times of stress or illness. The music therapist works with all the potentials of music to promote and maintain therapeutic change with the patient.

REFERENCES

Davis, W.B., & Thaut, M.H. (1989). The influence of preferred relaxing music on measures of state anxiety, relaxation and physiological responses. *Journal of Music Therapy, 26*(4), pp. 168–187.

Dileo Maranto, C. (1993) (Ed). *Music therapy: International perspectives.* Pipersville, PA: Jeffrey Books.

Edwards, J. (1999a). Music therapy with children hospitalised for severe injury or illness. *British Journal of Music Therapy, 13*(1), pp. 21–27.

Edwards, J. (1999b). Anxiety management in pediatric music therapy. In Cheryl Dileo (Ed.), *Music therapy and medicine: Theoretical and clinical applications.* Silver Spring, MD: American Music Therapy Association.

Edwards, J. (1998). Music therapy for children with severe burn injury. *Music Therapy Perspectives, 16*(2), pp. 20–25.

Hadley, S. (1996). A rationale for the use of songs with children undergoing bone marrow transplantation. *The Australian Journal of Music Therapy, 7,* pp. 16–27.

Hogan, B. (1999). Music therapy at the end of life: Searching for the rite of passage. In D. Aldridge (Ed.), *Music therapy in palliative care* (pp. 68-81). London: Jessica Kingsley.

Krout, R. (2001). The effects of single-session music therapy interventions on the observed and self-reported levels of pain control, physical comfort, and relaxation of hospice patients. *The American Journal of Hospice & Palliative Care, 18*(6), 383–390.

Magill, L. (2001). The use of music therapy to address the suffering in advanced cancer pain. *Journal of Palliative Care, 17*(3), pp. 167–172.

O' Callaghan, C.C. (1996a). Lyrical themes in songs written by palliative care patients. *Music Therapy Perspectives, 2,* 74–92.

O' Callaghan, C.C. (1996b). Pain, music creativity and music therapy in palliative care. *The American Journal of Hospice and Palliative Care, 13*(2), 43–49.

O' Callaghan, C.C. (1997). Therapeutic opportunities associated with the music when using song writing in palliative care. *Music Therapy Perspectives, 15,* 32–38.

O' Callaghan, C.C. (2001). Bringing music to life: A study of music therapy and palliative care experiences in a cancer hospital. *Journal of Palliative Care, 17*(3), pp. 155–160.

Robb, S. (1996). Techniques in song writing: Restoring emotional and physical well-being in adolescents who have been traumatically injured. *Music Therapy Perspectives, 14*(1), pp. 30–37

Salmon, D. (2001). Music therapy as psychospiritual process in palliative care. *Journal of Palliative Care, 17*(3), pp. 142–146.

Stratton, V., & Zalanowski, A. (1997). The relationship between characteristic moods and most commonly listened to types of music. *Journal of Music Therapy, 34*(2), pp. 129–140.

Trauger-Querry, B., & Haghighi, K. R. (1999). Balancing the focus: Art and music therapy for pain control and symptom management in hospice care. *The Hospice Journal, 14* (1), pp. 25–38.

Chapter 10

UNLEASHING THE POSITIVE THROUGH MUSIC

Jennifer Buchanan

MY ROOTS

There is always music amongst the trees in the garden,
but our hearts must be very quiet to hear it."
Minnie Aumonier (The Spirit of Gardening)

When I was a young teenager, my grandfather had a stroke that left him partially paralyzed, unable to speak, and requiring full-time care at a nursing home. There, my grandfather shared accommodations with fifty residents, eating every meal in his room, and rarely interacting socially with the others who resided just a door away. Over the next eight years, my family and I would travel once a week, for what I perceived as obligatory visits to a grandfather I barely knew. During one of these visits, my grandmother suggested I perform music during an upcoming afternoon get-together. What I experienced next would be the beginning of a meaningful and rewarding musical journey.

While I sang, a woman who typically yelled in the hallway began to hum and sing to the familiar songs. Other residents began to leave their rooms and follow the music, and my grandfather cried during his favorite song. Although I knew very little music from this by-gone era, it seemed that the few songs I did know created for the residents a feeling of being at home with family and friends. Later, when I learned of music therapy as a profession, I saw it as a path of potential and purpose, something I wished to embark upon.

This journey has included training to become an Accredited Music Therapist with the Canadian Association for Music Therapy, becoming the owner of a successful music therapy company, and a speaker on music, health, and relationships. When I reflect on how I got to this place, I am grateful for many moments, like visiting my grandfather and later with the hundreds of children and adults with whom I have had the privilege to work. These experiences have heightened my appreciation for people of all ages and circumstances and have underlined the importance of community and the role music can contribute to everyone's well-being.

In this chapter, I will discuss three individuals in different situations and stages of life, who have inspired me by unleashing themselves from physical constraint (a child with cerebral palsy), perceived unworthiness (a young teen at risk), and lonely confusion (a senior with dementia) and ignited the positive within themselves. The aim of each narrative is to contribute to the central theme of this chapter; that is, when properly used, music is a door to the hidden potential within us. It can inspire and motivate, soothe and calm, and can provide an outlet for self-expression.

MUSIC THERAPY'S HISTORY

The overview of the history of music therapy was drawn from the following websites:

- Canadian Association for Music Therapy www.musictherapy.ca
- American Music Therapy Association www.musictherapy.org
- McCalestar College http://www.macalester.edu/~psych/whathap/ UBNRP/Audition/site/history%20of%20music%20therapy.

The Bible contains the earliest recorded account of music being used as a "healer," as David soothed a distraught Saul. Later, an English text entitled *Medicina Musica,* written by Dr. Richard Browne in 1729, and discussed later by Darrow, Gibbons, and Heller (1985), identifies eight arguments that remain central to the theory and practice of music therapy today:

1. that success in music (from a therapeutic standpoint) does not depend on attaining a predetermined level of proficiency
2. that music can change and evoke moods
3. that music can stimulate extra-musical associations
4. that stimulative and sedative music can have differing effects on individuals
5. that music can influence physiological processes
6. that music can be harmful in treating some conditions

7. that music has a wide variety of therapeutic applications
8. that music could be useful in preventative health care (p. 18).

In the nineteenth century, music was used to ease the stressed minds of King Philip V of Spain, King Ludwig II of Bavaria, and George III of Great Britain (Podalsky 1954), and Florence Nightingale encouraged her nurses to use vocal and flute melodies to distract the hospitalized soldiers from their pain and anxiety (Nightingale 1859). In the twentieth century, music continued to be used in a similar fashion, such as in the care of those in emotional and physical distress. Community musicians in the Western world, both amateur and professional, visited World War I and II veterans suffering from both physical and emotional trauma. The patients' positive physical and emotional responses to music led the medical staff to request the hiring of musicians on a regular basis to support their patients' recovery. During the early 1950s, colleges and universities in North America began to create competency standards for practicing music therapists, and the professional associations emerged to promote the role and value of music therapy for a range of populations.

Initially, music therapy's primary aim was to identify elements of music to treat a specific condition. However, therapists quickly identified the importance of unique responses to music of each individual and the power of the therapeutic relationship (Farnsworth, 1958). In the same way that I found that music helped connect me to my grandfather and the residents at the nursing home, music therapists in many countries continue to be trained to unleash the positive through unique music interventions in diverse settings and with a range of people.

APPLICATIONS OF MUSIC

> Music expresses that which cannot be put into words
> and that which cannot remain silent.
>
> Victor Hugo

During a casual conversation with one of the mothers with whom I work, she made mention of the monthly reports she received from the several therapists and teachers who work with her daughter. The reports were lengthy and went into great detail about her daughter's behaviors. This mother told me that every month she hoped for only two or three sentences identifying what her daughter did well that month. She concluded by saying in a quiet voice, "the other information I already know."

It is therefore important to mention to all persons seeking music therapy

for themselves or someone they care about, that although music has incredible history, it can be more than just a treatment of disease and conditions. Indeed, using music therapeutically can be an opportunity to highlight all a person IS and CAN do.

Hanser (1999), author, music therapist, and professor at Berklee College of Music and Harvard Medical School, describes her work as guided by her own musicianship and her intuitive sense of how music affects the people she serves. Every music therapy session is unique in design, offering a variety of approaches, interventions, sounds, and silences. Both a directive (structured and planned) and non-directive (improvisational) model to music therapy may be used depending on the needs of the person. Therefore, being a confident musician with a well-developed intuition is very important as a music therapist. This principle is illustrated by the following story of my work with a child who has limited communication capabilities.

Story 1: Music Is Magic for a Special Child

I am in awe of the parents who raise children with special needs. In my opinion, these parents often demonstrate great wisdom in their caring practices. They search many resources to locate as much information as they can, hunting for interventions and programs best suited for their child's needs. It is through a collaborative therapy plan with families that I have witnessed some of the most significant successes not only for the child but also for the entire family. Here is one illustrative example of this collaboration among doctor, parents, and music therapist.

Stimulation Through Song

Rachel (pseudonym) was diagnosed with cerebral palsy at birth. The doctor prescribed music as an adjunct to her medical treatment as he believed that this type of stimulation was very important to her overall development. It was through music that Rachel's parents were able to connect with their daughter in a special way, singing, cooing, laughing, and listening together. Rachel began participating in a weekly music therapy group program at the age of eighteen months. Due to the nature of her condition, her muscles would often feel stiff and appear to ache. However, during live music making, Rachel would stop crying if she were feeling any physical discomfort and would lift her head to show her twinkling eyes. After one difficult operation that was designed to release tension in her legs and promote a greater chance for walking, Rachel displayed many symptoms of pain. The parents called me from the hospital and

asked if I could make a special trip out to her recovery unit. As I sat close by and strummed my guitar, Rachel seemed to relax, leaning back in her father's lap, listening to lullabies that she had been aware of since birth, and seeming to find refuge away from her discomfort.

Music Motivates

As Rachel grew, her parents indicated that communication and motor control were their immediate and primary considerations for therapy. Rachel's parents believed that her struggle with language and her stiff physical movements were creating feelings of constant frustration leading to unresponsive behaviors. Therefore, it was important during the music therapy session that Rachel realize all that she could do and not focus on what she could not do. As she intentionally reached with both hands towards my guitar and then later alternating one hand and then the other, slowly and intentionally, over and over, I witnessed her face becoming brighter, more cheerful, and she appeared more satisfied. The achievement of such goals is noted to have a direct impact on how positive children see themselves (Baily 1974). It was evident that Rachel, in this moment, felt capable and confident.

Energy Through Emotion

In order to access more expressive communication, I suggested to Rachel's mother that she introduce Rachel to opera music throughout the week. My experience was that when Rachel vocalized, she consistently seemed to express every sound with great intent and emotion, often reminding me of an Italian opera full of life and vigor. Today, at age three, Rachel vocalizes along with opera CDs, increasing her volume in synchrony with the music's dynamics, exploring her voice in complete musical freedom.

Bean (1995), who was awarded the Churchill Fellowship in the United Kingdom to investigate music therapy in the treatment of cerebral palsy, contended that music therapy, as a medium for interaction, is a critical intervention for a child with cerebral palsy. He further postulated that music offers variety when the child is performing repetitious activities for enhanced development. The music routine seems to lighten the task and thereby "sustains the child's spirit in his or her continuing struggle towards greater independence" (p. 201). Rachel's music therapy program allowed her to test her potential, build interest, and encourage self-motivation in the confines of repetition, direction, and structure.

Rachel's mother summarized her child's progress in the following man-

ner: "Music helped Rachel, her dad and I to survive. Now we are witnessing how it will help her grow."

Story 2: Music Expresses the Heart of a Teen

Recent studies suggest that group music therapy can provide an environment for "teens at risk" to transform frustration, anger, and aggression (Montello & Coons, 1998; Johnson, 1981). I believe and have experienced group music making leading to a sense of competence, significance, and personal success for adolescents. After we have physically stopped growing, there still seems to be room for our spirit to strengthen as we struggle to cope, make do, and strive for more. There is no better example of the strength and courage it requires to face these day-to-day challenges than that of a teen living on the streets.

Kerry (pseudonym) and I met only once, and she did not talk much. However, Kerry was far from having nothing to say. During a drop-in music therapy group session, the participants were asked to write a word or a short sentence on a piece of paper that reflected their thoughts about life and relationships. These words became the title of their song. They were then encouraged to write phrases that deepened their message. Here is what Kerry wrote:

Questions of a Broken Heart

The lightening brightens the blackest sky
The rain softens my skin
The wind deafens my strongest ear
In turn my patience grows thin.

Why do all these things happen?
Why must I be alone?
Why must they speak these words
And cover my heart with stone?

I'm chained down to the coals
Where the fire freezes my tears
I'm strapped down with a hope of desire
And the shadows fuel my fears.

I shake here by myself
I shake here all alone
Why must they say these things
And crush my heart with stone?
Why must they walk away
And leave me here alone?

As I sang these words to an improvised ballad, Kerry sat quietly with her head down, and the young man sitting next to her began to cry. Kerry and this young man decided they wanted to share Kerry's song on the streets where they lived. At the end of the session, Kerry said she was grateful that someone listened to how she felt.

The music environment can replace many of the insecurities and frustrations, which someone like Kerry may have, with a sense of confidence and success. By increasing her self-esteem, the group session provided the opportunity for her to unleash her thoughts, feelings, convictions, and point of view, thereby allowing her to be heard and validated.

Story 3: Music Offers Comfort to a Tired Senior

I believe seniors should be acknowledged for all that they have contributed and continue to contribute and that music provides a means to celebrate their lives with them. I appreciate Ruth Bright's (author, founding music therapist in Australia and a senior citizen herself) perspective in her book *Music in Geriatric Care* (1991). She wrote, "that we are now far more aware of the destructiveness of 'age-ism,' that mode of thinking which separates older members of society as if they were somehow a different (and lesser) category of human being, rather than ourselves a few years into the future" (p. 4). It is with this in mind that I share this final example of music meeting the needs of a senior citizen and the staff that serve her.

In her earlier years, Thelma (pseudonym) was the head nurse of a care facility. I was informed that she was a hard working, no nonsense, organized person during that time. As I walked with Thelma through the halls, she carefully cleaned the hallway banisters. This behavior is both a window to her past life and may be an indicator of dementia. When I started to sing, she would begin to walk to the tempo of the music, stepping slower and then quicker, following the pace that the music made for her. Her nurse commented earlier in the day that Thelma was having difficulty sleeping, thereby causing stress for the staff. The nurse asked if the music therapy session could focus on this area of need. As Thelma and I continued to walk the halls, we eventually entered her room, and sat on the edge of her bed. Singing has been described in the literature as one of the most popular activities for Alzheimer's patients (Clair, 1996; Olderog Millard, & Smith, 1986). As Thelma began to sing a favorite song, I hummed with her. It was evident that the momentary stress, demonstrated from the perseverative cleaning of the banisters, had passed, and she began to rest in the slow melody lines of something familiar, leaning her head against mine as stillness soon encompassed the two of us. Shortly thereafter, she

slowly lay down and began to sleep. While the staff breathed a sigh of relief, Thelma found some time to rest.

Kumar (1999) confirms that music raises melatonin levels and improves the sleeping patterns in individuals with Alzheimer's disease. The implication of his study was that the participants became more active, more cooperative, and slept better after music therapy sessions. Many other studies that I reviewed correlate the behavior changes in nursing home residents with increased strain on staff and show that music based programs can provide stress relief for the staff and residents (Clark, Lipe, & Bilbrey, 1998).

In their daily interactions with patients, caregivers should therefore be encouraged to use music listening to facilitate an environment of health and well-being just as Florence Nightingale did in the mid nineteenth century. Music is but one intervention that seems to be effective with seniors, like Thelma and my grandfather, in providing a familiar, peaceful, and meaningful experience for the resident and stress relief for those who care for them daily.

FIVE STEPS FOR USING MUSIC INTENIONALLY IN YOUR LIFE

> Where words fail, music speaks.
> Hans Christian Andersen

Having reviewed short case studies of a child, teen, and senior during music therapy sessions, it becomes apparent that music has long been an important influence on each of us. From our first lullaby to musical games, we have been educated, entertained, and moved to creativity through music. People have celebrated many of life's events, weddings, funerals, accomplishments, and anniversaries, with melodies, lyrics, and rhythms. Although I have been a music therapist for many years, I am still impressed by music's potential to help improve people's health and well-being.

Over the past twenty years, we have witnessed a birthing of books, journal articles, and community music programs aimed at gaining the attention of health care practitioners, educators, and the mainstream community, claiming that music can decrease stress, advance children's learning and improve everyone's quality of life. It is perhaps only a matter of time before "sound spas" will be as common as a daily cup of coffee. Andrew Vickers (2000), an assistant attending research methodologist from New York, has written many articles concerning the therapeutic effects of music. He suggested that complementary therapies are becoming more integrated into the health care system. Although music therapy requires a certified practitioner,

there are many other ways music can be incorporated in patient care into one's daily life at little or no cost.

It may be helpful at this time to share five practical ideas for using music that everyone can incorporate into their life.

1. IDENTIFY YOUR PERSONAL MUSICAL JOURNEY. From the beginning of your life, music has played an important role in key life celebrations. Years later, music can trigger these specific memories, giving you a snapshot of the past. Keeping a log or journal of the music that has accompanied you since childhood is a gift to yourself, your children, and your children's children.

2. TURN UP THE MUSIC IN YOUR HOME. Playing music quietly in the background as soon as you get up can promote a less hectic start to your day, while turning up the music as the family does their chores on the weekend can facilitate an atmosphere of motivation. I strongly encourage families to share in each other's music. Experiencing music together can bring harmony to a family, thereby allowing each person to share his or her music in full acceptance. However, personal headsets come in handy when required.

3. UPDATE YOUR MUSIC LIBRARY. Your music library says a lot about you, your past, and when you last purchased recorded music. Make a shopping list of music that you would like to digest, perhaps for the first time: jazz, hip hop, roots music, opera, classical, medieval, celtic, rock, swing, Broadway, ethnic, relaxation, or country. Visit your local music store or second-hand album retailer and explore the diverse, creative, and vast amount of music available. Going to the music store can be as satisfying as shopping in your favorite bookstore or visiting your favorite coffeehouse. Make a deal with yourself to purchase at least two new albums a year and to give your favorites as gifts to others throughout the seasons. Gradually build a personal collection of musical selections that enhances your clarity of thought, induces excitement, and eases your mind.

4. TREAT YOURSELF TO LIVE MUSIC. From visiting the opera to a Broadway musical to a rock concert, live music can soothe, excite, or inspire us. If money is a concern, there are other ways to experience live music while supporting your community musicians, from weekly open microphone nights to listening to a local busker, to keeping apprised of the concert schedules at your local high school or community center.

5. MAKE MUSIC TOGETHER. Community drum circles are becoming quite popular. Similarly, local choirs, ranging from the fun to the professional, are also available. In addition, many community band groups provide opportunity for people to continue to play instruments that they began to play in their youth. City recreation guides are often a good source to find local music opportunities for the beginner.

CONCLUSION

By using a health and wellness approach to music therapy, I have witnessed individuals directly address personal goals such as creativity, self-exploration, enhanced quality of life, memory, performance, stress reduction, motivation, accessing feelings, empowerment, and communication. Whether music has been a large or small part of your life, you can use music intentionally at home, at the office, in your car, during a one-day workshop, or at weekly music therapy sessions. By increasing your exposure to music, you will acquire more meaning and fulfillment in your life along with added health benefits such as decreased stress and improved growth.

For the special child, music therapy was a motivating factor to use her arms intentionally; for the teenager, music drew a path to self-expression; and for the senior with dementia, it may have provided one of the only ways that she and her caregivers could receive any relief. For everyone else, George Eliot offered these words:

"I think I should have no other mortal wants, if I could always have plenty of music. It seems to infuse strength into my limbs and ideas into my brain. Life seems to go on without effort, when I am filled with music."

REFERENCES

Alvin, J. (1975). *Music therapy*. London: John Claire Books.
American Music Therapy Association. www.musictherapy.org; The spirit of gardening.
Anderson, H.C. Build a Button, retrieved on March 28, 2004 from http://members.aol.com/BuildaButton/music.htm.
Aumonier, M. *The Spirit of Gardening*. (Retrieved March 28 2004 from http://www.gardendigest.com/hear/htm).
Bailey, P. (1974) *They can make music*. Oxford: Oxford University Press.
Bean, J. (1995). Music therapy and cerebral palsy. In T. Wigram, B. Saperston, & R. West (Eds.), *The art and science of music therapy: A handbook* (pp. 194–208). Churr, SWIT: Harwood Academic Publishers.
Bright, R. (1991). *Music in geriatric care: A second look*. Wahroonga, New South Wales, Australia: Music Therapy Enterprises.
Canadian Association for Music Therapy. www.musictherapy.ca.
Clair, A. (1996). The effect of singing on alert responses in persons with late stage dementia. *Journal of Music Therapy, 33*(4), 234–247.
Clark, M.E., Lipe, A.W., & Bilbrey, M. (1998). Use of music to decrease aggressive behaviours in people with dementia. *Journal of Gerontological Nursing, 24*(7), 10–17.
Darrow, A.A., Gibbons, A.C., & Heller, G.N. (1985). Music therapy past, present,

and future. *The American Music Teacher,* September/October, 18–20.

Eliot, G. The Quotations Page, retrieved on March 28, 2004 from http://www.quotationspage.com/quotes/George_Eliot/.

Fransworth, P.R. (1958). *The social psychology of music.* New York: Dryden.

Hanser, S. (1999). *The new music therapist's handbook.* Boston: Berklee.

Hugo, V. Brainy Quote, Retrieved on March 28, 2004 from http://www.brainyquote.com/quotes/quotes/v/victorhugo106867.html.

Johnson, E.R. (1981). The role of objective and concrete feedback in self-concept treatment of juvenile delinquents in music therapy. *Journal of Music Therapy, 18,* 137–147.

Kumar, A. (1999). Music therapy. *Alternative Therapies, 5,* 49–57.

McCalestar College http://www.macalester.edu/~psych/whathap/UBNRP/Audition/site/history%20of%20music%20therapy.

Montello, L., & Coons, E.E. (1998). Effects of active versus passive group music therapy on preadolescents with emotional, learning and behavioural disorders. *Journal of Music Therapy, 35,* 49–67.

Nightingale, F. (1859). *Notes on nursing: What it is and what it is not.* New York: Dover. Reprinted 1969.

Olderog Millard, K. A., & Smith, J. M. (1989). The influence of group singing therapy on the behaviour of Alzheimer's disease patients. *Journal of Music Therapy, 26,* 58–70.

Podalsky, E. (1954). *Music therapy.* New York: Philosophical Library.

Vickers, A. J. (2000). Complementary medicine. *British Medical Journal, 321* (7262), 683.

Chapter 11

HOW MUSIC MOVES PEOPLE: AN ANALYSIS OF THE EMOTIONAL RESPONSES OF UNIVERSITY STUDENTS TO "A MUSICAL PHARMACY" USING HEVNER'S MOOD WHEEL

JON PARR VIJINSKI, DIANE PIRNER & CAROLE-LYNNE LE NAVENEC

SUMMARY

The purpose of this case study is three-fold: (1) to illustrate the many different ways that an identical piece of music may move or affect people emotionally; (2) to offer insights from the literature as to why these responses vary; and (3) to discuss the implications of those findings for planning ways to enhance one's mood through the use of carefully selected music. The focus of this discussion is on the emotional responses of a group of university students, who, as part of an assignment for an undergraduate nursing course on music and sound, listened to selections of music from a compact disc (CD), *A Musical Pharmacy,* which was composed, arranged, and produced by the first author. They subsequently recorded the feelings that each selection evoked, using one or more of the sixty-six adjectives provided in a modified version of Hevner's (1937) Mood Wheel (see Figure 11.1). The final section of the chapter includes a discussion of the possible reasons for the variations in emotional responses to the same music. The concluding discussion highlights the implications for both the health care professionals who are working with an accredited music therapist (MTA) to develop a music listening program for clients, and for individuals wanting to use music to enhance their feelings of well-being.

INTRODUCTION

Since the development of music therapy throughout the world in the 1940s, there is increasing acknowledgment by health care professionals of what McClellan (1991) refers to as *The Healing Forces of Music*. Both anecdotal evidence and recent studies have found that the use of carefully selected music—or the "right music" (Goldstein, 1980)—can promote changes in an individual's well-being on many levels (i.e., physical, psychological, cognitive, emotional, and spiritual). This effect may be attributed to the fact that music is "rhythmically formatted," thereby allowing it to be "processed through all levels of the brain . . . in a unique manner, which is different from all other auditory stimuli" (Scartelli, 1989, p.140; see also Groer, 1991; Knox, 1992; Lloyd, 1987, and recent investigators in psychoneuroimmunology or PNI). According to Scartelli (1989), this field of psychoneuroimmunology adopts a holistic model of health and illness in its emphasis on the "constant reciprocal action and communication between the mind and body" (p. 137). This "mind/body" connection is accomplished via the secretion of various types of neurotransmitters that are triggered in an individual by "environmental, emotional, physical, social, and even spiritual changes" (p. 137). These changes in turn affect the functioning of one's autonomic nervous system, endocrine system, and immune system.

The Effects of Music on the Individual

The topic addressed in this chapter pertains to the emotional effects of music. However, before discussing the emotional effects, let us briefly address some of its other effects. For example, music has been found to create positive physiological outcomes in "heart rate, pulse, breathing, galvanic skin response and muscle strength" (Harvey & Rapp, as cited in Le Navenec, McEachern & Epstein, 2003, p. 20). The role of music and related sensory information for helping people with Parkinson's disease has been highlighted in recent research by Dr Bin Hu, professor of neurosciences and scientific director for the Movement Disorder and Therapeutic Brain Stimulation program at the University of Calgary Faculty of Medicine (Thomas, 2004). His research team expects that this discovery of how the brain processes the sensory cues that prepare the body to move will facilitate the development of effective treatments for the recovery of sensorimotor functions in patients with Parkinson's disease and related neurological (i.e., thalamo-cortical) disorders (see also www.ucalgary.ca/news/jan04/parkinsons_3.html).

A second outcome of exposure to carefully selected music that has been discussed in the literature is its alleged effects on cognitive and psychological functioning. Although still a matter of considerable debate (because of the

nature of the research methods used), certain types of music have been found to enhance learning, attention, memory, and related cognitive effects (Castleman & Spangler, 1994; Sacks, 1998; Sacks & Tomaino, 1991, 1998; Storr, 1992; Tomaino, 1998; see also Campbell, 1992). Furthermore, the use of music has been found by some researchers to have the following effects on hospitalized patients: decreased levels of confusion, agitation, restlessness, depression, and increased appetite at mealtimes (Gottell, Brown, & Ekman, 2000; Meei-Fang, 2001).

Music can also promote the social and spiritual well-being of people, in both health and illness situations. For example, Gerdner and Buckwalter (1999) have indicated how carefully selected music can promote meaningful social interaction, as well as enhance spiritual well-being in palliative care situations (see also Le Navenec & Slaughter, 2001, p. 42).

The fourth and most emphasized effect of music, which is the focus of this chapter, is in the emotional sphere. Scartelli (1989) implies that this sphere is "the prime target of music" (p. 139). Perhaps its alleged impact on the emotional sphere accounts for the growing use of music in films, the retail market, and advertising. That author has also noted music's ability to decrease feelings of anxiety, which in turn, may "enhance one's energy level in long-distance running, aerobics and competitive sports" (p. 139). In addition, the well-known neurologist, Oliver Sacks (1998), offered a similar assumption in his statement that "whatever other effects it may have, the primary impact of music is emotional" (p. 13). One example that Sack cites pertains to "Harry," who had experienced gross destruction of both frontal lobes secondary to a major cerebral hemorrhage:

> Emerging from a coma, he . . . recovered most of his formal intellectual powers but he remained severely impaired, bland, flat, and indifferent emotionally. [Despite being] surrounded by all the emotions, the drama, of others in the hospital . . . he . . . remained entirely unmoved, seemingly incapable of any human feelings.
> But all this changes, suddenly, when he sings . . . he does so with a fullness of feelings, a tenderness, a lyricism, that is astounding . . . [particularly] because one sees no hint of [such feelings] at any other time [which may lead one to] think [that] his emotional capacity [is] entirely destroyed.
> He shows every emotion appropriate to what he sings–the frivolous, the jovial, the tragic, and the sublime–and seems to be transformed while he sings. . . . It is as if the songs enable him to retrieve emotions to which he otherwise would have no access; as if music is somehow able to give him its content, to act as a "prosthesis" for his missing frontal lobes, for the brief time that he actually sings. (p. 14)

A related theme is evident in Sacks's (1998) account of "Stephen," a young boy with autism, whose repertoire of social reactions was based on rote

learning and not on feelings except for when he was involved in a musical situation: "He is able to sing and dance with real life and feeling with free, "normal," appropriate voice and movements and the external manifestations of his autism . . . all vanish . . . [during these activities]" (p. 15). Sacks concludes that "it seems, when he is singing, that he may be able to access a whole range of emotions and states of mind that are, for the most part, unreachable by him" (p. 15). His hunch is that, for Stephen, "music seems not so much a reminder, as a conferer [or] a creator of self, something that makes possible . . . that immensely complex neural and psychic integration that underlines the organization of the self" (p. 15).

Of particular clinical relevance is the finding that music may "generate positive emotional states due to its content and/or its association with past experiences" (Winiger & Porgman, 2003, p. 60). This enhanced enjoyment level may in turn serve to augment one's motivation to engage in an activity despite the feelings of discomfort (e.g., exercise regimes of a rehabilitation program) or despite the initial difficulties to maintain attention to the task at hand (e.g., increased restlessness in reminiscence sessions that do involve only talking but enhanced engagement in sessions that include music; see Le Navenec & Vonhof, 1996). Similarly, others report that certain pieces of music "just make me feel better," or "instill me with energy." Storr's (1992) work emphasizes these health promotion and related effects of music on personal well-being:

> in a culture [that] requires us in our daily working lives to separate rational thought from feelings, music reunites the mind and body, restoring our sense of personal wholeness. It is because music possesses this capacity that many people, including the author, find it so life enhancing. . . . (inside the front sleeve of Storr's, 1992 book entitled *"Music and the Mind"*)

An Overview of the Undergraduate Nursing Course

The focus of this chapter will be on the emotional responses to four selections of music among a group of undergraduate nursing students enrolled in a course entitled *An Introduction to Music and Sound for Health Professionals*. This course was developed in 1995–1996 by the third author (Le Navenec) in conjunction with two music therapists (Jennifer Buchanan, MTA and the late Gaile Hayes, ARCT, MTA) and a musicologist (Dr. Marcia Epstein). The purpose of the course was to introduce the students to the research that had been done on the effects of music and sound for populations across the lifespan in a variety of health and illness and cultural contexts. The students were reminded that although there was substantial content on the therapeutic effects of music, this course was *not* designed to prepare them to practice music therapy. Instead, the course objectives pertained to affording the stu-

dents an opportunity to gain knowledge and understanding about (1) how the various elements of music and sound (including noise) might influence one's functional level and feelings of well-being or, conversely, one's feelings of ill-being; (2) the diverse ways that people use music in their daily routines; (3) the salient factors to consider in their assessment of one's responses to music and sound; and (4) the role of music therapists on the health care team so that they could initiate referrals to them or provide information to others about the range of services these therapists provide. The recent article by Le Navenec, McEachern, and Epstein (2003) contains further details about the focus and content of this web-based credit course that is available to interested students anywhere in the world.

The format of this chapter is as follows: (1) first, some background information is given about the salient "elements" of music, the nature of "stimulating" and "sedative" (or relaxing) types of music, and the characteristics of listeners; (2) next, the case study of the class assignment involving a modified version of Hevner's (1937) *Mood Wheel* is presented, including the findings and possible reasons for same, based on the salient musical elements of the pieces, as well as the listener characteristics; and (3) in the concluding section, the implications of those findings for health professionals are outlined.

BACKGROUND INFORMATION

Unlike noise, music can be conceptualized as "an orderly arrangement of sound consisting of melody, harmony, tone and pitch" (Watkins, 1997, p. 44) and related *elements* such as style or type; rhythm; tempo, or beats per minute; and intensity or volume. Illustrative examples of some of these elements of sound and music are outlined in Table 11.1. This Table is a much-abbreviated version of the one that the third author (Le Navenec) developed for the *Introduction to Music and Sound for Health Professionals* course. It is based primarily on the works of Bunt (1994), McClellan (1991), and other references cited in Table 11.1. Readers who want more detailed information regarding these and additional elements of music and sound may wish to consult a recent edition of the Grove's Dictionary of Music and Musicians, or they may wish to review one of the many pocket music dictionaries that are now available.

Two Types of Music: Stimulative and Sedative Music

Depending on which combinations of these music and sound elements are present, a piece of music can be described as either *stimulative* or *sedative* (relaxing). Katsh and Merle-Fishman (1985) point out that stimulative music

Table 11.1
ILLUSTRATIVE EXAMPLES OF BASIC ELEMENTS OF SOUND AND MUSIC

Bunt's (1994) Classification of Basic Elements of Sound (and significance of same)	*McClellan's (1991) Classification of the Parameters of Music (and significance of same)*
Musical Modes • Types of scales with a specific arrangement of intervals—e.g., Dorian, Locrian, Phrygian, etc. Sacks (1998) alleged that "they affect the nervous system in quite different ways," and . . . "tune" the nervous system, or modify it, irrespective of culture and age" (p. 13).	*Dynamics* • The degree of loudness or softness of the music (e.g., range is from silence to quiet [pianissimo], to very loud [fortissimo]. • Questions you may wish to pose about the dynamics of a musical piece include: (a) Does one level predominate? (b) Is the change in the level gradual or sudden? (c) Are there sharp and frequent contrasts of dynamic level? These changes in dynamic levels help one to understand why some music is considered "stimulating" on the one hand or "sedative," on the other.
Tone • Separable units with constant auditory waveforms, which can be repeated and reproduced. Storr (1992) states tones can be distinguished on the basis of pitch, loudness, timbre, or wave form (p. 3) e.g., monotone refers to a single, unvaried pitch.	*Structure* • The way a piece of music is built or constructed (e.g., a song is usually made up of verse [section A] and refrain [section B]; hence, this type of song would be AB) (Hindley, 1974). Classical examples include "theme" and variations and "sonata."
Timbre (or Tone Color) The combination of the individual patterns of overtones and their relationship to the fundamental tone. It enables us to distinguish sounds made by different instruments or objects, such as a door slamming, as well as to recognize different people's voices. Harmonics: individual tones that are combined to constitute a complex tonal color (e.g., a chord).	*Tempo* • The number of beats per minute and the nature of change in tempo; that is, does one tempo predominate or is there a gradual increase, or are there sharp and frequent changes of tempo? • Sounds of longer duration will obviously create a slower tempo than sounds of short duration

has been described as emphasizing "rhythm rather than melody or harmony and is characterized by loud, staccato passages with wide pitch ranges and abrupt, unpredictable changes" (p. 157). According to Gaston (1968), stimulating music consists of such elements as "strong rhythms, volume, cacophony [or sounds that are unpleasant to the ear] and detached notes" (p. 143). A

Table 11.1—*Continued*

Bunt's (1994) Classification of Basic Elements of Sound (and significance of same)	McClellan's (1991) Classification of the Parameters of Music (and significance of same)
Loudness The continuum from very soft to very loud, which can be measured according to the unit of decibels.	*Melody (Theme, Subject)* • An organized sequence of single notes— - Theme or the musical "subject" of a piece (usually a melody), as in a sonata form or a fugue. Variations: a form of change to the main melody (a theme, figure, or passage) by means of melodic, rhythmic, or harmonic changes.
Pitch • "The subjective aspects of a sound where such descriptions as 'high' or 'low' are used. - Harmony: pitches that are in agreement or pleasing to the ear. - There is a clear link between the *frequency* (the # of cycles the sound wave vibrates per second) and our subjective impression of the sound: the faster the vibrations, the higher is our perception of the pitch. • We have a preference for middle range pitches such as our mother's usual voice and are distressed by certain high-pitched sounds, such as someone screaming" (Bunt, 1994, pp. 53–55).	*Rhythm* • The pattern of long and short note values in music (e.g., contrast fast parade marches to slow funereal type music). • "This element is often considered to be the vital therapeutic factor by virtue of its power to focus energy and to bring structure into the perception of temporal order" (Bunt, 1994, p. 60). At a simplistic level, it can be a repetition of the same stimulus at a constant frequency of occurrence (e.g., tick tock of a clock; or the way we walk; see Bunt, 1994).

similar description of this type of music was provided almost two decades ago by a Baltimore psychotherapist and violinist, Helen Bonny (cited in Castleman & Spangler, 1994), who described it as having "an assertive rhythm that elicits reactions [such as] hand clapping, toe tapping, [and/or] dancing" (p. 70). One possible reason for the popularity of stimulating music is that it matches our natural rhythm; that is, "it has a rhythm similar to the average heart rate, seventy to eighty beats per minute" (Castleman & Spangler, 1994, p. 70).

By contrast, sedative music has been described as being "of a sustained melodic nature, and lacking in strong rhythmic and percussive elements" (Gaston, 1968, p. 143). Castleman and Spangler (1994) support Gaston's description in their depiction of sedative music as "mellower and more soothing [than stimulating music]" and as promoting "feelings of calm and

inner peace" (p. 70). These authors cite Helen Bonny's description:

> Sedative music has an easy flowing melody, and a tempo similar to the resting heartbeat. [It's] pleasing to the ear, not dissonant, and it has no major changes in pitch, dynamics, or rhythm. . . . [It] supports its listeners. It makes no demands on them. (p. 70)

According to Helen Bonny, the importance of this distinction between stimulating and sedative music is its implications for people who are seriously ill. She discovered during her recovery from illness that she no longer liked her long-time favorites because they were too stimulating. She argued that "people who are seriously ill need sedative music, pieces like Bach's *Air on the G String,* Pachelbel's *Canon in D,* Haydn's *Cello Concerto in C . . .* or sedative pieces in non-classical genres" (cited in Castleman & Spangler, 1994, p. 70). Hence, it is important for health professionals, when assessing a client's musical preferences, to take into consideration the client's current health status. However, there are several other factors to consider, which pertain to listener characteristics, and these aspects are discussed next.

Characteristics of the Listener

As may be already apparent, whether an individual experiences musical stimuli as stimulating, relaxing, or as an annoyance (or source of discomfort) depends not only on the previously mentioned musical elements but also on a range of characteristics of the listener. That music may be experienced as an annoyance is reflected in commonly heard statements like: "Turn off that noise"; or "I prefer the sounds of silence so I hope if I get sick, or when I get old, music will not be forced on me." Some of the salient research findings about the factors or characteristics that affect one's *musical preferences* include:

- Health status
 As previously mentioned, Helen Bonny (cited in Castleman & Spangler, 1994) found that one's preference for stimulating music may change when ill. She emphasized the need for sedative music at such times. Furthermore, depending on one's hearing status, certain types of music (e.g., with high pitches) may be a source of discomfort.
- Alertness or fatigue level
 Just as when we are ill, we prefer sedative music, so too when we are very tired; as one student put it: "during those times, I prefer the sounds of silence."
- Mood at the time of listening
 One common response to the question "What is your favorite type of music?" is "it depends what mood I am in." This aspect illustrates the

iso-moodic principle, which, as Katsh and Merle-Fishman (1985) have emphasized, means that we need to match the music to the current mood we are in. They add that if we wish to change our mood, we need to change the selection of music gradually by choosing music that evokes emotional responses in an adjoining category of Hevner's (1937) Mood Wheel (see Figure 11.1).

- Age
 There has been considerable research about musical preferences of various age groups. One illustrative example is the study by Moore, Staum, and Brotons (1992) of musical preferences of the elderly.
- Other sociocultural and environmental characteristics
 Examples in this category include how familiar the music is to the listener, cultural and ethnic background, and related contextual features (e.g., whom you are with, the physical environment in which you are listening to the music, etc.).
- Musical background
- How one uses music in daily life
 Smeijsters (1995) has provided an informative overview of the research on how music is used in everyday life and what functions music could have for various groups. Illustrative examples of the various functions by category type that he identified from past research include: Compensatory (e.g., diversion, relaxation); Emotional (e.g., "music supports the expression of emotions or moods"); Background (e.g., "background music stimulates me while working and it fills the silence when I feel not at ease with others "); as well as numerous other examples (see Smeijsters, 1995, pp. 386–387).
- Availability of various types or categories of preferred music
 Examples of the types of preferred music include: big band; country and western; classical; rock and roll; easy listening; spiritual/religious; dance music (waltzes/tango); and military (such as marches). Pittigro (2000) suggests that music from childhood and adolescence may be helpful for older people with dementia during reminiscence group sessions because long-term memory is often preserved.

By way of concluding this background portion of the chapter, the authors want to stress the importance of assessing the musical preferences of the persons for whom you are making musical suggestions. You might begin by reviewing their 'musical history' with them using recently developed questionnaires (see Le Navenec & Slaughter, 2001). Next, you could have them describe their responses to a particular piece of music. This approach was used in the student assignment to be described in the following case study.

THE MOOD WHEEL ASSIGNMENT

Purpose of the Assignment

The purpose of the Mood Wheel assignment was to raise awareness on the part of the students to the varied nature of emotional responses to identical pieces of music and to explore reasons for these variations (see Katsh & Merle-Fishman, 1985, pp. 173–177; Sloboda, 1985, 1992). In regard to the latter, the objective was to identify to what extent they were responding to various musical elements, or to factors external to the music such as the memories that a particular piece evoked, or to a range of related *contextual* factors (e.g., as one listener stated, "I was dead tired and in a bad mood, and could not even concentrate on the noise that I was hearing"). Knowledge in this area is important for nurses and other health professionals, who often are the people who select the music being played, perhaps as background music, at the workplace. Such knowledge will, we hope, allow them to understand more clearly how their selection of music is affecting the clients, their coworkers, and themselves (see Moore, Staum, & Brotons, 1992; Panksepp & Bekkedal, 1996).

Details About the Mood Wheel Assignment

The participants in the Mood Wheel Assignment were twenty-one female students, aged twenty-one to forty-nine. To assess their emotional responses to music, they listened to four musical compositions from *The Musical Pharmacy* compact disc (CD), which had been composed, arranged, and produced by the first author (Parr-Vijinski, 1997; 1999). Each participant was instructed to use the Mood Wheel (see description below) as a reference to jot down emotional reactions to the selected piece of music. All pieces were recorded using synthesizers. Special attention was given to imitating acoustic instruments as realistically as possible, as well as placing particular synthesized instrumental sounds to imitate the stereo placement of actual orchestral instruments.

A copy of Hevner's (1937) Mood Wheel (modified by third author) is provided in Figure 11.1. The sixty-six adjectives used to describe the range of emotional responses to music are divided into eight groups, with each group being represented by a salient adjective (see words in bold). Diagrammatically, the Mood Wheel has a wide variety of emotions and many sub-category descriptors. Similar emotional states are placed next to each other, progressing clockwise from 1.8 ("serious") to 8.1 ("vigorous"), and becoming cyclical, in that the final adjective of 8.7 ("exalting") seemingly blends back into Group 1 and its first adjective, "spiritual" (1.1). In addition,

ADJECTIVES FOR RECORDING THE MOOD EFFECTS OF MUSIC

Use the numbers preceding the adjectives below for recording your emotional response to:
_____ *(specify the name of the selection)*
Source: Modified by Le Navenec from Katsh and Merle-Fishman (1985, p. 177).

7
- 7.1 exhilerated
- 7.2 soaring
- 7.3 triumphant
- 7.4 dramatic
- 7.5 passionate
- 7.6 sensational
- 7.7 **agitated**
- 7.8 exciting
- 7.9 impetuous
- 7.10 restless
- 7.11 Other:

6
- 6.1 merry
- 6.2 joyous
- 6.3 gay
- 6.4 **happy**
- 6.5 cheerful
- 6.6 bright
- 6.7 Other:

5
- 5.1 humorous
- 5.2 **playful**
- 5.3 whimsical
- 5.4 fanciful
- 5.5 quaint
- 5.6 sprightly
- 5.7 delicate
- 5.8 light
- 5.9 graceful
- 5.10 Other:

8
- 8.1 **vigorous**
- 8.2 robust
- 8.3 emphatic
- 8.4 martial
- 8.5 ponderous
- 8.6 majestic
- 8.7 exalting
- 8.8 Other:

Kate Hevner's (1937) **Mood Wheel** is a listing of 66 adjectives in 8 related groups that classify the possible emotional attributes of a piece of music.

You will notice that groups right next to one another are related, while diagonally opposite groups are quite unrelated. The progression around the circle from group 1 to group 8 represents the full range of human emotions.

Review the iso-moodic principle in the above book (pp. 178–179) to learn about how your mood can be moved in the direction you desire. Please feel free to add your own adjectives under the "Other" category in a particular group. Be as specific as possible in your choice of adjective.

4
- 4.1 lyrical
- 4.2 leisurely
- 4.3 satisfying
- 4.4 serene
- 4.5 **tranquil**
- 4.6 quiet
- 4.7 soothing
- 4.8 Other:

1
- 1.1 spiritual
- 1.2 lofty
- 1.3 awe-inspiring
- 1.4 dignified
- 1.5 sacred
- 1.6 solemn
- 1.7 sober
- 1.8 **serious**
- 1.9 Other:

2
- 2.1 pathetic
- 2.2 doleful
- 2.3 **sad**
- 2.4 mournful
- 2.5 tragic
- 2.6 melancholic
- 2.7 frustrated
- 2.8 depressing
- 2.9 gloomy
- 2.10 heavy
- 2.11 dark
- 2.12 Other:

3
- 3.1 **dreamy**
- 3.2 longing
- 3.3 plaintive
- 3.4 pleading
- 3.5 sentimental
- 3.6 tender
- 3.7 yearning
- 3.8 yielding
- 3.9 Other:

Note: For an example of how a wide variety of musical compositions can be catalogued for each of the mood groups, see:
Bonny, H., & Savary, L. (1975). *Music and your mind: Listening with a new consciousness.* New York: Harper & Row.

Figure 11.1. Mood Wheel Assignment.

the opposite emotions are diagrammatically positioned opposite each other. Thus, Group 1 is diagonally opposite Group 5, Group 2 is opposite Group 6, and so on.

With each musical piece from the Musical Pharmacy CD that the participants examined, we will see the range of emotional attributes reported by the respondents, as well as the many similarities among them. We will also see how people differ in their interpretation of the same piece, or at least in the words they chose to identify their responses (see Storr, 1992, p. 70 for the variation in words that people use to express their emotional response).

FINDING FOR EACH OF THE FOUR MUSICAL SELECTIONS

1. The Song of the Nightingale

This piece is written in a late nineteenth century *Romantic* style (i.e., a style in which music progressed to a freer, more subjective form with increasing chromaticism (or use of notes outside the diatonic scale); the use of folk themes; the introduction of more virtuostic solo music; and larger orchestras). This selection uses the sound palette of a full orchestra. Dynamically, the piece is varied with a large range of sound combinations and many loud and quiet parts.

Table 11.2
EMOTIONAL RESPONSES BY NUMBER & PERCENTAGE
TO "THE SONG OF THE NIGHTINGALE" (N = 21)

Group 2	(sad)	N = 13	61%	Group 6	(happy)	N = 6	28%
Group 3	(dreamy)	N = 10	47%	Group 5	(playful)	N = 5	25%
Group 1	(serious)	N = 8	38%	Group 7	(agitated)	N = 3	14%
Group 4	(tranquil)	N = 7	33%	Group 8	(vigorous)	N = 1	4.7%

Several points deserve mention to help us understand the emotional responses of the participants to The Song of the Nightingale. One point to note is that the music is divided into a varied format of sections. The assorted uses of sounds, combinations and timbres of sound, the wide dynamic range, and related techniques are reflected in the participants' usage of all eight musical attributes. In addition, the general spread of percentages among most of the groups is similar. For example, six of the eight groups were selected by at least a quarter of the participants. Their perspective of

the music as more "sedative" in nature is revealed in the low percentages for the emotional attributes in Groups 7 and 8.

2. *Etude*

This fast tempo piano piece is written in a Chopinesque style, with some pungent harmonic changes. A main melodic theme with a uniform rhythm predominates throughout. This piece was composed with the picture of a very busy nurse in mind. Several listeners have commented that one should not to listen to this piece while driving or "you may end up getting a speeding ticket."

Table 11.3
EMOTIONAL RESPONSES BY NUMBER
& PERCENTAGE TO *"ETUDE"* (N = 21)

Group 5	(playful)	N = 16	76%	Group 4	(tranquil)	N = 2	9.5%
Group 7	(agitated)	N = 15	71%	Group 2	(sad)	N = 2	9.5%
Group 6	(happy)	N = 12	57%	Group 3	(dreamy)	N = 1	5%
Group 8	(vigorous)	N = 4	19%	Group 1	(serious)	N = 0	0%

What comments might one offer regarding the musical attributes that the students attributed to the Etude? To begin, one might note that this piece, in contrast to the first selection, is dynamically limited (or rhythmically similar throughout) and uniform in the expression of instrumental color (a piano timbre is used). Color here is represented in the manipulation of harmonic changes (instead of the element of instrumental coloring) and the wide-ranging dynamic changes of an orchestral piece. These aspects of the music may partially explain the pattern of responses of the participants to gravitate toward various musical attributes in Group 5 (playful), Group 7 (agitated), and Group 6 (happy). For this musical selection, one notes that the participants often used the emotional attribute that was listed first in the list for these three groups: "humorous," "exhilarated," and "merry" respectively. Taking into consideration that each group of musical attributes is closely linked in description to the one preceding and following it, it is not surprising that Group 7 and Group 8 accounted for 90 percent of the responses. Thus, the word, "soaring," from Group 7, can easily be matched to the word, "exalting," from Group 8, and this pattern was reflected in the findings. This finding is related to Storr's (1992) assertion that although a number of individuals may agree "in general terms about whether a work is tragic, humor-

ous, profound"... "specific descriptions of their subjective reactions may differ considerably" (p. 71).

3. Madrigal of Light

This piece is a moderately paced composition, focusing on harpsichord and Spanish guitar. Hence, we have the combined use of the percussive and unsustained tone of the harpsichord juxtaposed with the lyrical, singing quality of the acoustic guitar. In addition, there are voices, string sounds, and assorted percussion such as chimes. Several listeners have commented that "this one was the best of the four pieces," which may be related to the singing quality.

Table 11.4
EMOTIONAL RESPONSES BY NUMBER & PERCENTAGE
FOR THE "MADRIGAL OF LIGHT" (N = 21)

Group 6	(happy)	N = 11	52%	Group 7	(agitated)	N = 7	33%
Group 5	(playful)	N = 10	48%	Group 8	(vigorous)	N = 5	24%
Group 3	(dreamy)	N = 8	38%	Group 1	(serious)	N = 4	19%
Group 4	(tranquil)	N = 7	33%	Group 2	(sad)	N = 2	10%

By way of commentary for the Madrigal of Light, one might first note that approximately half of the participants described the piece as "merry," "cheerful," "humorous," "sprightly," which are all musical attributes from Group 6. In addition, as in the previous commentaries about the other two musical selections, we again see certain patterns in their emotional responses to the piece. For example, the participants "avoided" certain groups. That is, we see a marked decrease in the number of participants who selected adjectives from Group 8; this piece is not considered to be vigorous, or robust; instead, it is considered fanciful or graceful. It is the first author's contention that because this piece has a constant moderately-quick pulse, the selections of the musical attributes by the participants were not so much influenced by rhythm; instead, their responses appear to have been more influenced by the melodic, harmonic, and color elements of the Madrigal of Light.

4. Pastorale: The Dawning of the Day

The Pastorale is an orchestral-based piece of moderate tempo, with a middle section highlighting the piano and English horn.

Table 11.5
EMOTIONAL RESPONSES BY NUMBER & PERCENTAGE
FOR THE *"PASTORALE"* (N = 21 PARTICIPANTS)

Group 3	(dreamy)	N = 14	67%	Group 7	(agitated)	N = 5	24%
Group 4	(tranquil)	N = 13	62%	Group 6	(happy)	N = 3	14%
Group 1	(serious)	N = 12	57%	Group 2	(sad)	N = 3	14%
Group 5	(playful)	N = 8	38%	Group 8	(vigorous)	N = 0	0%

For the Pastorale, the majority of the participants selected Groups 3 and 4, followed closely by Group 1. Hence, they were quite explicit in their indication that this piece was "dreamy" (Group 3), "lyrical" (Group 4), and "spiritual" (Group 1). By contrast, Groups 2, 6, and 8 were clearly not popular choices. Once again, we see individuals coming up with a consistent pattern in explaining the emotional attributes of the music. Such a piece may provide a soothing effect.

Interestingly, Group 2 is only 14 percent, whereas Group 1 and Group 3 are 57 percent and 67 percent respectively. Although Group 2 is related to Groups 1 and 3, a close examination of Group 1 reveals that the predominant adjectives that they selected from this Group were: "spiritual" and "sacred," and from Group 3: "dreamy" and "longing." By contrast, the adjectives that they selected from Group 2 were: "melancholy" and "mournful." However, even though only 14 percent of the participants selected emotional attributes from Group 2, when it was selected, the adjectives they chose were somewhat related to the more frequently chosen groups. For example, we can see that there is a link between the words "mournful" (in Group 2, section 2.4), and "spiritual" (in Group 1, section 1.1), and "longing" (in Group 3, section 3.1). Further inquiry about this finding is needed, particularly in regard to whether the short duration of this musical piece had an impact on their selection of the emotional attributes that included adjectives like "happy," "playful," and "agitated."

The above-mentioned examples of the variation in the words we select to describe the emotional attributes of a piece of music were evident in the findings reported in this case study of the Mood Wheel Assignment. This variable should be kept in mind for readers who may wish to repeat this assignment in their setting to understand the way(s) we respond emotionally to a particular piece of music. It appears that the elements of the music, the meaning that each respondent accords to the particular word that is used for a musical attribute, and the characteristics of the listener all played a role in the similarities and variations in the emotional responses to music reported by the students in this case study.

DISCUSSION

Although this assignment was not designed to be an empirical investigation, it did afford the students an opportunity to engage in inquiry-based learning in regard to the emotional effects of specific types of music that had been composed, arranged, and produced by the first author (Parr-Vijinksi). It also afforded the students an opportunity to listen attentively and to engage in considerable reflection before recording their choices of the specific musical attributes for each of the four musical selections. Several students mentioned that this assignment was an entirely new experience for them. One student explained its uniqueness in this manner:

> I never thought about the question of "what" in the music I was responding to; instead, I would just say that I liked the music because it made me feel excited, energized, or relaxed, and sometimes it was because the lyrics make me think of something that was important to me.

Those comments remind one of the assertion that Sloboda (1992) made over a decade ago: "Although it is well-established that people respond emotionally to music, little is known about precisely what in the music they are responding to" (p. 39). His research serves to remind us that the "elements" of music and sound are one set of factors to consider in understanding such responses. Hevner (cited in Katsh and Merle-Fishman, 1985), the person who developed the Mood Wheel in 1937, concluded from her study that "the perception of emotion in music was most influenced by the tempo, modality, and pitch level of the music, and less by the harmony, rhythm, and melodic direction" (p. 176). These emotional effects of music are thought to arise due to the effect of these elements on the brain's limbic system, which is believed to be the "seat" of our emotions.

In regard to the impact of musical elements on the emotional responses of the students, the findings from this assignment lend some support for Hevner's assumption. However, the results also suggested that the meanings of certain adjectives (i.e., musical attributes) in one or more of the eight groups were not clear to some of the participants. Thus, they chose adjectives that were more familiar to them, which, in turn, might explain why some of the musical selections were assigned to one of the more infrequently chosen groups of attributes. Interestingly, all the students elected *not* to add an adjective of their choice in the "Other" category for any of the eight groupings. The third author (Le Navenec) had added that category in the belief that some of the younger students might use adjectives like "cool," "awesome," and other terms that are popular.

As is perhaps apparent in the above discussion, the music and sound elements play an important role in one's perception of a particular emotion in

a piece of music. A second factor to consider, however, in understanding the various emotional responses to a piece of music are the characteristics of the listener, some of which were described in the background section of this chapter. The majority of these students were nursing students, and many of them did not have any musical training or in-depth knowledge of musical elements. In addition, most of them came to this late afternoon class after a full day's work and hence, may have been tired, finding it difficult to concentrate. Furthermore, the fact that Professor Le Navenec made the musical choices for the students, using music that was instrumental, and largely classical music in nature, may have resulted in many students being in a situation where their preferred music was absent. No doubt there are several other listener characteristics that played a role in their selection of emotional attributes for the four pieces they analyzed.

In order to further our understanding of the latter, Professor Le Navenec recently incorporated a one-page questionnaire with the assignment in order to address a range of (a) listener characteristics such as: age, gender, preferred type of music, whether they liked this piece or not and why, current mood at the time of listening to this selection, fatigue level at the time of listening, including the time of the day and day of the week, significant memories of a non-musical situation that this selection evoked; and (b) contextual information such as the geographical location where the listening occurred, whether earphones or a CD player was used to listen to the piece, and the circumstances at the time of listening, including the amount of time one had to listen to the piece. It is our belief that this contextual information is needed to gain more precise insights about one's emotional responses to music, as opposed to concentrating solely on the impact of the musical elements.

CONCLUSIONS

The implications of these findings regarding the two sets of factors (i.e., the musical elements and listener characteristics) that influence one's emotional responses to music are important for health care professionals who are working with an accredited music therapist (MTA) to develop a music listening program for clients on the one hand, and for individuals wanting to use music to enhance their feelings of well-being on the other hand. In regard to the former, Le Navenec and Slaughter (2001; p. 42) have outlined several essential considerations. These considerations include the need: (a) to provide a definition of the desired outcome, based on a discussion with the client, his or her family, the attending physician, and the treatment team; (b) to explore "the [client's] background, musical interests, and/or abilities"; (c) to determine the "the frequency and timing" of the listening, including who

is responsible for implementing, evaluating, and recording the client's responses; (d) to ensure that the person responsible for implementing the listening session "individualize the music intervention by providing . . . headphones, personal stereos, and an audiotape with recordings of each [client's] preferred music" and ensure that "the volume level is not too high" (p. 42). Finally, the treatment team and music therapist will need to work together to develop specific and "sensitive" *outcome indicators* of the emotional responses to music because such changes for some client populations are often very subtle. Furthermore, it is important to monitor the changes over a substantial period of time because they arise in a very gradual fashion. That is, as one staff member put it, "instead of us focusing on how far Mr. X has to go in terms of behaving appropriately, let's review how far he has come [toward meeting the specified desired outcome]."

What about the implications of these findings for individuals wanting to use music to enhance their own feelings of well-being? The authors believe that an important first step in the development of one's own *Musical Pharmacy* is to review the research findings that indicate the "mind/body/spirit" effects of music, which "thereby [make] it a truly holistic resource that can foster positive change on many levels" (Le Navenec et al., 2003, p. 20). We found that many listeners prior to taking this course, were not aware of the voluminous literature on this topic. A second step involves exploration and discovery of what types of music "work" best for you when you are in a particular type of mood or challenging situation. Hence, when listening to, say the radio, make some mental or actual notes about the music that you will subsequently put in what we refer to as "My Reflective Musical Journal." Your journal notes might include a few details about the musical elements that you "tuned in to," or that "struck the right chord," and the circumstances at the time (a headache, difficulty falling or remaining asleep, or early morning awakening, an upcoming exam or job interview, workplace or family stressors, or issues with other individuals in one's social network). It is also important to note the "dosage" of the music listening that you "took," and any "side effects" (or undesirable results) and subsequently explore what adjustments may be needed. Once you have completed this process of discovery about your emotional responses to the various pieces of music assembled, you are now ready to assemble a set of audiocassettes that constitute your brand of a *Musical Pharmacy* that will promote "self-care" (Orem, 1995), prevent negative outcomes in your role as a formal or informal caregiver (see literature on workplace stress and the burden experienced by family caregivers), and enhance your quality of life in the ways suggested by Smejsters (1995). In answer to Clark's (2000) question, we would say, "Yes, definitely. . . . Tunes can fine-tune your health, for both patients and staff who are providing their care."

REFERENCES

Bunt, L. (1994). *Music therapy: An art beyond words* (Chapter 3: pp. 45–74). London: Routledge.

Bonny, H., & Savary, L. (1975). *Music and your mind: Listening with a new consciousness.* New York: Harper & Row.

Campbell, D. (Ed.). (1992). *Music and miracles.* Wheaton, IL: Quest Books.

Castleman, M., & Spangler, T. (1994, September/October). The healing power of music. *Natural Health, 24*(11), 68–72.

Clark, C.C. (2000, December 11). Can tunes fine-tune your health? *Nursing Spectrum: Career Fitness Online.* Retrieved May 14, 2001 from: http://community.nursingspectrum.com/MagazineArticles/article.cfm?AID=2942.

Gaston, E.T. (1968). *Music in therapy.* New York: Macmillan.

Gerdner, L.A., & Buckwalter, K.A. (1999). Music therapy. In J.C. McCloskey & G.M. Bulechek (Eds.), *Nursing interventions. Effective nursing treatments* (3rd ed., pp. 451–468). Philadelphia: W. B. Saunders.

Goldstein, A. (1980). Thrills in response to music and other stimuli. *Physiological Psychology, 8*(1), 126–129.

Gotell, E., Brown, S.A., & Ekman, S. (2000). Caregiver-assisted music events in psychogeriatric care. *Journal of Psychiatric and Mental Health Services, 7,* 119–125.

Groër, M. (1991). Psychoneuroimmunology. American Journal of Nursing, 91(8), 33.

Hindley, A. (Ed.). (1974). *Larousse encyclopedia of music.* London: Hamlyn.

Hevner, K. (1937). An experimental study of the affective value of sounds and poetry. *American Journal of Psychology, 49,* 419–434.

Jourdain, R. (1997). *Music, the brain and ecstasy.* New York: Avon Books.

Katsh, S., & Merle-Fishman, C. (1985). *The music within you.* New York: Simon and Schuster.

Knox, R.A. (1992, November 23). In music, whole brain gets involved. *The Boston Globe.* Retrieved April 22, 2004 from The Foundation for Human Potential: http://www.fhphonline.org/pubs/in_music.html.

Le Navenec, C., & Slaughter, S. (2001). Laughter can be the best medicine: Music, reminiscence and humor. *Nursing Times, 97*(30), 42–43.

Le Navenec, C., McEachern, O., & Epstein, M. (2003). An introduction to music and sound for health professionals: Overview of an undergraduate web-based nursing course. *The Australian Journal of Holistic Nursing, 10*(2), 19–24.

Le Navenec, C., & Parr-Vijinski, J. (2000). *A video soundscape: Using music and nature scenes to facilitate well-being.* Unpublished Videotape. Available from jonparr@sympatico.ca.

Lloyd, R. (1987). *Explorations in psychoneuroimmunology.* Orlando, FL: Grune and Stratton.

McClellan, R. (1991). *The healing forces of music.* St. Louis, MO: MMB Music.

Meei-Fang, L. (2001). The use of music to decrease agitated behaviour of the demented elderly: The state of the science. *Scandinavian Journal of Caring Science, 15,* 165–173.

Moore, R.S., Staum, M.J., & Brotons, M. (1992). Music preferences of the elderly.

Repertoire, vocal ranges, tempos, and accompaniments for singing. *Journal of Music Therapy, XXIX* (4), 236–252.

Panksepp, J., & Bekkedal, M.Y.V. (1996). The affective cerebral consequences of music: Happy vs. sad effects on the EEG and clinical implications. *International Journal of Arts Medicine, 5*(1), 18–27.

Parr-Vijinski, J. (1997). *A musical pharmacy.* Compact disc: Available from jonparr@sympatico.ca.

Parr-Vijinski, J. (1999). *Pastorale.* Compact disc: Available from jonparr@sympatico.ca.

Pittigio, L. (2000). Use of reminiscence therapy in patients with Alzheimer's disease. *Lippincott's Case Management, 5*(6), 216–220.

Sacks, O. (1998). Music and the brain. In C.M. Tomaino (Ed.), *Clinical application of music in neurologic rehabilitation* (pp. 1–8). St. Louis, MO: MMB Music.

Sacks, O., & Tomaino, C. (1991). Music and neurological disorder. *International Journal of Arts Medicine, 1*(1), 10–12.

Scartelli, J. (1989). Music therapy and psychoneuroimmunology. In R. Spintge & R. Droh (Eds.), *Music Medicine* (pp. 137–141). St. Louis, MO: MMB Music.

Sloboda, J. (1985). *The musical mind: The cognitive psychology of music.* Oxford: Oxford University Press.

Sloboda, J. (1992). Empirical studies of emotional responses to music. In M.R. Jones & S. Holleren (Eds.), *Cognitive bases of musical communication* (pp. 33–50). Washington, DC: American Psychological Association.

Smeijsters, H. (1995). The functions of music in music therapy. In T.Wigram, B. Saperston & R. West (Eds.), *The art and science of music therapy: A handbook* (pp. 384–395). Churr, SWIT: Harwood.

Storr, A. (1992). *Music and the mind.* New York and Oxford: The Free Press.

Thomas, K. (2004, February 6). Treating Parkinson's. *On Campus: University of Calgary, 1*(18), 4.

Tomaino, C.M. (1998). Music and memory: Accessing residual function. In C.M. Tomaino (Ed.), *Clinical applications of music in neurologic rehabilitation* (pp. 19–27). St. Louis, MO: MMB Music.

Watkins, G. (1997). Music therapy: Proposed physiological mechanisms and clinical implications. *Clinical Nurse Specialist, 11* (2), 43–50.

Wininger, S.R., & Pargman, D. (2003). Assessment of factors associated with exercise enjoyment. *Journal of Music Therapy, XL* (1), 57–73.

Chapter 12

A SOUND BASIS FOR WELL-BEING: THE ACOUSTICS OF HEALTH

Marcia Jenneth Epstein

SUMMARY

In this chapter, actual and hypothetical examples will be discussed to illustrate: (1) the principles of Acoustic Ecology and their application to health care institutions; and (2) how one might achieve the following outcomes pertaining to "a sound basis for well-being":

- greater awareness of environmental sound and its effects on health.
- improved conditions for recovery and healing in institutional settings, including hospitals, through control of noise and provision of atmospheric music.
- adoption of measures for the protection of hearing by staff in institutional settings.

Suggestions for institutional applications by health care professionals will be presented throughout the chapter, along with recommendations for the reduction of noise and the protection of hearing.

INTRODUCTION: WHAT IS ACOUSTIC ECOLOGY?

Defined as the study of sound in natural and cultural environments, acoustic ecology investigates the effects of sound, noise (usually considered to be unwelcome sound), music, and silence on human health and learning. It is an emerging branch of study first articulated by Canadian composer R. Murray Schafer (1977), whose work began with experiments in "sound-map-

ping" the neighborhoods around the campus of Simon Fraser University in British Columbia. Schafer and his students observed that such natural noises as birdsong and rain, as well as the added layers of traffic and electronic appliances, reached peaks and low points of activity in daily, weekly, and seasonal cycles. Recording these cycles and translating them to visual maps could provide evidence useful for anti-noise legislation, for city planning, and for examining the social and physical health of neighborhoods and their residents. The acoustic ecology movement developed gradually from its beginnings with Schafer and his students. It now includes practitioners in Canada, the United States, the Netherlands, Finland, Germany, Switzerland, Japan, and Australia. Among them are musicians, educators, sound technicians, engineers, sculptors, architects, and health care professionals.

One of the innovative concepts defined by acoustic ecology is that of the *soundscape,* the auditory ambience of a place (Schafer, 1993, 1977). A soundscape is first identified through what is heard there: the physical sounds of natural, human, animal, and mechanical activities, air flow, resonance, and other acoustical properties. Its secondary identity is composed of its effects on human listeners: the emotional, physical, and spiritual responses it evokes. According to Schafer, such phenomena as evocation of positive or negative emotions, memory recall, the startle response, the relaxation response, and trance induction can be activated by these ambient sounds, as well as by music.

Although physical responses to sound can be measured with standard tests (e.g., blood pressure, galvanic skin response, electroencephalogram, electrocardiogram, magnetic resonance imaging or MRI), emotional and spiritual ones are far more difficult to trace. Mood indicator scales (e.g., the Beck Depression Inventory, a self-rating scale) may be useful, but interviewing the listener is probably the most accurate way to determine what s/he is feeling. For this reason, research in acoustic ecology, music therapy, and auditory perception—all fields that study human responses and reactions to sound—is extremely complex and often qualitative. The variables that have been studied include previous musical exposure and training, age, gender, culture, hearing acuity, and fidelity of equipment used for recording, playing, or testing (Topf & Thompson, 2001). As well, methods used in research may be shaped by the perspectives of each medical or academic discipline. Medical or nursing research, although strong in clinical aspects, sometimes lacks specificity with regard to technical descriptions of sound or music. For example, Philbin (2000), examining the literature on the effects of noise stimuli on premature infants, faults some studies for failing to measure and analyze significant levels of ambient noise.

Like landscapes, soundscapes can encompass tremendous variation and contrast between adjoining locales. Consider, for example, a busy city street

adjacent to a park. You may hear traffic in the park, but it is easier to ignore; while physically heard, the sound does not demand as much of your attention as it would in the street itself. Thus, one's responses to sound can be conscious or subconscious. Noises that one hears every day may become so routinized that they are no longer noticed or even actively heard. They can, however, affect the nervous system and emotions (Krumhansl, 2002). For this reason, it is important that health care professionals be aware of the soundscape in health care facilities. Not only are patients being affected in subtle ways, but staff also may find their stress levels rising or falling with changes in what they can hear at work.

Sound, Health, and Ambient Noise in Health Care Facilities

Sounds signal health or disease in many ways, many of them taking place beneath the level of awareness. The cries of a newborn indicate that respiration has begun, while the labored breathing of a terminally ill patient suggests the ebbing of life. A weakening or dulling of the human voice suggests that some physical or psychological ailment, fatigue, or depression is present (Epstein, 1995). Nurses and other health care professionals are trained to interpret these signals constantly, whether diagnosing a sore throat or assessing the recovery process after surgery. The signaling function of noise is also part of the pattern. The sirens of ambulances, the rumble of equipment carts along corridors, the signals given by cardiac monitors, all broadcast information about the common activities of a hospital. The soundscape of a hospital, clinic, or nursing home can indicate to patients or residents whether it is a safe place for processes of healing to happen, just as it alerts staff to the carrying out of routines.

Noise is a carrier of information. Combined with other sensory cues, sound becomes critical to the comfort of a bedridden individual. A noise unnoticed by day can become a major source of stress at night. For example, patients in post-operative recovery should always be guarded against intrusive noise because deep relaxation is crucial to their healing process. Sounds can also bring comfort—the gentle tone in a caregiver's voice or footsteps approaching in answer to a summons are reassuring.

The literature of ambient noise in hospitals and nursing homes suggests that noise levels appropriate to rest and sleep are often exceeded in hospitals (Alvord & Walker, 1999; Holmberg, 1999; Topf, 1992; Topf, 2000; Wallace, Robins, Topf, & Bookman, 1998). The United States Environmental Protection Agency (EPA) specifies 45 deciBels (dB) as the upper limit for noise levels in an area where people are sleeping. However, an American study (Topf, 1992) found a minimum of 50 dB and a maximum of 86 dB in hospital corridors at night. The latter is loud enough to damage hearing (EPA

website). Clearly, monitoring and control of noise levels at night in hospital rooms and corridors is advisable.

MINI CASE STUDY

Children may be especially sensitive to auditory signals, and to the ambient noise of their surroundings. In 2000, while teaching an *Introduction to Acoustic Ecology* course for the Faculty of Communication and Culture at the University of Calgary, I was able to send a team of students to observe and graph the sounds of a waiting room at a Children's Hospital. They reported that the waiting room was set up for convenience and contained a child-friendly visual ambience, but that the low-level ambient noise of the room, which was caused by the ventilation and lighting systems, was constantly punctuated by two sources of discomfort. One was inevitable—the vocalizations of anxious children, particularly babies and toddlers. These sounds "came with the territory," and were soothed to some extent by parents. A detailed listing of noise sources by one student included the following:

- the squeak of wet rubber soles as they screech over freshly washed corridors
- a loud shuffle as a wooden desk is moved across the floor around the corner
- the creak of a rigid stroller as it is pushed down the hall
- the repetitive creak of a mop as a janitor cleans the floor
- the faint voices of hospital staff down the corridor
- a thump as vertical sliding doors are slammed by children in the play area
- the excited voices of two small boys as they discover the play area
- the happy squeak of a baby
- the persistent sobbing of an infant
- the heavy panting of an exhausted child
- an exasperated sigh from a tired mother
- the muffled babble of a small child amusing himself
- quiet, indignant protests from a child refusing to put on his winter coat
- the sounds of a small child experimenting with her voice

The student researchers and waiting room occupants that they consulted found childrens' sounds far less disturbing than another source of noise, which was the drills used in a nearby room to remove plaster casts. Older children, and many parents, associated the drill noises with the dentist's office, while the younger ones were simply anxious. The observation team's suggestion for improving the situation was to increase soundproof-

ing in the waiting area and the rooms where the drills were used. They also suggested that the hospital provide soft background music, perhaps derived from soundtracks of classic movies for children, in the waiting areas.

Music as Ambience

The use of music to set an ambient soundscape is a possible solution to problems with noise (Shertzer, 2001). The selection of background music is always a challenge in institutional settings because pleasing everyone is nearly impossible. Outpatients occupy waiting rooms for a matter of minutes or hours and may appreciate a high degree of repetition in listening choices. By contrast, staff are likely to experience boredom and annoyance in response to hearing the same music over and over again. Individual musical preferences may be attributed to cultural origin, hearing acuity, presence or lack of musical training, age, gender, emotional state, and aesthetic preferences. Since music is a powerful catalyst for memories and emotions, all employees within earshot of the sound system in a waiting room, lobby, operating room, or office should be consulted before a program of background music is implemented. What seem to be safe choices for musical style and volume may produce unpleasant reactions and subsequent complaints in some situations and individuals.

Music in patients' rooms should always be their choice and limited to their personal space. For this reason, portable listening units with earphones are highly recommended. A library containing individual tape players or CD units with earphones, and a variety of audio tapes or CDs with a catalogue to facilitate requests, is advisable. Consultation with a music therapist, musicologist, or music librarian will help in finding appropriate selections. If the patient is unable to communicate verbally, consultation with his/her family may be necessary. Use of earphones may require instruction; for example, they should never be turned up to maximum volume. Dial settings should adhere to the manufacturers' guidelines.

There is no fail-safe system for designing a program of background music for general listening. Individual tastes vary so much that appreciation cannot always be assumed, and some negotiation among listeners may be necessary. An object lesson occurred for Dr. LeNavenec and me on the first day of teaching our course called *"Introduction to the Use of Music and Sound for the Health Professions."* We wanted to relax and soothe the students, many of whom were nurses taking the course after work, with recorded music as they came into the classroom. The piece we chose for the first class was *Pachelbel's Canon,* a classical selection used in many relaxation tapes. Drawing the students' attention to the recording, we asked for their reactions. Nearly all were

pleased with it, but one young woman had to leave the room briefly, stating that she could not bear to listen to that piece because it reminded her of a failed romance. We subsequently discussed with her and with the other students the importance of individual responses to music and the variety of emotional reactions that different people can have to the same piece.

General guidelines for the selection of background music, based largely on my own experience as a musicologist, include the following:

- Avoid music that contains dramatic contrasts of volume (loudness). It may startle listeners, particularly if earphones are used. For this reason, classical symphonic music of the Romantic period (nineteenth century) and some styles of rock music are not advisable as background music, although both may be appropriate as personal selections.
- In general, instrumental selections are less likely to cause controversy than songs, because lyrics may interfere with concentration on tasks and cause strong opinions to form. There are many exceptions to this assumption such as light classical rock (e.g., Beatles), some Broadway and movie soundtracks and songs, or popularized opera selections on occasion (e.g., "favorite arias" recordings by Luciano Pavarotti, Andrea Boccelli, Cecilia Bartoli, and many other artists).
- For relaxation, choose music that is at or below the tempo of a resting human heartbeat (http://www.fitnesscomplete.co.uk/chapters/ft/RHR.htm: approximately 50–70 beats/minute, depending on age and gender). Tempo is the speed at which the "beat" of the music proceeds. It can be detected by tapping the rhythmic pulse of the music and comparing it to the speed of your own heartbeat. "Slow movements" in European classical music often produce a tempo appropriate for relaxation. Another option is the traditional music of East Asia (China, Japan). This style is often based on variable rhythmic phrasing, which eliminates the expectation of rhythmic regularity and consequent "drive" inherent in European-based musical styles. In effect, there is no "beat," so the listener is free to concentrate on the floating sensation of gentle melodic lines.
- For stimulation, choose music with a tempo faster than a resting heartbeat. Music designed to accompany dancing is often this type. Be aware that responses to music are typically influenced by cultural background. Whereas many patients from North America respond most positively to stimulating music in major keys, those of East European or Middle Eastern cultural background may prefer fast-paced music in minor keys, since these characteristics are common in their traditional music styles.[1]
- To facilitate the release of emotions such as sadness and anger, choose music in minor keys. When such music is played, always provide sup-

port for the patient: for example, journaling, private space, or referral to another professional. It is not advisable to use music in minor keys and slow tempo extensively for general background ambience because it may depress some patients. However, the occasional selection of music in a minor key is helpful to provide variety in a program. For example, classic blues can be a wonderful addition to an otherwise upbeat program.
- If background music is used in the operating room, it is often chosen by the surgeon (Adams 2001). Ideally, this should be done in consultation with assisting personnel. If consensus is hard to achieve, the preference of the individual(s) doing most of the surgical procedure may take precedence.
- When choosing musical selections, expand your horizons. Investigate jazz, classical, and world music repertoires, as well as the standard pop, country, or easy-listening options. Although most listeners respond almost immediately to familiar music, the element of surprise, if it is not abrupt, can be heartwarming.

Familiarity as a Therapeutic Benefit?

Studies of the efficacy of music as a therapeutic tool show that for most listeners without a background in music instruction, familiar examples produce the most favorable responses (see the websites of the Canadian Association for Music Therapy and the American Association for Music Therapy for literature lists and links). For example, whatever an elderly patient heard in her youth will bring the greatest attention and relaxation. This characteristic helps to explain why some elderly Alzheimers patients who have lost the capacity for speech can still sing the lyrics to a 1930s pop song with perfect accuracy and why this may result in their depression being somewhat alleviated. Others of the same generation, raised and living in the western states or provinces of North America, may refuse to listen to anything but country and western music even if the nurse or music therapist insists that it is not an option for "healing music." In fact, some recent and controversial research suggests that familiarity and personal taste may be more effective in producing a response than any stylistic element in the music itself (Silverman, 2003). (For a differing view, see Hirokawa, 2003.)

1. The key system in music is a technical concept known to anyone with training in European classical music and to most folk and jazz musicians. If it is not familiar to you, seek advice from a musician or music therapist. In general, "major" keys are perceived as extroverted or cheerful, "minor keys" as introverted or sad. Such perceptions, however, vary with cultural background: there is apparently nothing inherent about them.

If the familiarity factor has validity, there may be an evolutionary component to the phenomenon. Our prehistoric ancestors had to accustom themselves as children to a soundscape of weather patterns, which signaled or curtailed activity; bird songs, which signaled the possibility of food or danger; and the grunts and snuffles of predators passing nearby, which warned them to keep hidden. What our ancestors learned in their youth was imprinted, as were the voices, songs, and drumming patterns of their families, clans, and tribes. Such imprinting might also be a factor in responses to music. For many people in the culture of twenty-first century North America, age and generation identity are important cultural factors. Today's middle-aged adult, having experienced the strong cultural imprinting of adolescence in the 1960s, may currently listen to the Beatles and Bob Dylan to produce a feeling of relaxation and well-being. People born in the 1980s may someday–paradoxically–get the same sense of security from the pounding rhythms and speed of 1990s rock genres. Thus, the definition of what sounds are relaxing or healing may vary from one generation and one culture to another. If you have never heard European classical music before, the loveliest concerto of Mozart may confuse you. If you grew up within earshot of an airport, the sound of distant jet engines may actually produce a feeling of calm at low levels of volume.

Culture also governs taste and therefore therapeutic efficacy. Patients who are immigrants are most comforted by the languages and musical styles of their countries of origin. This aspect brings up the possibility of using spoken language as a mode of therapy as well. Volunteers who can provide conversation, reading aloud, and storytelling in languages other than English (or any other majority language) may prove to be agents of comfort and healing for immigrant or aboriginal patients of any age. Volunteers with the requisite language skills may be found among the elders in an established ethnic community, immigrant populations, and university students specializing in linguistics or particular languages.

Religion plays a role, as well, especially in palliative care. In addition to spiritual counseling, palliative patients may feel a need for the music associated with their religious backgrounds. Such music comes in many forms–for example, church hymns or masses; Russian Orthodox choirs; traditional Buddhist, Jewish, or Christian chants; recitations from the Koran; Hindu *bhajans;* North American and African aboriginal drumming; Japanese music for *shakuhachi* flute. Always ask the patients or the family if they want music to assist them with prayer or contemplation. Recorded examples can usually be found most quickly in the patient's or family's own collection, so ask family or friends to bring favorite recordings to the patient. Otherwise, contact the patient's spiritual community, ask a university music librarian, or search the Internet.

It should be emphasized, however, that health care personnel are not expected to become experts in Ethnomusicology (a term used to refer to scholars of "world music"; that is, traditional and popular music from a variety of cultures). If patients request music outside of your knowledge, consult university music departments and music therapists for advice. It is also important for the health care institution to provide equipment for listening and some personal space (or earphones) and time. If sound-based therapies are considered a priority by the institution, a collaboration of nursing staff, psychologists, and music therapists may be developed to deal with noise problems and to provide ambient music and a listening library for a variety of situations (Cabrera, 2000).

Hearing Protection

Everyday life in an urban society is noisy. Rooms with hard-surfaced walls and floors, such as kitchens, institutional corridors, and operating rooms are especially noisy. If you work with machinery in such a room, your hearing can be at risk. Protective earphones may be appropriate; otherwise small earplugs, available over the counter at pharmacies, are recommended. Noise hazards are particularly common in Intensive Care Units (Akhtar, 2000; Cropp, 1994; Kahn, Cook, Carlisle et al., 1998; Tsiou, 1997), imaging rooms, such as magnetic resonance imaging (MRI) rooms (McJury, 1997), neo-natal units (Guimaeres, 1996), psychiatric units (Holmberg, 1999), and children's clinics or hospitals (Couper, 1994). Simple interventions such as closing doors, wearing soft-soled shoes, and wearing beepers to reduce the use of alarms can be effective. In psychiatric or children's wards and clinics, additional soundproofing in walls, floors, and ceilings may be needed. As well, electronic devices that block sound frequencies by reversing their wave patterns are available on the market and may be advisable for some institutional settings where mechanical infrastructure noise is problem (Akhtar, 2000). If you are involved with building a new facility or remodeling an existing one, consultation with architects, building contractors, and engineers about the acoustical qualities of building materials and flooring is recommended.

CONCLUSIONS

Noise, whether it results from mechanical sources or human activity, is a recognized problem in health care institutions. Infrastructure design should include adequate sound proofing of work areas, and staff should cultivate habits that decrease noise in the workplace. Patients need to be protected from disturbances of sleep that result from continuing ambient noise as well

as sudden bursts of noise. Infants and children are particularly susceptible, so units that care for them need close attention to the acoustics of areas where machinery is in use.

Along with methods for controlling noise, music may be used to alleviate noise-induced stress. Attention needs to be given to the patient's (or staff member's) preferences and cultural origins in the selection of appropriate music. Consultation with a music therapist may be appropriate if music will enhance the patient's perceived sense of well-being, even in the absence of quantifiable results.

REFERENCES

Aaron, J.N., Carlisle, C.C., Carskadon, M.A., Meyer T.J., Hill, N.S., & Millman, R.P. (1996). Environmental noise as a cause of sleep disruption in an intermediate respiratory care unit. *Sleep, 19*(9), 707–710.

Adams, D. (2001). Surgical soundtrack: Tunes to operate by. *AMNews* (online: www.amnews.com). Retrieved November 12, 2001.

Akhtar, S., Weigle, C.G., Cheng, E.Y., Toohill, R., & Berens, R.J. (2000). Use of active noise cancellation devices in caregivers in the intensive care unit. *Critical Care Medicine, 28*(4), 1157–1160.

American Association for Music Therapy. Website address: www.musictherapy.org.

Cabrera, I.N., & Lee, M.H. (2000). Reducing noise pollution in the hospital setting by establishing a department of sound: A survey of recent research on the effects of noise and music in health care. *Preventive Medicine, 30*(4), 339–345.

Canadian Association for Music Therapy. Website address: www.musictherapy.ca.

Couper, R.T., Hendy, K., Lloyd, N., Gray, N., Williams, S., & Bates, D.J., (1994). Traffic and noise in children's wards. *Medical Journal of Australia, 160*(6), 338–341.

Cropp, A.J., Woods, L.A., Raney, D., & Bredle, D.L. (1994). Name that tone: The proliferation of alarms in the intensive care unit. *Chest, 105*(4), 1217–1220.

Cureton-Lane, R.A., & Fontaine, D.K. (1997). Sleep in the pediatric ICU: An empirical investigation. *American Journal of Critical Care, 6*(1), 56–63.

Epstein, M. (1995). Accessing trauma through the voice. In E. Donaldson (Ed.), *Caring for your voice: Teachers and coaches,* 113–132. Calgary, Canada: University of Calgary Press.

Guimaraes, H. (1996). Le bruit dans une unité de soins intensifs. *Archives de Pédiatrie, 3* (11), 1065–1068.

Hirokawa, E. (2003). The effects of music listening after a stressful task on immune functions, neuroendocrine responses, and emotional states in college students. *Journal of Music Therapy, 40*(3), 189–211.

Holmberg, S.K., & Coon, S. (1999). Ambient sound levels in a state psychiatric hospital. *Archives of Psychiatric Nursing, 13*(3), 117–126.

Kahn, D.M., Cook, T.E., Carlisle, C.C., Nelson, D.L., Kramer, N.R., & Millman, R.P. (1998). Identification and modification of environmental noise in an ICU

setting. *Chest, 114*(2), 535–540.

Krumhansl, C. (2002). Music: A Link between cognition and emotion. *Current Directions in Psychological Science, 11*(2), 45–50.

Liu, E.H., & Tan, S. (2000). Patients' perception of sound level in the surgical suite. *Journal of Clinical Anesthesiology, 12*(4), 298–302.

McJury, M., Stewart, R.W., Crawford, D., & Toma, E. (1997). The use of active noise control (ANC) to reduce acoustic noise generated during MRI scanning: Some initial results. *Magnetic Resonance Imaging, 15*(3), 319–322.

Moore, M.M., Nguyen, D., Nolan, S.P., Robinson, S.P., Ryals, B., Imbrie, J.Z., & Spotnitz, W. (1998). Interventions to reduce decibel levels on patient care units. *American Surgeon, 64*(9), 894–899.

Philbin, M.K. (2000). The influence of auditory experience on the behavior of preterm newborns. *Journal of Perinatology, 20*(8), S77–S87.

Schafer, R. M. (1977). *The tuning of the world.* New York: Knopf. See also Revised edition (1994), *Our sonic environment and the soundscape: The tuning of the world.* Rochester, VT: Destiny Books.

Schafer, R. M. (1993). *Voices of tyranny, Temples of silence.* Indian River, Ontario, Canada: Arcana Editions.

Shanker, N., Malhotra, K.L., Ahuja, S., & Tandon, O.P. (2001). Noise pollution: A study of noise levels in the operation theatres of a general hospital during various surgical procedures. *Journal of the Indian Medical Association, 99*(5), 244–247.

Shertzer, K.E., & Keck, J.F. (2001). Music and the PACU environment. *Journal of Perianesthetic Nursing 2001, 16*(2), 90–102.

Silverman, M. (2003). The influence of music on the symptoms of psychosis: A meta-analysis. *Journal of Music Therapy, 40*(1), 27–40.

Topf, M. (1992). Stress effects of personal control over hospital noise. *Behavioral Medicine, 18*(2), 84–94.

Topf, M. (2000). Hospital noise pollution: An environmental stress model to guide research and clinical interventions. *Journal of Advanced Nursing, 31*(3), 520–528.

Topf, M., Bookman, M., & Arand, D. (1996). Effects of critical care unit noise on the subjective quality of sleep. *Journal of Advanced Nursing, 24*(3), 545–551.

Topf, M., & Thompson, S. (2001). Interactive relationships between hospital patients' noise-induced stress and other stress with sleep. *Heart & Lung, 30*(4), 237–243.

Tsiou, C., Eftymiatos, D., Theodossopoulou, E., Notis, P., & Kiriakou, K. (1997). Noise sources and levels in the Evgenidion Hospital intensive care unit. *Intensive Care Medicine, 24*(8), 845–847.

United States Environmental Protection Agency. Website address: www.epa.gov.

Wallace, C.J., Robins, J., Alvord, L.S., & Walker, J.M. (1999). The effects of earplugs on sleep measures during exposure to simulated intensive care unit noise. *American Journal of Critical Care, 8*(4), 210–219.

Section 3
CREATIVE WRITING

Chapter 13

FINDING THE "FRIEND AT THE END OF YOUR PEN": WHAT MAKES JOURNALING "THERAPEUTIC" FOR PATIENTS AND "PROFESSIONAL GROWTH" FOR STUDENTS

Susan "Boon" Murray

SUMMARY

This chapter applies the work of Adams (1990), founder of the Center for Journal Therapy, who offers techniques for journaling as self-discovery, to examine excerpts from patients' journals. A journal-keeper using Adams' methods might safely release tension, frustration, and strong emotion; make a record of experience as it unfolds (e.g., hospitalization); look back to celebrate progress (e.g., recovery and rehabilitation); track cycles and patterns (e.g., fatigue or endurance); and revitalize identity and biography.

Part of this chapter profiles how "stories are medicine" (Pinkola-Estes, 1992) and "art is medicine" (McNiff, 1992) in the creative journals of two patients in an acute physical rehabilitation unit. These findings were part of a lived experience research project facilitated by the author as a recreational therapist. One patient's journal featured an interdisciplinary collaborative approach wherein staff contributed journal entries as progress notes when she was unable to write; the other patient's journal featured self-mediated artwork, captioned digital photographs of therapy sessions, and comments from research interviews where she explained what made journaling "therapeutic."

The final portion of the chapter focuses on journaling as professional development wherein students' written reflections reveal how insight into oneself and clinical practice evolve during field placement. All the following

examples of journaling demonstrate potential techniques for utilizing journaling as a creative arts modality across health care disciplines.

INTRODUCTION

The objective of this chapter is a two-fold exploration of journaling as a potential creative arts approach across health care disciplines: (a) to illustrate what makes journaling "therapeutic" for people with a disabling condition, and (b) to illustrate journaling as a professional growth tool for students becoming helping professionals. The first section contains a working definition of journaling as a modality and insight into the evolution of journaling as a therapeutic endeavor. Next, two brief case illustrations of journaling with patients reveal how journaling might be an interdisciplinary professional approach to support a client or a more self-mediated construction of a client's journey to recovery. Finally, the benefits of students' journaling during field placement are presented, accompanied by techniques to guide this process as personal and professional growth.

Belle (pseudonym), the subject of the first case study, reflected on keeping a journal during her admission to an acute physical rehabilitation unit for a spinal lamenectomy:

> These are my words. Nobody had a gun drawn on me and said "Look we want to hear your story about rehabilitation." The person that his journal is written about is not the same person that went in the hospital. I think I'm a totally different person because of the experience of the therapists and how they worked with me and just their genuine feeling for me. You could vent your frustrations: you could set goals for yourself just by doing this 'rating yourself daily' [a preformatted checklist]. I enjoyed the therapists writing in my journal every day because that really gave me an incentive. I enjoyed discussing it with Boon at the end of the day. This energized me because you're talking about your experiences and your goals. You are the person it's happening to. (Belle's Journal Notes ND)

Kimberley, a patient in an acute physical rehabilitation care unit for pylon training after leg amputation recorded these reflections of her hospital experience:

> Keeping a journal gave me a way of puttin' down how I felt instead of sayin' it.... I don't like to talk so I can say more on paper.... It also showed me my progress. Each day showed me progress. As I look back now I can see the progress I made when I was there and where I was at.... Making the journal helped me think more about things. It also made some of the time go faster. It gave me somethin' else to do than just sit around and think espe-

cially of problems–it was therapeutic. (Kimberley's Journal Notes ND)

Kevin, a therapeutic recreation student working with adults on locked units of a state psychiatric hospital, wrote these comments in his "Daily Log":

> At the day center I observed a patient, he was very sombre. He was sitting there and started singing "Man in the Mirror"–no music, it was like he was desperately searching for answers within himself and had little hope. I only wish I had his rendition on tape as a constant reminder of my job and the services I strive to provide." [Next day]: "I heard a song being whistled by a different patient this time," 'Somewhere Over the Rainbow' by my smoking-restricted-can't-leave-the-ward patient. It was a pure reflection of the ward and his struggles. The patients do take to music quite often, as music treatment is offered, but nobody sings anything upbeat–it always implies change of self, place, and environment. Where's "Don't Worry, Be Happy"?

The final case study records Liz, a therapeutic recreation student working with adolescents in a residential treatment facility. She wrote in her "Daily Log":

> I entered the internship timid and scared and have matured to be confident and assertive. I do not wait for anyone–I do not always need direction, although a guiding hand is good for anyone in any position. I look at my mentors. . . . I have some of all of them in me.

Each of these journal keepers discovered the "friend at the end of their pen" (Adams, 1990) that helped them to make sense of their daily experience as a patient or a student. What therapeutic outcomes did the two rehabilitation patients, Belle and Kimberly experience using the modality of journaling as hospitalized patients?

- Belle found direction and clarity in her rehabilitation goals and motivation when therapists took interest to record progress in her journal and discuss it with her.
- Kimberly revised her identity as an amputee and revitalized her biography as a person with chronic illness as she self-mediated a documentation of change.

What were professional growth outcomes for students using the modality of journaling?

- Kevin's metaphoric reflection about patients singing aloud to themselves developed insight into the mystery of mental illness and his role as advocate and supporter.
- Liz witnessed her transformation from hesitant intern to self-reliant and

autonomous health care professional thanks to mentoring from supervisors and colleagues.

WHAT IS JOURNALING AS A MODALITY?

Journaling is a specific form of narrative activity. It is the distinct immediate expression of subjective personal experience unbound by any writing convention. It may be words spoken and tape recorded, videotaped, or written; symbols, scribbles, stamping, doodling, list-making, mind-mapping (clustering), photo journaling, recording dreams, or art making. Journaling for personal growth and creative expression has evolved in the twentieth century thanks to psychology luminaries (i.e., Carl Jung, Marion Milner, also known as Joanna Field) and Ira Progoff and literary luminaries (i.e., Christina Baldwin, Anne Frank, Anaus Nin, Tristine Rainer, and Florida Scott Maxwell). A journal has been described as "a personal book in which creativity, play and self therapy interweave, foster, and complement each other . . . a unique unrepeatable story of self" (Rainer, 1978, p. 26). Because diary writing is the only form of writing that safely encourages total freedom of expression, journaling is literally an activity of "re-creating" the self.

As a therapeutic endeavor, journaling joins other writing forms as a bibliotherapy approach (Pardeck, 1991) (a) to generate insight through self-reflection about reactions to an illness/disability experience; (b) to explore options for thinking, acting, and coping with clinical issues that arise when discussing daily experience with a caregiver; (c) to reveal people's unique and individual stories and progressions through a recovery experience; and (d) to process feelings regarding intervention and disabling conditions. Journals and diaries have been used successfully as clinical tools to monitor identify, mark a continuum of development or recovery, and integrate and strengthen what happens during therapy (Hymer, 1991).

HOW HAS JOURNALING EVOLVED AS A THERAPEUTIC TOOL?

In 1985, Baer, a social worker and quadriplegic who used the art experience with cancer patients to deal with extreme stress, emphasized that there was little ready-made literature available to guide her in a creative arts context:

> . . . the professional person must be willing to explore expressive modalities in order to discover appropriate therapeutic techniques in an unstructured milieu. There are no protective ground rules. . . . The restorative properties of self-

expression are almost completely uncharted. (206)

While that may have been true in 1985, a burgeoning interest in journaling has given rise to a proliferation of journals for healing across therapeutic populations and settings. Many journals are designed as self-mediated tools or may be completed in workbook fashion under the guidance of a health care professional. An example of this latter is *The Write Way to Wellness*™ (Adams, 2000). Journaling can be a facilitated group process across health care and human service settings and in support groups. In the following portion of the chapter, some of the ways that journal writing has been used as a therapeutic tool since 1985 by nurses, patients and grieving parents are outlined.

Hobus (1992) explored written journals as a dimension of nursing therapeutics and as an innovative use of literature as intervention. She narrates a clinical application featuring a young male injured in a motorcycle accident. His mother began a journal during the first weeks of his hospitalization, recounting his struggle to survive. As recovery and rehabilitation progressed, he assumed that task and used it for "attitude adjustment" on bad days by looking back to see how far he had come. He cherished an entry from his father—a poem which metaphored the strenuous effort of rehabilitation as a mirror of his former dedication to football. As a person adjusting to chronic illness, this "Touchdown in Slow Motion" entry continually instilled hope inspiring him to persevere in treatment. Nealon (1993) identified a way to integrate writing with nursing as healing art. "It is a tool. No more or less than a diabetic diet list of food exchanges, a back brace, or a video on self-injection" (p. 91). Nealon has facilitated journaling with oncology patients, female inmates, and people dying of AIDS. She believes that nurses use the journal themselves as compassionate providers and healers "to shelve and catalogue our experiences" (p. 93), thereby reasserting order in the face of daily trauma.

Parents could be trained to address grief and loss with Marge Heegaard's *When Something Terrible Happens: Children Can Learn to Cope with Grief* (1992), a guided workbook to be illustrated by children. *Fire In My Heart, Ice In My Veins: A Journal for Teenagers Experiencing a Loss,* written by a social worker (Traisman, 1991), could be usedwith adolescents who had experienced violence such as the Columbine High School massacre or with survivors of the World Trade Center attacks on September 11, 2001. In these situations, nurses who treat and de-escalate front-line trauma could collaborate with other professionals who use journaling as intervention such as counselors, professionals providing solace or spiritual comfort, or recreational therapists debriefing traumatic experience through writing. Or nurses and other health professionals could construct journals as interactive workbooks to elicit writ-

ten, spoken, or drawn responses from patients in order to identify specific therapeutic issues or concerns (Schumacher, Wantz, & Taricone, 1995). For example, Dion's (n.d.) *WRITE NOW: Maintaining a Creative Spirit While Homebound and Ill* is available without charge to patient groups and service providers. It is disseminated with a generous open-duplication policy supported by the Puffin Foundation.

Additionally, *The Healing Way: A Journal for Cancer Survivors* (Davis, 2000) could be used by a professional to facilitate a support group activity. This spiral-bound journal is formatted with ruled blank pages and writing prompts that structure and contain the experience of cancer before, during, and after treatment. The table of contents is a psycho-social menu that includes, for example, the following writing prompts: "before treatment begins" (your treatment decision, your hopes and fears, taking stock); "about yourself (loss of dignity, your appearance, photos, image, counseling); "spirituality" (spiritual comfort, pets, insights, and miracles); "end of treatment" (fear of recurrence, thanking your caregivers).

For children with cancer, The Children's Legacy publishes two life journals by Tartakoff titled *My Stupid Illness* (1991) and *Let Me Show You My World* (1994). Each spiral-bound journal lays flat and is preformatted with open-ended statements for a child to express emotions with word completion and photographs. Each journal becomes a legacy-building memoir after the child's death to be treasured by family and friends.

The Way of the Journal was designed by psychotherapist Kathleen Adams (1993) as a self-paced journal therapy workbook for clients and was successfully tested with clients at The National Centre for the Treatment of Dissociative Disorders in Torrance, California. It contains many simple journaling techniques featured in *Journal to the SELF: Twenty-Two Paths to Personal Growth* (Adams, 1990). It is an ideal clinical resource for the studied and ethical facilitation of journaling. Adams provides direction on how to build a journal therapy library, explanations as to why journal writing is a powerful adjunct to therapy, and journal therapy interventions for common clinical situations.

Adams recommends that health care professionals should not facilitate journaling casually. They should experience journaling firsthand to realize its emotional impact. They should become skilled in facilitating writing techniques that suit the context of various populations and healing purposes (e.g., bereavement journals or exercise and fitness journals). Adams provides a Clinical Journal Therapy Home Study Series approved for continuing education by the National Board of Certified Counselors that is open to related fields (www.journaltherapy.com). Her Write Way to Wellness™ workshop is pending RN continuing education credit approval with the American Holistic Nurses' Association.

The authors of *A Recovery Workbook: The Road Back from Substance Abuse* (Neal & Taleff, 1999) address the issues of chemical dependency counselor education through journaling. The workbook begins by urging journal keepers to record affirmations before they explore spirituality, recreational activities, family and social life, employment, legal issues, health, education, and home. Recovering individuals are also encouraged to create their own categories. This workbook could be assigned as "homework," or it could be completed during group sessions or at least processed and debriefed as chapters/topics are finished.

The Insomnia Journal (Liebowitz, 1997) delightfully but practically illustrates the improvisational context of designing journals for specific conditions such as for people with sleep apnea. This spiral-bound journal with an elastic closure provides a Twelve-Step Sleep Checklist, ruled blank pages for writing entries with simple suggestions such as deep breathing and use of herbs, and a resource list of Sleep Disorder Centers in the Untied States. All of the above-mentioned contemporary journals represent the facilitation of writing as nurturing self-acceptance and a healing tool to befriend oneself.

HOW IS JOURNALING FACILITATED BY PROFESSIONALS AND SELF-ADVOCATES?

The use of diaries, which some people equate to journals, has received limited clinical attention as a therapeutic tool (Hymer, 1991). In contrast, famous and familiar writers have used journaling to create records that teach about the meaning of illness and recovery. Although these authors may not have been deliberately applying the stylistic conventions of journaling, their journal entries can be analyzed and categorized by a writing technique described by Adams (1990) as the "journaling toolbox." Adams is a licensed psychotherapist, certified poetry therapist, author, trainer, and founder of The Center for Journal Therapy. She explores various strategies for recording journal entries in *Journal to the SELF: Twenty-Two Paths to Personal Growth* (1990) and in the *Journal to The SELF Instructor Training Manual* (1997). Adams has designed training workshops that apply techniques based on poetry therapy to train health care professionals in the use of the journaling toolbox.

There are a number of journals that could be used by those who are unfamiliar with the journaling process for healing one's illness such as the following: *Risking Hope* by Kathleen O'Connell Chesto (1990); *Intoxicated by My Illness* by Anatole Broyard (1992); *The Measure of My Days* by Florida Scott Maxwell (1968); *In Search of Wings* by Beverly Bryant (1992); and *All the Way Broken* by Iolene Catalano (1995). Those unfamiliar with journaling could frame their exploration of existing journals for healing with an understand-

ing of these basic journaling techniques for possible facilitation.

Each of these aforementioned journals demonstrate one or several of Adams (1990) journaling techniques. For example, *Risking Hope* demonstrates captured moment technique while *Intoxicated by Illness* illustrates both journal notes and perspectives technique. In contrast, *Measure of My Days* was character sketch technique of self as patient. *In Search of Wings* "can best be described as part calendar, part diary, part reminders . . . an addendum to your brain" (Adams, p. 125) which she used after her traumatic brain injury. Finally, *All the Way Broken* was classified as a "stream of consciousness or meditative reflection" (Adams, 1990) technique and telling the story behind the story technique. All five examples reveal how journals and diaries can afford patients the expression of emotional depth with a resulting sense of self-understanding that can be liberating (White & Epston, 1990). These journal excerpts "teach" helping professionals about suffering and how patients make sense of their situations–expressively with humor, poetry, music, and language.

The two illustrations that follow of facilitating journaling with patients will profile more specifically what makes journaling "therapeutic." This context derives from a recreational therapist's humanistic perspective, which assumes that the central goal is empowering participants to "re-create" themselves by focusing on leisure*ability,* not incapacitation (Peterson & Stumbo, 2000). Using a creative arts approach helps people gain control themselves because "clients . . . own the power that brings significant change in clinical practice" (Cowger, 1994, p. 264). In summary, journaling can assist "not only as a diagnostic and therapeutic endeavor, but also as a human interaction addressing moral, emotional, and metaphorical levels of meaning" (Charon, 1986, p. 71).

BELLE'S AND KIMBERLY'S CREATIVE JOURNALS OF REHABILITATION

From 1994 to 1997, this chapter's author conducted dissertation research to understand, describe, and interpret patients' "lived experience" of acute physical rehabilitation (Murray, 1997). The purpose was to understand more deeply the patient's perspective and then to apply this understanding to make recreational therapists' caregiving more action-sensitive. Although the aim of this phenomenological approach (see also Van Manen, 1990; Munhall, 1994a) was understanding and interpretation, not intervention or experimentation, the study became a mutual discovery of the *meaning* of rehabilitation where participants' first-person accounts of recovery included their journal entries. Journals were containers of their subjective experience along with interviews and participant observation.

Belle's Creative Journal of Rehabilitation

Belle was a pilot participant in this research and a middle-aged survivor of a lifetime of chronic illness. She was recommended by unit recreational therapists for her talkativeness, a favored quality in selecting an informant who can describe experience. Belle had chronic rheumatoid arthritis and recent surgery, a C2 corpectomy with mandibular ostcotomy. Her severe hand contractures and lack of upper body mobility inhibited self-generated writing and artwork. This posed an immediate challenge to writing a creative journal. This obstacle was circumnavigated in two ways: (a) using a collage approach where Belle verbally directed me to manipulate art materials to create journal entries as daily summaries of experience, and (b) Belle asking nursing staff or transport aids to place her journal in her wheelchair bag enabling her to carry it to therapy gyms where therapists would retrieve it and compose progress entries.

I provided Belle with a one-inch vinyl binder customized with the name, *Belle's Creative Journal of Rehabilitation*. It contained (a) preformatted blank pages titled by discipline (e.g., "Conversations with My Nurse" or progress across disciplines "Today in Physical Therapy, Today in Occupational Therapy, Conversations with My Doctors" (see Figure 13.1)); (b) calendar pages to mark the days of her hospital stay, and (c) a three-hole punched zippered bag of color markers and pens. Belle and I reviewed her journal as a daily "debriefing" process in later afternoons after active treatment, working together at the tray table over her bed in her hospital room. Nurses necessarily interrupted our research activity to administer medication or provide treatment on this acute level unit, and Belle and I welcomed their looking at her journal pages. We would stop to incorporate a nurse's entry as a comment about Belle's experience of medication or treatment issues. Alternatively, nurses might write a short motivational message to Belle in her journal.

As the principal investigator, I utilized *Magazine Photo Collage* (Landgarten, 1993) to facilitate additional journal pages about Belle's overall daily experience of recovery. This culturally sensitive art therapy approach requires a facilitator to collect popular magazines representing the ethnicity of the client. The client tears out images to create a "people" folder and a "things" folder to create thematic collages. The facilitator invites the client to free associate with the magazine images utilizing directed tasks such as, "Tell me anything that *comes to your mind* about each picture," and "Pick out four, five, or six pictures that stand for something *good* and something *bad*." *Magazine Photo Collage* is a highly intuitive process tool designed to explore treatment issues with a possible thematic orientation. It appeals to helping professionals who prefer right-brain

approaches.

In Belle's case, I offered her black women's popular magazine's and color catalogs of rehabilitation aids. On her verbal instruction, I turned the pages for her and tore, positioned and glued images on blank journal pages. She directed me to tear out a wheelchair, reachers, therapy mats, and a mirror and then related the good and bad, positive and negative aspects of these items as relevant to her rehabilitation experience. When she was invited to select one thing to talk about, she selected an incontinence product—an adult brief (see Figure 13.2). In this manner, this collage sparked our continued exploration of constrained dependence and dignity in relation to Belle's functional independence and recovery.

Belle's journal became a public document and a source of curiosity among nursing staff on the three shifts in this hospital unit. The nurses wrote daily motivational messages, often with a spiritual theme honoring Belle's professed values. In the therapy gyms, physical and occupational therapists completed daily entries of Belle's progress and illustrated them with drawings and doodles explaining treatment sessions in a non-clinical language, which also included good-humored teasing and motivational messages (See Figure 13.1). When Belle expressed amazement at this

Figure 13.1. Belle's preformatted journal page completed by PT and OT.

attention, the therapists became playfully competitive, making creative entries or opting to use whole blank pages. For instance, a physical therapist drew stick figures to represent Belle's progress to move from a sitting to a standing position (see Figure 13.3). An occupational therapist began illustrating handwritten progress notes with watercolor drawings during treatment sessions, thereby aligning Belle's immediate functional goals to her self-articulated goal of recording her life story. One illustrative example would be learning how to turn her journal pages with a pencil grip (see Figure 13.2).

One journal entry during her recovery at an acute physical medicine and rehabilitation hospital summarized her thoughts and feelings about the journal process in this way:

> It had a tremendous effect on me. I was really able to express me in ways that I wanted to for a long time and the response that I've gotten in return from my therapists has been overwhelming. I had no idea that they felt that way towards me. It was all useful to me because again, I got a chance to express my feelings through the pictures, the collages that we made and listening to the therapists' descriptions of the daily things we did. It makes you dig back in your mind and think over the things that annoy you, things that make you happy, things that you have to do to make your health be better. (Belle, personal communication, July 26, 1994)

> Is this something GOOD or something BAD? This represents something bad. This is something that I use on a daily basis that I'm not too comfortable with cause when I go down to therapy. I'm very uncomfortable with it cause having to wear slack I just feel so bulky with it on. But I have to because I'm not able to use the commode yet. I don't have the stand and pivot well enough for them to assist me in the bathroom. So for that reason in case I can't control it until I get upstairs I have to use that. And at home I sleep with it at night because I can't get up and go to the bathroom. So I'm hoping for the day when I can get up during the night and use by bedside commode. I think that's when I won't look at it as a bad thing but a good thing that I could get out of it.

Figure 13.2. Belle's journal page as Occuational Therapy Progress Note.

Figure 13.3. Belle's journal page as Occupational Therapy Progress Note.

Belle's occupational therapist described Belle's therapeutic outcome in the following manner:

> I just think it was incredible especially with this patient. This is something that I personally have been looking for in my treatment. It seemed to bring the team together and allowed us to look at her function across the board and coordinate that in a way. But also I think it gave the patient a real inspiration and really affirmed her sense of, "These people are caring about me. This is what I'm doing. This is concrete on paper. This is showing me my progress." Also, I think it represented that she was able to express herself. (J. Cassell, ITR/L, personal communication, July 28, 1994)

The creation of Belle's journal was effectively a rehabilitation team approach given that her functional limits for creative expression had to be circumnavigated. By contrast, Kimberly's journal, which is discussed next, was a more self-mediated experience facilitated by a creative arts approach.

Figure 13.4. Belle's journal page as Occupational Therapy Progress Note.

Kimberly's Creative Journal of Rehabilitation

Kimberly was a 48-year-old female who had diabetes since age twelve. She was hospitalized for amputation of her right leg below the knee and subsequent pylon training. Fluctuations in blood sugar complicated her rehabilitation progress and extended her hospitalization as medications were adjusted so she could tolerate strenuous therapy. Kimberly created metaphors of these bodily experiences by titleing her recovery, "The Story of Kimberly Who 'Buried an Old Friend and Found a New One' While 'Doin' the Dip.'" She called her amputated right leg her "old friend," pylon training "her new friend" and fluctuations in her blood sugar "doing the dip."

Kimberly dons her pylon.	Kimberly attaches her waist belt to her pylon.	Kimberly practices in physical therapy.
Kimberly practices walking in physical therapy.	Kimberly practices activities of daily living in occupational therapy.	Kimberly gardens in recreational therapy.

Figure 13.5.

Kimberly was one of four research participants who completed journals in the post-pilot study of their lived experience. The journaling approaches had been revised following the pilot study (Murray, 1997). For example, digital photography was added. I photographed Kimberly in therapy gyms and during unit activities such as donning her pylon, walking between parallel bars and on stairs, practicing Activities of Daily Living (ADL), and gardening in recreational therapy sessions (see Figure 13.5). She memorized her progress by archiving photographs and making captions for them as journal entries. "I get the memory of the feeling, it's a good thing because it makes you think about what you went through. . . . I came a long way" (Kimberly, personal communication, July 31, 1995).

During her treatment, Kimberly was provided with a one-inch vinyl binder customized with a cover featuring her name on rainbow paper; she titled it *Kimberly's Creative Journal of Rehabilitation*. It contained: (a) blank preformatted pages, which were categorized by the disciplines involved in her care—nurses, doctors, and rehabilitation therapists; (b) pages to record her Daily Experience of Rehabilitation Scale, her bodily response, social relationships, sense of comfort in physical space, and sense of time; (c) a monthly calendar page to mark days and events; (d) vinyl sheet holders for business cards of caregivers for outpatient contact; (e) blank hole-punched sheets of paper and a zippered bag of colored markers for drawing and collage-making; and (f) blank hole-punched envelopes for storing greeting cards, menus, prescriptions, or any memorabilia from her hospital stay.

I brought Kimberly's journal to the weekly treatment team conferences where I, as her recreational therapist, reported her progress. At that time, I updated the team on Kimberly's activity as a research participant by passing the emergent journal around the conference table, thereby sharing her treatment and research outcomes with nurses and therapists. In order to share her journal entries with other professionals, I used "process consent" (Munhall, 1994b), which is a continual negotiation of commitment to research activity with her permission. Some therapists joked that they found reading other disciplines' journal entries more interesting than reading Kimberly's medical chart thanks to the excitement of animating treatment sessions with personalized illustrations and photographs. Staff also questioned whether most clinicians could make time to contribute journal entries for a large number of patients if all patients were encouraged to journal their hospital stay.

One day, Kimberly pulled her pylon onto her hospital bed and began drawing on it with the color markers in her journal (see Figure 13.6). Drawing on her pylon had the outcome of accelerating self-acceptance and emphasizing her former identity as a woman who was not an

Figure 13.6.

amputee. Kimberly stressed that using several colors was important because it reinforced what she learned in therapy about the complexity of donning a pylon. Her tone of instructive caution mimicked her therapists' cues and revealed that adjustment to amputation is a uniquely individual process:

> Because it pertained to me, by lookin' at it and puttin' it on paper. . . . it gives you more knowledge about it. It makes you more interested and I do have to learn it for the rest of my life. They tell me this won't be the final one [definitive leg], but this is the one to *get used to* [emphasis added]. So I still have to know about it and it stays on my mind by puttin' it on paper. (Kimberly, personal communication, June 7, 1995)

In addition to her enjoyment of drawing, Kimberly enjoyed making collages. One Sunday, she made her way independently to the hospital chapel. When she described her day, she reminisced about the morning service and her health and medical history. She wanted to create a representation of "something in the preacher's words that meant I learned and listened" (Kimberly, personal communication, May 28, 1995). Because Kimberly was black, I followed Landgarten's (1993) culturally sensitive approach to provide ethnically relevant images that is described in the *Magazine Photo Collage*. I brought her a stack of popular black women's magazines. She created a collage that she titled "Amazing Grace" (see Figure 13.7). As a person oriented to spirituality, churchgoing, and Bible reading, she especially related to magazine images of black women with outstretched arms raised to the sky. She explained to me that this was "praisin." If I had unwittingly provided her with white women's popular magazines representing my own ethnicity (see Figure 13.7), she would not have expressed this important aspect of her cultural and spiritual experience. One collaged image was a woman using a wheelchair: "Well, from this picture, it looks like they feel happy even though they're in a wheelchair and there's hope—somebody is 'praisin,' just glad to be there" (Kimberly, personal communication, May 28, 1995). Kimberly added a health promotion reminder by labeling her collage with affirmations written in a red marker around the images of the women, "Eat the right foods, take your medication." She also hinted at the source of her own motivation: "God gives you strength for the times you use excuses that you just don't want to do nothing."

Making artwork deepened the feeling quality of their daily experience in such a way that both Belle and Kimberly were surprised with their subsequent gains in self-awareness with self-recognition. As Dewey (1934) explained, "It brings to definite perception values that are concealed in ordinary experience because of habituation. Ordinary prepossession must be broken through if the degree of energy required for an aesthetic experience is to be evoked" (p. 173).

The rehabilitation journals of Belle and Kimberly suggest their therapeutic value from a holistic healing perspective because they demonstrate their ability for self-responsible goal-seeking (Howe-Murphy & Charboneau, 1987). This holistic model is in contrast to traditional medical model approaches, in which patients are passive recipients of prescribed care, such as in surgery and medication treatment.

According to Adams (1997), outcomes of journaling may include the following: developing self-reliance and self-esteem; stress management; reality orientation; greater awareness of emotional triggers; gaining focus, direction,

218 *Creating Connections Between Nursing Care and Creative Arts Therapies*

Figure 13.7. Kimberly's magazine photo collage, "Amazing Grace."

and clarity; documenting change; mood and behavior management; insight orientation; increased expression of thoughts and feelings; witnessing one's own healing process; improved relationship skills; and telling the "story behind the story."

Additionally, a journal can unlock professional development through reflection about practice. A disability self-advocate cautions,

> I tell teachers and therapists all the time, "If you really want to work on professional development, keep a journal . . . you don't gain the ability to deal with the complexity of people just by acquiring an abundance of strategies. You gain the ability . . . from depth of thought." (Giangreco, 1996, p. 10)

Students who keep journals awaken to the nuances of clinical insight as they gain self-knowledge and achieve personal growth through looking back on their daily experience. Nursing and many other health care disciplines require students to maintain journals as an academic assignment during coursework and especially during field placement (Baird, 1999).

CAN JOURNALING EVOKE STUDENTS' PROFESSIONAL DEVELOPMENT?

Health care professionals need to care for clients while simultaneously engaging in their own personal and professional development. Many health care practitioners in the UK relieve the stress of practice through reflective writing courses via the Internet, where they can process their daily experience (Bolton, 1999). Similarly, students can begin to make the transition to a professional role by reflecting on their clinical practice through writing. Nursing education is increasingly incorporating reflective writing to achieve various outcomes: (a) to instill social responsibility and cultural sensitivity (Mayo, 1996); (b) as self-assessment of personal wellness and making sense of experience (Button & Davies, 1996); (c) as critical thinking, observation and description, and to enhance empathy and release of feelings (Patton, Woods, Agarenzo, Brubaker, Metcalf, & Sherrer, 1997); and (d) as promotion of autonomy and self-direction (Riley-Doucet & Wilson, 1997). Nursing students connect clinical experience to classroom learning by journaling their exploration of their deepest feelings (Dobie & Poirrier, 1999). Nursing, social work, and pharmacy students use journaling to write informal reactions to the professional literature to gain confidence in their fields of knowledge, to shape their opinions, and to discover their professional identity (Balkema, 1999).

The practice of journaling as an educational tool has been the subject of some debate (Cameron & Mitchell, 1993). On the one hand, it is viewed positively by educators who are proponents of student-centered learning, and who thereby relinquish control to their students (Jasper, 1995). Another concern is whether the facilitators have adequate training to equip them to be competing in the technique and in ethically handling understanding of the techniques to use writing assessment as personal revelation (Swartzlander, Pace, & Stamler, 1993). Holmes (1997) recommends that grading student journals can sabotage "speaking and listening to the voice of practice" (p. 492). Supervisory expectations for articulating professional identity, or too much emphasis on writing mechanics, may inhibit students from writing their true perceptions which may differ from the journal reviewer's values or clinical knowledge.

Educators or clinicians who use students' or clients' journal entries as clinical or instructional examples should secure written consent as a ritual of respect. This consent may be embedded in informed consent if the author is a research participant; if not, Table 13.1 exemplifies a way to solicit and document consent to use writing expression. Since journal entries represent a writer's state of mind at a moment in time, an individual whose perspective

has changed may or may not claim self-representation in a designated journal entry. The writers may want to reveal their identity in order to verify subjective experience (Personal Narratives Group, 1989). On the other hand, a writer may prefer anonymity, especially when material is confessional (Sparkes, 1995).

Holly (1989) categorizes and displays various styles of journal writing that may include: (a) journalistic writing (logging detailed descriptions of daily occurrences), (b) analytical writing (focusing on relationships between topics), (c) evaluative writing (synthesizing information formatively and summatively as one looks back at experience), (d) therapeutic writing (uncovering unconscious patterns of personal behavior and reactions to doing therapeutic work), (e) reflective writing (pondering and reconsidering one's experiences), (f) introspective writing (examining one's thoughts, sensory experiences and feelings), and (g) creative and poetic writing (entries that uncover experience with fresh and playful interpretive viewpoints).

Just as clients gain therapeutic outcomes from writing a log or journal, students can also benefit from this activity. That is, journaling can assist them to release tension, frustration, and strong emotion safely; to make a record of field placement as it unfolds; to track cycles and patterns that facilitate their understanding of interactions with clients and staff; to identify progress by reviewing earlier entries; to clarify goals; and to write spontaneously rather than clinically (Murray, 2000). Journaling one's field placement experience to identify the transformation from student to professional can be a collaboration between academics, students, and agency supervisors. There is ample room for innovation, including integration of the creative arts process with the clinical supervision of students who journal back and forth with mentors from other disciplines (Durkin, Perach, Ramseyer, & Sontag, 1989). One example from therapeutic recreation literature illustrates how a journal might be structured and contained as reflective writing.

How Do Therapeutic Recreation Students Journal Field Placement Experience?

Murray (2000) collaborated with students to illustrate how they might "re-create" themselves in their journals through reflection as beginning professionals. *A Daily Log for the Therapeutic Recreation Intern* (2000) allows students, academics, or agency supervisors to construct a preformatted field placement log using revisable and reproducible journaling templates on an accompanying diskette. A laminated guide illustrates how agency supervisors and educators might tailor journaling categories within settings and job tasks, encourage use of the log for mentoring or clinical supervision, and how they

might even journal with the students.

A Daily Log for the Therapeutic Recreation Intern contains preformatted, two-sided blank pages that invite students to: (a) summarize daily experience in "the daily entry"; (b) ask what is unanswered, confusing, or puzzling in "questions"; (c) record new terminology in "vocabulary of the setting and profession"; (d) relate and mark change or inertia in "progress on goals"; (e) express hunches and insights in "perceptions"; and (f) explore emotional reactions to therapeutic work in "awareness of emotions." Sample entries from students Kevin and Liz show how introspection yielded insight and empathy across these six categories. Kevin completed his field placement in locked psychiatric units of a state mental hospital while Liz completed her practicum in a residential treatment facility for adolescents. Kevin's "daily entry" 4/12/98:

> TGIF. I was unsupervised for most of the day. I enjoy this, I don't get nervous, I run the show and need permission from no one. I made this point clear to my supervisor that I am more vocal in ITPs and rounds with the team—where I don't have the security of the supervisor. For the last two weeks she is going to observe my groups, so away we go!

Liz's "Questions" 2/08/98:

> How do the clients perceive themselves as compared to other teenage girls? I ask this because twice today at treatment conference I heard the term "normal teenage girl." It was said once by a client and once by a parent. In fact, the client whose parent said this was told by his daughter to repeat it numerous times. How are clients viewed? I realize they have a disabling mental condition but are they not still teenage girls? Granted, the majority of their lives have by no means been common or traditional development. But when I look at my clients in my assigned cottage, I first see teenage girls, then I see their mental condition. Can we not all see this?

Liz's Vocabulary of the Agency 1/29/98:

> **Dynamic crisis**–a child has run out of effective, rational, healthy ways to cope. Strategies include these staff roles toward clients: **accounting**–routine minded continuity, **reflecting**–listener, **relating**–relationship builder, **structuring**–giving reward/consequences, or **teaching**–process-oriented.
> **Lifespacing**–an intervention technique using talking to calm a client in crisis to prevent putting the client in restraints.
> **Offroutine**–the highest level of punishment, when a client cannot leave his or her bedroom eats meals in his or her room, and cannot attend school or activities.
> **Participation log**–a common log kept by TR (Therapeutic Recreation) personnel to record clients' progress on their treatment objectives.

Kevin's "Progress on Goals" 3/26/98:

> I will be writing up a protocol for my program **Stress Management**, completing Objectives 3 and 4 of Goal 4. Post-entry check will be provided in the box, if completed √ I'm changing the format of my group for my special project. So I am exchanging my protocol called **Address Your Stress for Men's Town** which will deal with men's health issues, and skill development for our more restricted patients. I hope to get these guys to help me develop this special project.

Liz's "Perceptions" 4/14/98:

> Things are moving well on my internship. Everyone calls me "low maintenance" intern. Well I know what's expected, and I do it. It's simply my personality. No one has to tell me to do things twice. Give me directions once, and I'm all set. I also enjoy taking the initiative. For example, over April recess I want to do a craft group. I want to make birdhouses out of milk jugs. No one gave me this idea, I came up with it, it's me. What can I say? I love what I have chosen to do...."

Kevin's "Awareness of Emotions" 3/18/98:

> As James Brown once said, "I feel good!" The other CTRS (Certified Therapeutic Recreation Specialists) are supportive, they give me ideas. My supervisor is open to ideas and shows concern for me and assures me when I feel clueless. It felt odd to finally start the role of a therapist. The time it clicked with my 1:1 patient during our conversation. I wasn't in a hypothetical situation at school about the real deal. I let him speak, I asked questions that were open-ended, yet providing him an opportunity to tell me as much as he would like, unrestrictive, yet productive.

Although language can illustrate the predominate journal entries of the students across disciplines, art making can add depth and metaphor to their expression of feelings. Another student, Tonya, who had recently completed her field placement involving the facilitation of recreational activity for people with developmental disabilities in group homes, culminated her "Awareness of Emotions" category with a collage (see Figures 13.8 and 13.9). She contrasted her initial expectation of "an undemanding experience" with the reality of "a perpetually frenzied experience" in ways that mirrored the complexity of health care and human service delivery.

Figure 13.8. Tonya's Collage, "What I Thought/Expected My Internship to Be."

Figure 13.9. Tonya's Collage, "What My Internship Has Actually Been."

Table 13.1
CONSENT AND RELEASE FORM FOR CLIENTS' OR STUDENTS' JOURNALING

> ***CONSENT AND RELEASE TO USE WRITING EXPRESSION**
>
> You are being asked for permission to use your journaling as a powerful example of technique or meaning as writing expression. Please complete this form and attach it to a copy of your requested work. Thank you.
>
> 1. **Permission to Quote, Copy, and Read Aloud, or Public Your Work:**
>
> This is to acknowledge that I, _____
>
> authorize and grant permission to _____NAME OF CLIENT OR STUDENT_____ to use the
>
> attached writing expression as a teaching example for classes, lectures, presentations,
>
> workshops, or scholarly articles about journaling.
>
> 2. **Description of Writing Expression**
>
> Approximate Date Written:
> Technique or Subject:
>
> 3. **Preference of Author for Anonymity/Disclosure of Identity:**
>
> Unless I specifically request acknowledgement of a given identity, I understand that my anonymity and confidentiality will be protected. Please [(] one of the following:
>
> o I DO want my given legal name acknowledged which releases the Professional or Instructor from normal confidentiality/anonymity protection in copying, reading, or publishing my work.
>
> o I DO NOT want may name acknowledged; please keep my work anonymous and confidential.
>
> I understand that signing this release does not in any way waive copyright to my writings:
>
> Date:_____ Client / Student Signature: _____
>
> Date:_____ Signature of Witness:_____
>
> Date:_____ Signature of Professional or Instructor:_____

*Adapted from training materials provided by Kathleen Adams, 1997 Instructor Certification Training for Journal to the Self, Center for Journal Therapy, Arvada, Colorado.

CONCLUSION

What are the outcomes of journaling among patients, students, and professionals? Nurses and other health professionals who help clients and students journal their stories assist the former to make sense of their disabling conditions and also facilitate students to make sense of entry to professional practice issues. Reading and listening to clients' journals and those of students who relate challenge and change may foster renewed excitement for practice among nurses, other health care practitioners, and academics (Murray, 2000). Those health care professionals who engage in journaling often discover coping strategies for stress management, a way to track their growing knowledge and competence, and an approach for expanding awareness of self and others. As more knowledge and understanding develop about journaling as a creative arts approach to healing, it is likely that more nurses and other health care practitioners will create journals themselves or facilitate others to create journals that restore or comfort. Additionally, academics and mentors may begin to create open-ended journals with students as collaborators to integrate the creative process.

As journaling gains increased acceptance as a therapeutic endeavor and as a learning strategy, measures will be needed to ensure that consideration is given to multicultural aspects and that the catharsis or release of emotions is skilfully handled by the facilitator. Journaling has the potential to heal and enlighten clients and students for whom it is appropriate, providing that the facilitators engage in ongoing studies about how to provide effective facilitation including continuous training in method and process skills.

REFERENCES

Adams, K. (1990). *Journal to the self: Twenty-two paths to personal growth.* New York: Warner Books.

Adams, K. (1993). *The way of the journal: A journal therapy workbook for healing.* Lutherville, MD: The Sidran Press.

Adams, K. (1997). *Journal to the self instructor certification training manual.* Lakewood, CO: The Center for Journal Therapy.

Adams, K. (2000). *The write way to wellness.* Lakewood, CO: The Center for Journal Therapy.

Baer, B. (1985). The rehabilitative influences of creative experience. *The Journal of Creative Behavior, 19*(3), 202–214.

Baird, B. (1999). *The internship, practicum, and field placement handbook: A guide for the helping professions.* Upper Saddle River, NJ: Prentice-Hall.

Baldwin, C. (1977). *One to one: Self-understanding through journal writing.* New York: M. Evans.

Balkema, S. (1999). Developing a professional identity with journal reading and writing: The advanced composition course for nursing, social work, and pharmacy students. In S. Gardner & T. Fulwiler (Eds.), *The journal book: For teachers in technical and professional programs* (pp. 31–41). Portsmouth, NH: Boynton/Cook.

Bellas, R. (2001). Nurses and personal journal writing. *Creative Nursing, 3,* 11–14.

Bolton, G. (1999, July 17). Stories at work: Reflective writing for practitioners. *The Lancet, 354,* 241–243.

Broyard, A. (1992). *Intoxicated by my illness.* New York: Fawcett Columbine.

Bryant, B. (1992). *In search of wings.* South Paris, MA: Wings.

Button, D. & Davies, S. (1996). Experiences of encouraging student-centred learning within a wellness-oriented curriculum. *Nursing Education Today, 16*(6), 406–412.

Cameron, B. L., & Mitchell, A. M. (1993). Reflective peer journals: Developing authentic nurses. *Journal of Advanced Nursing, 18*(2), 290–297.

Catalano, I. (Speaker). (1995, September 9). *All the way broken–the life story of Iolene Catalono.* (Cassette Recording No. 9509090205). Washington, DC: National Public Radio, All Things Considered.

Charon, R. (1986). To render the lives of patients. *Literature and Medicine, 5,* 58–74.

Cowger, C. D. (1994). Assessing client strengths: Clinical assessment for client empowerment. *Social Work, 39*(3), 262–268.

Davis, M. (2000). *The healing way: A journal for cancer survivors.* Boston: Element.

Dewey, J. (1934). *Art as experience.* New York: Perigee Books.

Dion, S. (n.d.). *Write now: Maintaining a creative spirit while homebound and ill.* Carneys Point, NJ: Write NOW.

Dobie, A., & Poirrier, G. (1999). Connecting classroom and clinical experience: Journal writing in nursing. In S. Gardner & T. Fulwiler (Eds.), *The journal book: For teachers in technical and professional programs* (pp. 20–30). Portsmouth, NH: Boynton/Cook.

Durkin, J., Perach, D., Ramseyer, J., & Sontag, E. (1989). A model for art therapy supervision enhanced through art making and journal writing. In H. Wadeson, J. Durkin & D. Perach (Eds.), *Advances in art therapy* (pp. 390–432). New York: Wiley.

Field, J. (1936). *A life of one's own.* London: Chatto and Windus.

Frank, A. (1952). *Anne Frank: The diary of a young girl.* New York: Doubleday.

Giangreco, M. (1996). "The stairs don't go anywhere!" A self-advocate's reflections on specialized services and their impact on people with disabilities. *Physical Disabilities: Education and Related Services, 14,* 9–14.

Heegard, M. (1992). *When something terrible happens: Children can learn to cope with grief.* Minneapolis, MN: Woodland Press.

Hobus, R. (1992). Literature: A dimension of nursing therapeutics. In J.F. Miller (Ed.), *Coping with chronic illness: Overcoming powerlessness* (pp. 323–352). Philadelphia: F. A. Davis.

Holly, M. E. (1994). *Writing to grow: Keeping a personal-professional journal.* Westport, CT: Heinemann.

Holmes, V. (1997, December). Grading journals in clinical practice: A delicate issue. *Journal of Nursing Education, 36*(10), 489–492.

Howe-Murphy, R., & Charboneau, B.G. (1987). *Therapeutic recreation intervention: An*

ecological perspective. Englewood Cliffs, NJ: Prentice-Hall.

Hymer, S. (1991). *The diary as therapy: The diary as adjunct to therapy.* Englewood Cliffs, NJ: Prentice-Hall.

Hymer, S. (1991). The diary as therapy: The diary as adjunct to therapy. *Psychotherapy in Private Practice, 9*(4), 13–30.

Jasper, M. (1995). The portfolio workbook as a strategy for student-centred learning. *Nursing Education Today, 15*(6), 446–451.

Jung, C. G. (1961). *Memories, dreams, reflections.* New York: Random House.

Landgarten, H. (1993). *Magazine photo collage: A multicultural assessment and treatment technique.* New York: Brunner/Mazel.

Liebowitz, F. (1997). *Insomnia journal: Between dusk and dawn.* New York: Stewart, Tabori & Chang.

Mayo, K. (1996). Social responsibility in nursing education. *Journal of Holistic Nursing, 14*(1), 24–43.

McNiff, S. (1992). *Art is medicine: Creating a therapy of the imagination.* Boston: Shambala.

Munhall, P. K. (1994). *Qualitative research proposals and reports: A guide.* New York: National League for Nursing.

Murray, S. (1997). Patients' lived experience of acute physical rehabilitation and recovery contained in a creative journal. *Dissertation Abstracts International.* (University Microfilms No. AAD97-24259).

Murray, S. (1997, May). The benefits of journaling: Stories are medicine/art is medicine. *Parks & Recreation, 32*(5), 68–75.

Murray, S. B. (2000). *A daily log for the therapeutic recreation intern.* Ashburn, VA: National Therapeutic Recreation Society.

Neal, A. K., & Taleff, M. J. (1999). *A recovery workbook: The road back from substance abuse.* State College, PA: Venture.

Nealon, M. J. (1993). Journal keeping and increased self-awareness: A working tool for healers. *Addictions Nursing Network, 5*(3), 90–93.

Nin, A. (1975). *A woman speaks: The lectures, seminars, and interviews of Anais Nin.* Chicago: Swallow Press.

O'Connell Chesto, K. (1990). *Risking hope.* Kansas City, MO: Sheed & Ward.

Pardeck, J. T. (1991). *Using books in clinical practice.* Kansas City, MO: Sheed & Ward.

Pardeck, J. T. (1991). Using books in clinical practice. *Psychotherapy in Private Practice, 9*(3), 105–119.

Patton, J. G., Woods, S. J., Agarenzo, T., Brubaker, C., Metcalf, T., & Sherrer, L. (1997). Enhancing the clinical practicum experience through journal writing. *Journal of Nursing Education, 36*(5), 238–240.

Personal Narratives Group. (Eds.). (1989). *Interpreting women's lives: Feminist theory and personal narratives.* Bloomington, IN: Indiana University Press.

Peterson, C., & Stumbo, N. (2000, 1984, 3rd ed.). *Therapeutic recreation program Design: Principles and procedures.* Needham Heights, MA: Allyn & Bacon.

Pinkola-Estes, C. (1992). *Women who run with the wolves.* New York: Ballantine Books.

Progoff, I. (1975). *At a journal workshop.* New York: Dialogue House Library.

Rainer, T. (1978). *The new diary: How to use a journal for self-guidance and expanded cre-

ativity. Los Angeles: J. P. Tarcher.

Riley-Doucet, C., & Wilson, S. (1997). A three-step method of self-reflection using reflective journal writing. *Journal of Advanced Nursing, 25*(5), 964–968.

Schumacher, R., Wantz, R., & Taricone, P. (1995). Constructing and using interactive workbooks to promote therapeutic goals. *Elementary School Guidance and Counseling, 29,* 303–309.

Scott-Maxwell, F. (1968). *The measure of my days.* New York: Penguin Books.

Sparkes, A. C. (1995). Writing people: Reflections on the dual crisis of representation and legitimation in qualitative inquiry. *QUEST, 47,* 158–195.

Swartzlander, S., Pace, D., & Stamler, V.L. (1993). The ethics of requiring students to write about their personal lives. *Chronicle of Higher Education, 39,* B1–2.

Tartakoff, K. (1991). *My stupid illness.* Denver, CO: The Children's Legacy.

Tartakoff, K. (1994). *Let me show you my world.* Denver, CO: The Children's Legacy.

Traisman, E. S. (1992). *Fire in my heart–ice in my veins: A journal for teenagers experiencing a loss.* Burnsville, NC: Rainbow Connection.

Van Manen, M. (1990). *Researching lived experience.* New York: State University of New York Press, SUNY Series in the Philosophy of Education.

White, M., & Epston, D. (1990). *Narrative means to therapeutic ends.* New York: W. W. Norton.

Chapter 14

THE EMBODIMENT OF NURSING ART: UNDERSTANDING THE CARING-SELF IN NURSING PRACTICE THROUGH REFLECTIVE POETRY-WRITING AND ART-MAKING

A. LYNNE WAGNER

INTRODUCTION

Caring, the essence of nursing (Saewye, 2000), is a complex phenomenon of nourishing behaviors and relationship-building that has been identified as the art of nursing (Naden & Eriksson, 2000; Nightingale, 1969). Levels of caring range from task-oriented "doing for" another with little relationship toward a more interpersonal "being present" for another with intertwining relationship (Benner & Wrubel, 1989). The higher level of caring relationship between nurse and patient/client, which is therapeutic, transforming, and life altering, is like dancing with another, responding sensitively to the signals of one another, and moving with purpose through a space that is defined by the music of the relationship. Such a "caring dance" offers a myriad of healing possibilities through transpersonal connections that bolster human resources toward a renewing wholeness (Watson, 1999).

The nurse is instrumental in establishing such therapeutic relationships. To care artfully, to "dance" therapeutically with another, requires a conscious knowing of nursing science and art, knowing of self and an ethical commitment to another (Carper, 1978). From this multifaceted knowing, nurses are able to respond to patients' needs, and healing possibilities emerge from the "caring moment" (Watson, 1988). Understanding self and the impact of self in caring relationships is a crucial part of creating a caring practice in nursing.

The development of a caring nurse is a complex phenomenon. The caring nurse-self is an evolving "personality" that is influenced by multiple realities and relationships with others (Schon, 1987). Each therapeutic nurse encounter with a patient or client is a learning experience and a unique connection to another human being. When two people are in a caring relationship, however brief, each person in the dance gives to and takes from the other in a sacred space that is both intricately bounded and uniquely separate. Each person is forever changed, whether subtlety or dramatically, by the knowing of the other (Watson, 1999). Yet, this change, which has the potential to inform the caring-self, is often unheeded or unappreciated amidst busyness. The ability to honor and understand the process and to engage in artful caring is hampered, at times paralyzed, by the lack of knowing self and the impact of self in nurse-patient relationships, as well as by the often routine nature of nursing tasks in this current cost- and time-efficient health care milieu (Wagner, 1999).

Such personal knowing comes from increased self-awareness of who one is and what one brings to a nursing relationship. As suggested by Silva, Sorrell and Sorrell (1995), nurses need to move beyond task-oriented questions "What do I do or know?" to more relationship-oriented questions of "Who am I in relationship with another?" "What meaning do I find in what I do or know?" Coming to know and understand self, relationships, and the meaning of caring requires a constant reflective practice of exploring nursing experiences, personally and collectively (Johns, 1998).

One reflective strategy for increasing awareness of self and nurse-patient relationships is reflection on caring encounters through poetry-writing and art-making. Aesthetic expression that emanates from personal experience (Dewey, 1934) is a powerful medium for telling stories, which tap and help release inner feelings and emotions. Aesthetic knowing is different from rational cognitive knowing, represented by descriptive factual accounts (Chinn, 1994). Poetry and art, by creating a mosaic of images and metaphor, weave universal threads of human experience into the fabric of the story portrayed. Both inform the science about the human experience more fully by probing the heart and capturing the inexplicable that narratives often miss (Wagner, 2000). The aesthetic process enables nursing students and practitioners to step beyond the cognitive foundations of empirical knowing toward a more personal knowing of human connections. Such knowing shapes the ability to enter into therapeutic caring relationships through honoring both the uniqueness and the sameness of being human.

As such, poetry-writing and art-making have inherent personal value of capturing elusive feelings about nursing experiences in representative frames and, in the process, revealing the meaning of these experiences (McNiff, 1992). Such framing allows for further reflection and broadened understand-

ing of collective experiences. It also provides a visible form for others to share. Sharing aesthetic expression provides a milieu that fosters personal insight as participants "find a part of themselves, of their story in the image the artist puts before them" (Wagner, 2000, p. 9). Collective interpretation can add new dimensions to the meaning of one's experiences as others identify with the human story from which the aesthetic product emanated. Thus, art and poetry serve both as therapeutic outlets for emotions and vehicles of communication that can heighten the conscious level of insight about self and human relationships.

THEORETICAL FOUNDATION

The theoretical posits of Watson's (1988, 1999) *Theory of Human Caring,* Newman's (1990) *Theory of Expanding Consciousness,* and Paterson and Zderad's (1976) *Humanistic Nursing Theory,* as well the conceptual model of reflective practice (Johns, 1998) give foundation to the use of poetry-writing and art-making as reflective tools for personal knowing and for understanding nursing practice. Each of these theorists addresses the use of caring-self in nursing relationships and the profound impact of personally connecting to another human being.

Watson (1999) describes the depth of transpersonal caring that expands healing change. Transpersonal caring is a journey with another person in need and requires the integration of nursing science, caring-self, and moral commitment in the artful giving of care. Watson (1988, 1999) addresses the fact that every nursing experience is unique, each one informing the next. She speaks of a sacred space in the coming together of nurse and patient that has more of an aesthetic sense than a cognitive one. Reflection on the meaning of this space and relationship is best gained through aesthetic expression.

Paterson and Zderad (1976) distinguish between linear objective (outside, rational) and subjective (personal) knowing and the deeper, more therapeutic intersubjective relational connections. It is at the intersubjective level that the importance of human relationship is clear: "In the process of synthesizing personal insight of self with the commonality and separateness of the patient's experience, the nurse attains new understanding of reciprocity and mutuality, creating environment for the complimentary synthesis of the lived experience" (Wagner, 2000, p. 8). Newman (1990) further describes the contextual and temporal journey with self and others in nursing relationships that moves one toward a higher sense of personal and cognitive knowing. The resulting expanding consciousness of changing self allows for insight and continued growth of connectedness with the world.

Reaching the higher levels of transpersonal caring and expanded con-

sciousness of nursing requires that nurses understand the mutuality and the reciprocity of therapeutic relationships and honor the impact of their actions (Mayeroff, 1971). They must appreciate the teaching power of experience over time and engage in the process of active learning. Such learning requires a thoughtful, confrontational reflection on experiences to see patterns, contradictions, and new possibilities for future practice (Johns, 1998). Thus, the experience of nurse-patient relationship becomes a "teacher" through reflection. Aesthetic expressions that emerge from relational experiences (Dewey, 1934) are a form of reflection that is confrontational and revealing (Wagner, 1999). Poetry-writing and art-making are reflective vehicles for expanding the consciousness of caring-self and transpersonal connections in nursing practice.

BACKGROUND

This chapter presents a case study of one Registered Nurse (RN) to Bachelor of Science in Nursing (BSN) student nurse who examines her nursing experiences through story, poetry, and art to reach a fuller understanding of who she is as a nurse and what healing impact she has in her nursing practice. The case illustrates the evolving process the student experienced in creating aesthetic expressions as reflective tools. She shares her struggles and her triumphs in the process but clearly demonstrates an expanded awareness of herself and her nursing practice as a result of the process.

The presented case study is part of a larger multi-case qualitative study (Wagner, 1999) that explored the pedagogical strategy of using reflective story, poetry, and art with RN-to-BSN nursing students to help them examine their caring practice. The nurse researcher followed a group of five students who were enrolled in an elective Holistic Nursing seminar course over a fourteen-week period. For each class, which met biweekly, the students were asked to write a story about a "caring moment" with a patient and, secondly, to translate the story into a poem or art, alternating each class between the two modes of creative expression. The third part of the assignment was to share the story and the aesthetic expression in class. To dispel concerns about creative abilities, emphasis was repeatedly placed on the process rather than the products.

The multiple sources of data collected included field notes from each class, three personal interviews with each participant throughout the study, the students' written stories and poems, their artwork, and their journals that they kept during the process. The interpretive descriptive approach (Thorne, Kirkham, & MacDonald-Emes, 1997) demanded a continual inductive data analysis through transcribed data, repeated emersion in the data, and dis-

cussion with the participants. Analysis of the content and meaning of the emerging themes were continuously intuited by familiarity with the literature on caring, reflective practice, and the therapeutic and teaching possibilities of aesthetic expression. Significant phrases and statements were extracted from the text as exemplars. The following case study exemplifies the process and the power of aesthetic expression to help nurses discover who they are and to embrace their nursing art with new perspective.

CASE STUDY: JULIE

Julie (pseudonym) is a 37-year-old, single, diploma-prepared nurse with ten years nursing experience. She professes to be a deeply religious person. She believes that she was "called to be a nurse," to be a part of God's service in caring for people. This belief is foundational to her nursing philosophy of holistically and non-judgmentally caring for patients as individuals. Her caring encompasses empathy, sensitivity, and "unconditional love" for each patient. Working in an acute care setting, Julie also asserts that nurses need to work efficiently, "to move quickly, think critically, and make decisions rapidly." She returned to school for her baccalaureate degree to advance further but more acutely "to try to fix a burnout feeling" she was experiencing. She did not think that she could "nurse the way she wanted . . . to really care about her patients." Julie represents what Benner (2001) called an "expert nurse," who intuitively and continuously adjusts her nursing actions to meet her patients' needs. However, in the frenzy of her nursing shifts, Julie no longer perceived her actions as caring.

At the beginning of the course, she had a vague sense that the arts could be used as "therapy," but had not thought about nursing being an art or personally using art in her nursing. She was the most hesitant student in the group about using poetry and art as expressive media. Her journey of struggle with the reflective process and her discovery of her caring-self unfolds through her own words and her creative interpretations of her stories.

Story and Collage

The first experience Julie chose to write about and translate into an artful collage happened many years ago, but it "stuck in [her] mind as a very strong memory." She explained this as unusual because "I don't have many clear memories of what I have done." The experience was further described as "the epiphany of her nursing," in which Julie made a difference to a patient and was actually thanked for her caring. The story cen-

tered on her care of a patient who was terrified of a needed thoracentesis due to a previous traumatic experience. Thoracentesis is "the surgical perforation of the chest wall . . . with a needle for the aspiration of fluid for diagnostic or therapeutic purpose or for . . . biopsy" (p. 1549, Mosby's *Medical Nursing & Allied Health and Dictionary,* 1994, 4th ed.).

> I admitted a patient who . . . presented with dyspnea. She had pleural and pericardial effusion. Some of the details are fuzzy, but what stands out was her terror. The doctors felt the patient needed to have another thoracentesis done. The patient remembered the procedure was traumatic. She was extremely reluctant to have this procedure done again. (Julie's Journal Notes, ND)

Julie perceived the patient's fear and stepped beyond her "routine" duty as a nurse to spend more time than usual with this patient and to advocate for her in attaining help.

> She and I discussed how the procedure is performed. We talked about the benefits to be gained if the procedure was done. Then we talked about what benefits (if any) if the procedure was not done. This was not a short conversation. I elected to skip break. I know this sounds trivial, but the patient felt it was important and made her feel I truly cared about her. I offered to be with her the entire time. Also I conveyed to the house staff her fears. The House Officer and I talked about getting anesthesiology involved to do conscious sedation. I made multiple phone calls tracking down anesthesiology. Unfortunately, no one was available. Another nurse, who was trained to give conscious sedation, said she would try to be there when the procedure was to be started. We were both able to be there during the procedure. By the time the thoracentesis was done, it was almost anticlimactic, because the patient's fear was almost totally alleviated. She expressed her thankfulness with our efforts. She also sent a thank you note after her discharge, stating again how much she appreciated our efforts. That day was very special for me. I felt I really made a difference in someone's life. (Julie's Journal Notes, ND)

Julie further explored the multi-sided aspects of this "patient as a person" through a three-dimensional collage (Figure 14.1) made out of felt material in the shape of a fan. It was evident that much effort and detail was put into the crafting of this art work.

> My collage is this funny looking thing. I didn't know how to represent it at first; a picture on a flat surface wasn't going to work. Then I got this idea with the material. At first she was dark and terrified, so one side of this object is just black and blank. On the other side, I added bright strips of color that are randomly decorated to show life, her aliveness. It represents the complexity of who she is behind her dread and being scared. (Julie's Journal Notes, ND)

Figure 14.1. Julie's collage about a patient who needed a thoracentesis.

Her presentation of the collage in class spurred much discussion and interpretation from other class members. Julie was obviously pleased at how her creation was received and stated that she "gained even more perspective about the meaning of her experience [through discussion] than she had even thought about."

Reflecting on the process in her journal, she found that writing the story solidified her thoughts that were needed for the collage-making. The assignment required her "to go deep into her memory and recall a nursing moment" and to ask herself what happened in this particular story, which was "monumental" in her career. However, she did not much benefit in the collage-making process.

> Writing the story made me think and was most definitely helpful in putting together a collage. Sitting down and recollecting past significant experiences of my nursing career was beneficial. I realized this is not something I normally do. I'm not big on reflection. I don't think that way. . . . I'm a great denier; I just kind of move on. I don't like to think about things. Things happen and I go on. I was a little surprised at how few clear memories I have of my many years in nursing. It was difficult at first for me to put together a story. I had to visualize it and think about what happened. As far as the collage part, I didn't find that particularly helpful or insightful. That was done

out of necessity to complete the required assignment. I didn't see the point in the assignment. (Julie's Journal Notes, ND)

Julie was hesitant in the first class about the value of this elective course, based on the class content and assignments. When she voiced her opinions after the sharing in the second class, her classmates reassured her. She spoke of this in her first interview.

I was apprehensive [about doing all the stories and artwork] and I was not going to come back after the first class. . . . I didn't want to run. That's the thing; I run from things that make me uncomfortable and this is not right. . . . I just have to face it and stand up to what I believe and say what I think. . . . So I decided to just talk about it [my feelings]. People said that it was good that I said what I said. That was reassuring. So I didn't feel unwanted. I didn't feel that anyone was judging me for what I said. (Julie's Journal Notes, ND)

Julie also was unsure of herself and uncomfortable during the second class in the sharing of her first story and her art piece because she doubted the worth of her work. She apologized for the quality of her work before she even presented it. However, her classmates praised her story, her caring, and her creative approach to the assignment (see Figure 14.1). She also addressed this issue in the first interview.

[Presenting] was hard, because. . . . I thought my story and art were not very good. I doubt myself. But they [classmates] said good things about my story and project. It made me feel good. So I wanted to share more. (Julie's Journal Notes, ND)

She continued to grow in the process.

Story and Poetry

In her second and fourth projects, Julie translated nursing stories into poetry. Although still focusing on very memorable experiences, her second story related a "profound" experience in which she felt she "failed as a nurse." To acknowledge publicly an "uncaring moment" was a significant step for Julie and speaks to the building of trust and level of sharing in the class by this third meeting. In her very factually written story, Julie described a patient who needed complete care and whose competency to make decisions about his own care was questioned. Although the patient had discharged himself earlier from rehabilitation, he was now hospitalized because of his children's "strong wishes" to do everything possible, "since he may get better." However, Julie sensed that the patient did not want to be in the hospital or have any more treatments.

> He was mostly nonverbal. He spoke strongly through body language. He slept in a fetal position with the blankets pulled over his head. Upon return from a test, he had tears coming from his eyes when I was helping him get back to bed. His facial expression was one of profound sadness. He would never answer my questions. Taking care of this man was painful. His body language clearly spoke of his reluctance to receive care, as well as his dissatisfaction with being in the hospital. (Julie's Journal Notes, ND)

My hunch that he was competent and that he did not want care was confirmed by the patient's brother and by an encounter he had with the patient.

> The third day I took care of him, he was becoming more alert. His brother was visiting with him and told me the patient didn't want the feeding tube placed. His competency was questioned because he never spoke or responded to our questions. One busy day, I couldn't bathe this patient until early afternoon. When I walked into the room, I saw the patient close his eyes. I thought this was due to my presence. After doing a few things, preparing for his bath, I started to wash him. He looked at me with hatred in his eyes and said, "You woke me up. I was sleeping. Couldn't you see I was sleeping?" I apologized profusely, explaining I thought he was deliberately closing his eyes to avoid me. He had no response to this, other than to stare at me. He then asked me, "Haven't you ever been woken up before?" Then he told me to do "what ever I wanted to do. It didn't matter. . . . The hard part was over [me waking him up]." (Julie's Journal Notes, ND)

Julie's written story ends with a rationally stated commentary on the meaning of the experience and the dilemma it presented to her as a nurse.

> My dilemma with this patient was his apparent reluctance to receive care and our continuation to treat him against his will. He would rarely answer us, so we respected the family's wishes. But as I worked with him, I began to believe he was competent. (Julie's Journal Notes, ND)

After reading her story to the class, Julie added more details that were absent in the written story about caring for this patient and about her emotions related to her reluctance to give him care.

> It was a dilemma for me because I was not effective in caring for him. He was clearly unhappy. I felt I should have spoken up more for him. I did four twelve-hour [shifts] with him and I could not do it another day. I felt I had let him down. I felt lousy. It seemed he was looking at me with hate, not letting me reach him. I didn't do a good job. . . . I did not give him all my energy. (Julie's Journal Notes, ND)

The poem she wrote and shared about the story is a powerful testimony of this nurse's insight and sensitivity to the patient's needs and pain. It cap-

tures her emotions and feelings of inadequacy to meet those needs and of letting the patient down. The poem also voiced Julie's own pain as caregiver as she reflected on her sense of rejection and the "noncaring moment."

> Pain Pain Pain
> It's always there . . . Reaching
> Reaching . . . Reaching . . . Clinging.
> Why won't you let me go?
> Why aren't you listening?
> Look at me! See my tears.
> Why won't you help me?
> Misery . . . Agony . . . Emptiness
> Let me fade away. Don't come back.
> Chills, shaking, trembling . . . Make it stop.
> Eyes moist from tears. Body curled into itself.
> Room darkened. Covered head to toe with blankets.
> Why can't you see?
> Why can't you hear?
> Let me be.
> Close the door on your way out.

The poem enhances the story, presenting a raw feeling that is absent in the written story. These feelings emerged unknowingly to Julie through the process of translating her story into poetry. The story-writing offered an opportunity for this nurse, who usually just "moves on" after an experience, to reflect on an unexamined experience that continued to have a strong yet vague presence in her mind. Julie states, "Writing about it helped. It pushed me to examine the situation for first time. I know the patient was angry because his wishes were not being honored, but I didn't do anything about it. I guess it has bothered me for a long time without really knowing it" (Julie's Journal Notes, ND).

Despite her initial hesitation with the process, Julie reflected on this story in creating the poem and asked, "What's important in this story?" Through the process, which she describes below, Julie gained insight and confidence in both her nursing and her poetry-writing.

> As I thought about writing the poem, I had to figure out a way to express the experience, the theme of the story. I thought that would be a way to write the poem. . . . That man was in pain, maybe physical, I don't know. . . . Emotionally, I know. . . . I didn't realize that I was doing this [analyzing]. . . . I knew I just had to write a poem. So how do I do that? I kept asking myself: What was happening? What was going on here? What's important? It was helpful doing that poem. But the work was slow. . . . I think with something like that you have to think; you have to sit and reflect and dwell on it. I guess at first that's why I was hesitant about it. But I wrote it so quick-

The Embodiment of Nursing Art

> ly. It came out and I thought, "Well, it's done.". . . I was surprised I could do it. I liked writing the poem. (Julie's Journals, ND)

Discussing the process later in her third interview, Julie added that she first drafted the poem and then rewrote it, but the "bulk of it seemed to just come." The poem captured the image of "who this patient was," and perhaps more significantly, revealed her own pain as a nurse. New awareness emerged about her nursing.

> The poem eliminated all the technical stuff, all that garbage. It had no floss. It was the purity of the moment, the essence of that person. . . . It made me see more clearly. I should have confronted the family to see why they were allowing him to be this way. How come you're not listening to him? Why do you not see what is happening here? . . . It's so clear now. I had a responsibility to ease his burden, his ache, but I didn't. That's what I felt after I wrote the poem. I hurt for him; I knew what he was feeling, but didn't help him. I would do things differently now. (Julie's Journals, ND)

In her last interview, Julie identified this experience of using poetry to reflect as a turning point in the course for her. It promoted deeper insight of her nursing and gave her confidence in her ability to participate in the class assignments.

> The turning point, I think, was the first poem I did. I remember I felt excited. I thought, "This is pretty decent; I like this; I can do this." I could see what the poem was doing that the story wasn't. It showed the caring, or lack of caring in this case, more clearly. It also showed my feelings, which I felt but never acknowledged. And I remember when I finished the first poem, I knew I needed to do something about this patient's situation. To me this caring moment was incomplete. (Julie's Journals, ND)

Julie's fourth story, the antithesis of her second one, depicts a very recent experience caring for a dying woman for whom she acted as advocate. Beginning with details about her medical condition, Julie then continued a long discourse of how she interceded between the family and doctors to increase the quality of the dying process for the patient and family. Her caring is encased in her reaching beyond her routine duties.

> Over the course of two days, it became clear she was not getting better. . . . On the second day, a family meeting was held. The family felt she had suffered long enough and the decision was made to initiate comfort measures and not be aggressive. . . . She had been in a semi-private room. I was able to procure a private room that evening. . . . She appeared comfortable near death. . . . The family was all there for the death vigil.
> On the third day I saw an order for a blood draw. I was surprised to see the order. I called the intern about it and he said, "I wanted to see how she was

doing medically. I wanted to see if her renal function was improving." I was stunned. He told me that family had agreed to the blood draw. Again, I was surprised. We talked on the phone for a while about the rationale for obtaining blood. We weren't going to change our management based on that blood test. The only person it would benefit would be the physician. He thought maybe she was doing better, so it would be worthwhile.
I told him I would check her vital signs and call him back.... I spoke with the family about the blood test. They had thought it could be obtained through the existing IV, not a peripheral stick. I explained to them gently the intern's request. I asked them if they thought she was terminal. By taking this blood sample, it wasn't going to change anything. Just taking the BP [Blood Pressure] was uncomfortable to the patient. Her face got scrunched up and the tremors came back. The family felt it was best not to get this blood test. Later in the day, the intern thanked me for questioning him. He said, "I didn't know what I was thinking." (Julie's Journal Notes, ND)

After reading her long story to the class, Julie continued to add more details about the patient, the family, and her feelings about the family's and nurse's role in this situation.

The family was part of my care and my responsibility. The first day was so frustrating. She was too sick to be on our floor. She should have been in ICU [Intensive Care Unit] because we didn't have the time she needed because of all our other patients. On the third day, she finally did die with support and in peace. That was a good day.... This illustrated the value of family and relationship and the role of the family and nurse in advocacy. (Julie's Journal Notes, ND)

It was out of this observation of the family's love and grief and Julie's perception of the healing process of letting go that Julie crafted her poem. The poem is an intimate snapshot of a family grieving. Her observations came from taking a closer look at the situation.

Daughters
A caress of the cheek,
A kiss to the lips,
Wipe the shiny brow,
Embrace the body,
Enfold the hands,
Beseech the Lord, tender mercies,
Quietly reminders begin.
Soon tears slow,
Chuckles come forth,
Riotous laughter ensues,
Silence occurs.
Such are these, O Lord, tender mercies.

The poem brings to the foreground the emotions going on in the situation that are only background in the story. Reflecting on the process of translating her story into the poem, Julie related similar comments in her journal and during the interview:

> Prior to this course, I don't recall ever writing poetry. To me, my poem reflected a poignancy that wasn't expressed in the story form or by drawing. . . . It had a tenderness that the story didn't have, I think. The story was more factual and the poem was more feelings. You get a flavor of what was going on. I think for me, it [the poem] seemed to be more representative of what went on in that room with that patient and the family, the love, the letting go. (Julie's Journal Notes, ND)

In general, poetry began to represent a vehicle to bring to the surface feelings that did not emerge from the written story. The process forced Julie to go "inside the story."

> I think poetry is a way of expressing inner feelings, something that's inside you and you have to tap it in a special way. It allows you to bring it to the surface and allows other people, maybe, to see it as well. . . . It allows you to express a feeling that you couldn't express any other way. It gives you a way to share a moment. . . . It's a thought, an image that creates a picture, a feeling....It produces an emotion; it evokes the senses. (Julie's Journal Notes, ND)

At this point in the course, sharing the poem and receiving feedback was a positive experience that allowed Julie to examine her practice more closely, to be more in tune with her caring actions.

> Sharing is always helpful. I find it rewarding hearing others' experiences. Having positive feedback about my own experiences is rewarding as well. . . . I don't think my understanding of caring and healing changed significantly, I just looked more closely and understand better. (Julie's Journal Notes, ND)

Story and Art

Julie completed three art projects around her third, fifth, and sixth stories. Unlike her first "collage" story, which was a dramatic, memorable past experience, each of the "art" stories represented seemingly insignificant day-to-day recent situations. However, they were chosen, as Julie's understanding of caring widened, to demonstrate caring moments in which small nursing interventions caused a change or made a difference. Each drawing (Figures 14.2–14.4) symbolizes a "before" and an "after" image.

Her third story described the routine nursing care she gave to a middle-aged woman who was recovering from a heart attack and the relationship she established with this patient. Sensing the patient's anxiety, Julie therapeutically assisted the patient, fostered confidence, and allowed the patient to expand her capabilities.

> The time came when she could shower. However, she was frightened and fearful of being alone and off telemetry [a cardiac monitoring device]. We reviewed how far she had come and the progress she had made. I offered to assist her with her shower. She was relieved and accepted my offer. I found a shower chair, set up the call light and was nearby the entire time. When she finished her shower and I was helping her get dry, she said she was all set. I could leave the room. She felt confident she could finish on her own and would be just fine. Indeed, she was fine and was eventually discharged, planning to take part in the cardiac rehab program. (Julie's Journal Notes, ND)

After reading her written story, Julie again added more detail to the story and presented her abstract drawing translation (Figure 14.2), prefaced with an apology for her lack of talent. Encouraged by her classmates, Julie began to explain her drawing (Figure 14.2), demonstrating much reflection and insight about the patient's healing progress.

Figure 14.2. Julie's drawing about a patient recovering from a myocardial infarction.

> After her [the patient's] myocardial infarction (MI), her world was black and blank (static). The colors changed as she tried to make sense at what had happened to her and what life held for her. Thus the light colors and the ups and downs of the waves. Yellow is in the middle to represent her world coming together again. There were many changing moods in her healing with peaks and valleys—green for healing and red for anger of the grieving process. The time of discharge was expressed by all the colors affecting her again, but in a more orderly fashion: thus, the vertical lines with space in between to be herself, but with questions of what's going to happen?
> How you come into a situation that is life threatening and how you leave [it] are very different. There are many questions still as you leave. But nurses can be pivotal and how patients do can depend on the nurses. If we do our job well, we are able to help patients reach healing. (Julie's Journal Notes, ND)

Later in her journal, Julie reflected on the reflection process itself, reiterating her struggle and discomfort with the art. However, she recognized that she had found a style that increased her comfort with the process. Her art was uniquely creative.

> I don't consider myself an artist and I initially feel inadequate for the task ahead of me. I have a fondness for colors, particularly bright ones, so I thought that was a good place to start. The piece flowed from there. I began to see the story emerge from the art in a different way. (Julie's Journal Notes, ND)

At the second interview, she described art as an effective reflective tool.

> I guess the art just makes the story richer, the experience, maybe more precious. You create a moment in your mind and then you record it as a picture story. You put it in a form that is more tangible and there is something there that you can hold on to. That would be the largest impact of the art, making me look at what I'm doing, that nursing is most definitely important. It confirms to me that we make a difference. (Julie's Journal Notes, ND)

The fifth story, which Julie entitled *The Interview*, was a short and simple one about a very recent experience. It related how Julie made a special effort to spend time with a patient and form a relationship.

> Last week I cared for a woman who presented with a respiratory flare-up. The patient had been in the hospital a day and a half when I met her. Looking over her chart, I discovered there was no documentation by nursing on her flow sheet—no mention of her being admitted, no admission health assessment, not even a note. Because of this, I was determined to spend as much time as possible with the patient and find out what she was all about. . . . I felt that we bonded and she appreciated the time I spent with her. In the morning she had frequent episodes of breathlessness. By mid-

afternoon, they had decreased in frequency. I'd like to think it wasn't just medicine that improved her respiratory condition. (Julie's Journal Notes, ND)

In a later interview, Julie admitted that because of the reflection required in this nursing course, she now thought more about caring and how nursing impacts patients. She resolved to make a difference for this woman. The accompanying drawing (Figure 14.3) consisted of a two-sided interpretation of this story. One side was mass confusion of scribbled lines; the other side was a sun with orderly rays.

> I drew a "before" and an "after" picture. In the "before," represented by this scrambled mess, there is indifference, non-empathy, confusion, unknowns. In the "after" scene, with the nurse involved, there is brightness, light, understanding and everything is unscrambled. When I thought about this patient, I knew there is a story there, but it wasn't clear until I mapped it out in the picture. The patient is in the center of it all, but you can't tell in the "before" picture. Then there is clearness. . . . My picture clearly shows the patient's progression from confusion to order in a much simpler way [than the story]. This reflection through art has made me more aware of how I do change a patient's course of illness. (Julie's Journal Notes, ND)

Figure 14.3. Julie's drawing about a patient with respiratory flare-up.

Julie continued to describe the process of doing art as difficult due to her perceived inability to draw, but she continued to experiment with her method. In the process, she put much effort into discovering what was important in this story.

> There wasn't any big [moment]. The scene wasn't clear. So I had a hard time thinking, how do I translate this seemingly insignificant moment with a patient into art from words? . . . First, I just drew stick people. I did a little in pencil. I then forgot that idea, because that was not going to work. I didn't have the talent to tell the story in that way. I had to do it in colors and I had to do shapes more abstract to show the change. (Julie's Journal Notes, ND)

In reflecting further on the process, Julie wrote in her journal of her increased awareness of the power of nursing, despite the common placeness of the experience.

> Creating the drawing prodded me to reflect on my nursing and the impact it has on the patient. It made me really think about what my role was and how the patient was feeling on this ordinary day. To do the art, I had to think about images and I saw myself there again. Doing the drawing painted a picture of contrasts. It showed me that being an involved nurse you can make a difference in a patient's life. Even a small difference is special. (Julie's Journal Notes, ND)

Julie's last story again centered on a recent routine nursing experience around a "needy, demanding" patient, who had an unusual affect and presented a difficult caring challenge for the nurses.

> I took care of her for three days. The first day she was on the light constantly for minor things. I remember when assisting her back into bed she would panic if lying flat, saying, "I can't breathe. Raise it. Raise it" [the head of the bed]. She would repeatedly say "sorry" after requesting anything. Before I had a chance to arrange everything (phone, call light, etc.), she would instruct me on what to do. By the second day we developed a routine and she was much less needy and more independent. Also she didn't say sorry as often. Working with her for 12-hour shifts over 3 days was a good thing for her, I think. With consistency of nursing, she became more trusting of us and was able to progress and not become so easily distraught over seemingly minor things. (Julie's Journal Notes, ND)

After reading her story, Julie elaborated on it, adding details about the patient's situation and presenting her drawing (Figure 14.4).

> I think my nursing care focused on trust and consistency. So my drawing shows the chaos I think the patient was feeling and then over time, the order. I saw patterns on the left side, but they were all mixed up. So I wanted to show her change by reordering the same colors, but this time with a pattern.

Figure 14.4. Julie's drawing about a demanding patient.

When asked by the class professor what Julie felt made the difference and if there was a particular caring moment that she remembered with this patient, Julie answered:

> I realize now that my nursing made the difference. I looked at what I was doing and where she was coming from. Other nurses would ask, "Why do you want to take care of her?" I liked her; I was somehow drawn to her. I believed in her, believed that she could do more, but just needed some encouragement and trust. [The caring moment was] when she smiled and laughed with me. She had such a flat affect, but I connected with her. There wasn't all despair. I can't say in what particular moment it occurred. It was our relationship over time, I think. (Julie's Journal Notes, ND)

After discovering the approach of symbolically representing through lines and color a change in the patient because of some nursing intervention, Julie consistently used this medium of representing "before" and "after" to reflect on the significance of the story. This approach helped put her caring in perspective.

> The art was hard, because I could not separate my expectations of what the product should be. So to get started, I just thought about what was going on

in the story. Then, what was important? It always seemed when I was doing the art that I was comparing and contrasting. What was the change? How did it occur? That's what I looked for in the story. This process ended up validating my role as a nurse. (Julie's Journal Notes, ND)

Further describing the process of translating her story into art in her third interview, Julie distinguished between the details she included in her report-like stories and the perception that emerged from the art expressions.

[With] the art, you didn't have the technical things, all the padding of the words. My art showed a relationship between the nurse and patient and the effect the nurse had on the patient or even the patient on the nurse. I guess you can't separate that, it's interactive. [The art] gives clarity to what you are saying in the story. . . . In all the pictures I did, the clutter or chaos before and the order afterwards is very vivid; in the story it is buried. (Julie's Journal Notes, ND)

SUMMARIZING THE PROCESS AND MEANING

Rich details and insight emerge from Julie's descriptions of individual assignments. However, a closer look at the collective blended process of story-writing, poetry-writing, art-making, and sharing offers a more holistic understanding of her growth. This overall process and the meaning she gained from the process are discussed below.

Intertwining of Product and Process

Story-writing

The process of choosing a story changed over time. The first story Julie had "to find" was a story in her memory that represented a "big caring moment." The process became easier as Julie's concept of caring changed to include day-to-day routines.

The first story was such an important event in my nursing career; it was easy to find it, even though I had to look hard for the details in my memory. After that it was harder. It's like, now I have to select a story, I have to choose from many as opposed to trying to find a story. But that's the exciting thing, I think. What's going on here in this class is that there is more awareness of what I'm doing and what impact it has on patients. Toward the end, nothing outrageous went on [in the story] so that definitely changed. The story I wrote about just spending time with a patient was not a big thing.

> It was a simple common thing, but I thought about it differently. Before, I didn't have that understanding of caring. (Julie's Journal Notes, ND)

Selecting the specific story for each assignment, Julie had an opportunity to review her nursing experiences, to uncover some unconscious aspects of her nursing, and to remember anew the buried stories from which she could learn.

> I really dug into my memory. I would review all my patients and think about the one that would be the best example of a caring moment. . . . I can't say specifically why I chose one story over another, other than it just seemed to fit. . . . a caring moment or in one case a situation that I felt I could have advocated more for the patient. (Julie's Journal Notes, ND)

The next aspect Julie attended to was how much detail she put into her stories.

> I always had to think, to recall the situation. . . . It was always a struggle as to how much detail to put in. Should I put in all the technical details or what care was given and all the background information. That was always an issue. (Julie's Journal Notes, ND)

Julie needed to write the story first as a foundation or frame for her creative art. She stated, "I need to see the story in writing. Maybe my imagination is not good enough, but I need that step of creating the story before the art." Writing the story made her think more about her nursing and each experience.

Poetry-writing and Art-making

Julie described a delay between the story-writing and the aesthetic translation. At first, the delay was "hours," during which she "wrote the story, thought about it, then did some errands thinking about it." Then the art process was only fifteen to twenty minutes.

> It just seems there's always a delay between stories and the art form. I guess just thinking about it, mulling it over, meditating, thinking how to best express visually what was going on. Then something happens. Usually I doodle, and then something flows. It just kind of comes and it comes very quickly. (Julie's Journal Notes, ND)

The art and poetry transcended the story by distilling the many details into a more powerful representation of the story's essence, the "purity of the moment."

> The poetry and art make my stories clearer to me. I think the reason is they take away all the excess of words. The moment with the patient is more

pure, more vivid. The poetry and art summarize what was going on. You get to the essence of what it was. It makes it more precise. (Julie's Journal Notes, ND)

As mentioned earlier, for Julie, both the poetry and art serve as reflective tools that allow reflection at a different level than the story. However, each art form provided different insights. The poetry captured the "feeling of the moment," gave "depth of emotion," and a "tenderness" to the story. The art visually represented a more framed "change in the patient" that had occurred over time because of the nurse-patient relationship, a "before and after" motif. She described this perspective further in her last interview.

The poetry and art are different. The art seems less emotional, and the poetry seems more emotional. The poems were more reflective of the patient and the intense feelings and not of me as nurse.... The artwork was more how I perceived it [the situation] and the change in the patient that my actions caused. (Julie's Journal Notes, ND)

Sharing

The process of sharing in class dramatically changed over time for Julie. She identified that two of the potential barriers of a seminar course that deals with personal experiences are having "to share part of yourself" and making "yourself vulnerable." She did not feel "safe" in the first class.

I know when I left the first class, I had serious doubts about coming back. I didn't want to share and do all that poetry and art stuff. I didn't see the point. But I decided to stay.... It was still hard in the beginning. You know the part of wanting to have the perfect story, the perfect piece of artwork and if it's not, it's just inadequate. But my peers were certainly supportive and encouraging. That made me feel good.... And then the sharing began and I didn't want to run anymore.... I was more comfortable with the process. (Julie's Journal Notes, ND)

Motivation to do the assignments was high and identification with the other class members provided incentive to continue as a personal investment. This was recognized early in the course.

I find that [this course] affects me personally, more than others.... There is incredible incentive. This is not like me to go home and do assignments. What we are doing here is coming from the heart. It's within me.... I don't know how to explain it. It's like getting to know myself better and then talking about nursing and what nursing is. We [nurses] are sharing on a level we don't usually share. All our goals are the same. How we do it might be different, but our goal is to care for the patient and to make a difference in their

lives. What I like about the class, too, is the emphasis that nursing is not just technology, but caring. It's not just curing a person, but also increasing the quality of the patient's life. (Julie's Journal Notes, ND)

For Julie, the power of the sharing came from identifying with other nurses who had similar practice goals. In the process, she affirmed and renewed her own sense of nursing practice.

Sharing and listening in class to other nurses' experiences was powerful. People have insights into your work that you don't see. It made me proud to be a nurse. I'm excited that other nurses take their jobs seriously and genuinely care for their patients. I learned from them. Sharing produces within me a desire to be a better nurse by being more sensitive and aware of my patients' needs and doing what I can to meet them. (Julie's Journal Notes, ND)

In class, the stories were powerful, but it was the poems and art that stimulated class dialogue and inspired sharing of similar experiences, each on a different level.

Doing the poems and artwork made me think and organize my thoughts before I came to class. They became a neat little summary for sharing. But I never expected the sharing to be so special. The poems brought out feelings, sometimes tears, because we could all identify with what was being said and the poems were so full of emotion. There wasn't much discussion around the poem. I mean the poem was what it was. We listened intently to the poems and could just feel the situation. But the art, that was different. The art is more visible, right there in front of you. More time was spent interpreting the art. It is interesting that they [classmates] bring in a different interpretation than you had. (Julie's Journal Notes, ND)

Meaning

Julie, the most hesitant class member to share her story and art in the beginning, grew more confident in being who she is and in what she brings to nursing. She gained meaning from her personal reflections through creating story and aesthetic expression, as well as from group reflection of sharing. Both the personal and collective reflections increased awareness of self and nursing practice, which holistically are intertwined with each other, each influencing the other. Each step in the process provided different mechanisms for reflection and promoted different insights. The story writing was a strong reflective tool for Julie.

The writing part is good for me. It makes me think about my nursing care and what I am doing. It's like taking an inventory. What is happening in the

> situation? What is my role as a nurse? What is a nurse? What is her function? Because sometimes you forget what you're doing or what you're supposed to be doing. I know what I'm doing, but it becomes by rote almost. You just have to get through the day and sometimes you just forget you're taking care of a person. It's not that I actually forget, but the demands are such that it sometimes is hard to form a relationship. (Julie's Journal Notes, ND)

However, the story translation into the poetry and art provided another vehicle for reflecting at a different level, allowing meaning to become more "visible" in a healing way.

> The process of creating the poem and art is very powerful. I guess the power of it is having it in a different form. Being able to express it in a different way is revealing and healing. Maybe something is going on [in the story] that you don't realize and all of a sudden you see it visible in the art. This is insight. There's something happening when you're inspecting it in another way... You're examining yourself through the story.... Then when you are putting it into art form; you are examining it again with more awareness of yourself and the patient.... It's about the feelings and the consequences. (Julie's Journal Notes, ND)

This new awareness that came from the creative process led her to examine her caring actions in a different way. Through this insight, Julie found meaning in the analysis that affirmed her effectiveness as a nurse and made "visible" areas for improvement.

> The benefit to me is when I look at experiences in a different way, like wow, the confirmation of what I did well and the possible ways to grow... It's a good way of improving yourself, I think.... I think about things so much more now, my nursing and my caring for patients.... I feel as though I am getting burned out as a nurse. I find that it's harder to do what I want to do in this crazy overworked system.... That's the exciting thing. I now have more awareness of what I'm doing and what impact it has on patients.... Many times you have a bad day and just bury it somewhere inside. I don't usually reflect; I don't think about bad days or good days. Life just goes on. But now I do think about moments that have gone on and I look forward to seeing the same patient again the next day and taking care of them. (Julie's Journal Notes, ND)

For Julie, this awareness of herself in her practice and the impact she has on patients also generated an enlarged meaning of caring and a realization that the nursing culture does not always promote reflection or sharing at this level. The process reconnected her to her day-to-day nursing.

> I realized now that caring doesn't have to be spectacular; it doesn't have to be big life-saving events. It can be, but I think [it is also] ... taking care of

somebody every day. . . . Maybe it's obvious, but I don't think we [nurses] talk about those things, what our job is, or the things that we do, the impact, the emotions that accompany the experience. We talk about the things we didn't get done, things that need to be done; we complain a lot, but we don't talk about the good that goes on in the little interactions. This class made me more aware of that. (Julie's Journal Notes, ND)

This enlarged meaning of caring, in turn, enlarged her concept of her nursing practice, which was affirmed through the sharing of stories and artwork with her classmates.

I am amazed about the good days I discovered. If I do think about my days, it is usually the bad ones. But the course was stirring. All the stories made me realize that everyday is a caring moment. It is the little things that are important and worthy of being recognized. I feel I have been rejuvenated in what the role of the nurse is and that caring is the essence. . . . I never thought I'd get so much out of all that poetry and art stuff. But I think it was the creative stuff that helped me see better and be able to share my ideas. It helped me see how wrapped up I am with my patients. I see the consequences. But when we shared, I felt affirmed as a nurse. It just confirmed what caring was all about. (Julie's Journal Notes, ND)

DISCUSSION

This case illustrates the power of creative, reflective story telling to resurrect a sense of "caring nurse-self" and one's nursing practice, in essence, to foster the embodiment of nursing art. The case further supports the premise that different levels of reflection through story aid nurses in reaching a fuller understanding of the therapeutic possibilities of a transformative caring practice.

As identified in the literature, Julie typifies an experienced nurse (Boykin & Schoenhofer, 2001; Roach, 1984; Watson, 1988, 1999) who came to nursing with a mission and a passion to care for her patients and who practices from a caring perspective. However, like many such nurses, she has been severely challenged by the changing realities of the seemingly "crazed" health care system. In her self-identified burnout state of overwork and feeling inadequate to meet the caring needs of her patients, she perceived that she had lost a critical relational piece of her nursing, and a sense of who she is as a nurse. In essence, she had lost a sense of her "caring-self" in her nursing practice and of her rich stories that could teach her about her nursing. However, she did perceive a dissonance between the way she wanted to nurse and the way she did nurse. The discomfort caused by this dissonance was one of the motivating factors for returning to school to renew herself and

advance to "greener pastures."

A second factor that played a role in sustaining her dissonance was her lack of learning, as well as the lack of opportunity and role modeling in her work environment, to reflect on and process her myriad of daily nursing experiences. Julie admitted to burying her days' experiences and just "moving on" without much thought, driving her memories into a "safe" but unconscious storage. Since stories emanate from memories that are accessed through reflection, she initially found it difficult to remember her caring nursing encounters. The lack of inventory-accounting fills the "storage room" without the benefit of gaining perspective from life-teaching experiences. Julie was open to learning new survival techniques based on Murray's (1995) three prerequisites for insight: (1) an unconscious or conscious dissonance or puzzlement about an experience; (2) a recognition and confrontation of the discomfort; and (3) a process that enables the confrontation through examination, identification, and verification of one's thinking.

Julie illustrates that reflection on experience is a forerunner of written or verbal story-telling. Reflection brings memories to the foreground to reveal the details of experiences and to make them available for examination. As such, reflection served as an interpretive act that imparted meaning to Julie's life experiences as a nurse (Van Manen, 1990). Further, others have demonstrated that reflection on experiences increases self-awareness and one's sense of the reciprocal dance that occurs in nurse-patient relationships (Schon, 1987; Wagner, 1999; Watson, 1999). The resulting stories that emerge from reflection transmit knowledge (Sandelowski, 1993), create opportunity for dialogue, and can help one find meaning in life experiences (Diekelmann, 1989). Stories also serve as a vehicle for communication and learning about self and others (Nehls, 1995), foster a non-threatening way of self-disclosure and sharing (Wilson, 2000), stimulate critical thinking (Brookfield, 1987), and facilitate the creation of caring communities (Noddings, 1984, 1992).

Story-telling has been described as a "scientific art form" (Griffin, 1994) that creates a reciprocal dance between the teller and the receiver, with a sense of human connectedness, yet an invitation for personal interpretation and construction of meaning. As with any art, stories change in the remembering, the telling, and the receiving. This changing creates an evolving sense of the original experiences, so as to make the stories representative of events rather than the exact truth (Sandelowski, 1996). Julie struggled to recall and record details of her experience, elaborating more as her memory was stimulated yet again in the aesthetic and sharing process. In addition, Julie's sense of her story changed; it became accumulative as she moved from story-writing to creative expression to sharing. Each step tapped a different part of the story and offered a different perspective on a past nursing experience. This

"reauthoring" is similar to what Boykin (1998) calls "restoried" and Lanzara (1991) names "shifting stories" in the retelling.

The "reauthoring" was significantly driven by the different levels of reflecting. The story was changed as new insight was gained at each level of reflection, each fostering different questions in Julie's mind. This approach is similar to what Johns (1996) refers to as "cue questions" that he uses when he guides nurses in reflective practice. In Julie's case, the "cue questions" were self-initiated by the different reflective levels in which she participated. At the story-writing level, she searched for her story in her memory, bringing the details out of "storage" so they could be examined. Recalling the details of the situation, she asked herself, "What happened? Who was the patient? What did I do?" These are recall questions, cognitively constructed and answered in a factual, rational manner to make a coherent story. This aspect is much like the daily written and verbal reports about patients that nurses initiate. Such cognitive reports address the task-oriented aspects of nursing.

At the aesthetic level of translating her story into poetry or art, Julie asked herself, "What is important here? What is going on here?" Answering these questions, she shaved away the wordiness and the "technical stuff" in her written story. In so doing, Julie felt the poem and art represented the "essence of the story," "the purity of the moment." Poetry particularly "evoked the senses." This process revealed more of the human dynamics in the experience that was missing in the written, more cognitive story (Chinn, 1994). The poetry revealed feelings and emotions that Julie became acutely aware of for the first time, while the art illustrated more clearly her interactive relationship with her patients. The key theme in her art was the change that occurred in the patient because of her nursing actions that demonstrated being intentionally "present" for her patients. As she examined these aspects of the story further, she asked such questions as, "Who am I as nurse? What is my relationship with my patients? What is the meaning of my nursing?" This level of reflection transcends the cognitive to a more affective, relational process, revealing a side of nursing that is not often discussed or processed. She had risen to a transformative understanding of her nursing. Having done the reflective work of story-writing and aesthetic processing, Julie brought an enriched sense of her stories to the table for discussion, making the sharing more powerful.

The third level of reflection, sharing story and aesthetic expression with resulting dialogue, created an opportunity to enlarge the meaning of her nursing through collective stories. The reading of the written stories provided an outline of the situation. The sharing of the poetry and art pulled the participants into the story through the human emotions and visual images. Questions that Julie and her classmates asked as they discussed and explored each other's stories were, "Why did you do it that way? Do you realize how

much you did for that patient? What would you do differently? How can this make a difference in my nursing practice?" This line of questioning fostered further reflection and allowed affirmation of transformative caring (Watson, 1999), brought out as examples in the stories. The process also stimulated each to see what more is possible. A collective sense of nursing and caring emerged from their conversations, promoting a "sisterhood" among the gathered nurses and a "rejuvenation" of their burned out spirit.

Looking at the process in terms of development of the caring-self, Figure 14.5 models the spiral pathway of Julie's expanded consciousness and discovery (Newman, 1990). The three levels of reflection are each important steps in a nurse's ability to be a reflective practitioner. The spiral represents the shell that houses the core of the nurse-self with all the accumulated experiences stored in memory. Julie reached a fuller understanding or knowing of nurse-self in relationship with others through a series of reflective steps that tapped that memory and led her to a more enlightened world-view. The

Figure 14.5. Reflective process of delivery about caring-self as student moved through cognitive, affective, and collective levels of reflection.

process did not change the inherent basic core of her values or intent but did change how she was able to look at her experiences. This closer examination of her nursing increased self-awareness and enlarged the possibilities for her to care for her patients. It was a pathway to discovery.

Reflective process has implications for nursing education and nursing practice settings to teach, value, and provide opportunities for students and nurses to reflect individually and in groups. Story-writing is perhaps the least threatening and time-consuming of the three levels but alone does not complete the needed depth of reflection. Since it is evident that the aesthetic process adds a unique dimension to the discovery of caring-self in nursing practice, nurses should be encouraged to incorporate creative expressions in their reflective practice with emphasis on the process rather than the product.

As nurses' work becomes more stressful and isolating in the demands of the health care crisis, employers need now more than ever to provide opportunities for nurses to share experiences in a reflective and meaningful way. Such sharing will provide a vehicle for support and affirmation, as well as for continual renewal of the caring-self. Furthermore, sharing on the aesthetic level promotes a bonding that can carry over into helping each other in their daily work. It is noted that poetry and art reveal feelings and relationships, exposing part of the nurse-self and making one feel vulnerable. As Julie clearly indicated, the key to sharing on this level is creating a safe accepting environment. This approach has strong implications for redesigning the culture of practice settings. The payoff for this investment will be a strong force of caring nurses who do make a difference in their patients' lives and in the survival of the health care system itself.

REFERENCES

Benner, P. (2001). *From novice to expert: Excellence and power in clinical nursing practice.* Upper Saddle River, NJ: Prentice-Hall.

Benner, P., & Wrubel, J. (1989). *The primacy of caring.* Menlo Park, CA: Addison-Wesley.

Boykin, A. (1998). Nursing as caring through the reflective lens. In C. Johns & D. Freshwater (Eds.), *Transforming nursing through reflective practice* (pp. 43–50). Malden, MA: Blackwell Science.

Boykin, A., & Schoenhofer, S. (2001). *Nursing as caring: A model for transforming practice.* Sudbury, MA: Jones & Bartlett.

Brookfield, S. (1987). *Developing critical thinkers.* San Francisco: Jossey-Bass.

Carper, B.A. (1979). The ethics of caring. *Advances in Nursing Science, 1* (3), 11–19.

Chinn P. L. (1994). Developing a method for aesthetic knowing in nursing. In P. L. Chinn & J. Watson (Eds.), *Art & aesthetics in nursing* (pp. 19–40). New York:

National League for Nursing.
Dewey, J. (1934). *Art as experience.* New York: Perigee Books, Berkley.
Diekelmann, N.L. (1989). The nursing curriculum: Lived experiences of students. In *Curriculum revolution: Reconceptualizing nursing education* (pp. 25–41). New York: National League for Nursing.
Griffin, J. (1994). Storytelling as a scientific art form. In M. Madrid & E.A. Manhart Barrett (Eds.), *Roger's scientific art of nursing practice* (pp. 101–104). New York: National League for Nursing.
Johns, C. (1996). Visualizing and realizing caring in practice through guided reflection. *Journal of Advanced Nursing, 24,* 1135–1143.
Johns, C. (1998). Caring through a reflective lens: Giving meaning to being a reflective practitioner. *Nursing Inquiry, 5,* 18–24.
Lanzara, G. F. (1991). Shifting stories: Learning from a reflective experiment in a design process. In D. A. Schon (Ed.), *The reflective turn: Case studies in and on educational practice* (pp. 285–320). New York: Teachers College Press.
Mayeroff, M. (1971). *On caring.* New York: Harper Collins.
McNiff, S. (1992). *Art as medicine.* Boston: Shambhala.
Murray, M.M. (1995). *Artwork of the mind: An interdisciplinary description of insight and the search for it in student writing.* Cresskill, NJ: Hampton.
Naden, D., & Eriksson, K. (2000). The phenomenon of confirmation: An aspect of nursing as an art. *International Journal for Human Caring, 4* (3), 23–28.
Nehls, N. (1995). Narrative pedagogy: Rethinking nursing education. *Journal of Nursing Education, 34* (5), 204–210.
Newman, M.A. (1990). Newman's theory of health as praxis. *Nursing Science Quarterly, 3*(1), 37–41.
Nightingale, F. (1969). *Notes on nursing.* New York: Dover.
Noddings, N. (1984). *Caring: A feminine approach to ethics and moral education.* Berkeley, CA: University of California.
Noddings, N. (1992). *The challenge to care in schools.* New York: Teachers College Press, Columbia University.
Paterson, J.G., & Zderad, L.T. (1976). *Humanistic nursing.* New York: John Wiley.
Roach, Sr. M. S. (1984). Caring: The human mode of being, implications for nursing. In *Perspectives in Caring, Monograph 1.* Toronto: University of Toronto.
Saewye, E.M. (2000). Nursing theories of caring. *Journal of Holistic Nursing, 18* (2), 114–129.
Schon, D. A. (1987). *Educating the reflective practitioner.* San Francisco: Jossey-Bass.
Sandelowski, M. (1993). We are the stories we tell. *Journal of Holistic Nursing, 12* (1), 23–33.
Sandelowski, M.J. (1996). Truth/storytelling in nursing inquiry. In J.E. Kikuchi, H. Simmons & D. Romyn (Eds.), *Truth in nursing inquiry* (pp. 111–124). Thousand Oaks, CA: Sage.
Silva, M.C., Sorrell, J.M., & Sorrell, C.D. (1995). From Carper's patterns of knowing to ways of being: An ontological philosophical shift in nursing. *Advances in Nursing Science, 18* (1), 1–13.
Thorne, S., Kirkham, S.R., & MacDonald-Emes, J. (1997). Interpretive description:

A noncategorical qualitative alternative for developing nursing knowledge. *Research in Nursing and Health, 20,* 169–177.

Van Manen, M. (1990). *Researching lived experience.* Toronto: University of Toronto.

Wagner, A.L. (1999). A study of baccalaureate nursing students' reflection on their caring practice through creating and sharing story, poetry, and art. (Doctoral dissertation, University of Massachusetts Lowell, 1998). *Dissertation Abstracts International,* 99–(05), 334. (University Microfilms Inc. No. DAO 72699).

Wagner, A.L. (2000). Connecting to nurse-self through reflective poetic story. *International Journal for Human Caring, 4* (2), 7–12.

Watson, J. (1988). *Nursing: Human science and human care: A theory of nursing.* New York: National League for Nursing.

Watson, J. (1999). *Postmodern nursing and beyond.* New York: Churchill Livingstone.

Wilson, C.B. (2000). Caring connections: Self-disclosure of students' stories to teachers in nursing. *International Journal for Human Caring, 4*(2), 19–25.

Chapter 15

POETICS IN PALLIATIVE CARE: RECLAIMING IDENTITIES

ANNAMARIE FUCHS

> The broken solider, kindly bade to stay,
> Sat by his fire, and talked the night away;
> Wept o'er his wounds, or tales of sorrow done,
> Shouldered his crutch, and showed how fields were won.
> Washington Irving (1849, p.14)

In this chapter, the reader is invited to explore a means for learning to understand intimately the nature of suffering from the point of view of the sufferer. In Palliative Care settings, nurses encounter families who are facing intense suffering that often transcends the more common experience of physical suffering or pain. We all suffer in a variety of ways. But in the midst of suffering for the terminally ill who find themselves surrounded by the dominant nature of health care settings, nurses have an important role to play. By becoming caretakers of that suffering, nurses are often torn between the expectations of the profession and the awareness that a much more intimate type of "care" is sought by their patients. The only way to care truly for those who suffer is for that suffering to be "sufferer led" (Georges, 2002, p. 81).

This chapter discusses a method of poetry writing that helped its author express her feelings about her patients' suffering as if she was experiencing the suffering with them. The term poetics is defined by the *Merriam Webster Dictionary Online* as "a treatise on poetry or aesthetics, poetic theory or practice or poetic feelings or utterances." (available at http://www.m-w.com/home.htm). It is the last definition, poetic feelings or utterances, that is used in the chapter. Its application to nursing care is described in this chapter. The use of poetics, while seeming to be for the benefit of the nurse, may also ben-

efit those she has cared; for she uses her voice to further understand her patients while being fully present on the path they are walking. In the end, an awareness of the patient's identity is enhanced as the nurse attempts to comprehend what it actually means to be one of the dying. In this chapter, you will be offered three case studies where the author uses poetics to give voice to her own experience of caring for those with life limiting illness. These poetics, however, go a step further and offer this nurse's interpretation of her dying patients' experience while fully acknowledging that the patient can only know truly the intimate experience of dying.

Nurses spend a great deal of energy discussing strategies for maintaining an ethic of care within our professional practice environments. We have advocated for the incorporation of the ideals of caring throughout much of our history. However, the very environments where we practice often prevent our ability to maintain a consistent atmosphere for the exploration of personal meaning or the demonstration of understanding, empathy, or compassion. The urgent needs of critically ill individuals, traumatic efforts to resuscitate, advanced and frightening technological devices, and the constant drive toward task completion often leave nurses exhausted and morally conflicted. In turn, the voices of our clients are repeatedly silenced.

Hutchinson (1984) used the term "horror" to describe the dilemmas that nurses often face when their ideals are challenged by the realities of health care. She defines horror as "the triumph of unreason; [where] there are no heroes, only victims—whether they are nurses, physicians, patients, or families" (p. 86). Hutchinson (1984) believed that the only way to triumph over the horror that is experienced in health care is to create new meanings that are personal as well as shared through careful reconstruction of the reality that characterizes the practice environment. Simply put, the nurse is challenged to discover a new way of seeing the situation or the environment so that the horror is reduced to more manageable levels.

Benner et al. (1999) assert that the symbolism that was once embedded in the language that we associated with the experiences of caring and valuing has been diluted to "the margins of biomedicine (p. 374)." Nevertheless, there are numerous ways in which to recreate meaning that is rich with the imagery, and that can be associated with human caring. Leininger (1989) documented twenty-seven caring constructs that are designed to motivate nurses to respond to patients in ways that are positive, intimate, and personal. Hutchison (1984) also suggested that nurses apply the concept of culture to a particular health care environment to facilitate a broader understanding of the meanings that underlie the communication that exists between themselves and their patients. Thus, within the ideology of imagery, language, and culture lies the concept of poetics.

Aldridge and Stevenson (2001) invited a patient with schizophrenia to describe her experience through the use of poetics. These authors define

poetics as a method for health professionals to understand the unique and unrepeatable inner worlds of their patients. They explain further that poetics is associated with novelty or the processes of creation that lead us to the opportunity to give voice to something not heard before. Poetics allows us to respond to our interpretation of what we become sensitive to within the experience of caring and to create a dialogue *with* the patient rather than simply communicating *about* the patient. Poetics blends the art of caring with the expectations embedded in our practice, leading ultimately to a transformation of language and its enduring symbols.

According to Gadow (2000b), patients often end up loosing ownership over their own bodies. The use of objective and abstract language associated with professional symbolism shifts personal ownership of the body to that of an impersonal object that belongs to everyone. In fact, she suggested that "the safest body may be the one that disappears" (p. 90). However, Gadow (2000b) provided an alternative. She proposed that "when the words of the other (the patient) become a poet's text, the two are co-authors, composing not a new personal narrative but a relational narrative" (p. 91). Within the health care setting, a diagnosis has the potential to permanently label the patient either positively or negatively. But when the creative nature of poetics is integrated into our language as a way to understand one another, we can potentially help our patients to take back their bodies and recreate the meanings that were forced upon them by the environments and the events that surround us all. Moreover, when we silence the voices of our clients with our bold attempts to provide technically exceptional care, we are also in danger of succumbing to the "triumph of unreason" (Hutchinson, 1984, p. 86).

In the early years of my career, I struggled tremendously with what I called my professional crisis of faith. I believed that if I could become less emotional, and could distance myself from my patients as many of my more experienced colleagues did, then I would have "arrived." Somehow I would have found the secret to professionalism as a nurse. However, that belief was challenged when I moved into Palliative Care. As I began to spend my time with patients who were struggling to maintain their identities amidst the confusion of a highly charged and decidedly technical nursing environment, I experienced a level of stress in my practice that was only eased when I walked with my patients. When I followed my own instincts and allowed myself to be present with my patients on a more intimate level, I was able to find the balance in my professional life that had been lacking. It was when I learned to love, to grieve, and to "be" with my patients that my crisis of faith was ultimately resolved. Incorporating poetics into my practice allowed me to not only gain greater insight into the inner world of those with life limiting illness but also the opportunity to contribute to the gift of voice to the intimacy of dying. In that moment, as caring becomes more clearly defined for me, my

interpretation of the experience of the other (the patient) endures. When language is used in its various forms to create and reflect meaning, then we can conquer that suppression of individuality that is so evident in health care.

The idea of using poetics need not be complicated or frightening. Stelter (2000) suggests that we simply learn to listen to the "quiet dialogue (p. 86)" that exists in every relationship that we are exposed to and document our voices with those of the other. Nevertheless, Gadow (2000a) cautions us to remember that a phenomenon can never speak for itself. We can never convey the voices of our patients without adding our own and must never silence one voice with that of another.

In 1849, Washington Irving published a biography of a poet and author named Oliver Goldsmith. The book described the life, the sorrows, the joys, and the inner world of a man he had deeply admired. Scattered throughout his narrative are poetics written by Goldsmith and others that are rich with emotion and sentiment and carefully designed to enlighten the reader to Goldsmith's own feelings and experiences. The skilled and strategic use of poetics throughout the biography grants a harmony of voices so rich that the reader is left helpless to do anything but walk side by side with the character.

Interpretive poetics, much like those used nearly 200 years ago by Washington Irving, can potentially enhance interpretation of voices, thereby allowing us to understand each other on a much more intimate level. In this way, we can help our patients take back their bodies and we attempt to correct inaccurate meanings forced on them by various diagnoses or medical interventions. In turn, perhaps, we can also even participate in the restoration of our collective humanity.

CASE STUDIES

In this chapter I will provide examples of how I used poetics during my ten years in palliative care to offer my interpretation of the private character of my patients in my attempt to understand and to document their experiences with life-limiting illness. There are three case studies. Each case study begins with a background that describes the individual, the illness, and the setting. In order to ensure anonymity, names have been changed and no dates or locations have been provided. Following each case study is a poetic script where my interpretation of the voice of the patient can be found in the italicized portions of the text. My voice is written in normal text for ease of recognition. In addition, each poetic script is concluded with one passage from Washington Irving's "Life of Oliver Goldsmith, a Biography" which suggests that while emotion and sentiment may be a universal human phenomenon, it is still interpreted in distinctive ways by each of our own voices.

Case Study 1: Recognition

John (pseudonym) was a 75-year-old farmer who came to us after struggling with basal cell carcinoma for nearly 20 years. I will never forget the first time I met him. I had come onto the unit for a night shift. During shift report, I heard details concerning his diagnosis and his treatment plan. However, the taped report did not prepare me for what I was about to see. Shortly before walking into his room to introduce myself, the nurse who had cared for him on the previous shift came up to me.

"Prepare yourself Annamarie," she warned quietly. "John has no face left."

"What do you mean he has no face?"

"Exactly that—there is a cave where there used to be a face." And she walked away.

I entered the room on tiptoe, telling myself that I did not want to wake him if he was asleep but certain that my stealth was more an indication of my fear and disbelief. She was right. I stood in the soft glow of a nightlight gazing at the body and head of a heavyset man. A strangely hollow sound emanated from his pillows. Below his tousled head of salt and pepper hair was a cavern. Hanging in the center was a small piece of what had once been his nose. Otherwise, there was no remnant of where his face had been. Tears immediately sprang to my eyes.

Aware of my presence, he turned his head toward me and waited. "What must this poor man be thinking?" I wondered. "He knows that I am standing here staring at him in horror." I was immediately caught by the astonishing realization of what my silence was communicating to him.

"Hello, John," I whispered. "I'm Annamarie and I'll be your nurse for the next six nights." I reached for the large calloused hand that he had held out to me. Grasping it, I felt his warmth, and the price paid for years of hard work. I found myself liking this welcoming hand. "I don't know you at all John so you'll have to bear with me as we figure each other out." A sound from somewhere acknowledged that he had heard me as he squeezed my hand. "If I make a mistake just keep at me and we'll figure it out together, fair enough?" I smiled and squeezed his hand. John nodded and squeezed in response.

That was the beginning of what grew into a close relationship over several months until he succumbed to the complications of his illness. John found ways to communicate that astounded me. He taught me that we are not simply the image we present to the world. The essence of what we are is so much more than the physical symbols that belie our true nature. What I perceived made John the man that his wife and family adored was something far more elusive than that. I believe that John's identity rested

in his soul. Growing to know this man was like peeking over the wall into a secret garden filled with an assortment of blossoms. This process of getting to know him continued until he died four months later.

Recognition

How do I cry without eyes
without tears to shed?
I cry
with my body, and my spirit!
I cry with my soul, hidden in the deepest part of my being!

Who am I without my face?
My face defined my place in the world!
I am not this monster,
I am John!
I had a large whiskered face.
My smile once lit up my eyes,
And my laugh made everyone around me content.
My wife and children cherished my laugh.
And my wife loved to stroke my face.
I miss the feeling of her touch in the mornings.

But I no longer have a face
or a smile
or eyes
or even a laugh.
Who will know me?
or love me?

Will some despise me?
or gasp with shock at this abyss?
I am still here—I want to shout!
I am still here—I weep, from my core
as tears comfort my silent grief
and my body trembles.

I knew it was you!
The moment I looked at the picture I recognized you, John.
Tears are flowing now as I cry with you and your wife.
We are crying and laughing.
"It is amazing!" I laugh,
"I knew exactly what you would look like!"

We hug
I sit with you and your wife, holding your remarkable hand.

I knew you before I ever saw your face.
You are John!
Your smile lights up the world.
And your laugh - your laugh
is beautiful.
Fuchs Poetics, Case #1

* * * * *

... And as a bird each fond endearment tries
to tempt its new-fledged offspring for the skies,
He tired each art, reproved each dull delay,
Allured to brighter worlds, and led the way. . . .

Washington Irving (1849, p. 149)

Case Study 2: An Ordinary Life

Angela (pseudonym) was thirty-six years old when I first met her. She reminded me of a princess in a fairy tale. She was petite, blond, beautiful, and fragile. Angela had suffered from Crohn's disease for most of her adult life and was in hospital again for investigation of possible exacerbation of her condition. When the tests were completed, we were all devastated at the news. Angela had been diagnosed with advanced carcinoma of the colon. Her prognosis was poor.

When the physician arrived on the unit to confirm the diagnosis with Angela, he asked me to accompany him to her room. I stood at her side while he quietly told her the news. As he left the room, I stood there, helpless to ease the pain and shock that contorted this lovely young woman's face. Silently, I begged for the words that would comfort her. Angela rolled into a ball on the bed and rocked back and forth, weeping without a sound. I sat and rubbed her back, saying nothing until she finally whispered that she needed to be alone. I backed slowly out of her room, closing the door.

It was a year later when that beautiful girl was near death. She had said goodbye to her two little boys in the weeks prior to her last admission to hospital and sent them home with their father. She was determined that their memories would not be of their mother in her current physical condition. Her beautiful blond hair had long since fallen out as a consequence of her battle for life. Her abdomen was hugely distended and hard, her legs were swollen, and her color was deeply jaundiced. It was the middle of the night. I quietly opened the door to her room to check on her, hoping not to disturb her sleep. But when the smell of her favorite perfume hung heavily in the air, I knew she was awake.

She was sitting there in the dark, fingers intertwined holding the weight of her belly against her body as pregnant women often do. As I stood in the

doorway I realized she was weeping. I moved over to her and placed my hand on her head, stroking her scalp and whispering, "Oh Angela, I wish I could do so much more for you." Like a child, she gulped loudly and began to sob uncontrollably. Her tiny frame heaved as her sobs shook her. She wrapped her arms around my waist and buried her head against my chest, weeping as I soothed her.

"I just want this to be over," she choked. "I can't do this anymore." Her huge blue eyes stared into mine. "Do you understand? Do you think I'm giving up? I can't stand how I look and feel. I'm just so terribly tired."

I held her face in my hands and assured her, "I don't think you're giving up, Angela. You've fought harder than anyone I know, and it's okay to decide when you've had enough. It's more than okay. It's your right!" I continued holding her as she poured out her fears and her struggles to me. She revealed countless fragments of closely guarded secrets, her desperate loneliness, and the lost opportunity to live a completed life. I rocked her gently as the scent of gardenias encircled us. Two days later, Angela slipped away. She died on her own terms with only her sister in the room as she had insisted, her goodbyes previously shared with the rest of her family. Until the night we sat together, I did not completely understand her choice to push away all family including her sons with the exception of her sister. Her obituary contained a beautiful image of the way she was determined to have her family remember her.

An Ordinary Life

Will I ever be ordinary again?
Did this disgusting disease build a wall between me
and my ordinary life?
Like a tumour that separates health from illness
did cancer separate me from the familiar?

I gaze at her in astonishment.
Nothing about you has ever seemed ordinary to me.
I have known you for years.
You are so beautiful—one of those striking women I would have stared at
out there in the world walking with your boys,
laughing and tossing your long blond hair over your shoulders.
You are bright, funny, interesting, and beautiful; anything but ordinary!

Look at me!
Really look!
I want to be invisible again
To play in the soccer field with my boys
like every other mother—nobody really pays attention to . . .

But in this place
I don't want to be invisible
I WANT TO BE UNDERSTOOD
. . . to be left to grieve my death in my own way
. . . to be allowed to anticipate my death in my own time

Your strength is extraordinary.
I picture myself in your place–alone and dying.
I would want my family close by
would want to have every possible moment with my son, my husband, my sisters
before my light was extinguished.
before the scent of my presence was only a faint memory.
But instead you decide that it is the living
who will carry the burden of memory
and you have the courage, the strength, to choose what that memory will be.

Let me grieve.
Allow me the right to create the memories of me
that I want left behind.
Close my door
but don't leave me completely alone.
I am still frightened–frightened about what lies around the corner
waiting for me.

Let me fill the air
with the scent that defined my place in this world . . .
my place as an ordinary woman
with a body–a battle worn body perhaps
but MY body–one that I recognized
I don't know her anymore–the one who stares back at me in the mirror.

I know that this is where I am consigned to be.
Comfort me
and allow me to rest.
Allow me to close my eyes and rest.
But I beg you to remember me, as I was
as an ordinary life.

I sit quietly
rocking you in my arms while you weep.
It is my blessing to have become a safe harbour for your grief.
You have courageously taken the risk that another human being
may have a memory of you that is not one of your choosing.
Fear not little one.
I remember you–your strength, your courage and your beauty.
Fuchs Poetics, Case #2

* * * * *

But then they're so handsome, one's bosom it grieves.
What signifies handsome when people are thieves?
But where is your justice? Their cases are hard.
What signifies justice? I want the reward!

Washington Irving (1849, p. 208)

Case Study 3: The Battle

I was a senior nursing student when I first met Dan. I had little experience with the terminally ill, but somehow it always felt like I was where I belonged when I was caring for those with life-limiting illnesses or the frail elderly. Dan had fought lung cancer for two years before I met him, and he was now dying. He had been a complicated patient. In those days, the symptoms experienced by lung cancer patients such as the distress of the shortness of breath accompanied by the pain of tumor growth were more difficult to manage. Dealing with Dan's symptoms, however, was even more of a challenge. He had been found to have adverse or allergic reactions to virtually all standard therapies for providing comfort that had been tried. He and his family were tired and frustrated. And the latest attempt at relieving his pain had left him agitated, confused, and restrained.

It was an early morning in June. The sun had just risen and was peeking through the part in the curtains as I slipped into Dan's room to check on him and his medications. As I walked in, I was caught by the intent stare of a wide and frightened pair of eyes. He was restrained, but his hands were free, and he was reaching desperately for me. I reached to take his hands in mine and felt him tighten his grip. "Big mistake," I realized. "I'm not getting out of here any time soon!"

I looked around for a chair and found one within reach of my foot. I dragged the chair over and sat down, leaning my chin on the bed rails close to Dan's eyes. He diverted his gaze to my hands, turning them back and forth but not relinquishing them. He looked up from my hands back into my eyes as his breathing became more distressed. I knew there was no other place I was going to be for awhile. So I sat, talking quietly with him and allowing him to continue kneading and squeezing my hands. When I promised that I would stay for awhile, he relaxed his grip but only slightly.

Dan rolled himself as closely into the side rail near me as he was able. I continued to speak softly and prayed for him as he had requested. After awhile, I felt a presence behind me and turned to see that his grown son had arrived. His eyes were full of tears as realization dawned on him. "He's worse this morning, isn't he?"

"I think you should probably go home and get your Mom. I'll stay with him until you return," I assured him. As his son leaned over and kissed his father, Dan's breathing became more erratic.

"I'll be right back with Mom, Dad. I'll be right back."

My heart ached for this man's suffering and that of his family. Today was his son's wedding day. He had flown home with his fiancé to be married locally so that Dan could be at the wedding. No one had expected that Dan would deteriorate so quickly over the preceding week, and now it appeared that he had only hours to live. Dan continued to claim my hands and stare into my eyes. I talked about the sunrise, the flowers, the color of the sky, the wedding plans, and his family. He continued to listen and stare keenly at me. Tears began to inch their way down my cheeks as I knew that Dan would die shortly. "Please hold on until your wife and son come back," I begged silently. Finally after what seemed like hours, they walked into the room.

"Danny!" wept his wife. "I'm right here sweetie," and she slipped into my seat as I passed his hands into hers. He eagerly grasped her hands, and I stepped quickly away to allow them to be together. My last glimpse of Dan was of his beloved wife holding his hands and leaning closely; the quiet sounds of her weeping and whispered words barely evident as I stood in the doorway. Less than 30 minutes later, Dan died.

The Battle

Every breath frightens me and strengthens me at the same time.
Every breath
reminds me that soon there will be no breath.
Yet every breath
gives me a little strength to hold on.

The tunnel is narrow and echoes
with the sound of the wind blowing past my ears.
Trying to slow the wind down
is making me so very tired
I can't hold on much longer.

Someone comes in
Finally!
I am not alone—reaching
I reach for her hands, her warmth
If I can just hold on to her
I can forget what I know to be true
for awhile.

I feel so helpless, trapped alone with this man
and yet proud to be here.
I don't know the correct words
or the rules.
What are the rules—for being with patients when they die?
Should I be notifying someone other than his family?
I'll have to ask the staff what the right thing is to do.
Meanwhile, at least I know he won't be alone.

Where ARE they?
I need my wife and my son!
Can she hear me?
I am trying with all my strength to get her to hear me - to bring my family to me.
I look down at her hands.
They are so warm, and strong
not like mine.

I am dying you know—I want to yell at her!
Help me!
Get my family!
Do something!
Anything!

I try to calm him by singing songs from my childhood,
those lullabies we learned so long ago.
It's funny but even now they make me feel cared for.
I hope the songs and the stories and the prayers are helping.
I don't know what else to do
while we wait.

At last
I can hear the voice and feel the hands of my love.
She is here!

She has not forgotten me!
They are with me and all is well.
I feel the hands of my son on my forehead
And the touch of my precious love
So, they do know I'm dying!
All is as it should be.
The morning sun has begun to warm my face.
Fuchs Poetics, Case #3

* * * * *

I still had hopes, for pride attends us still.
Amid the swains to show my book-learned skill.
Around my fire, and evening group to draw,
And tell of all I felt and all I saw;

And as a hare whom hounds and horns pursue,
Pants to the place from whence at first she flew;
I still had hopes, my long vexations past,
Here to return—and die at home, at last.

Washington Irving (1849, p. 166).

CONCLUSION

Authentic care of the dying requires that the nurse be willing to move outside of the familiar; to have the "willingness to enter the landscape of another human's suffering—the place where healing truly begins" (Georges, 2002, p. 85). Identification of the role of the nurse in a "sufferer led" experience for the terminally ill may be found in a number of non-traditional therapies or expressions. Regardless of the method, ultimately the goals are twofold. The first is to provide a means for the nurse to establish an authentic presence with those she cares for. The second is to genuinely benefit the sufferer. Poetics is one way in which to reclaim the voice of the sufferer and the caretaker in such a manner that we perhaps truly begin to understand the experiences of the terminally ill enough to establish an intimate connection to suffering that will extend to the next experience, to the next patient who is reaching desperately for your warmth, your understanding and your strength.

REFERENCES

Aldridge, D., & Stevenson, C. (2001). Social poetics as research and practice; Living in and learning from the process of research. *Nursing Inquiry, 8*(1), 19–27.

Benner, P., Hooper-Kyriakidis, P., & Stannard, D. (1999). *Clinical wisdom and interventions in critical care: A thinking-in-action approach.* Philadelphia: W.B. Saunders.

Gadow, S. (2000a). I felt an island rising: Interpretive inquiry as motet. *Nursing Inquiry, 7*(3), 209–214.

Gadow, S. (2000b). Philosophy as falling: Aiming for grace. *Nursing Philosophy, 1,* 89–97.

Georges, J.M. (2002). Suffering: Toward a contextual praxis. *Advances in Nursing Science, 25*(1), 79–86.

Hutchinson, S.A. (1984). Creating meaning out of horror. *Nursing Outlook, 32*(2), 86–90.

Irving, W. (1849). *Irving's works.* New York: Hurst.

Leininger, M. (1989). Transcultural nursing: Quo vadis: (where goeth the field?). *Journal of Transcultural Nursing, 1*(1), 33–45.

Stelter, R. (2000). The transformation of body experience into language. *Journal of Phenomenological Psychology, 31*(1), 63–77.

Section 4

DANCE AND MOVEMENT

Chapter 16

DANCE/MOVEMENT THERAPY IN AN ADULT PSYCHIATRIC UNIT

CHRISTINE ZIMBELMANN

INTRODUCTION

In this chapter, an introduction to Dance/Movement Therapy (DMT) will be presented. The emphasis will be on its relevance and use on inpatient adult psychiatric units. It will provide a definition and an overview of some of the major principals and the theoretical framework of DMT. Attention will be paid to the role of DMT and the dance/movement therapist within the clinical treatment team. Case material will be presented to illustrate how theory is put into clinical practice.

Foundations of Dance/Movement Therapy

Throughout history, people have expressed themselves through moving together to a common rhythm. They danced before harvests, hunts, and wars. They danced in times of transitions: birth, puberty, adolescence, adulthood, and death. They danced at the most important times in their lives. Feelings and emotions were shared through common participation in movement; this aspect of communal dance is one part of dance therapy. (Schmais & White, 1986, p. 24)

Dance as a communal form of expression and healing has been in existence from the beginning of time (Schmais & White, 1986). The therapeutic aspects of dance, as it has been used throughout history, is a major source from which the discipline of Dance/Movement Therapy developed. As individuals, our earliest attempts at communication occur on a preverbal level. Before the development of spoken language, gesture and body expression were the ways

in which people shared and communicated ideas, feelings, and experiences. Historically, dance has been an integral part of worship and prayer as societies worldwide have attempted to structure and give meaning to their lives. Dance was also used as a means of controlling certain aspects of life, such as dances centered on themes of fertility, prosperity, and natural forces such as rain and sun (Serlin, 1993). Dance is a language whose vocabulary is built on the body, mind, and spirit to relate to and relay the deepest experiences—painful and joyous—to those who observe or use the language themselves.

Dance is a very fundamental art form in the sense that it involves direct expression of one's self through one's body. The dancers use themselves as the medium through which to present their art. Although DMT evolved from a tradition of early modern dance, it is different from dance training, dance classes, or dance for the sake of performance, recreation, entertainment, or exercise. The American Dance Therapy Association (ADTA) defines dance therapy as "the psychotherapeutic use of movement as a process which furthers the emotional, social, cognitive and physical integration of the individual" (ADTA website. Retrieved January 27, 2004 from www.adta.org).

Dance/Movement Therapy: Roots of the Profession

Although the roots of dance as a healing process can be traced to the practices of humankind in its earliest times, the profession of DMT as a discrete modality is relatively new in Western world. As a profession, it can trace some of its earliest roots to modern dance in the early 1900s in the U.S. and Europe (Levy, 1988).

During the first half of the twentieth century, several forces and trends have been identified by various authors (Lewis Bernstein, 1986, Levy, 1988, Serlin, 1993) that account for the development of DMT as a profession. One of these forces was modern dance. Before the beginning of the twentieth century, formal dance had developed as a performing art, which emphasized technique and aesthetics. However, at that time, there was little or no attention given to how the dance affected the audience or performer on a feeling level. By contrast, the pioneers of modern dance introduced a more natural, expressive, spontaneous, and creative dance style. The acceptance of the modern dance movement was a reflection of the social and intellectual climate of this time. In politics, as well as in the arts, there was a movement toward liberation and an examination of the full range of human emotion, behavior, motivation, and experience, as is implied in the following quote:

> Modern dance replaced the fading content of Western dance with certain key notations: spontaneity, authenticity of individual expression, awareness of the body, themes that stressed a whole range of feelings and relationships. The great pioneers of its early years personified themes of human conflict, despair,

frustration and social crisis . . . such innovations led directly to the essence of dance therapy. (Barteneiff, 1975, p. 246)

Marion Chace was undoubtedly one of the most influential people in terms of the development of dance/movement therapy as a profession in the Western world (Levy, 1988). Chace began her career as a dancer, choreographer, and performer, studying and performing modern dance in New York in the 1920s. In 1930, she moved to Washington, D.C. and began her own dance school. In addition, she was a student of psychology and various theories of personality development. She was most influenced by Harry Stack Sullivan in terms of the belief in the value of the relationship between therapist and patient as the vehicle for change and progress (Shelley, 1993). An additional influence on her work was Reich (cited in Chace & Dyrud, 1975), who developed a theory of character armoring and psychological defenses as demonstrated in bodily tensions (p. 151).

Chace (1993, pp. 12–16) began to explore the therapeutic use of dance while teaching modern dance classes in her own studio. She eventually started implementing her teaching approach and technique for children with special needs. Later, when volunteering on psychiatric units at St Elizabeth's Hospital, Washington, D.C., her ideas expanded and took shape in a program that she called "Dance for Communication" (Chaklin, 1975, p. 12). The locked psychiatric nursing units (the "back wards") where she worked in the 1940s did not yet have access to tranquilizers and other drug therapies. Many of her early clients were non-verbal, grossly psychotic, disorganized, catatonic, and considered to be "unreachable."

Marion Chace was a teacher and mentor to many of the first generation dance therapists. She founded the first training program for dance/movement therapists at the Turtle Bay Music School in New York City and brought her ideas and methods to Israel as well. In 1966, she became the first president of the American Dance Therapy Association (ADTA), which she helped to organize.

Dance/Movement Therapists specialize in understanding how the body and mind interact in healthy individuals and those who present with a physical, emotional, or psychiatric illness:

> . . . be it an illness of the mind, which is embodied or an illness of the body that impacts the mind and spirit. Whether the issue is the will to live, a search for meaning or motility, or the ability to feel love for life, for Dance/Movement Therapists healing has always meant mobilizing resources from that place within where body and mind are one." (American Dance Therapy Association website. Retrieved January 27, 2004 from www.adta.org/whoweare.html)

The American Dance Therapy Association has sought to maintain professional standards for ethical practice and education of dance/movement therapists since its inception in 1966. Training of the dance/movement therapist occurs on the graduate level, and a Masters Degree from an institution approved by the ADTA is the final degree necessary for entry into the field as a professional. The ADTA has delineated two levels of credentials, entry level post graduation (DTR) and an advanced level of credentialing (ADTR). A dance therapist wishing to attain his/her Academy of Dance Therapist Registered (ADTR) must meet additional educational, experiential, and supervisory requirements. At the ADTR level, the therapist is qualified to teach, provide supervision, and engage in private practice. The American Dance Therapy Association has a web site at www.adta.org which can be consulted for comprehensive information regarding the profession, training, credentialing, etc.

THEORY AND CORE PRINCIPLES

The basic premise or assumption of dance/movement therapy theory is that "dance is communication and thus fulfills a basic human need" (Chaiklin & Schmais, 1993, p. 77). According to these authors, Chace's approach to dance therapy is often used with groups of patients in inpatient psychiatric settings. It is particularly effective and relevant for this population, who are often non-verbal or lack well-developed verbal skills. The dance/movement therapist works with the client's personality, issues, or feelings as they are displayed in the body and in his or her movement behavior. Change usually occurs first on a bodily or movement level, and then the client becomes more aware of the feelings or thoughts related to the movement and works with the therapist to integrate this change. Chace's work is based on the following four principles: Body Action, Symbolism, Therapeutic Relationship, and Rythmic Group Activity (Chaiklin & Schmais). I will give a brief explanation here of each of these principles as they have been described by Chaiklin and Schmais, two of her early students. These principles will be illustrated and further illuminated during the discussion of case study material.

Body Action

There is inherent value in the movements of a healthy body. Distortions in body shape and function were seen by Chace to be unhealthy responses to conflict or pain as revealed in the following quote:

For example, some people bind energy, limit their use of space, hold their breath, and/r "disconnect" body parts in an effort to guard against feelings of guilt, aggression, or sexuality. Others become hyperactive exploding in time and space in response to real or imagined fears. (Chaiklin & Schmais, 1993, p.77)

Chace was aware that patients could feel both more alive and more relaxed by moving their bodies. When they were more engaged and/or relaxed, they were then more able to express their emotions. Moving also causes the patient to increase mobility and the range of motion of their muscles and bones. The therapist observes the ways in which patients routinely moves, i.e., holds tension, blocks energy, or holds parts of their body rigidly. The therapist then structures the movement sequences with the goal of having the patient develop a willingness to respond emotionally. Chaiklin and Schmais emphasise, however, that change does not occur as a result of only moving differently; instead, it occurs when "the patient is ready to allow himself to experience the action in his body" (p. 77).

Symbolism

In choreographed dance, as well as in the movement of a psychotic patient, body actions that may have a symbolic meaning can communicate feelings and thoughts. A dancer may purposefully choose bizarre or exaggerated postures or gestures to communicate to the audience. In contrast, psychiatric patients may unintentionally reveal their inner worlds and the intensity and complexity of feelings in their movement that may be extremely difficult to put into words. In dance/movement therapy, symbolism gives the patient a way to recall, re-enact, and re-experience in movement. The therapist accepts the symbolic expression and any meanings that the patient may attribute to the symbols. The DMT will also help the patient to create new, possibly more adaptive symbols. An example given by Chaiklin and Schmais (1993) illustrates this concept. When working with a patient who is indicating some physical tension and may be holding back anger, the image of chopping down a tree may be suggested by the dance/movement therapist. The following quote further illustrates this concept:

The strong direct movements required to perform this action may help to further bring the feelings of anger to the surface where they can be expressed, explored and handled. The dance actions may bring forth an image or memory. Skipping and hopping may lead patients to suddenly recall incidents or events from their childhood. (Chaiklin & Schmais, 1993, p. 79)

Some problems can be worked through on a symbolic level as will be illustrated in the case study presented later in this chapter. When the patients feel

their experiences are understood by the way in which the therapist responds to and joins their symbolic expression, they often respond with additional symbolic movement and verbal expression. This movement can lead to greater expression of thoughts and feelings in the session.

Therapeutic Movement Relationship and Mirroring

In dance/movement therapy, as in any other form of psychotherapy, the relationship between the patient and the therapist is of great importance. Chace found a way to establish a therapeutic relationship by moving with her patient. This connection was made "by visually and kinesthetically perceiving another's movement expressions" (Chaiklin & Schmais, 1993, p. 79) and by incorporating the emotions expressed in the patient's movements into her movement responses. In this way, "Chace entered a patient's world by re-enacting the essential constellation of movement characterizing his expression" (p. 80). She would "tell" the patient that she understood his behavior by reflecting, enlarging, or completing a movement that was tentative and not fully realized. This technique of mirroring and picking up the main essence of another's movement expression, joining them in it, and helping them to expand upon it establishes trust and empathy. This process of mirroring, also called empathic reflection, is used extensively in dance/movement therapy as Chace developed it. This technique can assist the patient in expressing repressed ideas and feelings and in risking new experiences and relationships.

Rhythmic Group Activity

Rhythm is a powerful force. It serves to unify people when moving together to a common rhythm. Marian Chace used it to engage and work with her patients in psychiatric settings, and it is discussed frequently in the literature which describes her approach (Chace, 1993, Chaiklin & Schmais, 1993). In dance/movement therapy, the power of group rhythmic action is used to facilitate and support expression of thoughts and feelings in a more organized manner. Even severely withdrawn or disorganized patients can be activated by the contagious aspects of rhythm. The use of reassuring and simple rhythms can be utilized as the medium for expression of otherwise chaotic, disturbing, or confusing thoughts and feelings. In addition to organizing the expression of thoughts and feelings into meaningful dance action, rhythm also helps to modify extreme behaviors such as hyperactivity, withdrawal from others, and the use of bizarre gestures or mannerisms. Chace eloquently described her use of rhythm in this way:

I have many times seen a patient who was so withdrawn from the life about him that he was unable to talk, eat, or care for himself, be attracted to a circle of people doing rhythmic action together and be able to participate with them. Occasionally, the closeness of the unison dancing will be too much for such a patient, but he will be able to dance by himself with the support of the circle doing a unison rhythmic dance around him. The group participation gives him a feeling of confidence in himself that he seems unable to find alone. (Chace, 1993, p. 200)

RUDOLPH LABAN: MOVEMENT ANALYSIS

Rudolph Laban (1879–1958) was an architect and a painter turned choreographer. He worked in Paris prior to World War I. In the 1920s he established several dance movement schools in Germany and developed systems for dance notation called "Labanotation" and "effort analysis" (Stanton Jones, 1992). His system of observation was based on the natural affinities of movement. Laban's theories originated in the early 1900s and became integrated into dance therapy practice in the United States in the 1960s. Many Dance/Movement Therapists use his method of movement analysis (Labanalysis) that gives them an objective language for recalling and describing movement and movement qualities that characterize a patient's movement profile (Bartenieff, 1980).

Brief information about this system of observing movement will be provided in this chapter. For a more complete description of Labanalysis or effort shape analysis refer to Bartenieff (1980). Laban identified space, weight, time, and flow as "motion factors" (Bartentieff, 1980, p. 51) or different attributes of movement. A person will have differing responses toward these motion factors or movement qualities dependent on their temperament, the situation, the environment, their mental status, that perceived threat or safety, and related factors. The quality, attitude, or approach toward the motion factors is called the "'effort' or drive towards" (p. 51). The effort that the mover is using is identified on a continuum between two extremes; for example, the mover's attitude towards the use of time will either be one of quickness or urgency in time, or one of indulgence and sustained slow movement. Effort is what makes our movement expressive. According to Laban (cited in Bartenieff, p. 53), the choice of effort elements is indicative of the inner state of mind which prepares a mover for a sequence of movements and is indicative of some aspect of her or his psychological functioning. He identified the mover's attitude toward space as having to do with attention and how one thinks and is oriented. Another factor, weight, has to do with a person's intention, i.e., creating a strong or a light impact. Time has

to do with the way one makes decisions, rushing or delaying. Lastly, flow is said to correlate with how one progresses; i.e., "how to get started and keep going" (p. 53), either freely or carefully. All people have preferred ways of moving and effort qualities that are most natural for them which make up their movement repertoire.

In many cases, the movement repertoire and range of qualities of our patients is underdeveloped or diminished due to illness, trauma, and situational factors. In addition, some movement qualities are maladaptive if overused or if used in a particular context or setting or to the exclusion of other qualities and combinations of qualities. For example, a patient who can only access strong, quick, and direct, "punch"-like (Barteniefff, p. 59) movement may have difficulty showing and experiencing tenderness. In dance/movement therapy, one of our primary goals is to help the patients expand their movement repertoire (Schmais & White, 1986, p. 27). This goal is based on the premise that the greater access a mover has to a wide range of movement qualities, the greater his or her ability will be to express clearly, adapt to change, behave appropriately, and "cope with the environment" (Bartenieff, 1980, p. x).

DANCE/MOVEMENT THERAPY: CURRENT USES

Currently, dance/movement therapy is used in a wide range of clinical and non-clinical settings with diverse populations. These settings include public and private psychiatric hospitals and mental health clinics, residential treatment centers, institutions and schools for the physically and/or emotionally handicapped, senior centers, cancer centers, and private practice. dance/movement therapists work with individuals or with groups. In psychiatric settings, their collaboration with psychiatrists, psychologists, and nurses vary in degree and kind. Often on multi-disciplinary inpatient psychiatric units, dance/movement therapy is an adjunctive therapy. dance/movement therapy is most effective and beneficial in a setting in which all members of the treatment team understand and support the modality. The work of a dance/movement therapist can be closely compared to that of a psychotherapist or psychologist. In fact, as per the definition cited earlier, dance/movement therapy is a form of psychotherapy.

The dance/movement therapist provides treatment to the client and provides unique and valuable assessment information about the patient to the rest of the treatment team. Often the observations and assessments gathered by the dance/movement therapist are unlike any that can be garnered through verbal interaction or other modalities alone.

Theory into Practice

A considerable number of dance/movement therapists work in psychiatric hospitals and community mental health centers, partly because one of the first dance therapists, Marian Chace, did much of her work in a psychiatric hospital. Furthermore, subsequent generations of DMTs have continued in this setting. In addition, extreme emotional disturbance is observable in movement behaviors. Whereas nurses and other health professionals may notice this movement behavior, but focus instead on verbal communication, the dance/movement therapist is trained to see the clients' movement as communication and to connect with them in movement. There are some general observations which can be made about the manner in which patients of various diagnostic categories often present in movement behavior (Davis, 1981). For example, Davis found that the more disturbed or acutely ill an individual, the more fragmented are one's movement patterns (p. 64). As Davis's study documented, the psychotic or schizophrenic patient exhibits a lack of connection between mind and body, an irregular and sporadic flow of energy, a lack of gestural or postural change or unity, or gestures and movements which are random, ritualized, or distorted. Often there is a limited use of the surrounding space or a lack of awareness of others in the space and of the importance to respect their personal boundaries. Several key goals for dance/movement therapists working with acutely ill psychiatric patients are therefore to aid in body integration and awareness, strengthen a realistic sense of body image, broaden the vocabulary of movement, and help the patient develop control over impulsive, random behavior (Chaiklin & Schmais, 1993, Stanton-Jones, 1992).

Dance/movement therapy is often a part of the milieu therapy on the inpatient unit. Treatment most often occurs in a group involving patients with varied diagnoses. The work of the therapist begins as soon as she/he gathers patients for the session. This process of "gathering" the patients together for the group is often quite trying. Inevitably, some patients will be in their beds, dressed in hospital gowns. There is often resistance on their part to engage in treatment. Many who have never experienced a dance/movement therapy session will respond to invitations to join the group with statements such as, "I can't dance," "I'm too depressed to dance," or "I have too much going on in my mind." These statements are, in part, a reflection of the patients' misconception about the nature, goals, and expectations of the DMT group. Interestingly, the staff may have the same misconceptions about the dance/movement therapy session. I have told countless patients that they should bring to the group whatever they are feeling or experiencing. When patients say that they are "too depressed to come to group," they need to be reminded that therapy is not only for when they are

feeling good. Furthermore, they need to be informed that the dance that is spontaneously choreographed and danced in the session will be first and foremost a reflection of the feeling state of the members of the group. Many people associate dance with celebration or feeling happy. They have difficulty accepting that the dance in the dance/movement therapy session will be about whatever is important or pressing to the group members. In contrast to the more withdrawn patients, some individuals pace the unit. They may be eager to engage in the group or already be in the group room. Staff and patients often mistake the dance/movement therapy session for a dance or exercise class; instead, it is part of the patient's assessment, psychotherapy, and overall treatment. There are several environmental factors that affect DMT and need to be addressed by the therapist. The physical space in the room is important. For example, there should be enough chairs in the room for everyone. However, those chairs should be moveable so that they can be pushed back to allow sufficient space for the group to move in a circle formation.

Each person should have enough room to be able to move freely and should be able to see each other in the group circle. It is also very important for the dance/movement therapist to ensure some degree of privacy by using a curtain on the door or window and by placing a sign on the door to prevent interruptions. Nothing is less conducive to creating a safe atmosphere for exploring feelings than the threat of intrusions or interruptions from the outside. The issue of privacy is quite challenging on a busy unit. Staff may need to see or speak to a patient during the session. Patients may be inclined to wander in and out of the group room. It is helpful if the staff is aware of the time and place of the group and which of their patients are scheduled to attend the group. The staff should have input regarding the scheduling of the group so that it is least disruptive to the nursing care responsibilities. In addition, when the nursing staff has a good sense of the nature of our work and its goals, they are generally supportive and respectful.

Dance/movement therapy groups stress the value of nonverbal means of communication. This approach is particularly relevant when working with clients with schizophrenia whose diagnostic criteria include disturbances in verbal expression and cognitive functioning due to delusions, hallucinations, incoherence, and marked loosening of association, as well as difficulty in social interactions.

CASE MATERIAL

Irene (pseudonym) is a forty-five-year-old single Caucasian female, living with her mother in an apartment in New York City. She is diagnosed

with chronic undifferentiated schizophrenia. Irene was hospitalized on the adolescent/adult inpatient psychiatric unit at a local hospital. Her admission was a result of an acute decompensation, most likely precipitated by her nonadherence with the medication regime for one month. At the time of admission, Irene was actively psychotic, with auditory hallucinations and fixed delusions. When she was stable, these psychotic features were more contained. She was very interested in dance/movement therapy and attended the group sessions willingly. She did, however, often refuse to take her medications because she did not "want to become a zombie." Although Irene attended dance/movement therapy sessions twice a week during her three-week admission, she did not consistently attend other therapeutic groups. She did not pose a serious management problem from a nursing perspective.

Prior to each group session, Irene would often be seated crossed-leg in the dayroom smoking cigarettes. (This was when smoking was still permitted on most inpatient psychiatric nursing units.) She would often be observed talking to herself or responding to internal stimuli. She seemed to be unaware that I had entered the room and was beginning to set up for the session. On various occasions when I addressed her directly, Irene would take a moment to respond, and she sometimes made eye contact for a few seconds. Irene loved music and loved to dance. I believe that she thought of the sessions as dance classes because from time to time, she would comment on what I had "taught" them in the group on a particular day. Many patients, as well as others, mistakenly believe that in Dance/Movement Therapy the leader teaches a dance form and technique. In contrast, the dance/movement therapist is concerned with observing the movement of the patients and reflecting those movements back to them.

From the beginning of the session, Irene had difficulty remaining in a circle formation. As a group develops more cohesion, they are able to tolerate being in a circle, and the formation of such is sometimes a gradual process. Irene demonstrated a lack of awareness of herself in the space, especially with respect to those around her. At times she would situate herself nearly directly in front of another group member, thereby blocking them out of the circle and eliminating the possibility of making eye contact with them. At other times, she would stand in such close proximity to others that it made full body movement impossible for either one. One of the tasks of the group leader during the warm-up is to facilitate group members making initial contacts with the leader as well as others in the group. To this end, I often needed to ask Irene to spread out, move back or try to be more aware of where she was standing in the room. I did so without forcing anything and noted her difficulty as an important indica-

tor of her ability to function in a group at this point in time (as well as of the group's overall level of cohesion). The majority of Irene's movement was peripheral, involving her limbs as opposed to her torso. There was very little integration between the upper and lower halves of her body, and rarely did a movement travel and flow clearly from one area of her body to another or from her upper body to her lower body with any clear sequence. These attributes of her movement pattern are characteristic of psychiatric patients as observed in Davis' (1981) study previously mentioned in this chapter. Although Irene did not seem aware of the group members, she was at times quite involved in the music.

On the day of this session, there were about ten patients and a dance/movement therapy student attending the group. During the warm-up period, we were reaching our arms into the middle of the circle, into the space overhead, and into the direction of another group member. As we began to loosen up our bodies and warm up the muscles and joints, I encouraged people to begin to notice who else was in the circle and to acknowledge someone as they reached in that person's direction. The warm up is a time to help people get their physical bodies moving, warmed up, loosened up, energized, and prepared to move with greater intensity. It is also a time to assist others in "warming up" to those around them and to notice, greet, and orient themselves to others and to the physical environment. A reaching movement is an effective way to accomplish some of these goals of the early part of the session. Irene was not reaching fully into the space. Her elbows did not straighten, nor was she was reaching with any sense of intention. Her arm movement did not appear to be focused in one direction but instead had a floating, vague quality. She had a poor sense of her own body and did not appear to know when her arms were fully extended. As the therapist, I speculated that her difficulty physically stretching out her arms could be a metaphor for her emotional experience. Perhaps she had few experiences of extending herself to others, and vice versa, in her life due to her mental illness. In the session, this inability to perform the body action of a full reach with clear direction and spatial intent kept her isolated and cut off from potential connection, touch, and intimacy from other group members. Her use of this floating, indirect quality of movement made it difficult for others to feel that she was relating to them; thus, they stopped reaching toward her, thereby creating a cycle of limitations perpetuating limitations. In addition, Irene continued to talk to herself noticeably at intervals during the warm-up phase. As group leader, I made sure to catch Irene's eye briefly and to reach in her direction, and for an instant there was a connection made. When she looked away, I moved on to reach toward someone else in the circle and the group went on.

We continued to stretch and warm up the body paying attention to perform body actions with all the different parts of the body. During the warm-up, the group leader is beginning to assess the general tone of the group and to make note of each participant and what is most noticeable about his or her movement quality, phrasing, etc. This group had a fragmented quality as evidenced by their way of moving and interacting with each other. Although there were other members who were somewhat withdrawn like Irene, there were also one or two patients who were more stable and less psychotic as they were nearing the end of their hospitalization.

Later in this session, a patient initiated a movement that was directed into the center of the space. It was a quick snatch-like action. I moved in a similar manner as this patient, mirroring the quality and essence of the movement. I directed others to join in, and I described how to execute the movement. I directed them to exaggerate their use of the time effort, i.e., to do the movement with more urgency. Furthermore, I directed them to lean into the middle of the circle when they reached in (i.e., to use the entire body rather than just a hand and arm action). People started to respond to these directives, and the quality of a snatch and all that could be involved in snatching something started to take shape. Irene's movement remained primarily gestural. That is, her arms moved while her torso remained immobile. Several members of the group had taken steps forward and were beginning to tighten the circle. Irene was performing the reach action, but she used less directness. She did not look in the direction of her own reaches, and there was a lack of synchrony between the two sides of her body. She also lacked rhythmic synchrony with others and with the music. I moved next to her and started to mirror her movement for a time. Her reaches began to extend out a bit further. I started to make a sound to delineate the rhythm. This intervention helped her to be more in time with others. However, she continued to demonstrate a lack of connection between the two sides of her body.

Furthermore, she did not move through space in and out of the circle as some other group members had started to do as they "snatched" and "grabbed" from the middle. When Irene and I had established movement synchrony and some sense of a connection, I began to change the quality of my movement slightly. I started to reach with slightly more quickness and directness. Irene followed suit. By this time, the group had labeled this movement a "snatch." I asked a variety of questions: "What are people snatching?" "What do you think you'd like to snatch?" Various responses followed, some of which we explored in movement. The movement softened and became more gentle in response to someone saying that they wanted to "take in love." We moved using this image, and a few patients

were able to say things about how it feels to be loved, while another patient said it made her sad because she felt unloved much of the time. I thought for a moment that a theme was going to emerge and develop around this idea.

However, I also noticed some members of the group still snatching with more energy, quickness, and use of direct space effort. Irene was one of them. Then she looked up and said with a bit of a smile that she was "snatching" the keys to the locked unit that the patients were on. Several group members laughed, and I asked if others would like to snatch the keys to the unit as well. The movement intensified. I wondered aloud if everyone was snatching as if they really wanted those keys. Again, the movement intensified, and Irene began to legitimately "snatch," however lopsided it was, for the first time in the session. Irene was no longer talking to herself. She was moving with clear spatial intent and with a more direct movement style. She was clearer, more focused, and made eye contact with me and at least one other group member. I saw the potential that she, and several other group members, had for identifying something that they would like to have and for taking the necessary action to try to get it for themselves. I also saw a sense of humor and spunk that I did not know that Irene and several other of the ten patients in the group possessed and that may have been dormant. Irene continued to remain somewhat disengaged from others in terms of her placement in the circle, but she had achieved rhythmic synchrony and had initiated a theme, which became central to the group. We decided that the chances of successfully snatching the keys would be far greater if it were a team effort.

What followed was an enactment of the group banding together, sneaking up on the nurse's station, and "snatching" the keys to the unit. As this movement enactment unfolded, a wider range of movement qualities was needed in order to perform the various tasks necessary to carry out this "stunt." We physically acted out how we would go out about doing this stunt: sneaking down the hall, quietly keeping watch, distracting the nurse with wild gesturing, snatching the keys, and finally racing toward the door. Not everyone in the group had access to such a wide range of movement qualities (i.e., sneaking, exaggerated gesturing, and racing with quickness and free flow of movement), and much work on my part was done to try to elicit these qualities.

While one or two patients remained fully involved until the imagined racing out the door of the unit, for many others the intensity of their involvement in the movement during this session decreased after the keys were successfully stolen. Several patients noticeably disengaged from the group process and some on a more subtle level. It struck me that perhaps people did not know what they would actually do if they were to be out

of the hospital on this particular day considering the quality of their outside lives or how acutely symptomatic they still were at that stage of their hospitalization. Before ending the session, we were grouped in a circle, and I led the group in various simple stretches and calming rhythmic movements. It is typical of a "Chacian" session to bring the patients back to a circle formation (Chaiklin & Schmais, 1993, p. 90) if, as in this case, the formation has changed during the theme development. During closure, it is also typical to do communal movement. At this time, the group leader assesses whether all members of the group are intact and able to leave the session, especially if any intense or upsetting material or issues came up during the session.

In many cases, as a dance/movement therapy group comes to an end, there is discussion and sharing of feelings. In processing this theme, it was surprising that the group talked less about breaking out of the unit and what it would be like and more about their feelings concerning planning the escape. Group members identified feeling a part of the group and being needed to complete an important task. The idea of having control over some aspect of one's life was discussed, and several people noted that they felt very little control over their lives or their symptoms at times and that they wish they had "the key." Some people spoke of the sensations they felt in their body and how much more alert, awake, or alive they felt. Other patients giggled while they stated that the session reminded them of their "sneaky side" and thought that "it was fun to play."

Irene participated very little in the verbal processing during the closure of the group. This limited involvement may indicate that she has had limited opportunities to express actions, experiences, symbols, and words. However, there was a noticeable improvement in her ability to relate with others and to tolerate closer proximity to them. This change may be indicative of decreased fear and an ability to trust others. She jokingly identified herself as the "ring leader," which may indicate her feeling that she had a distinct and accepted role within the group. Although staff believes that Irene could benefit from greater involvement with peers, it is unclear as to whether she could tolerate that level of social and interpersonal stimulation at this time. Based on this session, my assessment was that Irene does have the capacity for meaningful social interaction if it is in a safe, non-threatening, supportive environment. It is the belief of dance/movement therapists that in helping clients like Irene to broaden their movement repertoire that they will give rise to an increased ability to access a wider range of coping strategies and expressive potential (Bartenieff, 1980; Schmais & White, 1986).

The development of a fuller movement repertoire, including a greater range of body actions, takes time to develop. This development began to

occur, and Irene's movement repertoire became more diverse during the described session, and in the subsequent sessions. Furthermore, she stopped talking to herself out loud in the dayroom and limited this behavior to private settings.

CONCLUSION

There are innumerable themes that can arise in a dance/movement therapy session. Once the therapist picks up on non-verbal clues, mirrors another's movement, and helps him or her to broaden, clarify, and use more of the body, feelings and images start to arise that are related to the movement. Of course, the feelings that arise are related to what patients are experiencing at that time in their lives as well. These feelings can first be dealt with on a symbolic level. When this happens, a group often goes on a journey: in this case, the enactment of stealing the keys to the unit. Shared experiences, working together as a group, emersion of individual roles, or solos within the group all occur while the therapist uses both narration and dance movement to reflect, guide, support, and structure. The group leader helps to unite the group and clarify its intentions and direction.

An effective approach for patients who are non-verbal or who lack well-developed verbal skills or insight involves working with the body and movement first in order to promote psychological and behavioral change. Changes and improvements in functioning, which are observed in dance/movement therapy, do not occur in a vacuum. Patients such as Irene are concurrently being treated with psychotropic medications, nursing interventions, given three meals and a safe place to sleep, in addition to group therapy, which may include dance/movement therapy and/or another creative arts therapy. Although research has been done about the effects of dance/movement therapy (Ritter & Graff Low, 1996), there is a paucity of empirical data which supports and validates the work of dance/movement therapists. In the current health care climate, there is a lack of funding for such research, but there is clearly a budding interest in body-oriented therapies and in the age-old concept that the mind and body are connected. On psychiatric units, it is the nurses who often address the physical as well as emotional needs of the patients. Who better to recognize the inseparable mind/body connection that is at the core of dance/movement therapy theory? Thus, it seems that there is an opportunity for a strong bond of support and mutual respect to flourish between members of these two disciplines in the treatment of this extremely difficult, vulnerable, and wonderful population of people with schizophrenia. How can we foster this professional connection? This chapter contributes to that aim.

Author's Note

I would like to acknowledge and thank Laurel Bridges for her time, work, and effort in editing this chapter. She went above and beyond the role of editor, and I could not have written this chapter without her expertise and assistance.

REFERENCES

American Dance Therapy Association Website. (1997). Retrieved January 27, 2004 from http://www.adta.org.

Bartenieff, I. (1975). Dance therapy: A new profession or a rediscovery of an ancient role of the dance? In H. Chaiklin (Ed.), *Marian Chace: Her papers* (pp. 246–255). Columbia, MD. American Dance Therapy Association. (Reprinted from Dance Scope, 7 Fall/Winter, 1972–1973, 6–18).

Bartenieff, I., & Lewis, D. (1980). *Body movement: Coping with the environment.* Langhorne, PA: Gordon and Breach Science.

Chace, M. (1993). Therapeutic concepts and techniques. In S. Sandel, S. Chaiklin & A. Lohn (Eds.), *Foundations of dance/movement therapy: The life and work of Marian Chace* (pp. 193–251). Columbia, MD: American Dance Therapy Association.

Chace, M., & Dyrud, J. (1975). Movement and personality. In H. Chaiklin (Ed.), *Marian Chace: Her papers* (pp. 148–151). Columbia, MD: American Dance Therapy Association.

Chaiklin, S., & Schmais, C. (1993). The Chace approach to dance therapy. In S. Sandel, S. Chaiklin & A. Lohn (Eds.), *Foundations of dance/movement therapy: The life and work of Marian Chace* (pp. 75–97). Columbia, MD: American Dance Therapy Association.

Davis, M. (1981). Movement characteristics of hospitalized psychiatric patients. *American Journal of Dance Therapy, 4,* 52–71.

Levy, F.J. (1988). *Dance/movement therapy a healing art.* Reston, VA: The American Alliance for Health, Physical Education, Recreation and Dance.

Lewis Bernstein, P. (1986). Historical perspectives in dance movement therapy. In P. Lewis Bernstein (Ed.), *Theoretical approaches in dance movement therapy, Vol.1.* (pp. 3–8). Dubuque, IA: Kendall Hunt.

Ritter, M., & Graff Low, K. (1996). Effects of dance/movement therapy: A meta-analysis. *Arts in Psychotherapy, 23*(2), 249–260.

Schmais, C. & White, E. (1986). Introduction to dance therapy. *American Journal of Dance Therapy, 9,* 23–30.

Serlin, I. (1993). Root images of healing in dance therapy. *American Journal of Dance Therapy, 15*(2), 65–76.

Shelley, S. (1993). Marian Chace: Her later years. In S. Sandel, S. Chaiklin & A. Lohn (Eds.), *Foundations of dance/movement therapy: The life and work of Marian Chace* (pp. 20–43). Columbia, MD: American Dance Therapy Association.

Stanton-Jones, K. (1992). *An introduction to dance/movement therapy in psychiatry.* London: Roultedge.

Chapter 17

DANCE MOVEMENT THERAPY AND NURSING CARE

SUSAN KIERR

A new position was offered to me: ten hours weekly on a hospital floor where skilled nursing care was given to patients with chronic illnesses. It was 1988, and for the next ten years, the staff and I discovered ways we could use the creative arts therapies. I attended treatment team meetings weekly to understand the medical treatment goals for each patient and to give information to the staff about patients, which allowed me to help shape the treatment plans. I charted each day on what I did with individuals and spent time at the nurses' station to acquire information about how the patients were doing during each shift and where on the unit I could be most helpful. Specific requests for my input were made by the nurses on duty. For example, when a patient was getting more anxious or more depressed, I was notified in advance so that I could include a session with those people later that day. Dance movement therapy became a treatment of choice among the nursing staff on that floor.

When hospitalization is extended in order to provide medical care and rehabilitation, hospitals are expected to offer daily activities that add stimulation and enrichment to patients' programs. An activity director is hired to organize these activities, which sometimes can include movies, bingo, sing-a-longs, crafts, and exercise groups. For this reason, the position of dance movement therapist on such a floor was something for which I could qualify if I also acquired certification as an Activity director. Having achieved the latter role, I was now able to use my ten hours weekly with flexibility, as long as I arranged and posted a schedule that provided opportunities of possible activities for the patients seven days a week.

During the years that I held this position, I was in fact able to arrange diverse activities, some of which happened on the days I was not in the hos-

pital. Although I did not work on weekends, I arranged that coffee and pastries for patients and their visitors be delivered on Saturdays by the dietary department; on Sundays, the weekend nurse arranged for the patients to watch a televised religious service in the Day Room. No weekend bingo was ever scheduled, but dance, music, art, and drama were woven into the scheduled activities in ways that I will describe below.

For me, the defining moments of this work were the instances that music and dance filled a bedside interaction, and laughter or tears accompanied a group activity. These moments included my receiving a dance lesson from Sadie, an eighty-one-year-old Holocaust survivor, and a concert arranged by Ed, a seventy-six-year-old man, who had his grandson bring in a tape so that we could all listen to Ed's recording in which he played blues guitar for singer Ernie K-Doe. These were momentous occasions in spite of having Sadie's IV pole during our waltz and Ed's request to play his audiotape of blues music each time that he had a visitor to his room. The nursing aides knew where I kept the key to the cabinet with the tape player, and they were willing to bring it into Ed whenever he asked. Although I was the only one who waltzed with Sadie, she recounted the story of our dance to everyone.

CASE STUDIES

In this chapter, I will introduce six more people and describe parts of their dance movement therapy treatment programs. After I have shared these vignettes, I will then consider the theoretical constructs that help us to understand the dynamics taking place in the sessions. In each case, an attempt will be made to show how nursing staff supported the dance movement therapy. Additionally, we will see that the dance movement therapy itself was designed to support the treatment goals of the nursing staff.

Gloria's Case Study

Each day that I came to work, I checked in with the nurse on what was happening on our floor. Sometimes a patient had been discharged, as we had anticipated. At other times, several patients had been moved to an acute care floor due to the worsening of their condition. There were other days that I came to work to find that a patient had died. I appreciated the professionalism of the nursing staff who communicated these changes to me and also their responses of loss and concern. But sometimes, on busy days, I might be told "Admitted a CA of the liver to room 712."

In fact, that is how I met Gloria (pseudonym). The "CA to the liver" turned out to be an ebullient blonde, sixty-six-year-old, who had been hos-

pitalized with cancer for an extended round of chemotherapy. When I walked into her room for the first time, I introduced myself and asked if she thought music or dance or any of the other arts would help her to feel better while she was in treatment. Gloria burst out in song: "Let Me Entertain You."

This woman had made her living in the famous piano bars of the New Orleans French Quarter for over forty years, and she sang her songs in our sessions for the next three weeks. As she went through the emotional ups and downs of hope and despair related to her condition, she kept me informed of her emotional state through the dozens of songs that she chose to sing to me. Some days, I heard "There's No Business Like Show Business" and "On the Sunnyside of the Street"; other days, I heard her sing a weepy version of "Red Sails in the Sunset" and a few whispery lines from "September Song."

Gloria needed an audience. She needed to entertain, which she had always done, even as a child. Gloria talked about her role in her family as the child who sang at family parties. By having an appreciative audience now during her illness, she was able to reconnect with this important part of her self-image.

When I was not on the nursing unit for several days, I arranged for the transport orderly to drop by for a line or two of Gloria's music. He was the same orderly who took Gloria to her chemotherapy sessions. Music also became part of their communication system. Eventually, Gloria sang on her way to and from chemo while she was wheeled through corridors.

Gloria tried to talk about her illness and the grim possibility of her death, but she found it easier and more natural to express these feelings in song. I understood that when Gloria was not singing, it was because she was too sick to muster that energy or too despondent to find a song. In this way, she communicated her feelings, thoughts, and physical status through this mode of expression, thereby keeping us attuned to her feelings which otherwise were difficult for her to verbalize.

Gloria's songs were therapeutic in the way that music makes all of us feel better and allow us to express our emotions more fully. However, as her postures and gestures merged and her arms stretched on the diagonalplane, she drew her audience, me, toward her. The therapeutic relationship, contained in the moment's unfolding process, was not just entertainment, even when it was entertaining. The therapeutic aspects of our interaction were increased because she was given an opportunity to relive aspects of her childhood through the interaction with me. As Gloria sang, she became the adorable curly haired blonde of her childhood, and I was the mother, beaming approval.

Mammy's Case Study

Not every patient had such a readily accessible way to express herself. Mammy (pseudonym) stopped eating. When I arrived at work one day during Mammy's hospitalization, due to a stroke (CVA), the nurse told me that she was to have a feeding tube put into her stomach, so I might "just want to skip working with her that day." I groaned, "Why?"

"Well, Susan, the poor thing isn't eating," she reminded me.

"That's because she's depressed," I said.

"We can't just let her starve herself; we have to get a tube into her."

"When's the tube being put in?" I asked.

"Probably this afternoon."

"If I can get her to eat something, would you cancel the procedure?" I bargained.

"If she starts eating again this morning, then we wouldn't need the tube," was the nurse's reply.

Immediately, I began a session with Mammy using the soft relaxation music and some guided breathing. I asked her about the people who raised her, who took care of her when she was little, who nursed her when she was sick. She did not want to talk to me, but I persisted, knowing that she was facing a very invasive procedure in the afternoon (i.e., a feeding tube) in direct opposition to what appeared to be her wish not to eat. Eventually, she told me a little about being raised by both a mother and grandmother. When she was sick as a little girl, she stayed home in the care of her grandmother.

I asked Mammy to describe what kind of meals her mother and grandmother cooked. In particular, what did they prepare for her when she was sick. During our conversation, I kept the music playing on the portable tape player. The sounds helped block out the usual noises of the hospital hallway activity. Mammy's answers to my questions got more specific as I pushed for details about how her family cooked, when meals were served, how the beans were seasoned, what kind of jam was her favorite.

I told Mammy that I would like to get her something to eat that would remind her of what her grandmother fixed for her when she was sick as a little girl. She had told me about biscuits and syrup, toast and jelly, cornbread and buttermilk. As soon as I mentioned that I wanted her to eat something now, she turned away from me, appearing to sink deeper into her bed.

"No, I don't want anything," she said, looking at the wall.

"Mammy," I reminded her, "In a few hours the doctor is going to come operate on you to make a hole in your stomach and put in a tube that he will use to feed you a formula for nourishment."

She began to cry.

"Mammy, there is a little kitchen on this floor. I would like to go and get some hot buttered toast and spread it with apple jelly. You could smell the toast and that will make your mouth water a little and you would be able to have a few bites. If you would try that, we can convince the doctor not to put the hole in your belly."

"O.K."

I was surprised when I got Mammy's consent and pleased that she did eventually take a few bites. The nurse came in and praised her, and the surgery was called off, for the time being. Mammy had regained some control of what was happening to her, beginning with the simple agreement to nibble on the toast. Furthermore, her reminiscences may have evoked some sensory stimulation and the increased appetite.

On one level, we were attempting simple behavior modification. On another level, we were connecting food to the soothing early childhood experiences that had been healing for the young Mammy. The transferential relationship was to memory, reinforced with the taste of warm bread and butter. Instead of a tray of hospital food consisting of a "balanced," tasteless, institutional meal designed to nourish her eight-six-year-old self, Mammy once again had nourishment from her childhood, something that might have been fed to her as a young child by the caring woman who first loved her. My slow movements of offering, with one hand, never entered her personal movement space. I carefully avoided an invasion of the private space around her curled up body. My movements became the beginning of a dance duet as my hand waited until her hand reach out and she took the toast.

Dwight's Case Study

As with many of the patients on this medical unit, Dwight (pseudonym), age forty-one, had a serious medical condition that prevented his discharge or his admission to a rehabilitation unit. He was suffering from the devastating effects of diabetes mellitus. One foot had been amputated, and he was concerned that further amputations would be needed if the heavy doses of antibiotics did not stop his infection.

I was planning activities for the unit during a month without an obvious holiday theme. The first week of the month promised a full moon; therefore, I scheduled a full moon song contest.

Two mornings before the full moon, six patients attended the Movement Group. We sang songs on themes connected to the moon and stars while we did some stretches and range of motion exercises. One favorite song on this theme has always been:

I see the moon, the moon sees me, and the moon sees somebody I want to see.
God bless the moon and God bless me and God bless the somebody I want to see.

This chant lent itself well to reminiscences about people one longs to see and the feelings of empowerment that come from believing that one can direct God, through prayer, to send blessings to ourselves and others.

The second activity of the week was an event I called, "The Young and Restless Club," which is based on a soap opera that was televised every weekday at eleven o'clock. When there was a particularly dramatic development unfolding in the story, many of the patients wanted to stay in their rooms by their individual TV, rather than attend our therapy group. Consequently, by applying the basic dance movement therapy maxim, first applied by Marion Chace, of "be where the patient is," (Sandel, 1993) we could have an animated session watching the soap opera together in the Day Room.

During one of these viewing sessions, a young heroine was finally going to marry the man of her dreams. We were watching the preparations for the wedding, including the efforts of a wicked stepmother whose jealousy was leading her into attempts to sabotage the wedding. At the same time, memories of our own weddings were called forth. Reactions in our group of viewers were volatile. It happened that all those present that day were women. Some women stated that they understood how envious the older woman would feel. As people voiced their differences of opinion, I was reminded about the concept of values clarification.

When the soap opera was over, I led the group in a closing movement exercise of active imaging of us moving in beautiful gowns. When the nurse looked into the room, she wondered why no one was in a hurry to leave for lunch, not realizing that we were still sharing thoughts and feelings about weddings, including our own. I asked the nurse if lunch trays could be brought into the Day Room, which was an inconvenience because the trays had already been distributed on tray tables in each person's room. I offered to help wheel in the tray tables of the six people gathered. In this way, we were able to have what turned out to be one of many lunches eaten together after the "Young and Restless Club" session.

During the first luncheon, I left the Day Room to check with the four patients who had decided not to attend today's session. Dwight had watched the same soap opera in his room. He wanted to talk to me about this upcoming television wedding. Dwight, who had been married fifteen years, went on to discuss one of his favorite topics, the daughter that he and his wife had adopted. "I want to be at her wedding," Dwight said soft-

ly, looking out of his window. "I want to walk her down the aisle." Dwight's mother had come to his wedding in a wheelchair, both legs amputated because of diabetes. She had died two years later. He repeated: "I want to WALK her down the aisle."

It was quiet in his room for a few minutes. There were tears running down both our faces. Then Dwight looked at me and said, "I am a composer, and I composed music in college. I'd like to play a song at her wedding, too." What came to my mind first was, "I see the moon, the moon sees me." To my amazement, Dwight began to sing in a rich baritone, a slow and melodious version of the same song. He had slightly different words:

> I see the moon, the moon sees me, the moon sees somebody I want to see,
> God bless the moon, God bless me, and God bless the one I love.

I announced that he was without doubt the winner of our Full Moon Song Contest and invited him to sing his rendition the next day for the entire group, which he consented to do.

Later that day, I heard Dwight speaking on the telephone to his nine-year old daughter. She routinely called him when she got home from school so that he could review homework. He proudly reported to her: "I won a music contest today."

During the next week, I arranged with the Head Nurse to buy an electric keyboard for the hospital. We kept it in Dwight's room for part of each day. He reconstructed parts of music that he had previously arranged, including a march he had written for his high school band. For the birthday celebrations, we usually were able to convince Dwight to play happy birthday in the activity room. He was usually rewarded with a slice of angle food cake, that would comply with Dwight's diabetic diet.

Six months later, Dwight was back in our hospital to be treated with antibiotics and was fighting to keep two of his fingers (the index and middle fingers of his right hand). He continued to use the electric keyboard to pick out familiar tunes. However, he eventually lost those fingers and even refused to look at the keyboard.

As we approached the Mardi Gras season, one day I mentioned to Dwight that the parades and marching bands would be coming right by our hospital. With his corner room, I added, he could look out and see them. Dwight turned away from me. The next day, the head nurse greeted me with a wide smile and reported the following:

> During the evening shift, St. Georges' School Marching Band was in parade. They stopped at the corner of our hospital and they played for five minutes. When I went in to Dwight's room to watch the band, I noticed he was cry-

ing. I asked him what was making him cry and do you know what he told me? He wrote the song they were playing.

I kept bringing the electric keyboard into Dwight's room, even though he had not touched it for some time. But after the parade, he began to write new pieces with his left hand. Dwight lived for another year, and during that time, he had two more amputations on his fingers. He knew that his diabetes was so aggressive that he would not live long. When I asked him if I could write any of his thoughts or feelings down on paper for him, he agreed to tell me his story. He wanted me to record his school experiences with music, the attention he received from teachers and the band leader, and his college years composing and playing music. The story centered on his decision after college to learn to drive a truck so he could do interstate hauling, a more assured way to earn money than the music business.

"I was the oldest son. I knew I would have to take care of my Mama, even my sisters. Now I've got good insurance and good policies to take care of my little girl after I am gone," he dictated as the final, proud and reassuring legacy in the closing chapter of his story.

As Dwight became progressively weaker, he was eventually moved to an acute care unit. By that time, I knew which composers he most admired and set up a CD player in his room so that he could listen to Hayden, Beethoven, and Berlioz.

After Dwight's death, we kept the electric keyboard in my equipment closet, and occasionally we had a patient who used it. As long as those same nurses were on the floor with me, we called it Dwight's piano.

In Dwight's life, music was a self-soothing activity and a source of self-esteem. He was able to calm and console himself, first by playing music on the keyboard and later by listening to music. The ability to play and appreciate great music was a part of him that he knew was special. By listening to his story, and writing it down for him, I was a witness for this talented, introspective gentleman. Here was a person who could give music and love and support to others. I was able to mirror this image back to him and validate and affirm the parts of his self that gave him the most pride.

Audrey's Case Study

Another approach I used in the hospital was dramatic movement and role-play. Much of the conversation by patients focus on their complaints of pain, medicine, physicians, and even nursing care. Whenever possible, I used role reversal as an intervention to increase their awareness of emotions by dramatizing and playfully exaggerating them. My goal was to pro-

vide a safe place to act out feelings the patients experienced related to their care. For example, with Audrey (pseudonym), a cardiac patient who had many concerns about her treatment, I intervened in the following manner:

> "Doc breezes in and out in two seconds and thinks he knows what I need?" shouts Audrey.
> "Yeah," I begin, "what if you just stuck your foot out and tripped him before he could get out the door?"
> "Oh m'gad," an astonished Audrey stared at me. Then she grinned. While Audrey watched, I kicked a little with my leg, in the direction of her door, as if the internist might at that very moment suddenly appear and trip.
> "No, no, no," Audrey corrected me. "He's real light on his feet, if ya know what I mean. Ya got to get your leg up really high, and fast, like this, if ya want to catch him."

The "impish" delight of acting out these impulses and letting the emotions of retaliation take over offered relief and a heightened awareness of how much frustration she felt. Therapeutically, when Audrey acted out the mischievous role, she experienced new ways of moving and acting, in a safe place, in an accepting and uncensored partnership with the dance/movement therapist. In my therapeutic work with these patients, I found that it is in the relationship with the therapist, where all feelings, no matter how angry or spiteful or resentful, are permitted, that therapy takes place.

Vladimir's Case Study

Hospitals do not intend to make patients feel powerless, but the rules, regulations, medical schedules, restrictions, and requirements foster that type of experience. Pills have to be taken. Bedside buzzers may, or may not produce attention. Meals may be cold, or dull, or late, or early. Baths may be hurried affairs where patients are given a few cleansing moments in the time frame that works best for the busy staff. Dance movement therapy can provide patients with opportunities to play power roles. Even when those roles are just play, they release tension, usually seen in laughter.

"If they bring me one more plate of mashed potatoes and mystery meat, I am going to smear it all over this room," announced Vladimir (pseudonym), former chef, now lying propped in bed. He recently had knee replacement surgery and was now receiving treatment involving a motorized piece of equipment that flexed his knee every thirty seconds.

"Like this?" I asked, and began smearing the envisioned meat and pota-

toes along the sanitized walls of his hospital room. His eyes followed me as I slowly travelled from one end of his room to the other, bending my knees as I swept down, almost out of his line of vision, then up again, in thirty-second intervals.

"Yeah," Vladimir chuckled, "Just like that." Even though I was the one acting out Vladimir's threat, the power of authoring, producing, and directing the retaliation scene was all his.

"Hey, you forgot to put a pile of that red Jell-O on the floor in front of the door for the first guy who tries to come in and take the tray away," he added.

I acted out his directions with exaggerated gestures, spilling the imagined Jell-O right where he pointed, and then, wildly flailing about, I moved as if I almost lost my balance trying to step over the spot where the Jell-O was supposed to be. Vladimir's chuckles grew louder, so I started to make louder noises as well: "Eeeek, I'm slipping, oh oh oh, this is yuck."

"That's good, that's good," he shouted.

I played the role to his satisfaction. Vladimir had created a new role for himself, a power role, and together we practiced it. He had, in the process, discovered that it can be helpful to envision actions like throwing food, tripping people, and making fun with his own creative imagination.

Ray's Case Study

Ray (pseudonym), sixty years old, experienced chronic pain that was difficult to manage. Due to the osteoporosis and arthritic deterioration of his spine, he was always in some degree of discomfort. The nurse on our floor wanted to decrease Ray's use of as needed (PRN) pain medication and instead use dance movement therapy sessions. Relaxation techniques were designed for him, which involved the use of guided imagery accompanied by soft music. Ray verbalized the images that came to his mind. I told him there was an art gallery inside his head, and he could look at the pictures if he focused with his magic eye. The images, I assured him, would be inside his head, and he could focus on earlier times and places, such as his childhood, happy vacations, or other such periods in his life when he was not in pain.

When participating in these guided imagery sessions, Ray's breathing slowed, his hands relaxed on top of his covers, and his eyes closed. His eyebrows lifted as if, behind his eyelids, he was looking off at a distance. He began to describe the lake where his early summers were spent with a dozen sailboats bobbing on the water, pine trees on the shore, and fluffy clouds in the sky. As he spoke, I sketched on a large piece of newsprint, using quick, broad strokes to suggest the blue water, little triangles for sails,

some trees, a few clouds in the sky.

During these sessions, his bodily response would reflect the pleasure and relaxation experienced in his memories of these earlier times; that is, his biological responses to pleasure and relaxation were triggered. Ray seemed to sink into the bed as his muscle tension decreased. He was momentarily safe, anticipating the soft touch of a breeze, a whiff of a pine tree, the lapping of waves. His body let go of its vigilance and expectation of pain, and he rested.

When the session was over, my drawing of his memories was taped to his wall at the foot of his bed, as were other sketches created in subsequent sessions. At one team meeting, I recommended to the staff that when he complained of pain, that they suggest that he reflect on the memories that the pictures evoked and that these reflections likely to help him manage with less medication. That met with the physician's approval and became part of his treatment plan.

DISCUSSION AND CONCLUSION

What is happening with these patients? We can apply Winnicot's (1975) contributions to what makes therapy work. The affective state of the patient is mirrored in a way that gives form to the emotions the patient feels. Once the therapist begins more fully to understand what is happening for the patient, she mirrors it back to him or her. In that way, the therapist uses what the patient brings to the session. For example, when the patient brings pain and depression and a sense of powerlessness, such as Audrey and Vladimir were experiencing, the dance movement therapy session becomes a safe and creative place to express these feelings. In the therapist's presence, and with their empathic support, the patients are able to invent new ways of moving with and through these feelings.

In common with many psychological therapies, dance therapy is interested in accessing the information that organizes lives, influences choices, and regulates responses. However, dance therapy always includes an awareness of how that information is held in and expressed by the body movement. Dance therapy does not guide the choices, preferences, or decision-making process of people in treatment. Dance movement therapy tunes the individual to the memories that influence the decision-making process, which is always going on in the body. The impressions of the senses, and the awareness of physiological changes or bodily felt shifts, which come about as neurotransmitters generate hormone reactions and create what is referred to as body memories. Feelings are experienced as bodily felt sensations encoded and are categorized during years of life experiences, making up what gives

meaning to any one person's existence (Damasio, 1994).

The focus of Damasio's (1994) work in neuroscience involves the question of sensory-perceptual integration. As mind and body work together neurologically, sensory perceptions are organized according to the body's ability to experience pleasure and pain. According to Damasio, the brain has the ability to symbolize ideas and emotions. As noted in the discussion of Ray, he was able to access these symbols in images of lake, sky, and sailboats, from his life experiences. The sensory perceptions attached to those images were still available to him. Similarly, Dwight was able to return to his creative self and re-establish his relationship to music as it existed in his encoded memory of pleasure and self-esteem.

Cousins (1998) observed that healing cannot be achieved without the active participation of the patient. Feelings of helplessness can be reduced when patients actively participate and/or experience stimuli symbolizing safety, nurturance, and support. As Damasio (1994) postulates, the source of stimuli must be congruent with the earliest symbols encoded in that individual's neurobiology. However, it is important to identify the patient's perspective regarding which symbols represent safety and support. The therapist needs to be able to "read the clues" and follow the particular map that the patient provides through their gestures, focus of attention, their giggles and their wiggles, and tears and fears. The therapist facilitated past response by encouraging Mammy to reflect upon memories of childhood meals provided for her in a loving way by significant others. Gloria actively embarked on this search and traveled to the songs and dances that had always made her feel special. In this way, she was able to re-experience the unconditional positive regard that had been hers during childhood. As for Mammy (who had a CVA and was not eating), she became actively involved in finding a way to participate in her own health care, making her own choices, including the choice to eat.

The dance and movement activities that engage the therapist and the patient involve the inner core aspects of that person. The movements are not selected to improve strength or range of motion, even though they might also accomplish that outcome. The movements are meant to heighten awareness and bring energy to the expression of emotions held within the body (Chaiklin & Schmas, 1993).

The dance movement therapist, as a part of the medical team, often has the respect of the nursing staff and can contribute to the patient's treatment program. Three rules that guided my work as described in this chapter include the following: (a) the therapist assures her patients that their work is confidential; (b) there are no right or wrong ways to move; and (c) patients may say or do anything that comes to mind, as long as they do not hurt themselves or someone else.

Because there is no right or wrong, there is no judgment. Movement and words can be used to express the first association, without edition. When the patient knows or senses this, a feeling of unconditional positive regard is encouraged. The latter promotes the therapeutic transference: here is a time and a place and a person who is not judging, not requiring any particular achievement, and who is giving her complete mindful attention and support during an in-the-movement experience. Here is the good enough caretaker. Here is the place for positive transference to do its work.

The transference is physical since it is based on the neurological mechanisms of a lifelong process of mapping and coding pleasurable experiences. The transference is rooted in the physical imprinting of the nervous system, brain structures and functions, emanating from experiences in the original caregiver relationship and all the body experiences, nonverbal communication, images and sounds of a lifetime.

If emotions are impressions from the senses, generated by neurotransmiters, and feelings are the awareness of the reactions and changes in the body, then dance movement therapy, by exploring feelings and emotions, accesses the information that organizes our lives, influences our choices, and regulates our responses. When people are going through serious illness, these responses are critically important. To facilitate the use of this aspect of being human in the healing process, every medical staff needs the assistance of a therapist who can work with the interface of mind and body. Every medical team needs an expert who can attune to the effect of that invisible neurological trigger point that resonates and creates the spirit of the person seeking wellness.

REFERENCES

Cousins, N. (1998). *Head first: The biology of hope.* New York: Dutton

Damasio, A. (1994). *Descartes' error, emotion, reason and the human brain.* New York: GP Putnam.

Chaiklin, S. & Schmais, C. (1993). The Chace approach to dance therapy. In S. Sandel, S. Chaiklin & A. Lohn (Eds.), *Foundations of dance/movement therapy: The life and work of Marion Chace* (pp. 75–97). Columbia, MD: American Dance Therapy Association.

Sandel, S. (1993). The process of empathetic reflection in dance movement therapy. In S. Sandel, S. Chaiklin & A. Lohn (Eds.). *Foundations of dance movement therapy: The life and work of Marion Chace.* Columbia, MD: American Dance Therapy Association.

Winnicot, D.W. (1975). *Through paediatrics to psychoanalysis.* New York: Basic Books.

Chapter 18

APPLICATION OF DANCE/MOVEMENT THERAPY PRINCIPLES TO NURSING CARE FOR PEOPLE WITH A DEMENTIA: A NON-VERBAL APPROACH

LAUREL BRIDGES

INTRODUCTION

The ability to communicate is a basic human need, possibly second only to the survival need (Hill, 1999; Mayhew, Acton, Yauk, & Hopkins, 2001). Researchers in non-verbal communication have postulated that as much as 93 percent to 97 percent of the messages we send to others is not conveyed through our words but instead is communicated through our voice tone, gestures, facial expression, and our way of standing or moving (Hoffman & Platt 2000; Hubbard, Cook, Tester, & Downs, 2002). This chapter will focus on the ways in which an awareness of movement as communication can assist in the nursing care of people with cognitive impairment. This awareness includes and goes beyond observing another's non-verbal communication or communicating with others non-verbally. We can communicate our care, concern, and desire to connect with someone else both through our words and through the way we move. Nurses are very skilled in communicating care through words and are also aware of non-verbal gestures that can be helpful in communicating with people whose ability to communicate verbally is more limited (Hoffman & Platt, 2000). However, they may be less likely to know how to observe and respond in movement as a way of communicating. For example, only one study was found that assessed

1. Portions of this chapter were presented at the Geriatric Psychiatry Conference, Edmonton, Canada, May 1994.

the effect on nursing practice of participating in dance movement classes (Bostick, 1997).

We can learn to look at the way movement communicates feelings and to use our movement intentionally to communicate with the ones we care for. The author of this chapter, a dance/movement therapist, developed movement-based caregiving approaches when she was working with older adults in a continuing care setting. These non-verbal approaches were developed by applying the principles of dance/movement therapy, movement analysis, and non-verbal communication to the nursing care of cognitively impaired older adults.

For six years, the author was a member of a mental health team. My role was to assess nursing home residents with emotional or behavioral problems and to provide education and advice to their caregivers. I also introduced and led dance/movement therapy groups in nursing homes. I used the skills developed in my training as a dance/movement therapist, but not only when I led dance/movement therapy groups. Part of my role was to assess residents who were agitated, aggressive, or resistant to care and to make nursing care suggestions to their caregivers. I used movement observation and interaction skills to assess the older adult's problems and to suggest possible alternative approaches to the caregivers. Movement skills helped me connect with residents whose ability to communicate their needs verbally was severely compromised. Furthermore, these skills also helped me suggest ways that caregivers could approach the residents in everyday care situations. I found that the dance/movement therapy profession's awareness of and response to the patients' non-verbal communication was a valuable tool that could be applied to enhance nursing approaches.

Focusing on non-verbal communication is, of course, especially needed when the older adults' ability to communicate their needs verbally is compromised due to cognitive impairment (Hubbard, Cook, Tester, & Downs, 2002). The will to communicate, which is seen to be inherent in humans from birth to death (Hill, 1999), can be diminished by dementia and depression. These issues can make it difficult for others to understand the person's needs and respond appropriately.

The chapter will begin with a brief description of dance/movement therapy, the client groups treated, and the issues addressed. Dance/movement therapy is often introduced in nursing homes as a therapeutic group activity led by the dance/movement therapy professional. Dance/movement therapy is a specialized treatment that is usually done by a qualified professional dance/movement therapist. However, a recent pilot study has implemented its use in nursing homes led by nursing home staff who are trained and supervised by a dance therapist (Hokkanen, Rantala, Remes, Härkönen, Viramo, & Winblad, 2003). In addition to the use of dance/movement ther-

apy, various types of expressive dance have been used with good effect in dementia care by other health care professionals (Killick & Allan, 1999). In fact, social dancing has been found to "be a nursing intervention that supports patient's positive feelings, communication and behavior" (Palo-Bengtsson, Winblad, & Ekman, 1998, p. 545).

The ways in which dance/movement therapy has been used with older adults in a nursing home setting will be briefly described, but this will not be the chapter's focus. Instead, the reader will be directed to excellent articles that outline the variety of ways it has been used to benefit older adults. The dance/movement therapy literature may be of interest to nurses who work with older adults and desire to refer people for this treatment.

Dance/movement therapists are trained to be aware of their own movement style and non-verbal communication and its effect on those with whom we interact. Then therapists are also trained to observe the way others move and to communicate our acceptance of them, and desire to connect with them through how we move (Hill, 1999).

In *Comforting the Confused: Strategies for Managing Dementia,* Hoffman and Platt (2000) explain that one of the reasons nurses may not focus on non-verbal communication is a lack of awareness of and training in how to "notice this component of our communication" (p. 27). The non-verbal communication strategies for nursing care of the cognitively impaired that have been developed by Hoffman and Platt and other authors will also be briefly reviewed in this chapter. In Bostick's (1997) qualitative research of nurses and nursing students, her participants reported an increased ability to tune in, be connected, and relax after attending twelve dance movement classes.

The use of approaches inspired by dance/movement therapy may help increase the caregiver's rapport with their clients and may reduce resistance to care. The movement approaches described in this chapter will be illustrated by two case studies.

MOVEMENT AND DANCE AS COMMUNICATION

Movement is central to all human activity and is one of the ways that we can express our feelings. We communicate our personality, feelings, and needs to others through movement. Although the importance of non-verbal communication has been confirmed (Hoffman & Platt, 2000; Hubbard, Cook, Tester & Downs, 2002), we generally focus upon and remember what others say, not what they are doing. Most of us are largely unaware of non-verbal communication and the ways in which it can reassure or agitate, foster connection and trust or, conversely, engender distrust and distance in others. Our actions "talk" even when we do not realize it, and others react to

our actions and our words.

You may be thinking, I understand the importance of non-verbal communication in the care of persons with a cognitive impairment, but what does dance have to do with caregiving? You may see dance as an art form that highly trained professionals perform for an audience or as a form of exercise or as something we do at social events. As this quote illustrates, dance is those things and more. Dance can help us feel connected to ourselves and others: "We are all dancers. We use movement to express ourselves, our hungers, pains, angers, joys, confusions, fears—long before we use words, and we understand the meanings of movements long before we understand those of words" (Stevens, 1976, cited on Oakridge Civic Ballet Association website www.korrnet.org/orcba/reading.htm).

We each partake in a dance with one another whenever we are in conversation, nodding our heads in tune with the rhythm of the other's words, leaning forward to hear better and communicate our interest; leaning back when the ideas expressed come too close for comfort; or reaching out with our gestures or in response to the other's gestures.

The research in non-verbal communication and dementia that will be referred to later in this chapter suggests that not only do we understand the dance of conversation before we understand the words, we may also understand the movement conversation even when cognitive impairment has made it impossible to understand the words (Hubbard, Cook, Tester, & Downs, 2002). Therefore, it may help caregivers to become more aware of the dance in which they are partners so that they can intentionally use its steps to connect with and not confuse their patients.

DANCE/MOVEMENT THERAPY

Dance/movement therapy, one of the creative art therapies, uses creative and expressive dance or movement to address emotional issues and increase self-awareness and health. The American Dance Therapy Association, the professional association that represents dance/movement therapists in North America and has an international membership, defines it as "the psychotherapeutic use of movement as a process which furthers the emotional, social, cognitive, and physical integration of the individual" (http://www.adta.org/pubrela.html). Dance/movement therapy draws both from dance traditions and from psychological theory to use movement intentionally and purposefully to effect changes in feelings, thoughts, physical functioning, and behavior. Dance/movement therapy's basis premise is that "body movement reflects inner emotional states and that changes in movement behavior can lead to changes in the psyche, thus promoting health and growth" (Levy,

1988, p. 1).

Dance/movement therapists are trained at the graduate level in psychology, in the therapeutic use of movement, and in the observation and the analysis of movement. They work with a wide variety of people, including adults, adolescents, and children with eating disorders, learning disabilities, chronic pain, addictions, autism, abuse issues, psychiatric disorders, and older adults with cognitive impairment, psychological issues, or physical disabilities. They also work with those populations whose verbal communication is limited due to cognitive impairment, brain injury, developmental or psychiatric disorders, and with healthy people who want to become more aware of and to express their feelings physically in order to reconnect with themselves and others. They work with individuals, groups, or in a consultative role: "When words alone are not enough, dance/movement therapists are there to help" (http://www.adta.org/pubrela.html).

Dance/movement therapy has been used extensively with older adults. Because it works on psychological issues through body movement, it is ideally suited to help people who are dealing with a loss of physical functioning through disease or accident. Several articles describe the recommended approaches and benefits of group dance/movement therapy with clients with a dementia (Arakawa-Davies, 1997; Hill, 2001; Hirsch, 1990; Johnson, Puracchio-Lahey, & Shore, 1992; Shustik & Thompson, 2002), whereas others focus on therapy groups with older adults who have had strokes or other brain injury (Berrol, Ooi, & Katz, 1997) or with Parkinson's disease (Westbrook & McKibben, 1989). Of special interest, related to the focus of this chapter, Hill (1999) has described the role of dance/movement therapy as communication with individuals who have a dementia. Her suggestions will be discussed later in this chapter. Sandel (1987), a nursing home administrator and dance/movement therapist, describes the benefits of dance/movement therapy group for older adults in this way:

> Dance/movement therapy integrates physiological, psychological and sociological aspects and attempts to give meaning to movement through the development of images within the movement interaction. While encouraging emotional reactions and processing of affective responses (both positive and negative), dance/movement therapy also facilitates social interaction. Movement activities are not the goal of the group experience, but rather the tool for creating a therapeutic environment. This approach distinguishes dance/movement therapy from other physical movement therapies and offers a comprehensive treatment method for the elderly. (Sandel & Kelleher, 1987, p. 27)

Readers who want to learn more about how dance/movement therapy could assist their older clients could refer to one of the above-cited articles. Shustik and Thompson's (2002) description of the way in which they apply

a person-centered care approach (Kitwood, 1997a) to their dance/movement therapy groups for those with a dementia may be especially helpful.

Several studies have examined the effect of dance interventions with persons who have a dementia. Palo-Bengstsson, Winblad, and Ekman (1998) found that "for persons with dementia, retained abilities were prominent in dancing" (p. 545). In his description of non-pharmacologic approaches to manage disruptive behavioural symptoms in patients with a dementia, Cooper (1994) mentions that exercise and dance therapy "can improve mobility, circulation and self-esteem; also confusion, loss of memory and depression can be improved" (p. 55). In addition, the dance/movement therapy (DMT) literature has several studies that report a positive effect following DMT treatment with people with a dementia or stroke (Berrol, Ooi, Katz, 1997; Hokkanen, Rantala, Remes, Härkönen, Viramo, & Winblad, 2003). Notably, Hokkanen's et al. recent pilot study has found in a very small sample that "the dance/movement therapy group seemed to have a favorable effect on language abilities" (p. 576) and increased their ability for social interaction. The case study to be described later in this chapter illustrates an increase in communicative and social abilities in a person with a dementia following a dance/movement therapy intervention.

RECENT RESEARCH ON DEMENTIA AND NON-VERBAL COMMUNICATION

Researchers have investigated "the well known experience that non-verbal communication often remains effective even in patients with severe dementia" (Roudier, Marcie, Grancher, Tzortzias, Starkstein & Boller, 1998, p. 151). The research has begun to answer questions such as the following: Do we know whether patients with moderate to severe dementia communicate their feelings non-verbally? When people with dementia are no longer able to understand verbal communication consistently, can they accurately recognize the non-verbal expression of emotion by others?

When their cognitive abilities deteriorate, patients with Alzheimer's disease are able to understand expressions of emotion, especially anger, sadness, and disgust (Lavenu, Pasquier, Lebert, Petit, & Van der Linden, 1999). Their ability to recognize emotions expressed in sounds such as crying or screaming have been found to persist longer and more reliably than their ability to recognize emotion from others' facial expression or movement (Koff, Zaitchik, Montepare, & Albert, 1999). Roudier et al. (1998) discovered that the ability to recognize emotion in others remains after their ability to recognize faces has deteriorated. Similarly, Sabat and Collins (1999), in a case study of a woman with moderate to severe dementia, determined that

"she experienced a wide range of emotions, demonstrated creativity and self-expression" and used "non-verbal communication to convey her thoughts" (p. 11).

There are conflicting findings regarding this population's ability to use and understand gestures. For example, Dumont and Ska (2000) found that the patients' ability to understand pantomimed gestures that are directly related to speech, such as acting out of words or thoughts or symbolic gestures, deteriorated at the same time as their ability to understand the words. Another study reported that in assessing pain, patients with a dementia had a reduced physiological response to pain, an inability to report it reliably and verbally and an increased facial expressiveness which may or may not have been related to felt pain (Porter, Malhotra, Wolf, Morris, Miller, & Smith, 1996). When contrasted with healthy subjects of the same age range, the gestures of people with Alzheimer's disease were found by Glosser, Wiley, and Barnoski (1998) to be less related to their verbal content and less complex. In addition, people with a dementia produced more gestures referring to concrete than symbolic content. In contrast, Hubbard, Cook, Tester, and Downs's (2002) ethnographic study of the use of non-verbal behavior and their ability to interpret it found that it was a frequently used and moderately well-understood method of communication for these individuals. These researchers contend that persons with dementia understand and share the meaning of many of the gestures that they and their caregivers use.

Other researchers found that the most reliable interpretation of the patient's facial expression came when the caregiver did not rely on a coding system but combined his or her knowledge of the individual, the situation, and the usual meaning of the expression (Asplund, Jansson, & Norberg, 1995). These researchers maintain that it is important not to attribute either "too much meaning into the severely demented patient's sparse and unclear cues" or to overlook "the possibility that there is some meaning to be interpreted" (p. 527). Supporting this observation is a study that measured the dementia patients' ability to express their feelings non-verbally through both direct observation of them and through the range of emotion they expressed as reported by family and nurses. "All three measures indicated that patients with Alzheimer's disease expressed a range of affective signals. Some showed an intact and functional emotion system even during the last stage of the disease" (Magai, Cohen, Gomberg, Malatesta, & Culver, 1996, p. 383). Mayhew, Acton, Yauk, and Hopkins (2001) videotaped five individuals whose mental status exam results ranged from 0–7 to assess their response to the request to tell "a story about something that happened in your life." Although the researchers were primarily attempting to understand the individuals' verbal communication, much of what the residents told them came with scattered words and gestures. Although the results of these studies vary,

it is evident that persons with a dementia can communicate non-verbally and can interpret others' non-verbal communication, likely with more success than with verbal communication.

Another salient question regarding the use of movement-based communication approaches is related to the measured effect of communication strategies on the behavior of a person with a dementia. McCallion, Toseland, Lacey, and Banks (1999) studied the effect of verbal and non-verbal communication training on nursing assistants in two nursing homes and on their patients. They found that following the training of their caregivers, the residents demonstrated less depressed symptoms. In addition, the nursing assistants were better able to manage the residents' verbal and physically aggressive behavior. Also, after this training, the nursing assistants felt more valued and remained in the job longer.

NON-VERBAL NURSING APPROACHES

Many articles have been written about nursing approaches that include non-verbal communication (Bartol, 1979; Beach & Kramer, 1999; Hoffman & Platt, 2000). In an excellent early article about non-verbal communication and dementia, Bartol (1979) explained that persons with dementia interprets the environment as welcoming or threatening based on the non-verbal cues that they see, and they react with agitation and verbally or physically aggressive behavior in an environment that they perceive to be threatening.

> Our experience has been that the maintenance of the communication process between the patient and nurse through increased awareness and utilization of non-verbal methods is an effective way to modify or eliminate much of the distressing aberrant behaviour associated with the ATD (Alzheimer's Type Dementia) process. (p. 31)

Much of the nursing literature on non-verbal communication and dementia focuses on the actions that can be very helpful in assisting caregivers to interact more sensitively with their patients. Beck and Heacock (1998) have drawn from Bartol's work in their list of six non-verbal approaches. Hoffman and Platt (2000) describe the sensory changes that may make verbal communication difficult and encourage their readers to become more aware of the patients' non-verbal communication by observing their facial expressions, eyes, gestures, postures, and vocalizations.

Beach and Kramer (1999) assessed eight nursing assistants' communication experiences with this population when providing their care. The caregivers stressed the importance of continual observation of the residents' responses, sensitivity to the residents' non-verbal communication, following

caregiver instincts and adjusting their approach based on the factor illustrated in this quote from a caregiver who works with dementia patients:

> I mainly watch facial gestures with him, just as he tightens up his muscles and stuff like that when you are moving him around. If he's more relaxed, then he's not so worried about something. . . . He'll tense up and maybe it could be that you're moving him too fast, so the next time you try to do it slower. (Beach & Kramer, 1999, p. 18)

This example of this "non-verbal connectedness via direct observation" (p. 18) provided by one caregiver is very reminiscent of a dance/movement therapist's observation and matching of her movement to her client's movement which will be described in more detail later in this chapter.

The caregivers in Beach and Kramer's (1999) study found that the approaches most likely to increase compliance included connecting with the residents' personal history, confirming the residents' perception of reality, and changing caregivers if one's approach was meeting with resistance. The caregivers joined the clients where they were and thus validated and established an empathetic connection with them. The effectiveness of changing caregivers to increase compliance may relate to increased compatibility between the caregiver and the residents' non-verbal and movement style as will be discussed later in this chapter.

A topic that is not addressed in as much detail in the literature is how the caregiver's natural movement style can influence his or her patients. As Hill (1999) explains:

> in dance therapy, communication is very much an interaction, a dance between two people. This dance is characterized by its give and take quality- both participants contribute. The dance therapist, of course must be the more adaptable in the partnership. (p. 13)

In this chapter, the discussion of dance/movement therapy approaches will focus both on developing skills to observe the patient's movement better and on being aware of one's movement style as a caregiver. In addition, suggestions will be made on how to use one's movement intentionally to create a connection with the patient.

DANCE/MOVEMENT THERAPY PRINCIPLES APPLIED TO CAREGIVING

The dance/movement therapy principles that I have applied to nursing care are movement observation skills including Labanalysis (Bartenieff & Lewis, 1980; Davies, 2001) and aspects of the Kestenberg Movement Profile

(Kestenberg Amighi, Loman, Lewis, & Sossin, 1999), and empathetic reflection through movement (Sandel, 1993). Furthermore, the development of approaches that may reduce aggressive outbursts were also informed by Lamb's work on gestures (Lamb & Watson, 1987) and the actions identified by Henley (1977) that may communicate submission and dominance.

Basic Principles of Observing Movement

We communicate non-verbally not only by "what" we do, our conscious actions, but also by "how" we do it. Dance/movement therapists are trained to observe and work with this important aspect of movement. There is not only one way to do every action. In our normal activities of life, how we do these activities communicates something about us, how we are feeling, and the relationship we have with those around us. We each move in ways that are unique to us and that can reflect our personality whether we are moving in order to complete a task such as providing care or cleaning our house or are expressing our feelings non-verbally in the way we accompany our words with gestures or stand or hold our bodies as we move.

In the 1940s, Rudolf Laban, an architect, painter, and dance choreographer studied how factory workers moved. He advised them and their employers on "how they might work more fluently with less strain on their body and more enjoyment of their task" (Davies, 2001, p. 39) by doing their jobs in a way that best reflected their preferred movement style. He and his colleagues found that "each person's movement pattern . . . is as individual as their fingerprint or their DNA" and that by studying "this movement pattern it is possible to predict how a person will react and inter-act in any given situation" (Davies, p. 49). Laban and his colleagues developed a system of characterizing how a person moves which is called Labanalysis, or effort shape movement analysis. Dance/movement therapists use this analysis system in assessing clients, planning treatment, and measuring their clients' progress.

Learning how to observe and record people's styles of movement using this system and the other movement observation methods used by dance/movement therapists takes extensive training and lots of practice. I am not suggesting that nurses learn this detailed way of interpreting their patients' movements. However, being more aware of what we are doing and how we do it can increase our understanding of ourselves and others. It can be helpful to have a basic understanding of the various qualities of movement in order to identify their own movement preferences and those of their patients.

For example:

We can use quick direct actions	Or slow measured actions
We can focus on many things at once	We can focus and do one task at a time
We can use a lot of effort in doing a task and look fairly tense as we move	Our movements can appear to flow freely almost as if they cannot stop
We can have a light feather touch	Our movement can feel or look firm or heavy
We can use lots of space around us	We can use very little space around us

As you read about these movement qualities, you could try moving in these ways and see what each feels like. You could also spend some time observing others in your daily life or on television and see what you can notice about how they move. Do you see any of the qualities described above?

Most of us can and do move in all of these ways. We adjust our way of moving dependent on the needs of the situation. However, regardless of what we are doing, there are usually ways of moving that we prefer or that we return to most often. We are not always conscious of how we, or others, move. However, we may have feelings about others based on their movement preferences but not know why we have that impression of them. For example, we may feel that someone who prefers quick strong movements and may also speak rapidly and sharply are in a hurry, do not have time for us, or that we have to rush to keep up with them. We may also be communicating these kinds of impressions to our patients without knowing it.

Most people use all of these qualities at different times and use several combinations of these qualities in each movement depending on the purpose of our movement, the circumstances, our personality, and our preference. Laban identified eight common combinations of these movement qualities using three movement qualities at the same time (see Bartenieff & Lewis, 1980).

We also adapt our movement style to those around us without thinking about it, and they adapt their movement styles to us. In addition, we can choose to do a task in the way that suits us. When observing two or more people, you may be able to see two people in close proximity moving in similar ways or almost in conversation with each other non-verbally, one moving then the other moving in similar or very different ways. Sometimes it is easier to observe these non-verbal interactional patterns if you cannot hear what they are saying. When learning to observe movement, dance/move-

ment therapists often watch people's movement on videotape with the sound muted.

In a caregiving situation, the caregiver's movement preferences significantly influence patients with a dementia for several reasons. The caregiver is in direct physical contact with them and they may misinterpret or react to this physical contact due to their cognitive impairment. Furthermore, the patients are unable to do the task independently and often cannot adapt their movement style to another. Therefore, any adjustment needs to be made by the caregiver.

The basic elements of movement interactions can be observed with a bit of practice, and caregivers can vary their movement style to match a patient's style. However, for a more in-depth understanding of a client's movement, a dance/movement therapist could assess the situation and make specific suggestions that may assist the caregivers to understand and connect with a specific patient.

Connecting with Clients through Movement

No matter what the purpose of our interaction with a patient, the first thing we need to do is to create a relationship with them. The ability to make an empathetic connection is one of the most important tools in any caregiving situation. One of the ways we can establish a connection with another person is through non-verbally matching their movement. Hill (1999) explained "in dancing with you, I accept you" (p. 14). Marian Chace, a pioneer in dance/movement therapy, stressed the importance of "joining the patient where they are at" (Sandel, 1993, p. 99). In order to do that, we need to observe the individual and gather information about him or her through observation and listening. We then adjust our movement to move with him or her.

Dance/movement therapists reflect the feeling the client is expressing in his or her movement not by copying or mimicking exactly what the other person is doing. Instead, the dance therapist "incorporates into his own movements the essence or predominant quality expressed in the patient's movements. This tuning in results in a rapport with the patient" (Schmais & White, 1986, p. 26). Mimicking or exactly following the client's actions, may be perceived as ridicule and may anger him or her, but using just one or two movement qualities that he or she uses in your action can cause him or her to feel validated. For example, if I was with a resident who was stamping his or her foot, as I spoke to him or her, I may clench and unclench my hand using the same strength and emphasis he or she is using or reflect the staccato tempo he or she is using in his or her foot action in the rhythm of my speaking voice. I would observe their response and alter my movement

accordingly. Empathy can be communicated when I respond to the person by using similar but not necessarily identical words or movements or when I reflect the feelings I see in her or him through my words, facial expression, or movement. Shustik and Thompson (2002) add that it is important to wait for the person's permission before joining him or her in this intimate way. This permission is communicated through "eye contact, intuitive sensing, and recognition of facial affect and bodily movement" (p. 53).

Movement empathy, "mirroring of action and meaning," or "kinaesthetic empathy" (Levy, 1988, p. 28) are terms that dance/movement therapist use to describe this process of reflecting the clients' feelings in our movement. "Mirroring, which may occur as part of the empathy process, involves participating in another's total movement experience, i.e., patterns, qualities, emotional tone, etc. It implies a quality of selflessness, a sense of entering another's experiencing in an open manner" (Sandel, 1993, p. 100).

A way in which a nurse could establish a connection by using movement with a nursing home resident who is walking down the hall is described below.

- Observe how she or he moves when alone by glancing periodically, not directly staring at them.
- What qualities is she or he using? What do you feel as you watch them?
- Your first goal is not to change their actions but to join and connect with him or her whether she or he is moving in a fast agitated manner or a very slow manner.
- Approach him or her with a similar movement style; greet him or her verbally and with an open approachable body stance and facial expression.
- Accompany him or her and observe if she or he seems to welcome this contact, withdraw from it or are oblivious to it.
- Follow his or her lead as the tempo or movement changes.
- Once you make a connection with him or her, you could alter an aspect of your movement (e.g., its speed or strength) to see whether she or he follows you.
- If she or he does not follow you, seem more agitated with your contact or have drawn away, you may want to withdraw slightly and observe his or her response.
- If she or he initially welcomed your connection but did not follow you, you could resume his or her original tempo.

These principles will be illustrated in the case study below.

Case Study Demonstrating the Non-verbal Connection

A woman with a late stage dementia approached me near the nurse's station after she attended a group I had led. Her speech was usually garbled and difficult to understand. She was disoriented to time, place, and person. She was unable to recognize herself in a mirror. When she saw me across the room, she called, waved her hand, and walked towards me. She was agitated, and her facial expression was somewhat worried. She spoke rapidly, and I could not understand the content of her speech. I kept my facial expression and body stance open and welcoming as she approached me. She placed her arm around me and began patting my back in a strong and rapid tempo. I placed my hand firmly but gently on her back while I observed her response. When she held my gaze and appeared to welcome my touch, I began patting her back matching the tempo or rhythm but did not use the strength with which she was patting me. We stood there looking at each other and patting each other's backs for several moments while she continued to talk rapidly. Once I felt that a connection was established with her, I tried slowing the pace of my patting slightly, and she followed me. As I continued gradually to alter either the speed or the strength of my touch on her back, I noticed the strength of her touch changed to match mine. Her rate of speech also slowed down, and she gradually became less agitated. In the five minutes that we had stood together, her movement had slowed to stillness, her facial expression relaxed, and she stopped talking. She appeared peaceful and calm as she stood with her hand on my back. After a few moments, I smiled and said in a quiet voice, "I have to go! I'll see you next week." While remaining relaxed and smiling, she removed her hand from my back and stated in a very clear understandable voice, "That would be lovely. I'll see you next week". She then turned around and walked slowly away. What is even more remarkable is her response to me one week later. I sat down beside her as the dance/movement therapy group began, placed my hand gently on her back, and asked how she was. She spoke in voice that was understandable but not as clear as her speech at the end of our previous encounter. She stated, "last week, someone touched me."

This encounter illustrates the powerful effect that can occur when one is successful in entering the world of a person with dementia through matching their movement style. She was calmer for the rest of the shift that day, but she did become very agitated at other times. Of course, her very significant cognitive impairments remained. But she responded positively to being understood by a caregiver through this non-verbal connection during the time we were together and, to a less degree, one week later when she experienced a similar tactile stimuli.

CONCEPTS OF SHAPE-FLOW AND ATTUNEMENT

Early in my training as a dance/movement therapist, I was introduced to the Kestenberg Movement Profile (Kestenberg Amighi, Loman, Lewis, & Sossin, 1999), and several of its concepts contributed greatly to my understanding of how we connect with each other through movement and how our desire to connect with or withdraw from each other is expressed in our subtle body movements.

The Kestenberg Movement Profile (KMP) is a movement analysis system developed by a psychoanalyst, Judith Kestenberg, and her colleagues based on and extending Laban's original concepts. It is a very complex system that analyzes nine different movement patterns and measures subtle changes in flow of muscle tension and how the body shape changes as individuals respond to their environment. It requires trained observers and annotators to interpret the meaning of non-verbal behavior (Loman & Foley, 1996). The KMP can assist the trained observer in getting "a deeper understanding of the individual through his or her non-verbal behaviour" that "can greatly supercede intuition" (Kestenberg Amighi et. al., 1999, p. vii). It has been used with independent trained observers providing the movement analysis to measure the change in nursing home residents' attitudes about their bodies following ten-sessions of dance/movement therapy (Bridges, 1989).

In my work in continuing care centers, I applied the KMP concepts as I first observed caregiving situations and attempted to establish a connection with older adults in a nursing home setting without doing a formal KMP movement assessment. Because the movement that the KMP records is subtle and does not require that the individual move in specific ways, it is well suited for use with older adults whose movement range is limited. I was primarily aware of and responsive to changes in the patients' shape-flow patterns, especially the bipolar and unipolar shape-flow:

> Shape-flow can be seen in the continuous changing shapes of the body in respiration. . . . Breathing and other shape-flow rhythms provide structure for increasing and decreasing contact with the environment. Through these rhythms, we express self-feelings and mood through expanded or contracted body shapes and facial expressions. . . . These bipolar shape-flow (symmetrical) patterns serve the expression of self feelings, providing the non-verbal medium for demonstrating feelings and moods related to pleasure and displeasure. . . . Unipolar shape-flow (asymmetrical) patterns form a basis of communication, interactional rhythms and the core of attraction and repulsion. (Loman & Foley, 1996, p. 342)

In observing residents' responses to my approach or to a caregiver, I was sensitive to subtle changes in the shape of their bodies either bilaterally as in

the expansion and contraction of their torso as they breathed (bipolar shape-flow) or in one-sided or one-directional drawing back or expanding towards in response to touch or other interaction (unipolar shape-flow). Observing these movement changes helped me to understand more about the needs of verbally non-communicative residents. In this way, I gathered information about whether they were non-verbally welcoming or discouraging the contact or the care they were receiving as I saw them very subtly shift their body shape.

Another primary concept related to the KMP that I applied when observing care was that of attunement: "Kinaesthetic attunement is the process of translating movement qualities observed in another person into one's own body" (Sossin & Kestenberg Amighi, 1999, p. 13). This can be done through physical contact, matching the tension you feel, or through just observing and assuming the same muscle tension, body shape, or rhythm in your body (Loman & Merman, 1999, pp. 214–215). This kind of attunement can assist the dance/movement therapist in mirroring the client's movement, in communicating empathy and in developing a relationship through non-verbal means. In the case study previously described, I used both visual attunement (i.e., observing the woman's body shaping and movement patterns), and touch attunement (i.e., matching the muscle tension and rhythm I felt when patting her back). This quote from Loman and Merman (1999) describes what I did when interacting with this woman:

> Responding with visual, tactile or auditory/vocal/verbal attunement can soothe an upset child or adult and lead to mutual understanding. The degree of tension exhibited by the mover can be matched initially and then developed into less intense, more soothing patterns. (p. 215)

In contrast, the KMP concept of clashing is seen when we use very different or opposite movement qualities from the person with whom we are interacting. In this case, we are likely to feel unconnected or out of step with him or her. For example, in a caregiving situation, if the patient moves in a slow methodical way and the caregiver prefers to move rapidly, often changing his or her focus and task, the care provided may feel overwhelming to the patient. A mismatch also may occur when the movement of a frail patient is characterized by light, feathery, small, tentative movements and the caregiver has a strong direct "no frills" style in which she takes a lot of space around her. However, the goal is not to attune with another perfectly. In fact, complete attunement can feel intrusive and make it difficult for a person to develop independently.

As I describe the ways in which I extrapolated these concepts and applied them to nursing care, I am aware that there is a grave danger that complex concepts can be distorted and misrepresented by simplifying them and

applying them for a different purpose. This is not my intention. I recommend that readers who are interested in understanding this movement profile and its many clinical applications in dance/movement therapy and psychotherapy read *The Meaning of Movement: Developmental and Clinical Perspectives of the Kestenberg Movement Profile* (Kestenberg Amighi, Loman, Lewis, & Sossin, 1999).

I will now describe the ways in which I applied the concept of attunement and clashing to caregiving situations. Caregivers generally feel good when they can meet their patients' needs quickly and frustrated when their patients resist or refuse care in spite of their best efforts. The patients feel more secure and less irritated when the caregiver's style of movement is similar to their style. This natural similarity between the caregivers' and patients' movement style could be part of the reason that some patients respond better to some caregivers than others. If the caregiver has established a rapport with the patients through speaking and interacting with them and through reflecting their movement style, they may tolerate caregiving because they want contact with you.

Both patients and their caregivers like and dislike certain types of interaction and movement. For example, some caregivers are comfortable touching their patients, while some are less so. Some patients feel reassured with touch, and some feel uncomfortable with it. Lack of ease with touch can be attributed to a variety of reasons related to cultural background, personality style, physical illness, or cognitive impairment. If patting a resident's back or placing a hand on his shoulder is how you prefer to reassure him, then his negative response can be frustrating or confusing.

In my assessment of a difficult caregiving situation, I would first consider whether physical pain, infection, illness, depressed mood, sensory impairment, or misunderstanding of the caregiver's intention could be contributing to the difficulty. Patients with a dementia also often have difficulty responding to multiple stimuli and could be overwhelmed in a caregiving situation. I would examine the amount of stimulation present and observe for non-verbal and verbal indicators of how they were tolerating it. Facial expression, agitated movement, and subtle changes in their shape-flow would be my primary cues. I would be aware of the sensory stimuli including odors, background sounds, touch, and verbal instructions. If the patient was becoming agitated or was withdrawing from contact, stimuli could be reduced one by one to see if the patient demonstrated less tension, agitation, or withdrawal.

When those issues had been dealt with, I would consider whether the caregiving difficulties could be related to differing movement styles. When the patient's movement style is very different from the caregiver's, as in the examples above, he or she may respond with irritation or agitation, may push away or become more "clingy" and reluctant for the caregiver to leave.

In addition, as the disease process progresses, the patient may either move differently or be less able to adapt to the caregiver's style. In this way, patients who previously responded well to a caregiver's approach may now have difficulty with it.

Sometimes, I would make suggestions to the caregivers about ways they could alter their approach to better match the patients' needs and personality style. In order to adjust, the caregivers need to be aware of their preferred style, to observe how the patients move, and to experiment by adjusting their style. The patients are not usually aware of their movement style or capable of changing it.

Another factor I considered was the quality of movement needed to do a certain task. The style of movement needs to be appropriate to the task. For example, if a job requires strength, speed, and directness, soft gentle movements may not be effective or may put both the patient and caregiver at risk and increase both parties' frustration. In this case, the caregivers could perhaps use a patient's preferred soft gentle style in their voice tone, facial expression, or touch, either during or after care provision in order to maintain the emotional connection with the patient. By experimenting with different styles of moving, and speaking while providing care for each patient, the caregiver can discover the style that works for each one. This is not a static process. Each person's movement style (e.g., patterns and rhythms of tension, or body shape) changes constantly and may reflect one's mood and cognitive functioning.

PROVIDING REASSURANCE AND PREVENTING AGGRESSIVE BEHAVIOR THROUGH BODY LANGUAGE

When working in continuing care centers, I developed information for caregivers concerning how to communicate non-verbally with their patients. I based these presentations on my experience working with persons with cognitive and communication impairments and their caregivers and on the non-verbal communication and movement observation literature (Bartol, 1979; Henley, 1977; Lamb, 1987).

There are many resources developed by nurses and other health care professionals on managing disruptive behaviors (Cooper, 1994; Jervis, 2002; Patel & Hope, 1993; Slone & Gleason, 1999; Williams, Wood, Moorleghen, & Chittuluru, 1995). The information on a non-verbal communication approach to managing this issue that is presented in this chapter provides another perspective. It also serves as another illustration of how the nursing care of clients in long-term care centers can be seen through the lens of dance/movement therapy.

I began to investigate the ways in which the non-verbal communication literature could assist me in responding to agitated or aggressive behaviors because I was often asked to assess residents when they were very agitated, had resisted care, or were physically aggressive. I researched the various elements of non-verbal communication such as facial expression, touch, tone of voice or way of speaking, gestures, posture, and proxemics. The *Merriam-Webster Dictionary* defines proxemics as the "nature, degree, and effect of the spatial separation individuals naturally maintain (as in various social and interpersonal situations)" (available at http://www.m-w.com/home.htm).* In addition, I noticed that when I paid careful attention to my distance from the residents, my posture, body stance, facial expression, and voice tone, I was able to calm and reassure them without saying very much.

The guidelines listed below on behavior that could communicate dominance or aggression were primarily taken from Henley's (1977) book, *Body Politics*. In addition to discussing her own research into the effects of non-verbal communication, Henley also reported the results of many other studies of non-verbal expressions of power or dominance as they relate to gender. Several of her conclusions pertained to providing care for older adults in continuing care. These older adults may feel disempowered because of their need to depend on caregivers to provide for their basic needs. Henley offers the following conclusions:

> Non-verbal behavior is a major medium of communication in our everyday life. Power (status, dominance) is a major topic of non-verbal communication; and non-verbal behavior is a major avenue for social control on a large scale, and interpersonal dominance on a smaller scale. . . . Because our culture considers trivial, ignores, and doesn't educate its members to non-verbal behavior, it constitutes a vague stimulus situation. Its interpretation is then highly susceptible to social influence. . . . The behaviors expressing dominance and subordination between non-equals parallel those used by males and females in the unequal relation of the sexes. (pp. 179–180)

Table 18.1 includes a summary of the actions that may reassure or cause anger or aggression. Most of the actions listed in the left hand column were informed by Henley's (1977) research about actions that communicate dominance or exert control. The alternative actions primarily came from my own experience as a dance/movement therapist working in this setting and from my observations of caregivers who had good rapport with their patients. The alternative suggestions were also informed by Henley and Bartol (1979) and Lamb (1987). As mentioned previously, very helpful non-verbal nursing approaches have been also discussed in the nursing literature (e.g., Beach & Kramer, 1991; Hoffman & Platt, 2000; McCallion, Toseland, Lacey, & Banks,

*By permission. From the *Merriam-Webster Online Dictionary* ©2004 by Merriam-Webster, Incorporated (www.Merriam-Webster.com).

1999).

A caution needs to accompany these guidelines about the possible meaning of gestures. As a dance/movement therapist, I observe a person's movement style over time and in context. That is, I do not just interpret one gesture. One of the movement specialists who has carried on Rudolf Laban's work, Warren Lamb stresses the importance of seeing movement in context and not just isolating a single gesture and attaching meaning to it (Lamb & Watson, 1987, p. 21). There are, in fact, many possible meanings to any gesture. It is important to examine each gesture in the context of the whole body stance, the person's personality and usual way of moving, the social and cultural context, and other associated meanings of the gesture.

Another principle discussed by Lamb and Watson (1987) that I emphasize in any presentations on non-verbal communication is that we are believed and trusted by others more readily when the content of our words and the gestures and the postures we use are sending the same message. As stated earlier in this chapter, we all receive verbal and non-verbal messages from others. As professors, we are most easily understood when our verbal and non-verbal messages agree. I usually summarize my presentations on this topic with the information that is highlighted below. I illustrate this principle by approaching a participant and verbally encouraging him or her to "trust me, you will be perfectly safe" while I assume a threatening stance and gesture or by telling them to relax and take their time while I appear tense, ready to take off, and repetitively look away and at my watch.

> If the words you are saying do not match your body language (e.g., how you stand, facial expression, tone of voice, and what you say with your hands), people will have difficulty understanding what you are saying and have difficulty trusting your message.

There is support in the recent literature for this application of non-verbal communication to reassure, communicate, and reduce aggressive outbursts. In their recent controlled study of 405 nursing home residents, Talerico, Evans, and Strumpf (2002) found that older adults with impaired communication and depression were more likely to exhibit physical and verbal aggression. The goal of the movement interventions, described in my chapter, are to improve our communication with those who have a cognitive impairment.

Furthermore, Kitwood (1997b) has stressed the importance of creating a supportive connection between the carer and the person with a dementia

Table 18.1
OUTCOMES OF NONVERBAL NURSING ACTIONS
WITH CLIENTS WHO ARE AGITATED

ACTIONS THAT MAY EVOKE AGGRESSION	ACTIONS THAT MAY PROMOTE REASSURANCE
Standing or Walking	
Looking down at or standing over a person while talking or listening	Crouching down to be at the client's eye level while talking or listening
Standing close to, leaning forward or swinging your arms close to a person	Explaining purpose before getting close to them or asking permission before touching
When walking with a person, pushing them from behind or walking in front of them and pulling them along	Walk by their side, or slightly in front and encourage them forward with conversation
Touch	
Being touched by strangers or people they can not remember	Introduce yourself before touching a person with dementia. Explain the purpose of touch. "Hello Mr. ____ I am ____ and I am here to change your shirt"
Being touched quickly in a brushing action and/or spoken to in a loud impatient voice	Being touched in a soft, soothing way and being spoken to in a calm, relaxed way
In public, reaching out to straighten a person's clothing	Ask permission before fixing clothing in public (e.g., arranging one's collar)
Slapping a resident on the back, playfully tapping them or patting their cheek could comfort or could make then feel irritated	Assess their reaction and use touch to reassure. Ask permission before touching
Facial Expression	
Staring at people even by accident can cause anger and decrease willingness to comply with care	Looking at people briefly with a smile shows them you like and respect them
Frowning or a stern facial expression can cause a resident to believe you are angry and respond with anger or fear	Having a relaxed facial expression or smiling reassures and makes you more approachable

Continued

through shared body language in this quote: "Even more significant is the language of the body: expression, gesture, posture, proximity, and so on. This conveys emotion and feeling with great authenticity, and here we are coming close to cross-cultural universals" (p. 71).

Table 18.1–*Continued*

ACTIONS THAT MAY EVOKE AGGRESSION	ACTIONS THAT MAY PROMOTE REASSURANCE
Gestures (speaking with your hands)	
Asking people to come by beckoning with your hand may cause them to feel like they are being summoned and should not refuse	Approaching them and asking them to come
Gesturing to stop talking or to stop doing something can cause one to feel devalued	Approaching them, crouching down to eye level if necessary, asking them to speak more quietly or distracting them to another activity
Gestures found to communicate dominance Hands on the hips Fists clenching Pointing fingers Gesturing with fist Arms crossed (Henley, 1977, p. 127)	Gestures found to be non threatening Playful laugh Smiling Tilting head Dropping head or gaze Open palms, facing upward or by side (Henley, pp. 152, 172)
Tone of voice/Way of speaking	
Interrupting often as a person speaks may contribute to a feeling of being devalued or not important	Allowing them to finish their sentence or asking permission to interrupt
A fast or loud speaking voice can irritate, agitate or cause fear.	A slower, even speaking voice at a moderate tone can reassure

In addition, Hubbard, Cook, Tester, and Downs's (2002) study of the meaning of the non-verbal communication of persons with a dementia suggested that "despite verbal communicative deficits and cognitive impairments, older people with dementia use and interpret non-verbal behavior" (p. 163). Their findings suggested that the participants with a dementia "acted in the context of shared meanings and expectations" (p. 163). Their study further suggests that "encouraging non-verbal communication may offset a spiral of decline because it is one of the ways that older people with a dementia meaningfully engage and preserve a sense of self" (p. 163; see also LeNavenec & Vonhof, 1996, p. 176).

Role Play Group Case Study

When I teach dance/movement therapy classes or do presentations on non-verbal communication with older adults, I invite the participants to

role play both a caregiver and an older person who lives in a long-term care center. In my experience teaching these approaches, I have found that students learn more readily if they have a "physical" experience of these approaches. The participants are given a character to play and information about the person's health history, culture, and personality. Whereas those playing an "older adult" in a care center are provided with information about the character's mental status and situation in the care center, those playing "the caregivers" are provided with information about their character's work and home demands. It is important to understand the context of the care giving situation and the other stressors that may be evident for both caregiver and resident. The characters of the residents and caregivers that I give the participants are based on a composite of many of the people with whom I have worked in long-term care centers. Various props are provided, including clothing and hats, to help them get into the character. In addition, for the roles of the older adults with a physical or cognitive impairment, I provide walkers, canes, and glasses with petroleum jelly on them to resemble visual distortions.

For the roles of caregivers, I provide props related to each scenario to be enacted. The format of these role plays is as follows. First, I invite the participants to spend time getting into their role, to feel what it would be like to be this person. Next, I gather the caregivers together, describe one of the scenarios listed, ask them to approach one of the participants who is role playing a resident and attempt to achieve the task described in the scenario by trying out some of the non-verbal approaches that have been

Table 18.2
SCENARIOS FOR CARE GIVING ROLE PLAY

#1	The dance/movement therapist has arrived and told you that she needs help getting four patients to her group. You had forgotten the group was scheduled today; the patients are still finishing up breakfast, and you feel frustrated that you have to do this as well as everything else. So you need to get the patients to the group quickly down a poorly lighted hallway.
#2	You have just arrived on the unit at 7:00 a.m. and find a note from the night supervisor telling you that your patient who is usually a late riser has an early appointment, so you need to get him up and dressed first thing. You know this is going to be difficult and will make you late in dressing the other residents.
#3	A new walking group has just started on the dementia unit to reduce late afternoon wandering by providing activities just before tea. You need to help the recreational therapist walk with the residents and then get them to sit down for tea after the exercise.

described. The participants who are playing the residents are invited to stay in the role and respond to the caregiving situation in a way that seems natural to them. Once the scenario has been role played, the caregiver-resident combination discuss their experience with each other, and have an opportunity to journal any personal reflections. Then the participants are invited to assume the opposite role (caregiver or resident) with another partner in one of the other scenarios. When the role play is finished, the participants are invited to return to their usual movement style and shake out any tension. Group processing and reflection occur at the end of the experience (Kitwood, 1997b). It is important to provide an opportunity for the participants to process the feelings evoked by this experience and to "de-role" by returning to their usual way of moving and talking.

On one occasion that I facilitated this experience, one of the participants in the role play was playing Mrs. Martin (pseudonym), a very frail, ninety-five-year-old woman with a hearing impairment. This character also had severe arthritis and a bent posture due to a kyphosis secondary to ostoearthritis. Mrs. Martin also had cataracts that caused her to misinterpret the situation when she did not see clearly. According to the mental status report for this character, she was alert but had a severe depression. This character was being treated with antidepressants that made her dizzy. She needed two canes or a walker to ambulate. Mrs. Martin was a widow whose four sons were deceased. She had lived in the nursing home for six years. One niece visited her periodically. Her caregiver was supposed to get her up early in the morning for an appointment. When the participant who played Mrs. Martin was processing the experience afterward, she stated, "I felt like I had very few options and that the only way I could communicate was to get angry and strike out." The emotional response to embodying this role gave her new insight into the resident's experience that could inform the way in which she approached long-term care residents in a caregiving role.

Kitwood (1997b) recommends role play as one way to increase our understanding of "the subjective world of dementia" (p. 15). He describes it in this way:

> Finally, there is the possibility of using role play: that is, actually taking on the part of someone who has a dementia, and living it out in a simulated care environment.... Thus role playing may be one of the most powerful routes to understanding. Here we are going far beyond a merely intellectual grasp and coming closer to a genuine 'standing under': feeling the shape and weight of things, knowing them in action rather than just in mere reflection. (p. 17)

CONCLUSION

I strongly believe that the creative arts and particularly dance and movement have much to contribute to health care provision and even more so in the care of those whose verbal communication is limited. When working in long-term care centers, I was committed to finding ways not only to "dance" with the residents, but also to apply the principles of dance/movement therapy to all aspects of patient care. The ways in which I achieved that goal have been described in this chapter. This application of dance/movement therapy (DMT) principles to the nursing care process is an example of how collaboration between various health professions can help all of us to serve the people with whom we work better. Furthermore, these psychosocial approaches developed with older adults could be adapted for use with other client groups.

REFERENCES

American Dance Therapy Association (2001). Who we are: The American Dance Therapy Association. (Online) Available http://www.adta.org/publrela.html.

Arakawa-Davies, K. (1997). Dance/movement therapy and reminiscence: A new approach to senile dementia in Japan. *Arts in Psychotherapy, 24*(3), 291–298.

Asplund K., Jansson L., & Norberg, A. (1995). Facial expressions of patients with dementia: A comparison of two methods of interpretation. *International Psychogeriatrics, 7*(4), 527–534.

Bartenieff, I., & Lewis, D. (1980). *Body movement: Coping with the environment.* New York: Gordon Breach Science.

Bartol, M. (1979). Non-verbal communication in patients with Alzheimer's disease. *Journal of Gerontological Nursing, 5*(4), 21–31.

Beach, D., & Kramer, B. (1999). Communicating with the Alzheimer's resident: Perceptions of caregivers in a residential facility. *Journal of Gerontological Social Work, 32*(3,) 5–26.

Beck C., & Heacock P. (1998). Nursing interventions for patients with Alzheimer's disease. *Nursing Clinics of North America, 23*(1), 95–124.

Berrol, C.C., Ooi, W.L., & Katz, S. (1997). Dance/movement therapy with older adults who have sustained neurological insult: A demonstration project. *American Journal of Dance Therapy, 19*(2), 135–160.

Bostick, C.A. (1997). Dance movement and its effects on rhythmic flow and nursing practice. *Dissertation Abstracts International, 58,* (4–B), 1797. (UMI No. 1997-95020-055).

Bridges, L. (1989). Measuring the effect of dance/movement therapy on the body image of institutionalized elderly using the Kestenberg Movement Profile and projective drawings. Unpublished master's thesis, Antioch New England

Graduate School, Keene, New Hampshire, USA.

Cooper, J. (1994). Managing disruptive behavioral symptoms: Today's do's and don't's. *Nursing Homes Long Term Care Management, 43*(1), 54–56.

Davies, E. (2001). *Beyond dance: Laban's legacy of movement analysis.* London: Brechin Books.

Dumont, C., & Ska, B. (2000). Pantomime recognition impairment in Alzheimer's disease. *Brain and Cognition, 43*(1-3) 177–181.

Glosser, G., Wiley, M., & Barnoski, E. (1998). Gestural communication in Alzheimer's disease. *Journal of Clinical & Experimental Neuropsychology, 20*(1), 1–13.

Henley, N.M. (1977). *Body politics: Power, sex & non verbal communication.* New York: Simon & Schuster.

Hill, H. (1999). Dance therapy and communication in dementia. *Signpost 4*(1), 13–14. Available http://www.phewartscompany.co.uk/dementia.html. Retrieved December 27, 2003.

Hill, H. (2001). *Invitation to the dance: Dance for people with dementia and their carers.* Stirling, Scotland: University of Stirling.

Hirsch, S. (1990). Dance therapy in the service of dementia. *American Journal of Alzheimer's Care and Related Disorders and Research,* July August, 26–30.

Hokkanen, L., Rantala, L., Remes, A., Härkönen, B., Viramo, P., & Winblad, I. (2003). Dance/movement therapeutic methods in management of dementia. *Journal of the American Geriatrics Society, 51*(4), 576–577.

Hoffman, S., & Platt, C. (2000). *Comforting the confused: Strategies for managing dementia* (2nd ed.). New York: Springer.

Hubbard, G., Cook, A., Tester, S., & Downs, M. (2002). Beyond words: Older people with dementia using and interpreting nonverbal behaviour. *Journal of Aging Studies, 16,* 155–167.

Jervis, L. (2002). Contending with "problem behaviors" in the nursing home. *Archives of Psychiatric Nursing, 16*(1). 32–38.

Johnson, C., Puracchio-Lahey, P., & Shore, A. (1992). An exploration of creative arts therapeutic group on an Alzheimer's unit. *Arts in Psychotherapy 19,* 4, 269–278.

Kestenberg Amighi, J., Loman, S., Lewis, P., & Sossin, M. (1999). *The meaning of movement: Developmental and clinical perspectives of the Kestenberg Movement Profile.* New York: Brunner Routledge.

Killick, J., & Allan, K. (1999). The arts in dementia care: Touching the human spirit. *Journal of Dementia Care, 7*(5), 33–37.

Kitwood, T. (1997a). *Dementia reconsidered: The person comes first.* Philadelphia: Open University Press.

Kitwood, T (1997b). The experience of dementia. *Aging and Mental Health, 1*(1), 13–22.

Koff, E., Zaitchik, D., Montepare, J., & Albert, M.S. (1999). Emotion processing in the visual and auditory domains by patients with Alzheimer's disease. *Journal of the International Neuropsychological Society, 5*(1), 32–40.

Lamb, W., & Watson, E. (1987). *Body code: The meaning in movement.* Princeton, NJ: Princeton Book.

Le Navenec, C., & Vonhof, T. (1996). *One day at a time: How families manage the expe-*

rience of dementia. Westport, CO: Auburn House.

Lavenu, I., Pasquier, F., Lebert, F., Petit, H., & Van der Linden, M. (1999). Perception of emotion in frontotemporal dementia and Alzheimer disease. *Alzheimer Disease and Associated Disorders, 13*(2), 96–101.

Leventhal, M., & Schwartz, J. (1989). The dance of life: Dance and movement therapy for the older adult. *Topics in Geriatric Rehabilitation, 4*(4), 67–74.

Levy, F. (1988). *Dance/movement therapy: A healing art.* Reston, Virginia: American Alliance for Health, Recreation & Dance.

Loman, S., & Foley, L. (1996). Models for understanding the non-verbal in relationships. *Arts in Psychotherapy 23*(4), 341–350.

Loman, S., & Merman, H. (1999). The KMP as a tool for dance/movement therapy. In J. Kestenberg Amighi, S. Loman, S. P. Lewis & M. Sossin (Eds.), *The meaning of movement: Developmental and clinical perspectives of the Kestenberg Movement Profile* (pp. 211–234). New York: Brunner Routledge.

Magai, C., Cohen, C., Gomberg, D., Malatesta, C., & Culver, C. (1996). Emotional expression during mid- to late-stage dementia. *International Psychogeriatrics, 8*(3), 383–395.

Mayhew, P., Acton, G., Yauk, S., & Hopkins, B. (2001). Communication from individuals with advanced DAT: Can it provide clues to their sense of self awareness and well-being? *Geriatric Nursing, 22*(2), 106–110.

McCallion, P., Toseland, R., Lacey, D., & Banks, S. (1999). Educating nursing assistants to communicate more effectively with nursing home residents with dementia. *Gerontologist, 39*(5), 546–558.

Merriam Webster Online. Available http://www.m-w.com/home.htm.

Palo-Bengtsson, L., Winblad, B., & Ekman, S.L. (1998). Social dancing: A way to support intellectual, emotional and motor functions in persons with dementia. *Journal of Psychiatric & Mental Health Nursing, 5*(6), 545–554.

Patel, V., & Hope T. (1993). Aggressive behaviour in elderly people with dementia: A review. *International Journal of Geriatric Psychiatry, 8*(6), 457–472.

Porter F., Malhotra, K., Wolf, C., Morris, J., Miller, J., & Smith, M. (1996). Dementia and response to pain in the elderly. *Pain, 68*(2–3), 413–421.

Roudier, M., Marcie, P., Grancher, A.S., Tzortzis, C., Starkstein, S., & Boller, F. (1998). Discrimination of facial identity and of emotions in Alzheimer's disease. *Journal of the Neurological Sciences, 154,* 2, 151–8.

Sabat, S., & Collins, M. (1999). Intact social, cognitive ability, and selfhood: A case study of Alzheimer's disease. *American Journal of Alzheimer's Disease, 14*(1), 11–19.

Sandel, S. (1993). The process of empathetic reflection in dance therapy. In S. Sandel, S. Chaiklin & A. Lohn (Eds.), *Foundations of dance/movement therapy: The life and work of Marian Chace* (pp. 98–111). Columbia, MD: American Dance Therapy Association.

Sandel, S., & Hollander, A. S. (1995). Dance/movement therapy with aging populations. In F. Levy (Ed.), *Dance and other expressive art therapies: When words are not enough* (pp. 133–143). New York: Routledge.

Sandel, S. & Kelleher, M. (1987). A psychosocial approach to dance-movement therapy. In S. Sandel & D. Johnson (Eds.), *Waiting at the gate: Creativity and hope in the*

nursing home (pp. 25–40). New York: Haworth.

Schmais, C., & White, E. (1986). Introduction to dance therapy. *American Journal of Dance Therapy, 9,* 23–30.

Shustik, L., & Thompson, T. (2002). Dance/movement therapy: Partners in personhood. In A. Innes & K. Hatfield (Eds.), *Healing arts therapies and person centered dementia care* (pp. 49–78). London: Jessica Kingsley.

Slone, D., & Gleason, C. (1999). Behavior management planning for problem behaviors in dementia: A practical model. *Professional Psychology: Research and Practice, 30*(1), 27–36.

Sossin, M., & Kestenberg Amighi, J, (1999). Introduction. In J. Kestenberg Amighi, S. Loman, S. P. Lewis & M. Sossin (Eds.), *The meaning of movement: Developmental and clinical perspectives of the Kestenberg Movement Profile* (pp. 1–20). New York: Brunner Routledge.

Stevens, F. (1976). *Dance as life: A season with the American Ballet Theatre.* New York: Harper & Row.

Talerico, K.A., Evans, L.K., & Strumpf, N.E. (2002). Mental health correlates of aggression in nursing home residents with dementia. *Gerontologist, 42*(2), 169–177.

Westbrook, B K., & McKibben, H. (1989). Dance/movement therapy with groups of outpatients with Parkinsons disease. *American Journal of Dance Therapy, 11*(1), 27–37.

Williams, D., Wood, E.C., Moorleghen, F., & Chittuluru, V.C. (1995). Decision model for guiding the management of disruptive behaviors in demented residents of institutionalized settings. *American Journal of Alzheimer's Disease, 10*(3), 22–29.

Section 5

DRAMA

Chapter 19

A TEMPLATE FOR THE MULTIDISCIPLINARY TEAM-LED SOCIAL AND LIFE SKILLS GROUPS UTILIZING DRAMA AND OTHER CREATIVE ARTS THERAPIES: ITS APPLICATION FOR GIRLS EXPERIENCING NEUROLOGICAL CHALLENGES

BONNIE OSOFF-BULTZ

Life isn't about finding yourself, life is about creating yourself.
George Bernard Shaw

INTRODUCTION

The Girls' Social and Life Skills Group described in this chapter was initiated in 1992 by this author, a social worker and drama therapist, together with another social worker and a psychologist. The participants in this group were pre-adolescent and adolescent females who attended neuroscience clinics at Alberta Children's Hospital (ACH), a tertiary center servicing southern Alberta, and the interiors of Saskatchewan and British Columbia in western Canada. They were drawn from the following neuroscience clinics: Cerebral Palsy/Developmental Delay; Myelomeningocele (Spina Bifida); Neurology (Seizures, Shunts, Tumors, etc.); Neurosurgery and Neuromuscular (Muscular Dystrophy). The clinicians who facilitated the group were from the disciplines of social work and psychology. These therapists were part of multi-disciplinary teams consisting of physicians, surgeons, nurses, physiotherapists, occupational therapists (OT), speech and language pathologists, dieticians, social workers, and psychologists treating children

and adolescents with these chronic conditions.

The impetus for starting this group was the need for these girls to develop and practice social and life skills. The author, a registered drama therapist, as well as a social worker, incorporated drama therapy and other creative arts to enhance creativity and the skill acquisition potential of the participants. Although the primary goals of the group were to gain psychosocial competencies, their functional skills were assessed by the team's occupational therapists and OT assistants with consultation by clinic physiotherapists, nurses, and physicians. Over the past fourteen years, several professionals from the disciplines of occupational therapy, social work, and speech and language pathology moved into co-facilitation roles in this group. Numerous undergraduate and graduate practicum students from social work, recreation/child life, psychology, and occupational therapy also assisted with these groups.

Five years after the group began, Roberts, an occupational therapist and the group co-facilitator, and Osoff-Bultz presented the initial research findings related to this group at the Academy of Cerebral Palsy (Roberts & Osoff-Bultz, 1997). Feedback from this international conference suggested that other professionals wanted to incorporate the template from this group for their centers.

SOCIAL SKILLS AND DRAMA TECHNIQUES FOR ADOLESCENTS WITH CHRONIC CONDITIONS

Social skills training is a widely accepted approach for improving the interpersonal behavior of children and adolescents. Many of the original techniques in skills acquisition behavior training such as instruction, modelling, role play, rehearsal, social reinforcement, and corrective feedback (McFall, 1976) are based on dramatic techniques such as warmups, concretizing, role reversal, scene enactment, monodrama, replay, mirroring, empty chair, psychodrama, spectograms, and surplus reality (Blatner, 1998). The need for these life skills in the pre-adolescent and adolescent having neurological or muscular disabilities has been well documented (Anderson & Clarke, 1983; Lutkenhoff, 1993).

Richard Walsh, Ph.D. (1990), is one of the few therapists in Canada who has documented his creative arts program in social skills training for early adolescents with delays in social-emotional development. He and his colleagues in the Psychology Department at Wilfrid Laurier University have shown that the use of creative drama was effective in improving their social-emotional development, particularly their peer skills (Smith, Walsh & Richardson, 1985). Other clinical research indicates that poor peer relations

during this pre-adolescent stage are predictive of mental health problems in later adolescence and adulthood (Achenbach & Edelbrock, 1981). There is consensus among drama therapists and educators of the effectiveness of a creative arts or drama therapy approach to social skills development in children and youth with special needs. It has also been found that small cohesive groups that use the creative arts strengthen peer acceptance and trust which are crucial psychological requirements for the early adolescents' self-esteem. That is, through peer feedback, stimulated by improvisational work, skills such as listening to each other, understanding others' feelings, turn-taking, negotiating conflicts, and working cooperatively are enhanced (Dequine & Pearson-Davis, 1983; Emunah, 1985, 1990, 1994; Jennings & Gersie, 1987; Schattner & Courtney, 1981; Shuttleworth, 1981; Walsh & Swanson, 1988; Warren, 1985).

DRAMA THERAPY, DISABILITIES, AND SELF-ESTEEM

According to the National Association for Drama Therapy (NADT), drama therapy is defined as

> the systematic and intentional use of drama/theatre processes and products to achieve the therapeutic goals of symptom relief, emotional and physical integration, and personal growth. It is an active, experiential approach that facilitates the client's ability to: tell his/her story; solve problems; set goals; express feelings appropriately; achieve catharsis; extend the depth and breadth of inner experience; improve interpersonal skills and relationships and strengthen the ability to perform personal life roles while increasing flexibility between roles. (Website: Retrieved February 16, 2004 from http://www.nadt.org/html)

A drama therapist is trained in theatre arts, psychology, psychotherapy, and drama therapy. In addition to studying developmental psychology, theories of personality, and group process, these therapists use the following the approaches: improvisation, puppetry, role-playing, mask work, pantomime, theatrical production, and psychodrama.

Most of the drama therapy literature with adolescents focuses on its unique role in helping young people with mental health and abuse issues through the tumultuous life passage known as adolescence. As mentioned earlier, few drama therapists focus on neurological, muscular, or sensorial disabled adolescents.

Experimenting with roles is fundamental to drama therapy. According to Landy (1990), role is "the container of those qualities of the individual that need to be enacted in therapy. Story is the verbal or gestural text most often improvised that expresses the role, naming the container" (p. 223). Landy

(1998) further states, in reference to role-play, that in less severe forms of disability, the young adolescent will usually be able to generate roles (verbally or gesturally) in a somewhat limited way. He recommends a treatment through drama therapy based on an attempt to build new roles or restore old ones.

The author and her three colleagues in the Neuroscience Clinics at the children's hospital had received numerous requests for a social skills group from various sources, including the parents of children who attended our clinic, community therapists, pediatricians, teachers, various caregivers, other professional staff, and the girls themselves. Many of these health professionals had been involved with the girls and their families from infancy through eighteen years of age. The hospital administration was also looking for cost-effective ways of developing group treatment with greater positive outcomes.

The psychologist, social worker, and this author hoped that the girls would gain an awareness of acceptable social behavior through audio-visual feedback, expressive and experiential learning (Khalsa, 1996). Our team hypothesized that the hands-on learning would increase self-esteem because some of the girls may not have words to express feelings and ideas verbally (Schwartz, 1995).

The concept of self-esteem as applied here was drawn from Khalsa's (1996) definition: "how highly one values oneself through collective thoughts, feelings and experiences throughout life" (p. xi). The therapists had observed low self-esteem in this population and how it had impacted self-trust, self-respect, and entitlement to happiness. Many had not had opportunities to learn and practice social competency or understand that when they did perform, specific behaviors and defenses melded with that of Khalsa's research to identify the most obvious behaviors: ". . . needing to win; perfectionism; bragging; attention seeking; clowning; sulking; teasing; complaining; physical/verbal aggression; self-criticism; avoidant behavior; withdrawal; isolation and blaming" (p. xv).

A NEEDS ASSESSMENT CRITERIA

In developing this social skills group, the therapists did a needs assessment of interested parents and the girls from all of the hospital's Neuroscience clinics. These parents reported that their daughters had difficulty coping with the following issues:

- Diagnosis and chronic condition
- Age appropriate peers and friendships

- Social skills
- Life skills
- Teasing and bullying
- Ventilation of feelings
- Isolation
- Need for participation in leisure activities
- Adherence with therapy regimes
- Anger management
- Poor self-esteem
- Difficulties with developmental tasks
- Numerous surgeries
- Post-surgical and equipment protocol adherence
- Independence and self-care
- Cognitive and learning problems
- Fine, gross, and/or oral motor impairment.

Mitchell (1997) has found that girls with disabilities perceive themselves in the following way:

> Being different . . . is a major problem because they place great value on belonging to a group, being part of the crowd. The perception of being different impacts the adolescent disabled girl by translating that perception into feeling inferior to and less capable or less desirable than other girls whom they perceive as belonging to the "best group in school." Low self-esteem presents many challenges as the girls are vulnerable to unfavorable opinion, often seem to remain passive instead of risking to expose themselves to situations that place them in interpersonal conflicts, they have a greater tendency to describe themselves as shy and react to new situations with tension and stress. (p. 1)

The majority of the girls who were to attend the group were in situations similar to that described by Mitchell (1997). That is, they did not have age-appropriate peers, were in integrated school settings with few other special needs students, and did not know others with similar disabilities. The therapists were motivated to begin group work with the input of the parents and their own clinical experience. Coming from a family-centered care team focus, the facilitators valued the parents as "experts" of their own children. However, the therapists were initially troubled that the girls' goals did not concur with many of the parental goals. It was then realized that in trying to address the girls and their families under a diagnostic label, we were not looking at the child and the family holistically.

Each family had to create a meaning for their child's condition and the symptoms displayed which would enable the parents to preserve a sense of competency and mastery for themselves as parents. Every child and family had different instrumental and affective styles and were at various develop-

mental stages. Furthermore, their values and transgenerational history of dealing with illness, loss, and crisis varied substantially (Rolland, 1987).

In the latter planning phase of social skills group, our team followed similar guidelines as the strength-based group work approach described by Malekoff (2001):

> those of you who work with young people in groups will learn that a group shouldn't be formed on the basis of a diagnosis or label. . . . It should be formed on the basis of particular needs that the group is being pulled to address. Felt needs are different than ascribed needs. . . . Structure your groups to invite the whole person and not just the troubled or hurt or broken parts. (p. 247)

In planning the group, we were committed to reaching girls who may previously have been excluded from groups because they were too cognitively impaired, developmentally delayed, unable to communicate in a global way, or the girls' mobility was significantly restricted. There may have been an additional concern that due to their profound impairment, these girls would not be able to "demonstrate change." However, there is some evidence in the literature that young people who are involved in group activities do have the potential for developing higher self-esteem. Group activities have been found to be associated with freedom and with enabling youth to choose, within fixed limits, the activities in which they want to participate and the manner in which they want to do it. As noted by Mitchell (1997), the benefits of participation in a group activity include an increased ability to contribute more to class discussion in school and to act more independently (p. 1). Additionally, there is the potential benefit of role-modeling for each other.

The admission criteria for the group that the team developed is listed below:

1. A willingness on the part of the girls to participate in a group
2. Registration as a patient with one of the hospital's neuroscience clinics
3. Access to transportation to and from the clinic
4. Ability to understand and communicate with each other and the facilitators
5. Parents willing to participate in pre- and post-sessions and in completing questionnaires.

EARLY STAGE OF THE GROUP AND PARENT SESSIONS

In the first group that was run, the girls identified that they wanted to have a peer group and that the most important element for them was to be able to share their experiences and feelings in a safe, confidential environment.

They voted on potential names for their group and unanimously decided upon a popular song title: "Girls Just Want To Have Fun." It was at this juncture that they took ownership of their group, and their enthusiasm propelled the subsequent sessions. With this in mind, it became the task of the facilitators to imbue the sessions with verbal and nonverbal creative activities to encourage self-actualization.

The therapists knew that these girls had many stories to tell and that dramatic play would allow them to externalize, sometimes collectively, these impactful life experiences. This imaginative playing out of events in their lives could help them gain mastery over trauma related to having a diagnosed, chronic, and organic medical condition that required numerous medical and surgical treatments. In this way, their reality can be transposed through role enactment, object substitution, and actions (Erickson, 1950; Piaget, 1962).

There was an attempt in pre- and post-parent sessions to assist the parents in managing the ongoing emotional and instrumental tasks associated with their daughters' chronic conditions. Not only did they have to go through the stages of adjustment to their child's condition, they simultaneously also had to be primary caregivers and advocates. According to Canam (1992), these tasks included:

1. accepting the child's condition
2. managing the child's condition on a day-to-day basis
3. meeting the child's normal developmental needs
4. meeting the developmental needs of the other family members
5. coping with on-going stressors and periodic crises
6. assisting family members to manage their feelings
7. educating others about the child's condition
8. establishing and maintaining a support system. (Canam, 1992, p. 46)

The task of coping with a child who has a chronic illness is daunting. Nursing professors Robinson and Thorne (1988) delineated the increased expectations on parents to advocate for their children to take responsibility for and execute care at home with diminished systemic resources. In addition, their research punctuates the inherent differences between the perspectives of parents and health care providers, particularly the parents' feelings of anger (p. 782). Thorne and Robinson (1989, 2002) have also written extensively about the stages that parents go through to begin trusting health professionals and feeling competent themselves. These authors contend that in the beginning, when a child is diagnosed, parents hope that health care can "fix what's wrong." This concept is poignantly illustrated by the comment of one overwhelmed parent in our group who told us, "You saved her in the neo-natal unit when she was two pounds and we had to go through all of

these surgeries, clinics, almost losing her numerous times . . . here she is a pre-teen . . . it's impossible . . . you can have her back" (Social/Life Skills Group Notes, 1999). By contrast, other parents at a different stage of acceptance of their child's condition feel so attached to their child that they could not attend these parent sessions without "bringing her along" from force of habit (Social/Life Skills Group Notes, 1997).

The first stage of the Thorne and Robinson (1989; 2002) model is "Naïve Trust." The parental hope in this stage is that the problem will be fixed. At this juncture, parents may become more passive and give up power to the health professional in hopes that what is important will happen. It is the "sit back and wait" period which is a time when the parents often have unrealistic expectations.

A triggering event usually occurs that may then tip and shatter the trust in health professionals, which leads to the "Disenchantment" stage. This period is characterized by frustration, anxiety, anger, fear, intense self-doubt, and insecurity. Parents find themselves as vulnerable as their children, and they have the perception that information may be withheld from them (Thorne & Robinson, 1989). The behavior of the parent(s) at this point may become blurred with that of the child, and any reactions from the child may become amplified by the parents' response to hospital staff.

At the final stage, "Guarded Alliance," the parents have already become "hyper-vigilant" of the child's every symptom and care need, in an attempt to explain their experience to themselves and others. Parents are frustrated that they cannot control any meaningful outcome or make sense of the chaos. Their despair and hopelessness motivate them to take more responsibility for their child's care and to know the inherent limitations of the health care system (i.e., it cannot cure a chronic condition). Parents may then feel that "they are now in charge" and have become a part of the child's health care team (Thorne & Robinson, 1989).

The two aspects of the "Guarded Alliance" stage are trust in the health care professional and trust in one's own ability to manage. Furthermore, this phase is synonymous with consumerism and the belief that "we are the experts, we are competent and we are team players" (Thorne & Robinson, 1984, p. 600). By contrast, the "Naïve Trust" and "Disillusionment" Stages engendered "Hero Worship" toward the professionals while, at the same time, parents felt disempowered, resigned, and hopeless.

In working with each family system, the therapists foster a reciprocal trust, worthiness, respect, and non-judgemental collaboration. To achieve these outcomes, the interventions with the parents were based on the following:

1. active listening
2. facilitating their ability to pose questions about their child

3. playing the role of the compassionate stranger which involved "doing the dance" of staying far enough away in order to not get "stuck in the problems," yet close enough to be truly present
4. co-creating solutions that would work for both parents and facilitators
5. mirroring family strengths and commending them on positive changes
6. reinforcing or affirming the parents' sense of knowing what they need as self-interventions
7. considering a variety of different responses and incorporating families' perspectives and unmet expectations
8. providing the families with alternate explanations of the process to enable them to respond differently and thereby increase their level of satisfaction with their illness experience (Thorne & Robinson, 1989).

As the first group drew to a close, the facilitators evaluated the outcomes. They realized that the clinical value of any social skills group depended upon whether the clients used their new skills in interactions outside of the therapy situation (Wong, Morgan, Crowley & Baker, 1996, p. 2). Although the sixteen girls responded most positively to the sharing time and the creative interventions, it was doubtful that they had practiced their skills outside the group.

The facilitators continued the open-ended social skills "Girls Just Want To Have Fun" Group for four years before deciding to expand the concept to include life skills application. In 1992, we included occupational therapy and OT assistants as co-facilitators. At this time, psychosocial and life skills adolescent groups for those with neurological or muscular disabilities were not a routine part of health care services (Hills & Lutkenhoff, 1993).

In 1996, the author and three colleagues began three series per year of seven-week treatment sessions with six to twelve participants in each group. A description of the format of these sessions is listed below.

- Each two-hour weekly session included discussion, demonstrations, guest speakers, role-play, rehearsal, and life experience activities that promoted sharing and peer support. The final session of each unit culminated with an event to demonstrate skill acquisition.
- The group met at the hospital in a play or therapy space with access to kitchen and bathroom facilities and equipment for practical skills and arts exploration.
- A multidisciplinary approach was utilized. Practicum students from social work, drama therapy, occupational therapy and their assistants, and Master of Education programs for specialized training were also involved in the sessions
- Guest lecturers included pediatricians, nurses, psychologists,

researchers, an adaptive clothing and equipment specialist and other experts from the community.
- Pre- and Post-Parent Sessions were included in this treatment approach.

RATIONALE FOR THE GIRLS' SOCIAL SKILLS PROGRAM

There were a number of indicators for the development of this Girls' Skills Program. First, there was a need for improved services for the adolescent population that had recently been identified by health care restructuring committees in this province in western Canada. Parents and other professionals had also requested such a service. Second, it was thought that a group format might be more efficient and effective than individual and family therapy sessions to target common issues of female pre-adolescents with physical and/or learning challenges. Third, there is evidence that social skills groups facilitate the attainment of self-advocacy and independent living skills, thereby reducing learned helplessness and dependency (Roberts & Osoff-Bultz, 1997). In part, such groups promote the development of peer relations and social networks that are imperative for preventing social isolation and future mental health problems. In addition, parents' pre- and post-group sessions provided the following needed elements: opportunities to connect with other parents (social networking) and to permit ventilation of feelings; discussions about the girls' progress; psychosocial interventions provided; education on parenting strategies, adaptive equipment, resources, and other specific topics (Roberts & Osoff-Bultz, 1997).

OBJECTIVES

The overall objective of this group was to encourage development of social and life skills through practical experiences, creative arts, and discussion for adolescent females who have physical and/or learning challenges.

Within this broad objective, there were several specific objectives:

- social skills acquisition and communication strategies
- self-concept enhancement
- increased self-control
- life skills acquisition
- peer relationship formation and maintenance
- manage isolation, alienation, and depression
- address "feeling different" related to learning problems
- adherence or compliance with treatment

- recognize their sedentary lifestyle and increase activity level
- manage teasing and ridicule
- gain assertiveness skills
- manage personal or self-care needs
- increase awareness of self and others
- identify family problems and, if necessary, seek support from health care professionals (Roberts & Osoff-Bultz, 1997).

It was understood that the group would be offered in treatment blocks varying from six- to ten-week sessions. The participants could continue attending until they reached the upper age limit of eighteen. Each series of sessions would focus on a variety of topics (which will be discussed later in this chapter) depending on the rank ordered choices of the group members through Canadian Operational Performance Measure (COPM, 1979) surveys.

METHODS

The girls, who ranged in chronological age between eleven and sixteen years, had developmental ages that were similar to each other. They had functional limitations that ranged from mild to moderately-severe in the cognitive, physical, and/or psychosocial realms. Their diagnoses included seizure disorders, cerebral palsy, myelomeningocele, muscular dystrophies, and other conditions. They all attended a variety of neurological clinics at this hospital. It was an open-ended group; new members were always welcome. Although the majority of the participants were recruited from the Neurological Clinic caseloads, a few requests from these caseloads were community referrals. Group inclusion criteria included the following abilities: (1) interact with the environment; (2) verbally communicate with others; (3) arrange with their parents their own transportation to the meetings; and (4) identify difficulties in social and life skills areas.

GROUP PROTOCOL

This client-centered group began with the girls completing a life skills inventory. The results of these inventories assisted the facilitators to identify the focus for each group session. This inventory included topics on personal management, home management, and community access as adapted from the Canadian Operational Performance Measure (COPM, 1979). In completing this inventory, the girls ranked their top three selections of topics

such as kitchen skills, personal hygiene skills, leisure skills, and personal adjustment methods. The girls' preferences were subsequently presented to the group in a summarized format.

Next, the facilitators presented options for creative and dramatic activities in order to achieve goals related to their chosen topics. Outlined below are the specific activities that were used to address the five topics based on the work of Roberts and Osoff-Bultz (1997).

1. Health & Hygiene

- discussion, role-play, and rehearsal through mime of bathing and hair care methods during which time they addressed the needed frequency, adaptive aids needed, and alternative methods of achieving these tasks.
- menstrual care needs were reviewed and each member created a personal care kit.
- skin care, including the application of make-up, was demonstrated.
- creation of life-size sculptures of one's idealized self, which were then compared to photographs/mirror reflections of their actual hygiene practices.
- The culminating event to celebrate their increased awareness of Health and Hygiene issues involved a hair-washing and styling session.

2. Kitchen Management

- a discussion with parents to identify the kitchen management skills that their daughters needed to acquire and the parents' greatest fears concerning this issue.
- discussions and practical sessions with the girls focused on food preparation, using or adapting the microwave, stove, and oven for cooking and education in utensil and appliance use.
- The culminating event for the Kitchen Management skills area involved preparing and cooking a meal for the group and their invited guests (i.e., parents).

3. Leisure Skills

- discussion with the girls about the use of restaurants, including how to find the telephone listing, how to make a reservation, restaurant accessibility details, restaurant prices and available discounts.
- rehearsal sessions to practice telephoning restaurants and role-playing assertiveness sessions to practice interacting with the waitress or waiter. These sessions involved the use of table manners, etiquette, and ordering methods. Actual menus and coupon books were used.
- The culminating event for the Leisure Skills area involved making a

reservation, arranging for their transportation to an accessible restaurant, and going out as a group to the restaurant.

4. Personal and Social Adjustment

- discussion of how to initiate and maintain interactions with peers.
- role-playing and videotaping sessions on coping strategies to deal with teasing and bullying.
- creating characters and scenes that express the differences between passive, assertive, and aggressive behaviors. The girls learned how each of those behaviors "felt" by using them to interact with each other.
- The culminating event for the Personal and Social Adjustment area involved making invitations, planning a games and pizza night to which they each brought a friend.

5. Home Safety when Baby Sitting

- discussion with the girls about child care, which included dramatic demonstrations.
- exercises addressed the following child care responsibilities: selection of appropriate developmental toys and activities; self-assessment of the physical capabilities needed for babysitting; and how to deal with children in emergency situations.
- discussion of safety procedures and hazardous substances identification included mime, gesture, and scene enactment.
- storytelling of personal encounters with emergencies and processing of feelings associated with those types of situations.
- The culminating event for the Home Safety when Babysitting Skills area involved inviting infants and young children to attend the session with their parents so that the girls could have hands-on experience playing with and caring for younger children, including how to feed, diaper, and nurture these children. Mock emergencies were also enacted (Roberts & Osoff-Bultz, 1997).

FORMAT OF THE SESSIONS

The block treatment session format for the girls has evolved over time. In the ten years that this group has been offered, we have provided three series of six to eight sessions per year; each session has typically been two hours in duration. We have also provided pre- and post-parent sessions before and after the girls' block treatment.

The girls attending the sessions were grouped according to developmen-

tal age. There was one group for pre-adolescents (ages ten to thirteen) and one for adolescents (ages fourteen to seventeen). These groups were run alternately (i.e., one year there would be one group for pre-adolescents and two groups for adolescents, whereas the following year, it would be the opposite). The groups have been held in the late afternoon so that the girls could come to it directly from school.

Other details about the group format deserve mention. The rationale for having two-hour sessions was based on the research about time required for goal attainment (Shulman, 1979, p. 13; Walsh, 1984, p. 133). The location selected for the group sessions at the Children's Hospital had access to an adapted kitchen and to bathrooms. Parents could attend the group only when invited by the girls and the facilitators, due to special circumstances related to attachment or separation issues. The rules for the group were co-created by the girls and the facilitators. At the beginning of the group series, the participants were asked to compile a list of rules that they believed would ensure safety, security, confidentiality, caring, and respect. The facilitators added rules that related to making healthy choices such as the amount of parental input, appropriate use of the premises, and relevant health concerns. The girls were informed that any disclosures of physical, sexual, or emotional abuse would be immediately dealt with by the appropriate hospital personnel. Furthermore, if the girls disclosed that harm had been done to them, or if they intended to harm themselves or others, this information would also be reported promptly to the appropriate authorities. Finally, they were informed that in the event of illnesses or accidents, they would be treated in the emergency department of the Children's Hospital.

DISCUSSION

The group format has evolved over time with increased client and family centered input and life skills focus. There have been numerous tools developed to meet group needs. These tools include Life Skills Inventory; Special Information Sheet and Mailbox; Topic-Specific Parent Questionnaires; Topic-Specific Sub-Section of Life Skills Inventory for Girls; Documented Parent Feedback Sheet Summary; and Sample Certificate of Achievement. These tools are available on request from the author.

There have been many indicators of success of this Girls' Social and Life Skills Group over the past nine years. One important factor is that many of the girls and their families requested that the groups continue beyond the designated series of sessions. In addition, many of the original girls attended all sessions over successive years until graduation from the clinics (at age eighteen). A core group of girls was sustained for over five years. Newcomers

were frequent, and they were always welcomed. The girls and their families have continued to have contact with each other outside of the group. For example, they arrange activities together even during the summer months. More importantly, the girls themselves inquire about when the next group is to begin.

Another important indicator of the group's effectiveness has been the positive reports of the girls' progress from teachers, school administrators and their caregivers. Their reports emphasize the growth in social and life skills demonstrated by the girls.

CONCLUSIONS

Although the "Girls Just Want to Have Fun" group's primary focus is on female adolescents, the family operates as an interactive unit, and what affects one member affects all members. Parents coping with the chronicity of disability are dealing with issues of their child's sexuality, peer isolation and rejection, plans for the child's education and vocational future, and lack of socialization opportunities for the girls. The lack of peer acceptance among this population is painful for the entire family. For the parents of a child with a disability, there is an awareness that there may be delays or even an inability to reach a life-cycle stage successfully, which may lead to continued dependency on the part of the child. In addition, their parents are also concerned about their teenager beginning to date, as well as how to plan for the subsequent phases of development (Seligman & Darling, 1997).

There is ample research evidence of the need for support for parents who have children with disabilities. There is a high rate of marital breakdown among such families. Furthermore, single parents of such children find it extremely challenging to raise these children and may become hyper-vigilant, enmeshed or withdrawn, avoidant or disengaged (Houser, 1988; Keith-Burr, 1985, p. 27; Seligman & Darling, 1997). This Social and Life Skills Group affords the parents their own support network and an opportunity to "separate" from their young teenagers and reflect on their experiences.

This developmental stage is a time for all adolescents to begin to individuate from their parents and attempt to belong to their peer group. It is a time fraught with challenges, turmoil, and ambivalence (Johnson & Eicher, 1990). These developmental challenges are even more punctuated for adolescents with chronic neurological, muscular, or cognitive conditions.

In the author's clinical experience, many of these girls lack the opportunities to practice and experience these life and social situations. As a consequence, some of these girls have very vivid fantasy lives where they can retreat and experience life vicariously through the media. However, their

fantasies are not limited to a "normal adolescent crush" on a film, television, or rock star; some in the group truly believe that they will marry them! Thus, when a real-life encounter occurs with the opposite sex, these girls tend to be highly unrealistic about the incremental steps in forming and maintaining friendships. In addition, they tend to mistake friendship for romance. Also, many of the girls are so desperate for attention that they cannot differentiate when someone is showing them positive attention from those who are highly negative or destructive.

A number of benefits are gained by using drama therapy in this Social and Life Skills Group. One advantage is the creation of community. It may be difficult for these girls to meet others with characteristics in common, especially because many of them receive their schooling on-line versus in a traditional classroom. As facilitators, we knew that we had co-created an innovative community for these girls.

An additional benefit of using drama therapy was that it provided an opportunity to explore or "try on" a variety of new roles. Emunah (1994) puts it this way:

> The distinction between role and self is more explicit in theatre. In dramatic play, roles are spontaneously assumed and discarded in a natural and fluid manner. The development of a single role and scene is relatively inconsequential, whereas in theatre, role and scene development are emphasized. (pp. 7–8)

The vast majority of the girls in the group had a limited repertoire of roles, and the fantasy life through which many of them "lived" was the only role they had experienced. The group has given them a safe opportunity to differentiate between role and self. For some, it was a first exploration of self. The girls viewed a variety of videos showing people with special needs involved in recreation, extreme sports, and community classes. As well, they had guest speakers who acted as peer role models describing their lives and activities. These presentations expanded the participants' limited experiential repertoires, which subsequently became incorporated into their dramatic role-plays within the group.

In considering the possible further development of this Social and Life Skills Group, there are a number of areas that need further exploration. It is hoped that the facilitators can apply for funding to do ongoing research in drama therapy with these adolescents in order to develop standardized measures. Furthermore, integration of non-disabled peers has occurred to a minimal extent, which is believed will facilitate integrative growth. Relocation to a neighboring community school may also expedite this integration. A future publication and a "how to" workbook about this group should be explored. Inclusion of nurses and physiotherapists in group facili-

tation roles is anticipated.

The clinicians that have been involved in facilitating this group are continually energized by these animated, creative adolescent participants. Their resilience and that of their families makes it an honor to have the opportunity to work with them. The participants seem to reflect the qualities described by William James (cited in Goldhar, 2003):

> Seek out that particular attribute which makes you feel most deeply and vitally alive–along with it comes the inner voice which says: "This is the real me" ... and when you have found that attitude–follow it! William James (Retrieved March 2, 2004 from: calgarysun.com/cgibin/niveau2.cgi?=generic11&p=70226.html1&a=1)

Author's Note

The author would like to acknowledge the following colleagues who have contributed to the development and facilitation of this group: Gwen Roberts, B.Sc., M.S.O.T.; Sharon Seale M.S.W., R.S.W.; Stephen Maunula, M.A., C.Psych.; Julia Pernal, Speech and Language Pathologist; Colleen Little, B.SC.; O.T.; Beth Ritchie, B.SC., O.T.; Doreen Forter, O.T. Assistant; Loralea Morin, B.SC. O.T. (C) B.A; Tamara Janzen, O.T.Assistant; Gillian Ferris, O.T. B. SC.

REFERENCES

Achenbach, T.M., & Edelbrock, C.S. (1981). Behavioral problems and competencies reported by the parents of normal and disturbed children, aged four through sixteen. *Monograph of the Society for Research in Child Development, 46,* 1–82.

Blatner, A. (1994). Introduction. In R.Emunah (Ed.), *Acting for real* (p. 4). New York: Brunner/Mazel.

Blum Kelly, A., & Ireland, M. (2001). Health risk behaviors and protective factors among adolescents with mobility impairments and learning and emotional disabilities. *Journal of Adolescent Health, 28*(6), 481–490.

Canam, C. (1993). Common adaptive tasks facing parents of children with chronic conditions. *Journal of Advanced Nursing, 18,* 46–53.

Cherry, C. (1976). *Creative play for the developing child: Early lifehood education through play.* Belmont, CA: Fearon-Pitman.

Dayton, T. (1994). *The drama within: Psychodrama and experiential therapy.* Deerfield Beach, FL: Health Communications.

Dequine, E., & Pearson-Davis, S. (1983). Videotaped improvisational drama with emotionally disturbed adolescents. *The Arts in Psychotherapy, 12,* 71–80.

Emunah, R. (1985). Drama therapy and adolescent resistance. *The Arts in Psychotherapy, 12,* 71–80.

Emunah, R. (1990). Expression and expansion in adolescence: The significance of creative arts therapy. *The Arts in Psychotherapy, 17,* 101–107.

Emunah, R. (1994). *Acting for real: Drama therapy process, technique and performance.* New York: Brunner/Mazel.

Emunah, R. (1995). From adolescent trauma to adolescent drama: group drama therapy with emotionally disturbed youth. In S. Jennings (Ed.), *Drama therapy with children and adolescents* (pp. 150–169). London: Routledge.

Erickson, E. (1965). *Childhood and society.* London: Penguin.

Goldhar, E. (2003, January 26). *Careers-job talk: Learn to do what you love.* Calgary Sun, Calgary, Alberta.

Hills, R.G., & Lutkenhoff, M.L. (1993). Social skills group for physically challenged school-age children. *Pediatric Nursing, 19*(6), 573–577.

Houser, R.A. (1988). A comparison of stress and coping by fathers of mentally retarded and non-retarded adolescents. (Doctoral dissertation, 1988). *Dissertation Abstracts International, 48*(9–A), 2244 (University Microfilms No. 1989-50, 009–001).

Houser, R., & Seligman, M. (1991). A comparison of stress and coping by fathers of adolescents with mental retardation & fathers of adolescents without mental retardation. *Research in Developmental Disabilities, 12,* 251–260.

Indivra Self Quotations website. Retrieved February 16, 2003 from http://cotiimb net.fi/anyara/find1.htm).

Jennings, S. (1995). Dramatherapy for survival: Some thoughts on transitions and choices for children. In S. Jennings (Ed.), *Dramatherapy with children and adolescents* (pp. 90–107). London: Routledge.

Jennings, S., & Gersie, A. (1987). Dramatherapy with disturbed adolescents. In S. Jennings (Ed.), *Dramatherapy: Therapy and practice for teachers and clinicians* (pp. 162–182). London: Routledge.

Johnson, D.R., & Eicher, V. (1990). The use of dramatic activities to facilitate dance therapy with adolescents. *Arts in Psychotherapy, 17*(2), 157–164.

Keith-Burr, C. (1985). Impact on the family of a chronically ill child. In N. Hobbs & J. Perrin (Eds.), *Issues in the care of children with chronic illness: A source book on problems, services and policies* (pp. 24–40). San Francisco: Jossey-Bass.

Khalsa, S.S. (1996). *Group exercises for enhancing social skills and self-esteem.* Sarasota, FL: Professional Resources Press.

Landy, R. (1986). *Drama therapy: Theory and concepts.* Springfield, IL: Charles C Thomas.

Landy, R. (1990). The concept of role in drama therapy. *The Arts in Psychotherapy, 17,* 223–230.

Landy, R. (1993a). *Persona and performance: The meaning of role in theatre, therapy, and everyday life.* New York: Guilford.

Landy, R. (1993b). *Persona and role play.* New York: Guilford Press.

Landy, R. (1995). The dramatic world view: Reflections on the roles taken and played by young children. In S. Jennings (Ed.), *Drama therapy with children and adolescents* (pp. 7–28). London: Routledge.

Law, M., Baptise, S., Carswell, A., McColl, M., Polatajko, H., & Pollock, N. (1994).

Canadian occupational performance measure (COPM). Toronto: ACE/ Canadian Association of Occupational Therapy.

Malekoff, A. (2001). The power of group work with kids: A practitioner's reflection on strengths-based practice. *Families in Society, 82*(3), 243–249.

Manion, I.G. (2001, February). *Adolescent coping with chronic illness: Issues, illness, recommendations for prevention and intervention.* Ottawa, Canada: Children's Hospital of Eastern Ontario.

Marshall, L. (1993). Group therapy with adolescents. In M. Seligman, R.B. Darling, L. Marshak (Eds.), *Counseling persons with disabilities: Theoretical and clinical perspectives.* Austin, TX: Pro-Ed.

Maslow, A. (1962). *Towards a psychology of being.* New York: Van Nostrand.

Mc Fall, R.M. (1976). Behavior training: A skill-acquisition approach to clinical problems. In J.T. Spence, R. C. Carson & J.W. Thibaut (Eds.), *Behavioral approaches to therapy* (pp. 227–259). Morriston, NJ: General Learning Press.

Miller, A. (1990). *The untouched key.* London: Virago Press.

Mitchell, M.A.O. (1997). *Adolescent disabled girls presentation.* Washington, DC: U.S. Government Conference.

National Association for Drama Therapy–NDAT (ND). *Definition: What is drama therapy?* Washington, DC: NADT Office.

Neff, E.J.A., & Conkin-Dale, J. (1990). Assessment of quality of life in school-aged children: A method-phase 1. *Maternal-Child Nursing Journal, 19*(4), 313–320.

Piaget, J. (1952). *The origins of intelligence in children.* New York: International Universities Press.

Pitzele, P. (1991). Adolescents inside-out: Intrapsychic psychodrama. In P. Holmes & M. Karp (Eds.), *Psychodrama: Inspiration and technique* (pp. 15–31). London: Tavistock/Routledge.

Roberts, G., & Osoff-Bultz, B. (1997). *Adolescent girls' group: Alberta Children's Hospital.* Poster presentation at the American Academy of Cerebral Palsy and Developmental Medicine, Portland, Oregon.

Robinson, C. (2003, February 26). Health care relationships when children are chronically ill. *Grand Rounds Presentation,* Alberta Children's Hospital. Calgary, Canada.

Robinson, C., & Thorne, S. (1984). Strengthening family "interference." *Journal of Advanced Nursing, 9,* 597–602.

Rolland, J.S. (1987). Family systems and chronic illness. A typological model. *Journal of Psychotherapy and the Family, 3*(3), 143–168.

Schattner, G., & Courtney, R. (1981). *Drama in therapy. (Volume I): Children.* New York: Drama Book Specialists.

Schwartz, D. (1995). *Definition of expressive arts.* Unpublished Mimeograph Montpelier, VT: New England Art Therapy Institute.

Seligman, M., & Darling, R.B., (1997). *Ordinary families, special children: A systems approach to childhood disability.* New York: Guilford Press.

Shulman, L. (1979). *The skills of helping individuals and groups.* Chicago: F.E. Peacock.

Shuttleworth, R. (1981). Adolescent drama therapy. In G. Schattner & R. Courtney (Eds.), *Drama in Therapy (Volume 2): Adults.* New York: Drama Book Specialists.

Smith, J.D., Walsh, R.T., & Richardson, M.A. (1985). The clown club: A structured fantasy approach to group therapy with the latency-aged child. *International Journal of Group Psychotherapy, 35,* 49–64.

Thorne, S., & Robinson, C. (1988). Reciprocal trust and health care relationships. *Journal of Advanced Nursing, 13,* 782–789.

Thorne, S., & Robinson, C. (1989). Guarded alliances: Health care relationships in chronic illness. *Image, 21*(3), 153–157.

Walsh, R.T. (1990). A creative arts program in social skills training for early adolescents: An exploratory study. *The Arts in Psychotherapy, 17,* 131–137.

Warren, B. (1984). Practical approaches to the creative arts therapies. In B. Warrant (Ed.), *Using the creative arts in therapy* (pp. 131–159). Cambridge, MA: Brookline Books.

Warren, B. (1988). *Disability and social performance.* Cambridge: MA: Brookline Books.

Wong, S.E., Morgan, C., Crowley, R., & Baker, J.N. (1996). Using a table game to teach social skills to adolescent psychiatric inpatients: Do the skills generalize? *Child and Family Behavior Therapy, 18*(4), 1–15.

Wright, M., & Leahey, M. (1987). *Families and chronic illness.* Springhouse, PA: Springhouse.

Chapter 20

PERFORMANCE CREATION AS A MODE OF SELF-CARE: A PARTICIPATORY STUDY OF CAREGIVERS AND THE PREVENTION OF BURNOUT

Barbara Christofferson

Mutual service without sacrificing the self is the paradox at the very center of living.

Irene Claremont de Castillejo

SUMMARY

Two years after the project described in this chapter took place, participants reported improved self-care practice and increased insight into self-care. They concluded that being with other caregivers in a supportive, safe environment, which allowed them to explore new aspects of themselves, to discover hidden feelings and fears, to restore self-confidence and to increase their awareness of the kinds of spontaneous creative interaction that can take place when one lets go of worries and stress, combined with an opportunity to air situations that were causing pain, contributed to improved caregiving for themselves and their clients.

The literature on self-care and caregiver burnout informs us of the need for more research and innovative interventions in order to understand how to encourage and support a caring environment. This is especially important in educational settings preparing the next generation of helping professionals. The case study reported here is based on a project in a counselling service in West London, England, where creative drama exercises and perform-

ance creation were used to promote self-care and seek a preventive process against compassion fatigue and burnout (as defined below) for caregivers.

Self-care is defined here as healthy attention to the self, which has emerged as necessary for successful practice. It is the kind of "attention to the self and the world necessary for physical, mental, spiritual, and emotional health" (Miller, 1998, p.145). Continued education and training, interaction and cross-fertilization with peers, periodic diversion into pleasant activities, development of a sense of mission and purpose, and willingness to access help for ourselves when necessary can protect against premature burnout and contribute to our effectiveness as helpers and healers.

Performance creation can be an empowering facilitator of effective self-care practice. This "Healer as Artist Project," so named by the participants, was part of a larger study of formal and informal caregivers. The purpose of the study was to examine the attitudes toward, and practice of, self-care in a group of professional and informal caregivers. Freudenberger (1974) coined the term burnout. He used the term to describe a condition of being worn out or exhausted after having made excessive demands on energy, strength, or resources. Self-care, which is a preventive strategy for those "at risk" for burnout, includes having confidence in one's self and in others, thereby making it easier for a person to ask for help when needed.

Helping professionals may be subject to the cumulative effect of compassion fatigue (Figley, 1995, 1998), which is a form of burnout. Secondary trauma, one of the contributing factors in compassion fatigue and burnout, refers to the natural and consequent behaviors and emotions resulting from knowing about a traumatizing event experienced by a significant other, or the stress resulting from helping or wanting to help a traumatized or suffering person (Figley, 1995, p. 7). When left unacknowledged, secondary traumatic stress can cause Secondary Traumatic Stress Disorder.

Secondary trauma affects a significant number of caregivers, as expressed by feelings of isolation, anger, tension, powerlessness, hopelessness, anxiety, and emotional exhaustion. Symptoms such as confusion, tearfulness, and feelings of being overwhelmed, useless, and burdened with responsibility are often accompanied by increased alcohol use, headaches, gastrointestinal complaints, sleep disturbances, nightmares, and increased sensitivity to violence in general (Talbot, Dutton, and Dunn, 1992). According to the study results reported by Talbot, Dutton, and Dunn, sufferers of secondary trauma or compassion fatigue can also become emotionally demanding of family and friends. In addition, patients' problems seem insurmountable or insignificant, and clinical detachment is often lost. Added effects include a tendency to overidentify with patients, to intellectualize, to become rigid in one's thinking and resistant to change. Such caregivers are also found to practice denial as a protective strategy, thereby remaining unaware of how their work

is affecting them. This project was motivated by the desire to understand the responses of both formal and informal caregivers to both secondary traumatic stress and to performance creation and thereby explore ways to prevent similar long-term negative effects through the use of this creative art form.

Davies (1998) concludes from his study of stress in the social work field that there is also a strong need within that profession for structured support. There needs to be a shared acknowledgement of the impact the work has on social workers' lives. This view is consistent with Nathan's (1993) recommendations that plans be made for more supportive supervision and better understanding of how the emotions of the families that the therapists are working with can affect them negatively. That study emphasized the need to develop the ability to ask for support. Furthermore, by acknowledging the presence of risk factors, educators in the helping professions will be equipped to design more effective programs to prevent burnout and costly waste of valuable human resources.

There is also considerable evidence that secondary trauma affects nurses. For example, Buyssen (1996) has identified fourteen physical reactions in nurses in the Netherlands who had not received support after a traumatic event. He suggested that one of the reasons nurses are not receiving help is that in the context of coping with disturbing incidents, they tend to want to conform to the prevailing culture on their hospital unit, which is not to ask for help. If this is a culture of keeping silent, they will not have the courage to behave differently from what is expected of them. I have observed this tendency among other professionals as well. Asking for help in an atmosphere where it does not feel safe to do so is difficult for anyone.

Another reason caregivers often have difficulty asking for help is that they are hesitant to relinquish control and relax for long enough to recognize their need for self-care (Portnoy, 1996). Similarly, Norcross and Proshaska (1986) and Yalom (1989) have reported that caring professionals can be extremely tolerant of any vulnerability in their clients but remarkably intolerant of weakness or frailty in themselves. For this reason, effective intervention and self-care promotion programs are needed. Arts-based programs allow caregivers to participate in a creative activity that may facilitate relaxation and the recognition of the early signs of compassion fatigue. In particular, drama, with its focus on verbal communication and role enactment, affords the opportunity to create enough distance from the situation for the caregiver to see a situation more clearly and objectively. Communication and the use of self are both an integral part of drama and nursing. Drama is founded on the use of self to communicate. Collective performance creation as reported in this chapter facilitates self-care by allowing for connection with others. Interestingly, nursing theorists have recently begun to look at caring capaci-

ty as a communication style (Montgomery, 1993). Painter (cited in Sibbald, 2001) sees successful nursing practice as a kind of connectivity, or the courageous use of self in human relationships.

This project began in Saskatoon, Canada, at a conference on suicide and grieving called "Re-weaving the Web." I had been asked to perform a play I had written about healing from complicated grief. After several months of intensive and lonely work on the script and the rehearsal process, I arrived at the conference with everything I needed in my daughter's knapsack. The response was almost overwhelming. People who knew and cared about suicide prevention, secondary trauma, and compassion fatigue; people who had lost family members; or those who worked daily with the traumatized encouraged me to continue to reach out through the arts to caregivers who understand the varied costs of caring. I agreed that the process of performance creation had been empowering in my own life as an actor and a teacher, but was unsure how it might work for others, and was unwilling to continue the lonely process of performing my own one character play. I was therefore determined that any future exploration would be done collectively.

THE HEALER AS ARTIST PROJECT

Soon thereafter, an opportunity to test my theory afforded itself. I was invited to conduct an art-based research project with a group of caregivers in West London, where I was living. The group named it "The Healer as Artist Project." A group of caregivers who were interested in how the arts facilitate healing and self-care agreed to participate and to help me document the performance process. Our goal was to prepare a performance about our work in the caring professions for the counselling service at which all the participants donated some of their time. Thirty caregivers representing various backgrounds, training, and countries of origin, began to meet weekly. What we had in common was that all were caregivers; that is, providers of a substantial amount of care on a regular basis (Heron, 1998).

Initially, we experimented with collective performance creation using exercises from Boal's (1992) *Games for Actors and Non-Actors.* We were working from the theoretical perspective of Grotowski (1975), who believed that actors must draw images out of the depths of the unconscious, with the ultimate goal of encouraging a healing process for the actor and the audience to share. We wanted the planned performance to be our own collective creation, without elaborate and expensive requirements for rehearsal space, sets, or costumes. We were not interested in playing characters (roles) a playwright had created but in searching within our own experience for the characters we could discover within ourselves and present to an audience.

We started with an image of being stuck, which was taken from the plays of Samuel Beckett, because it is easy to feel that way when we are focused on the needs of others and are unable to objectively consider our own needs. Beckett's images of being stuck in garbage cans, piles of garbage, on a hijacked bus, or in a locked car or a toilet provided some very funny places to start the exploration of our lives as caregivers. Next, we moved to exercises based on the eight survival strategies developed by Paul Valent (1995). These coping strategies, which include rescuing, attaching, asserting, adapting, fighting, fleeing, competing, and cooperating, have maladaptive and adaptive ranges. Shortly afterwards, we were inventing exercises based on various relationships where these coping strategies might take over without our awareness.

As time went on, our group became more cohesive as indicated by the desire to engage in a range of social events related to the theatre. In the early planning phase, we had agreed to write an evaluation of the experience once it had finished and to maintain confidentiality of others' personal stories. There was no commitment to attend regularly or to perform in the final presentation.

Each member was encouraged to bring new members. It was very important to us that the group be as inclusive and welcoming to new members as possible. It was acknowledged that time spent in the group was time lost to clients, and that could restrict attendance. Already, we were choosing between spending time doing our jobs as caregivers or taking time for ourselves.

We all agreed that I would share my experience as an actor, and they would share their experience as caregivers in order to reflect on our practice of self-care. Gradually, as some of the initial participants chose to drop out of the project, others took their place. Those who could not rearrange their schedules to include our weekly sessions found other ways to take part, such as doing the videotaping, introducing us on the night of the performance, or coming "to visit" during the informal coffee and chat times preceding and following each session.

The ten-month project consisted of three phases. In the organizational phase, the thirty-five participants were divided into two groups. Their tasks involved various practicalities, such as finding reasonable meeting space that was accessible to transportation or scheduling the meetings to accommodate participants' work schedules. Over time, there were dropouts, necessitating the merging of the groups into one. This performance took place one year after the project began.

We began our once weekly sessions in winter, in a large room at the top of three flights of stairs, filled with interesting articles of clothing, furniture, and a window with a view of the enormous back garden. In the summer, we

met in that back garden, and in the fall, we returned to our room at the top of three flights of stairs. Because we enjoyed conversing with each other, we needed to be very disciplined to ensure that we actually spent two hours "working." As the weeks progressed, our experiments with role and improvisation became more and more interesting. There were some memorable sessions when newcomers joined in as if they had been part of the group all along. Others came irregularly because of their schedules. However, soon we were facing the real commitment of presenting our "work," which by this time seemed more like "play," to the entire counselling service. We had promised to present a theatre event at their annual general meeting.

Throughout the project, I had assured the group that performing our creation in front of their peers would be fun. I do not think many of them believed me. During the final few weeks before the scheduled "performance," our attention turned to choosing how to present the characters that we had created together. Decisions over what roles and scenarios should be included in the final performance, how they all fitted together, and in what order, became an exciting but sometimes tense part of the process. Because we were experienced caregivers, however, and generous with each other after months of interaction, there was very little fuss, and we promptly were able to arrange for a final rehearsal in our room at the top of the stairs. One week later, with still more excitement, we had one rehearsal in the actual performance space. The following evening, once the audience had gathered, our show began.

THE FINAL PERFORMANCE

The final performance of the Healer as Artist Project took place in a large room in a Benedictine Abbey Parish Centre. The director of the counselling service introduced us. One of the group, whose work commitments caused him to drop out of the performance, spoke briefly about the intent of the project, which was to research performance creation as a mode of self-care. Another friend of the project acted as videographer. Several times throughout the project, we had discussed that we did not want to video the sessions because we believed a video camera would be too intrusive. However, we needed a record of the final rehearsals and the performance because we wanted documentation in order to assess the project collectively.

The Nine Characters

The following seven characters in order of appearance were in the final performance: (1) the walker, (2) the parent, (3) the immigrant, (4) the elder,

(5) the teacher, (6) the visual artist, and (7) the lost boy or the student. Two characters were created who could not take part in the final performance, but remained with the group for the year we continued to meet after the performance and I have included them in this case study. They were (8) the daughter and (9) the singer. Each character represented a creative synthesis of our investigations into how we took care of ourselves, while interacting with each other, with clients, with friends, and with family. Each of these characters will be described next.

As the name implies, the walker's approach to self-care was to walk in order to overcome the loneliness she had identified as her issue at the time. This character overcame her loneliness, which she associated with a transition period between care giving duties, by learning how to be alone and enjoy her own company. The group had helped her to do that by supporting her and welcoming her each week and helping her to identify that regular daily walks refreshed and rejuvenated her. The group met on Wednesdays, and Wednesday became her "favorite day."

The parent came next. This performer had provided us with the large, comfortable room where we worked. Her generosity, commitment to, and belief in the project were fundamental to the group's success, and her weekly welcoming sustained all of us. Throughout the project, her role-playing was nearly always her child-self. She explored childhood in many different scenes and situations. Finally, she chose to direct a class herself and used an exercise she had witnessed at a workshop. She attached strings to her fingers, and gave each of us one to pull on as we represented various constituencies in the social service bureaucracy, and in the group of players involved in the life of a young person who is taken into care. Each of us pulled on the strings as we put forward an opposing viewpoint, playing the role of opposing voices in the young person's life, including various workers from Social Services. Most of the participants have had long and profound experiences with the "social safety net" as it operates in England. The parent's repeated attempts to achieve compassionate understanding of the situation of a child placed in care brought her to her choice of the role as parent in the final performance. She was uncomfortable creating her own dialogue, so she chose to dramatize a favorite poem. She performed Gibran's meditation on the role of parents, who do not own their children, but must prepare to release them to the world. Her movement towards that performance and our participation in it was a deeply moving experience for the whole group.

The next character was the immigrant, or probably more accurately, the transplanted wife. The participant who created her had spent twenty years in London and was considering returning to her country of origin. The scenes and exercises this participant used often explored the difficulties experienced by those who were living in London temporarily. The immigrant knew about

all the shows in London and often facilitated our outings because she had the information about the underground theatre scene. She was also an opera buff and loved the theatre. This participant made a difficult decision to leave the country after the performance. Her performance was based on an early exercise drawn from Beckett's images of being stuck. Her moving account of being an Arab wife who struggles to live up to her husband's business demands, despite her difficulties trying to adapt to the English culture, was a thoughtful and moving piece about relationships and the costs and the benefits of caring for ourselves and others. One of her scenes, which addressed the relationship one has to one's home, brought me to an important personal decision about moving.

The next member of our group I have named the elder because she was somewhat older than the rest of us. She had lived all over the world. The elder was trying to deal with the experience of no longer being, at age seventy, able to practice osteopathy regularly enough to justify the high costs of active membership in the professional organization. She also was struggling to pay for the required supervision needed to continue practicing as a counsellor. She explored her role in life and what it meant to her to care for others professionally as an osteopath and as a counselor.

The elder's contribution to the final performance was to position the other participants into a series of living statues, which depicted various aspects of the counselor, or roles the counselor fulfills. While the audience watched, the elder moved the rest of the group into position and accompanied her sculpting with dialogue. She had been very nervous about the whole performance and had been given a mask to wear, so that she would feel less exposed and vulnerable, but on the night of the performance, she "forgot" to put it on. I believe that the process she experienced during the project included a kind of unmasking of her own attempts to live simply and give as much as possible of herself to others. I shall never forget the moment the audience, counsellors themselves, recognized themselves in the sculpture the elder created. It was a moment of deep recognition, and the whole room was united in gratitude for the elder's graphic picture of the contributions made to the community by the counseling service, often quietly and without acknowledgement.

The teacher joined us in the summer. She had finished the school year and found herself unable to contemplate going back into the classroom, or even back to the school in another capacity. The final straw had been the disclosure, just before the end of term, of a case of child sexual abuse by one of the school's students. Although this disclosure was not the first in this teacher's career, she experienced it as one too many crises at the time. Our teacher found herself unable to function. Her final performance spoke eloquently of her need to be accepted into the group. Participation in the Healing Artist

Project had helped her to remember that her life had a past, a present, and a future, and that her story could continue because she was able to contemplate a future once more. Our acceptance of her and our interest in her story had helped her examine her life and make some changes that would allow her more freedom to live in a way that she could contemplate with joy and enthusiasm. Her situation illustrated our purpose collectively and creatively. We were researching who we are in relationship to each other, the need for caring communication, and the need for a safe place to come together and celebrate ourselves and our work. This was important in order to equip us to care for ourselves more effectively and to continue to care for others.

Our next participant explored how her work as a visual artist was helping her to understand her role in the counseling relationship. She was a teacher, supervisor, and practitioner in the counseling field. She led the rest of the group in a lively dance and exchange of symbolic feathers, all woven into a charcoal drawing she had made after nursing a wounded bird that she had found in her back garden. She used the image of the bird and her relationship with it to illustrate how much of ourselves we contribute to the care of others.

The only male performer came to be known as the lost boy, although this had nothing to do with his gender. There were other male participants who contributed to the project, but they were unable to take part in the final performance. The exercises and scene work we did was never gender-specific. Our male performer, who immigrated to London as a small boy, began his exploration with his first memories of being a young schoolboy and later a student in London. We chose to end our performance with the piece created by the lost boy, because it reinforced a final image of our collective journey that forced us to examine our aloneness and our ties to each other. We concluded that there was never really a time we were not at least a bit "lost" or "stuck." The key was to accept that fact and live well and to facilitate others living well.

The participant we called the daughter was unable to participate in the final performance. She was not part of the counselling service; nor did she consider herself to be a professional caregiver. The daughter participated because she thought it might help her son, whom she had brought with her. She had heard about the group from the elder. Not only did the daughter have difficulties with a son who had been diagnosed as having a personality disorder, but she also had a mother in urgent need of nursing home care. The previous year, the mother had come to live with the daughter's family and had caused no end of disruption. In the interests of preserving her own family, the daughter had reluctantly urged her mother to return home. Every week, the daughter drove to her mother's town to clean her house and give what care she could. She stayed in a small hotel, spending money that could

have been put to use in many other ways, but she could not bring herself to stay in a filthy house and was trying to deal with her mother's incontinence, in a house that Social Services refused to enter. During our initial group sessions, the daughter chose to role-play her mother. At the end of one session, she asked us to stay a few extra minutes, and announced that she could no longer "play" her mother, and that she could not perform with us. Later she discussed the options available for her mother's nursing care. At our urging, the daughter was able to face the fact that she needed to arrange for nursing home admission for her mother. The lessons we learned from the daughter are two-fold:

1. By choosing to leave the group and complete instrumental care giving tasks, the daughter reinforced the fact that real care giving tasks supercede the value accorded to dramatically enacting them. This was a valuable reminder of Wilshire's (1991) study on the limits of theatre as metaphor. No matter how real theatre seems, real life matters more.
2. By returning to the group in the post-performance period, she validated the value of the relationship formed during the development of our performance about self-care for caregivers. By sharing her situation, and our reaction to it, she provided an excellent example of the type of insights we discovered about our own needs for self-care by using a supportive and safe environment with caring peers so that we might ask for help when we needed it.

The participant, whom we came to call the singer, was a professional singer. She was exploring work options so that she could fulfill her care giving responsibilities and still have time to pursue a career, either as a singer or as a music therapist. The singer was the one member of our group whom I believe we were unable to help. For her, attendance at the group became an extra burden, rather than a release or a respite from her other problems. Although she was unable to perform with us, she did rejoin the group after the performance and was part of the plan to find a way to continue the work of the group after the study had been completed.

My roles in the project—as facilitator, director, actor, and stage manager—changed as the group and the project developed. Initially, I provided exercises to structure the weekly group sessions. However, over time, I noticed that if I said too much, or gave very detailed instructions, it stifled creativity, and the exercises would be less successful. More and more, the group defined the activities. Thus, I found myself, two or three weeks before the scheduled performance, walking along the Thames, trying to come up with a piece I could integrate into the performance. I wanted it to be a strong image of positive self-care and also of our work together. My daily hour-long walk along the Thames gave me time to think about the project and usually

produced insights regarding what we were trying to do. Obviously, my role would have to be about walking, what it meant to me in earlier life, and what it meant to me now, after experiencing the friendship and support of this group. I realized that the Wednesday afternoon sessions had become the highlight of my week and that this group had become very important to me because of what we had shared. We had all faced the costs we had paid to give care to others, whether family or clients, and we had come to accept our lives as they were. Our lives had become much richer and happier because of our interaction during the ten months of the Healer as Artist project. Even now, two years later, walking invokes the memory of the enormous value of our collective experience, of performing our own ways of keeping compassion fatigue out of our lives.

Lessons Learned from the Final Performance

On the night of the final performance, we provided the audience and performers with optional evaluation forms. Many respondents answered the following question: *Did the performance, or any part of the project, resonate with your experience as a caregiver?* The following responses are a synthesis of what we received. The audience contributed to the project by giving us further insight into and opening another level of dialogue about the project. The following direct quotations are representative of what the audience had to say:

1. "To be a good caregiver, I believe one has to have 'given care' to oneself. The performance was about being aware of ourselves as individuals."
2. "The whole performance was a celebration of the individual."
3. "I appreciate this celebration of people who put others' needs first and are able to sustain that."
4. "After being part of this performance, I have beautiful images of walking, of being solitary, on life's journey, and the importance in all of that of support and friendship."
5. "The immigrant character represented many of our clients. That particular scene, in the multicultural reality that is London, confirmed why we do our work."
6. "I am thankful they presented a celebration of different ways of being in the world."
7. "I didn't want the show to end and I thank the performers for giving a part of themselves to us."
8. "The performance managed to communicate the spiritual and existential reality of caregiving, all the while including fun, the humor, and the creativity that are part of the caregiver's reality."

One interesting response came from an audience member who felt left out of the performance because she saw herself as a compulsive rescuer, a part she did not recognize as represented in the performance. This comment was particularly poignant because all of us knew that we had to watch out for our tendencies to be compulsive rescuers. Indeed, one participant had spent most of the ten months that we were together as a group living with friends instead of in her own home because she had given her apartment to a woman who was being abused by her husband. Her sculpture of the various aspects of being a counsellor was a triumph because it assisted her in learning where caregivers must "draw the line." In fact, she was in the process of reclaiming her apartment as the time for the performance approached.

Another finding in regard to the performance evaluations was the difficulty to distinguish between responses given by the audience and by the performers. This finding demonstrated that we had communicated something that all the caregivers present were able to experience at a fairly deep level.

The strongest and most lasting image of the Healer as Artist Project was the sense of community that both performers and audience experienced. There was no distinction between patient and professional, client and counsellor, caregiver and receiver of care. We were all in this thing called life together, and we all experienced trauma, secondary trauma, and compassion fatigue in varying degrees and unique ways. The whole point of the project was to support each other when we needed it, in a non-judgmental, caring environment. Our commitment to teamwork in supportive environments will sustain our commitment to those to whom we give care.

REFERENCES

Beckett, S. (1966). *Happy days.* London: Faber and Faber.
Boal, A. (1992). *Games for actors and non-actors.* London: Routledge.
Buyssen, H. (1996). *Traumatic experiences of nurses.* London: Jessica Kingsley.
Davies, R. (1997). *Stress in social work.* London: Jessica Kingsley.
Figley, C. R. (1995). Compassion fatigue as secondary traumatic stress disorder. In C.R. Figley (Ed.), *Compassion fatigue* (pp. 1–20). New York: Bruner/Mazel.
Figley, C. R. (1998). Burnout as systemic traumatic stress: A model of helping traumatized families. In C.R. Figley (Ed.), *Burnout in families: The systemic costs of caring* (pp. 15–28). London: CRC Press.
Freudenburger, H. J. (1974). Staff burnout. *Journal of Social Issues, 30,* 159–165.
Gibran, K. (2001). *The prophet.* New York: Random House.
Grotowski, J. (1975). *Towards a poor theatre.* London: Methuen.
Heron, C. (1998). *Working with carers.* London: Jessica Kingsley.
Miller, L. (1998). Our own medicine: Traumatized psychotherapists and the stresses of doing therapy. *Psychotherapy, 35,* 137–145.

Montgomery, C. L. (1993). *Healing through community: The practice of caring.* London: Sage.

Nathan, J. (1993). The battered social worker. *Journal of Social Work Practice, 6,* 73–80.

Norcross, J. C., & Proshaska J.O. (1986). *Psychotherapist-heal thyself.* Psychotherapy, 23, 102–104.

Portnoy, D. (1996). *Overextended and undernourished: A self-care guide for people in helping roles.* Minneapolis, MN: Johnson Institute.

Sibbald, B. (2001). The circle of nursing. *Canadian Nurse, 97,* 60–59.

Talbot, A. M., Dutton, M.A., & Dunn P. J. (1992). Debriefing the debriefers: An intervention strategy to assist psychologists after a crisis. *Journal of Traumatic Stress, 1,* 45–62.

Valent, P. (1995). Survival strategies: A framework for understanding secondary traumatic stress and coping in helpers. In C.R. Figley (Ed.), *Compassion fatigue* (pp. 21–50). New York: Bruner/Mazel.

Wilshire, B. (1991). *Role playing and identity: The limits of theatre as metaphor.* Bloomington, IN: University of Indiana Press.

Yalom, I. (1989). *Love's executioner.* New York: Basic Books.

NAME INDEX

A

Adams, Kathleen, 201, 205, 206, 207, 217
Adams, Patch, 127
Aldridge, D. & Stevenson, C., 260
American Dance Therapy Association, 276, 277, 308
Averill, J.R., 39

B

Baer, B., 204
Bartenieff, Irmgard, 281, 282
Bartol, M., 312
Beach & Kramer, 312, 313
Bean, J., 160-161
Bent, Margaret, 5, 8, 76-108, v
Berk, L., 26
Berkowitz, L., 39
Best, Penelope, 8
Blos, P., 55
Blum, D. Clark, E & Marcusen, C., 30
Boal, A., 358
Bonny, Helen & Savary, L., 136, 137, 174
Bridges, Laurel, 3-14, 305-332, v
Bright, Ruth, 162
Briks, Alan, 5, 12, 53-75, v
Browne, Dr. Richard, 157
Browning, C.A., 131, 139, 140
Buchanan, Jennifer, 5, 133, 156-166, 170, vi
Bulechek, G. M., 10
Bunt, L., 133, 171, 172, 173
Burlingame, J. & Blaschko, T.M., 109, 110
Buyssen, H., 357

C

Canadian Association of Music Therapy, 132
Campbell, Don, 137, 139
Canam, C., 341
Carr, Gerry, 5, 106-115, vi
Carter, J. Van Andel, G, Robb, G., 106-108
Chace, Marion, 4, 277-279, 297, 316
Chaiklin, Sharon, 278-281
Christofferson, Barbara, 6, 355-367, vi
Cincotta, N., 25, 28
Cousins, Norman, 303
Csikszentmihalyi, M., 6, 120

D

Damasio, A., 303
Davies, R., 357
Davis, Martha, 283
Denton and Skinner, 80
Dewey, John, 230
Di Franco, J., 131, 133, 134, 137, 140, 141
Diamond, S.A., 39, 40, 41, 42
Dossey, et al., 12

E

Edwards, Jane, 5, 149-155, vi
Ell, Kathleen, 24
Emunah, R., 41, 350
Epstein, Marcia, 6, 171, 187-197, vii
Erikson, E., 24, 341
Esman, A., 55

F

Faller, K., 25
Figley, Charles, 356
Fowler, Karen, 5, 131–148, vii
Freudenberger, H.J., 356
Fuchs, Annamarie, 6, 259–271, vii

G

Gadow, S., 261, 262
Gaston, E.T., 172
Georges, J.M., 259
Goldman, J., 134
Grotowski, J., 358
Guzzetta, C., 139

H

Hanser, S., 136, 159
Hayes, Gaile, 170
Heath, Wende, 5, 116–128, vii
Henley, Nancy, 323–326
Hevner, K., 167, 175, 176–177
Hill, Heather, 309, 313, 316
Hobus, R., 205
Hoffman & Platt, 307
Holly, M.E., 220
Hu, Dr. Bin, 168
Hutchinson, SA, 260

I

Institute for Health & Healing, 116
Irving, W., 259, 262, 265, 268, 271

J

Johns, C., 230, 232

K

Kaplan, F.R., 39, 41, 42, 46, 50
Katsh, S. and Merle-Fishman, C., 171
Kestenberg, Judith, 313–314, 319–321
Khalsa, R.R., 338
Kierr, Susan, 6, 292–304, viii
Killick J. & Allan K., 11
Kornfield, J., 145

Kubler Ross, E., 23
Kumar, A., 163

L

Laban, Rudolf, 281–282, 314
Lamb, Warren, 314, 324
Landy, Robert, 9, 337–338
Lauria, M., 19, 21–23, 25
LeNavenec, Carole Lynne, 3–14, 167–186, vi
Le Vasseur, J.J., 11
Lenninger, M., 260
Linesch, D., 55
Loman, Susan, 319–320

M

Malchoidi, C., 7, 8
Malekoff, A., 340
Malmquist, C., 55
Maranto, C., 134, 150
Mayeroff, M., 232
McClellan, R., 135, 168, 171–173
McCloskey, Dochterman, J., 10
McNiff, S., 56, 201
Mitchell, M.A.O., 339–140
Montgomery, Carol L., 10, 358
Moon, B., 40, 50
Morrison, Kim, 5, 38–52, viii
Murray, Susan Boon, 6, 201–229, viii

N

National Association for Drama Therapy, 337
Nealon, M.J., 205
Newman, M.A., 315
Nightingale, Florence, 135, 158, 163

O

Osoff Bultz, B., 5, 167–186, ix
Olson, S., 134

P

Parr Vinjinski, Jon, 5, 167–186, ix
Parse, Rosemary, 4

Name Index

Paterson, JG and Zderad, L.T., 231
Peplau, H., 10
Piaget, J., 24, 341
Pirner, Diane, 5, 167–186, ix
Pope, D.S., 132, 136

R

Remen, R. N., 120
Ridenour, A., 118
Riley, S., 41, 56
Roberts, G., 344–345
Robinson, C., 341–342
Rogers, Carl, 77

S

Sacks, Oliver, 169–170
Samuels, M. & Rockwood Lane, M., 7
Sandel, Susan, 309, 314
Schaeffer, R. Murray, 187, 188
Scartelli, J., 134
Scartelli, J., 168, 169
Schell, B.B., 77
Schmais, Claire, 278–281, 316
Scotto, C.J., 10, 11
Sloboda, J., 176, 182
Smeijsters, H., 175
Society for the Arts in Healthcare, 116
Soderling, Elizabeth, 5, 17–37, x
Sourkes, B., 30–31, 32
Spinetta, J., 20, 27
Stelter, R., 262
Storr, A., 170, 179–180

T

Talbot, A, Dutton, M. and Dunn, P., 356
Taylor, Geraldine, 5, 8, 76–105, x
Thorne, S., 341–342
Tomatis, Alfred, 137
Topf, M., 188, 189
Turner, A., 77

U

US Environmental Protection Agency, 189

V

Valent, P., 359
Verny, T., 137, 140
Vickers, Andrew, 163

W

Wagner, A. Lynne, 6, 229–257, x
Walsh, Richard, 336, 348
Watson, Jean, 11
Watson, Jean, 231
Webb, N., 26, 28, 33
Winnicot, Donald, 302
Wolfelt, A., 23

Z

Zimbelmann, Christine, 6, 275–291, x

SUBJECT INDEX

A

Abandonment, 100
Academy of Cerebral Palsy, 336
Acceptable social behavior, 338
Acoustic Ecology, 187–188
 definition of, 187
 history of, 187–188
Adaptive equipment, 113
Adjustment, 31
Adolescents, 5, 25, 38–52, 54–58, 161–162, 349, 350
 treatment, 54–74
Adulthood, 5–6
Age appropriate peers, 358
Ageism of knowledge, 12
Aggression, 39
Alcoholism, parental, 91
Alzheimer disease, 162–163
Ambient Noise, 189
Anger, 39–40, 101
 management, 5, 38, 42–43
Anticipatory Grief, 24
Approval, need for, 86
Art, 15–128
 Materials, 43, 121–122, 124
Art in Medical Settings, 116, 118
 Image Cards, 122–123
 With Cancer Patients, 125
 With Children, 31, 124
 With Older Adults, 121, 125–126
Art making in nursing practice, 230–232, 234–236, 241–247
Art therapy, 5, 38–52, 53–75, 116–128
 and adolescence, 40–42, 54–58
 assessment, 60
 benefits of, 57–58
 case study adolescents, 44–50, 58–74
 conflict resolution, 42
 criteria for inclusion, 50–51
 directive tasks, 54
 practice of, 53–54
 session format, 43–44
 spontaneous art, 54
 and therapeutic transformations, 57, 58–74
 treatment framework, 54
 treatment goals, 54
Arts in medicine, 4, 7, 8, 116, 118–119, 121–122
Assessment, 25–30, 80, 82, 83
Audio visual feedback, 338
Auditory Ambience, 188
Autonomy, 25

B

Background information gathering, 81
Bibliotherapy, 204
Biological theories, 80
Block Treatment, 347
Body Action, therapeutic aspects of, 278–279
Body memories, 302
Brain Injury (*see* Traumatic Brain Injury)
Burnout (*see* Caregiver Burnout)
Buss Durke Hostility Inventory, 38, 43, 45, 50

C

Canadian Operational Performance Measure, 345
Cancer, 117, 118, 119, 125, 293–294

Cancer, Childhood, 5, 18-37
Cardiac patients, 300
Carative Behaviors, 10
Caregiver(s), 355-360, 364
Caregiver Burnout, 5, 355, 356, 357
Caregiving-non verbal aspects, 321-322
Caring, 3, 4, 10-12, 229-230
 caring communities, 253
 caring moment, 229, 246, 247
 caring nurse-self, 230, 231, 252, 255
 definition, 10, 229
 levels of caring, 230
 meaning of caring, 252
 transpersonal caring, 231
Caring Constructs, 260
Catharsis, 41-42
Cerebral palsy, 159, 335
 Motor control in, 160
Cerebrovascular Accident, 295
Childbirth, 5, 131, 136, 139-141, 143-145
Childhood, 5
Child Development, 24-25
Chronic Illness, 6, 341
Chronic Pain, 6, 301-302
Clay work, 90
Client-centred therapy, 77-78, 88, 93
Clinical reasoning, 77
Cognitive impairment, 162-163, 310-312, 340
Collaboration, 3, 8-9, 329
Community drum circles, 164
Communication in art, 30, 31-32
Communication in music, 160, 161-162
Compassion fatigue, 356-358, 365
Concretizing, 336
Consent Form for Writing Expression, 224
Control, 28, 29, 31
Coping, 28, 31
Corrective feedback, 336
Crafts, use in Therapeutic Recreation, 107-108, 112
Creative Nursing Journal, 6
Creative Writing, 6, 201-271
Creative Arts Program, 116, 117, 336
Creative Drama, 336
Creativity. 3, 6-7, 40, 116, 127
Creating Meaning, 260
Crisis theory, 24

D

Dance, 275-332
 Therapeutic aspects, 275
Dance movement therapist
 as part of treatment team, 302
 role as Activity Director, 292-293
 training, 309
Dance/Movement Therapy, 275-332
 case study, caregivers, 326-328
 case studies, chronic illness, 293-302
 case study, dementia patient, 318
 case study, psychiatric patient, 284-290
 definition, 276, 308
 history, 275-277
 goals, 282, 289-291
 outcome, 289-290
 populations worked with, 309
 theory, 278-281
 use of music, 294, 295, 296-297, 298, 299
 with older adults, 307, 309
 with psychiatric patients, 283-284
Dementia, 6, 12, 163, 310-312
Depression, 5
 art treatment, 126
 diagnosis of major, 82
Developmental age, 345
Developmental disability, 56
Developmental stages, 25, 26
Developmental theory, 24, 25
Diabetes mellitus, 296-298
Disenchantment Stage, 342
Disequillibrium, 24
Dolls, Therapeutic use, 123-124
 story dolls, 123
 worry or prayer dolls, 123
Drama, 335-367
Dramatic movement, 299-301
Dramatic play, 350
Drama therapist, 355, 337
Drama therapy, 6, 337-338

E

Electric keyboard, 298-299
Empathetic Reflection in movement, 316-317
Empty chair technique, 336

End of Life, 6, 263–271
Endings, 96, 101–102, 103
Enmeshed relationships, 349
Entrainment, 133–134
Environmental Application, 6, 27, 117–119, 187–196
Equilibrium, 24
Ethnomusicology, 195
"Etude," 179–180
Evaluation technique, 79
Expressive Art, 30, 31–32, 116, 118
Expressive Arts Therapy, 116, 119
 Case Vignettes, 118, 120–121
 Facilitating participation, 124–125
 Interns, 119

F

Family centered care, 339
Feeding tube, 295
Finding Meaning, 34
Flow, 120, 121
Formal Operations, 25
Friendship, lack of, 81
Friendship, loss and reconnection, 93, 94, 102

G

Goal attainment, 96, 97
Goal setting, 87
Grief, 23–24
Group activity, 340
Group therapy, 42–43
Grove's dictionary of music & musicians, 171
Guarded Alliance Stage, 342
Guided Imagery, 136–137, 301

H

Healing Spaces, 118–119
Healthy choices, 348
Health and hygiene, 346
Hearing protection, 195
Holistic Nursing Care, 11
Home safety, 347
Homework, 88
Hope, 96

Human occupation modal, 80
Hypervigilant, 349

I

Identity versus confusion, 25
Improvisation, 337–338
Individuate, 349–351
Integrated School Settings, 339
Interest checklist, 83
Independent Living Skills, 344–345
Instrumental tasks, 340–341
Intuition, 159
Iso-moodic principle, 175, 177

J

Journaling, 88, 93, 94, 100, 201–208, 234, 235–236, 237
 As Professional Development, 219–220
 As Educational Tool, 219–220
 Case Studies Rehabilitation, 208–218
 Case Studies Students, 220–223
 Definition of, 204
 Outcomes of, 217
 See also reflection through story, 247–249
 Techniques and strategies, 207–208
 Therapeutic Application, 204–207
 Toolbox, 207

K

Kestenberg Movement Profile, 319–322
Kitchen Management, 346
Knowing in nursing, 229
 personal knowing, 230, 231

L

Labanalysis, 281–282, 314–316
Laughter, benefits, 86–87
Leisure skills, 110, 346–347
Letting family down, fear of, 98
Lifecycle Stage, 349–350
Life skills, 335–336
Life Skills Inventory, 348
Limb Salvage, 19, 28
Lived Experience, 208
Locus of Control Inventory, 50, 57, 60,

65, 38, 43, 45, 46, 50
Loss, 23, 24, 28

M

"Madrigal of Light," 180
Magazine Photo Collage, 209
Mask work, 337
Medical Art Therapy, 117
Meditation Room, 126
Melody (theme, subject), 173
Mind/body connection, 168
Mirroring, 280, 299, 317, 336,
Mood disorders, 79–80, 82
Mood wheel, 167, 17, 176–178, 182–183
Monodrama, 336
Movement as communication, 307–308
Movement Analysis, 281–282, 314–316
Movement style, 312–313
 in dementia, 312–313
Multi-disciplinary team, 19, 336, 343
Music, 129–197
 as nursing intervention, 133
 benefits of in childbirth, 143–145
 case study, pregnancy, 141–143
 choice of in pregnancy, 137–138, 140–141
 dynamics of, 172
 effect on fetus & neonates, 137–138
 effect on Melatonin levels, 163
 effect on health & well being, 163–164
 emotional attributes of, 177–178
 emotional responses to, 176–181
 guidelines for caregivers use, 139–140
 healing properties, 132
 in childbirth education, 139–140
 in circumcision, 138
 in labor & delivery, 139–140
 in pregnancy, 137–138
 in postpartum period, 141
 intentional use of, 163–164
 library of, 164
 opera, 16–161, 164
 physiological responses, 134
 romantic style, 178–179
 structure, 172
 tempo, 172
 timbre, 172
 tone or color, 172

Music as Soundscape, 188–189
 background music, 191–195
 effect of familiar music, 193–195
 effect related to culture, 194
 effect related to religion, 194
 guidelines for selection, 191–193
 healthcare settings, 191–193
 individual response, 191
Music Therapy, 5, 132–133, 149–155, 156–166
 benefits of (wellbeing), 157, 158–159, 163
 case study-adolescent, 161–162
 case study, cerebral palsy, 159–161
 case study-older adult, 162–163
 competency standards, 157–158
 definition, 132–133, 149
 history of, 132, 157–158
 in nursing, 132–133
 music selection, 151–152, 164
 outcome evaluation, 152–153
 principles of, 157–158
 professional training, 150–151
 research, 152–153
 techniques, 151
 therapeutic process, 149, 151
Music therapist, 149–151, 157, 167
Musical journey, one's personal, 156, 164, 165
Musical journal, reflective, 184
Musical pharmacy, 167, 176–178, 184
Musical modes, 172
Musical/sound elements, 171, 172, 182, 183
Musicians, 158

N

Naïve Trust Stage, 342
Needs Assessment, 338–339
Neurology, 6, 335
Neuromuscular/Muscular Dystropy, 335
Neuroscience Clinics, 338
Noise, 188, 190, 195–196
Non verbal communication, 305–307, 310–313, 322–326
 in dementia, 310–313
Non verbal nursing approaches, 312–313, 317, 321–322, 322–326
Nursing, 4, 6, 6–8, 10–12, 120–121, 132–133, 229–231, 232–247, 256, 260, 261, 271,

292, 293, 303, 305, 307, 312–313
 art of, 11, 229, 252
Nurse-patient relationship, 230
Nurse-self, 230, 255

O

Occupational Therapy (OT), 5, 76–78, 342–343
 OT Assessment Tools, 80, 83, 84, 103
Object relations, 80
Observation, 80
Older Adults, 5, 121, 125–126, 156, 162–163, 309–313, 318
Osteogenic sarcoma, 18
Osteosarcoma, 18
Outcome indicators or measures, 103, 184

P

Palliative Care 6, 169, 261, 263–271
 case studies, 263–271
Pain medication, 301
Pantomime, 337
Parent Questionnaires, 348
Parents of persons with special needs, 159
Parental control, 89
Parkinson's disease, 168
"Pastoral: The Dawning of the Day," 180
Peers, 25, 29, 344
Performance Creation, 355, 356, 357, 358
 case study, 358–366
Person-in-environment, 19, 22, 25
Personal & social adjustment, 347
Physical discomfort, 159–160
Physical Rehabilitation, 6, 202, 208–218
Pitch, 133, 173
Play, 30–31, 122, 123
Poetics, 259, 260, 261, 262
 use of in nursing case study, 264–265, 266–268, 269–271
Poetry Writing in nursing practice, 230–232, 237–239, 240, 241
Pottery in therapy, 85, 89, 93, 96–97, 100, 104
Prayer, 297
Pre-adolescents, 355, 337, 344, 348
Presence in caring, 119–121
Professional Crisis of faith, 261

Prognosis in Childhood Cancer, 17
Projection, 86
Psychiatric, 6, 275, 283–291
Psychodrama, 336, 337
Psychological reparation, 69–70
Psychologist, 335, 338
Psychoneuroimmunology, 134
Psychosocial Issues, 20–22
Psychotherapy, 337
Puppetry, 337

Q

Quality of Life 106, 163

R

Reauthoring, 254
Reconciliation, 23
Recreation/Child Life, 336
Reflection after session by therapist, 82
Reflective practice, 230
 aesthetic reflection, 230–233
 aesthetic reflective process, 231, 254, 256
 case example, 247
 levels of reflection, 252–256
 reflection through art, 234–236, 241–243
 reflection through poetry, 237–239, 240–241
 reflection through sharing, 241, 249–250
 reflection through story, 247–248
Rehearsal, 336
Relaxation techniques, 301
Replay, 336
Resolution, 23
Rotation Plasty, 19
Rhythm, 173
Rhythmic Group Activity, 28–281
Roles, 104, 337
Role checklist, 82
Role-play, 299, 301, 326–329, 336, 337
Role-Reversal, 336

S

Scene enactment, 336
Schools, 5 42, 44
Screening, 25, 31
Secondary trauma, 356, 357, 358

Secondary traumatic stress, 357
Sedative/relaxing music, 172, 173, 177
Seizures, 335
Self-care, 184, 355, 356, 357, 361, 364
Self-esteem, 25, 28, 338, 339
Self-harm, 5, 58, 60-62
Self-image, 25, 28, 29
Sense of self, 89, 93-94
Sexual abuse, 62-64
Singing, 162
Stress Relief, 162-163
Skill acquisition theory, 80
Skilled nursing, 292
Social Skills Training, 336
Social Skills Group, 335, 337, 344-345
Social Work, 19, 20, 30, 335, 336
Social Work Oncology Group, 19
Song, 161, 162
"Song of the Nightingale," 178
Sound, 131-132, 187-193
 as signal of health, 189-190
 as carrier of information, 189
 case study Children's hospital, 190-191
 properties of, 133-134
 physiological responses to, 134
 psychophysical responses to, 135-136, 188-189
Soundscape, 188
Speech and Language Pathology, 335
Special Needs Students, 339
Spectograms, 336
Stages of Grief, 23
Stages of Illness, 22-23, 25
Strength-based group work, 340
Stimulative/stimulating music, 172, 173
Storytelling, 122
 image cards, 122-123
 story dolls, 123
 worry dolls, 123
Students, 5, 167, 170, 183, 203, 218, 225, 232-233
Suffering from sufferer's view, 259
Suicide, maternal, 91-92
Superego, 65
Supervision group, 88

Support factors, 29
Surplus reality, 336
Symbolism in Movement, 279-280
Symbols in Language, 260

T

Television, use in therapy, 297
Theatre arts, 340-341
Theatrical production, 337
Theoretical framework, 231-233
Therapeutic alliance, 60
Therapeutic brain stimulation program, 168
Therapeutic movement relationship, 280
Therapeutic Recreation, 5, 106-115, 203, 219-225
 adaptive devices, 112
 assessment in, 109
 case studies clients with TBI, 107-108, 114-115
 community resources, 113
 definition of, 107
 discharge planning in, 113
 history of, 106-107
 interventions, 111-112
 process of therapy, 108-109
 role of, 106-107
 treatment goals, 111, 114
 treatment planning, 111-112
Therapeutic relationship, 158, 229, 294, 302-303
Therapeutic transformation, 57, 58-74
Therapeutic transference, 304
Traumatic Brain Injury (TBI), 5, 107, 109-111, 115
 effect on leisure interests, 110-111
 treatment goals, 111
Treatment resistance, 55

V

Value clarification, 297
Vibration, 133
Victimization, 70, 73